J. RUSSELL HARPER

Painting in Canada
A History

SECOND EDITION







J. RUSSELL HARPER

Painting in
Canada
A History

SECOND EDITION

UNIVERSITY OF TORONTO PRESS
Toronto and Buffalo

©University of Toronto Press and
Les Presses de l'université Laval, 1966
Reprinted 1970
Second edition 1977
Printed in Canada

Canadian Cataloguing in Publication Data

Harper, John Russell, 1914–
Painting in Canada

Bibliography: p.
Includes index.
ISBN 0-8020-2271-5 bd. ISBN 0-8020-6307-1 pa.

1. Painting, Canadian – History. I. Title.

ND240.H3 1977 759.11 C77-001492-5

This book has been published during the
sesquicentennial year of the University of Toronto

J. RUSSELL HARPER, a highly respected art historian, has worked in many art galleries and museums across Canada. Among his books are *Early Painters and Engravers in Canada, A People's Art: Primitive, naïve, provincial, and folk painting in Canada,* and *Paul Kane's Frontier.*

Acknowledged for a decade as the 'ultimate authority' on the subject, J. Russell Harper's classic study, *Painting in Canada,* is now reissued in a compact edition. Although the size and the number of illustrations have been reduced, the text has not. It has been revised and expanded, incorporating the findings of Mr Harper's research since the original publication. The result is a comprehensive survey of Canadian painting from its beginnings in the seventeenth century to the present.

Through a happy combination of entertaining anecdotes, descriptions of the cultural background, biographical accounts, and critical judgments, the reader comes to know intimately the artists, their paintings, and their environments. The volume contains 173 black and white reproductions – 45 not included in the first edition – which allow the reader to see representative works from all periods.

In writing this history Mr Harper has considered the works of hundreds of artists who have contributed to the rich and varied heritage of painting in Canada, and traces in detail the forces that have moulded their styles and affected their choice of subjects. The reader gains a vivid impression of the significance of Canada's environment, physical and social, in shaping its artistic expression.

It is an especially important feature of this work that the author has placed studies of regional development of style in a broad perspective, giving a coherent and integrated picture of the national development of Canadian painting. Equally important is the recognition of the growth of Canadian art in relation to English and French traditions and of the pioneer painter's role as a moulder of older patterns into new forms having their own character and originality.

Painting in Canada provides a visual record of a developing nation which will be appreciated by all who are interested in the cultural and social history of Canada.

'the finest and most comprehensive history of Canadian painting yet published.' *artscanada*

'Harper adds a dimension to Canadian art we had no idea existed.' *Saturday Night*

Preface

A unique opportunity to record the development of painting in Canada was provided when the Canada Council, in cooperation with the University of Toronto Press, agreed to sponsor this volume for the nation's centenary.

The history, published in 1967 simultaneously in English and French, had been almost three years in preparation. The Council's assistance made possible a generous format that allowed extensive and well illustrated coverage of the various periods and movements in the growth of Canadian painting. Various factors entered into the selection of illustrations. It was felt appropriate to include a number of canvases that were familiar to the public and that have become permanent fixtures on the Canadian art scene. Several illustrations served a purely documentary purpose, and others demonstrated points of style discussed in the text. It was particularly satisfying to be able to present, in addition to a sampling of Canada's untold wealth of paintings from all periods, a broad selection of illustrations not previously available in books and catalogues and not widely known to the public, despite their high quality and importance.

There had long been a need for a volume that would trace the development of Canadian painting from its roots some three centuries ago to its diverse modes of expression in the twentieth century. My aim was to write a history that would present for the general public an accurate, documented survey of Canada's very considerable aesthetic achievement in painting, one that also incorporated the scholarship and research that had been done on the subject to date. I included a considerable amount of biographical and anecdotal material in the coverage of all periods. Such details provide useful background for a more thorough understanding of the artist's approach to painting and a fuller appreciation of his works.

The original edition of this book has been out of print for several years; public demand has prompted this revised edition. The text has been amended to incorporate both certain new attitudes in the field and additional details gleaned through continuing research. It seemed appropriate to complete the survey at about 1960 rather than extend it to embrace more recent developments. By that date older figurative approaches to painting were being challenged by radicalism throughout the country in an effective way, and subsequent developments seem to belong in an evolving present rather than fitting into a historical perspective. All colour plates of the original edition and a number of black and white illustrations have been deleted. Some resultant substitution of illustrations has been made to better demonstrate points in the text. This regrettable change in illustrations was necessary to reduce costs and bring the book within the easy reach of students and the wide body of Canadian readers for whom the original volume was conceived.

As I wrote in the preface to the first edition, it is of prime importance that a history of this nature reflect the bicultural traditions of our national life in both text and illustration. Few authors have examined critically the growth of art in Canada in relation to the English and French continental traditions. Such a study is of much significance, for it clarifies the pioneer painter's rôle as a moulder of older patterns into a form of painting characterized by its own originality. It helps make clear when Canadian painters, schooled in the French and English traditions, were first able to develop their own individual manners of expression.

This country's art also takes on more meaning when examined as an integral part of the life of an expanding nation. Painting, like the other arts, often reveals itself closely related to or interdependent with many elements in Canadian society, such as geography, economics, religion, and politics. What may be a minor achievement in the sophisticated twentieth century can loom as a major triumph in a struggling colonial environment. Thus late seventeenth- and early eighteenth-century ex-voto painting, Quebec portraiture of a century later, Group of Seven nationalism, and the post-war art revolution may each be of equal importance when assessed in terms of relative achievement in its own milieu. In addition, one must also search for true greatness in the works of isolated individuals; the real artists are those men and women gifted with sensitivity and vision beyond their companions.

While a substantial number of monographs and other studies have been published on individual artists and particular periods in the his-

tory of Canadian painting, the relative absence of a national outlook on this country's painting and painters has tended to produce regional thinking in art matters. For example, developments in the eastern and western provinces need to be described and evaluated in relation to one another as well as to those in Ontario and Quebec. Too many French-Canadian art publications appear only in the French language, and English-Canadian works are almost exclusively in English. The result is that a national public does not have the opportunity to appreciate the contribution of each section of the country to the scene as a whole, and it is appropriate that an attempt be made to place these regional studies in a broader perspective.

The history of Canadian painting is far too extensive a subject to permit encyclopaedic coverage in a volume of this length and scope, and not all phases and artists can be treated here. When one considers that approximately 4,000 painters were active in this country before 1900 and that an unprecedented surge of activity in painting is under way in our own century, some of the difficulties become evident. Within these limits, however, it has been my intention to present as thorough as possible a survey of the artists and movements that have contributed to the rich and varied heritage of painting in Canada.

In addition to the generous financial assistance of the Canada Council, to whom I should like to express my sincere gratitude, in the preparation of the first edition, I am also greatly indebted to a host of persons in all provinces for their assistance, including staff members of art galleries, artists, and others too numerous to mention individually. Many persons permitted the reproduction of paintings in their collections, and their kindness is much appreciated.

In my efforts to maintain proper perspective and balance throughout the writing of the first edition, I was fortunate to have the benefit of the excellent suggestions and constructive criticism offered by an advisory board arranged for by the Canada Council and the University of Toronto Press. I would like to single out its members, Dr Ian McNairn, M. Gérard Morisset, M. Guy Viau, and Dr Stephen Vickers, for special thanks.

The publication of this second edition was also assisted by the Canada Council through its program of block grants to publishers.

J.R.H.

Contents

Part One
The French Colony
1665-1759

1

The Age of Laval

Canadian painting had its quiet beginning in the Quebec City of three centuries ago. The streets were narrow and winding, the buildings crude and draughty, the residents rough frontiersmen, soldiers, with only a few aristocratic officials and churchmen. Yet the Catholic Church gave active patronage to the arts, and within half a century after the founding of the colony painting began to flower in this unlikely setting. Scattered and fragmentary anecdotes describe how a few dedicated professional artists and amateurs created canvases on the seventeenth-century frontier in imitation of those they had known in France.

Samuel de Champlain and other early explorers sketched in the New World, but Abbé Pommier was probably the first real painter to work in Canada.[1] His name appears frequently in Bertrand de Latour's biography of Bishop Laval de Montmorency,[2] which describes how Laval met the young priest from Vendôme when visiting Paris during the early months of 1663. The energetic first resident bishop of Quebec was recruiting religious workers for Canadian churches at the psychological moment when foreign missions had caught popular French imagination. An elegiac poem had been printed and widely distributed that very year describing in florid Latin the heroic Jesuits in Huronia and their savage murder by the Indians. The emotional Pommier volunteered for service and in the autumn boarded a man-of-war as its chaplain during the Atlantic crossing. When his ship halted at the little French community of Plaisance, Newfoundland, he found their local priest had been killed by Indians, so he remained for the winter to carry on the murdered curé's work. He proceeded on to Quebec by the first ship in 1664.

Pommier found himself in a town of seventy dwellings. There were only 2,000 French settlers in all Canada, chiefly fur-traders, *coureurs de*

bois, and military men. It was barren soil for cultivation of the arts. As a member of the Quebec Seminary staff, he soon was embroiled in the bitter petty quarrels between Laval and Governor Mézy as to which one took precedence in the colony, and, at the Bishop's order, he denounced the governor from the pulpit of the parish church. Mézy was furious. Next a pickpocket robbed Pommier when he was out for a walk in the street, and the event received much publicity when the thief was caught and then whipped in both the Upper and the Lower Town. Laval attempted to remove his unfortunate abbé from further embarrassments by assigning him in 1669 as first parish priest to Boucherville. But more troubles followed when the local parishioners accused their new priest of being lazy, for in one year he had performed no baptisms, no funeral services, and only four marriages. In all fairness, he did commence construction of a parish church in 1670. Later Pommier worked under Laval's instruction at Sorel, along the Beaupré shore, on the Île d'Orléans, and at Lévis. Evidently he had a restless and discontented artistic temperament, and when people murmured about his instability and there were continual rumblings about his apathy towards mission work, Pommier was returned to France at his own request after sixteen years in Canada.

Bertrand de Latour describes Pommier as an artist whose paintings were all bad, although he considered himself a neglected genius. Like other seventeenth-century artists in New France, he seems to have had little interest in recording the adventurous frontier life or other incidental happenings which could have brought alive a page of history. Rather he and his more important contemporary, Frère Luc, were disciples of the grand manner in art, of the Renaissance in its dying phases with its fondness for starkly posed and artificial tableaux so far removed from contemporary life that even the clothing is a reflection of the Near East of another day. Yet their adherence to the rules by which they were taught is quite understandable when one recalls that there was a great public outcry a century later because Benjamin West in painting *The Death of Wolfe* dared to dress his soldiers in contemporary army uniforms rather than the classical armour traditionally worn by heroes.

It has been suggested that this priest, who was probably more interested in art than in his parish duties, painted three canvases still in Quebec City. The difficulties of studying the three paintings attributed to Pommier are those which all serious students encounter in attempting research on Canadian art before 1820. He signed few canvases: early Canadian painters rarely signed their works. There are a few documentary records, but they are so ambiguous as to be almost

useless. Attribution of early works to individual artists on stylistic grounds is chiefly a matter of speculation, for these first painters seldom developed individual mannerisms. Only a few early Canadian works have been examined scientifically, and many have been repainted so often that the original artist's intention is altered completely.

A much mutilated canvas of the *Martyre des Pères Jésuites chez les Hurons* has hung for centuries in the Hôtel-Dieu, Quebec. In it several separate incidents occurring in the 1630s and 1640s have been gathered together into one composite historical painting. Fathers Jean de Brébeuf and Gabriel Lalemant, missionaries to Huronia, were tortured by the Iroquois in 1649, and in the painting these priests submit to mock baptism with boiling water, wear a collar of red-hot hatchets, and are subjected to other forms of excruciating pain. Father Daniel, Father Gabriel and each of the others undergoes his own particular trial in a different part of the painting, but the figures are so stylized and posed in this remote, sentimental tableau as to radiate little or no genuine emotion. The picture is copied from a European engraving which had been prepared by Grégoire Huret in 1664 for a history of Canada by Father Du Creux[3] and has all the tightness of execution found in the works of copyists. This book was probably sent to Canada immediately after publication since it was printed in part for 'The Band of Women of New France assembled under the name of St Joseph for looking after the health of the Indians.' These were the Hôtel-Dieu sisters who arrived in Quebec during 1639. Some assert that the canvas was painted by Pommier since Mother Marie de l'Incarnation wrote that he was the only painter then in Quebec. However, no documents support this attractive theory which would have made this the earliest oil painted in Canada. On the other hand, at least one other very early copy of the Huret engraving is known which was painted in France, and it is entirely probable that the Hôtel-Dieu canvas was also painted there and imported from overseas.

There are better reasons for believing that a second painting in the hospital, the portrait of Marie-Catherine de Saint-Augustin, was painted by Pommier in May 1668. The nun died amid great sorrow at the Hôtel-Dieu, Quebec, where the mourning sisters arranged for an artist to paint her portrait before her burial, a comparatively common practice in seventeenth-century Canada. The community still owns the canvas, and an ancient inscription states that this is Abbé Pommier's work. The original painting was completely repainted during the nineteenth century. An X-ray examination has disclosed the original head beneath. The lines of the habit around the face have

been altered, the eyes formerly closed in death, have been repainted as open, giving a less macabre effect, and recently added touches of colour flush the pallid cheeks.

Four years later Mother Marie de l'Incarnation was buried at the Ursuline Convent, Quebec. She was renowned for her skilful decorative embroidery and needle-work which was donated to churches and chapels throughout New France, and she also painted altar frontals, some of which are still in the Ursuline Chapel. Her features are known from a posthumous portrait painted at the conclusion of the long and elaborate funeral ritual. The circumstances as recorded are these:

Everyone present in looking at the mortal remains of the Venerable Mother, at the moment when they were going to close her coffin ... was struck by the divine radiance which still shone in her face. And so, when the crowd had left the holy place, M. de Courcelles [the Governor] and M. Talon [the Intendant] agreed with the ecclesiastics present, and the community, that it was necessary before sealing this tomb, to preserve for posterity the features of the deceased. They withdrew the body from the grave, and the next day an artist sent by the governor succeeded in painting, with a lifelike resemblance, this gentle face, marked with the halo of the saints. The bier being then closed, they placed on it the inscription.[4]

This artist was probably Pommier. The original portrait was burned in the Ursuline Convent fire of 1686 but a replica, previously sent to France, was returned to the new building where it still hangs and conveys some idea of the original.

Subject matter is the only Canadian element in these paintings with which Pommier's name is associated, and he was obviously a French-trained provincial artist who continued to work overseas in the same style he had practised at home. The majority of early Canadian artists, like Pommier, painted in a provincial Baroque or a provincial mannerist or some other provincial style, and were painters working in Canada rather than Canadian painters. No strong distinctive Canadian style or tradition emerged until the end of the eighteenth century, but the earlier paintings are of the greatest historical interest for they symbolize the determination of colonists that Canada should be something more than a trading state. These three canvases, like most of the surviving few dozen others painted in Canada under the French colonial régime, have been handed down from generation to generation by religious communities or church authorities. Other repositories of earlier art are the Ursuline convents in Quebec and Three Rivers, the Hôtel-Dieu hospitals in Quebec and Montreal, the Grey Nuns' Moth-

erhouse in Montreal, and the shrine at Sainte-Anne de Beaupré.
There are scattered examples also in some older churches, museums,
and private collections.

Virtually all canvases painted in Canada before 1700 have religious
subjects since they were painted for churches and monastic houses.
Many biblical scenes were displayed on church walls so that humble
parishioners – *habitants*, labourers, and the poorer people of New
France – could visualize the Gospel through paintings. Others, such as
martyrdom scenes, commemorated church activity in the New World.
Most portraits were of churchmen, from the bishop to the lowly parish
priest, and they were hung in the halls of buildings where the sitters
had spent their religious years to keep alive a memory of their weary
labour in the cause of faith and mercy.

Religious paintings sometimes were called upon to play unexpected
rôles in French colonial Canada. One remarkable instance occurred
when the British Navy under Admiral Phips laid siege to Quebec in
1690. Governor Frontenac decided to resist the enemy's attack even
though the town's defences were in an appalling state. Bishop Laval
invoked divine protection for the city and ordered that a canvas of the
Holy Family be borrowed from the Ursulines and mounted on the
parish church tower for all to see; the painting (possibly one still
owned by the Ursulines and attributed to Frère Luc; see p. 11) was
unharmed during the unsuccessful siege, although English cannon fire
riddled much of Quebec.

As this account has suggested, it was the Catholic Church which
chiefly advanced artistic as well as educational and other cultural
affairs in New France. Bishop Laval, posted to Quebec in 1659, ex-
erted his organizing genius on all aspects of religious work; the church
in turn participated in every phase of community life. Even with his
limited resources, Laval actively began to strengthen the rôle of the
church in order to keep pace with a new and more vigorous coloniza-
tion scheme initiated early in the 1660s. He built elaborately deco-
rated churches, and schools for the education of both scholars and
craftsmen, promoted hospitals, and despatched priests to found new
parishes in the outlying settlements and to carry Christianity to the
Indian tribes. Paintings by Pommier and other later artists were a by-
product of the church's promotion of the arts.

Two French missionaries, both amateur painters, passed through
Quebec en route to the Iroquois mission field; they, like so many
others, were playing a part in Laval's ambitious religious organiza-
tion. The Jesuit Father Pierron came to North America in 1667 and
worked as a missionary among the Iroquois in upper New York state.

When he visited Quebec, Mother Marie de l'Incarnation wrote that he 'preached by day and painted by night.' Father Pierron used his paintings, which apparently were miniature views illustrating the virtues and vices, Heaven and Hell, and the like, for teaching the meaning of Christianity to Indians at his mission. Father Chauchetière, another Jesuit, worked among the Caughnawaga Indians from 1679 to 1694. He sent to France, as did other missionaries of his order, an annual narrative of the year's most important incidents which was then published, but his manuscripts differed from those of others by being illustrated with small drawings. Father Chauchetière painted teaching aids like those of Pierron. Chauchetière finished a portrait of Catherine Tekakwitha, a naïve rendition, stilted in execution and conception, showing an Indian girl standing in prayer; a painting now at the Caughnawaga mission may be Chauchetière's original, although it is more likely to be a very early (and accurate) copy. One associate described the circumstances under which the canvas was completed, recounting that in 1683 the artist had twice seen the girl in a vision and was then 'commanded by a heavenly voice to paint what he had beheld.'

Canadian painting received an unexpected impetus when the Recollets returned to the New World in 1670. They had had missions in Quebec during Champlain's day, but left abruptly in 1629 after many dissensions and quarrels. Bishop Laval warmly welcomed six members led by Father Allart, who undertook to re-establish the order in Canada, since this would be a further strengthening of the religious element in the community. One member, Frère Luc, was a well-known Parisian painter, and his paintings of the Virgin, the Christ Child, and the mysteries of God must have been like some heavenly vision to simple people living in tiny Quebec.

Frère Luc spent only fifteen months in Canada. He arrived in 1670 after painting the portrait of Talon, the Intendant (Hôtel-Dieu, Quebec), on the long voyage across the Atlantic. Immediately after his arrival, he designed the new Recollet headquarters in Quebec, which Charlevoix described in 1720 as the greatest 'House' in Canada, even worthy of larger French cities; it is the present Hôpital Général. But Frère Luc spent most of his time in painting religious canvases to glorify buildings in the little colony. On his return voyage to France, he travelled with Bishop Laval and prepared for him plans of a proposed new Quebec seminary which later was built to his designs. Frontenac muttered that the Bishop was better housed than the governor himself when Laval moved into the seminary after his retirement. Laval and Frère Luc continued their friendship in France, the artist painting sev-

eral canvases there which he sent to Canadian religious houses at the Bishop's request.

Frère Luc, baptized Claude François, was the child of an Amiens cloth manufacturer, who died during his son's infancy. He copied religious paintings as a boy and then received his first lessons from an itinerant painter. After studying in Paris under Simon Vouet, he went to Rome like many young French artists of the time to complete his training by copying the great masterpieces of Raphael, Guido Reni, and others. There he met such influential French painters as Nicolas Poussin, Claude Lorrain, and François Perrier. The young man was back in Paris by 1640, assisting Poussin in no less a task than the decoration of the Louvre. He was honoured with the title 'Painter to the King,' but joined the Recollets after his mother died in 1644, assumed the religious name of Frère Luc, and thereafter directed the *atelier* which worked on paintings for his order's buildings in Paris. He had an uneventful religious life except for his Canadian visit.

Frère Luc's paintings were shown to visitors as among the wonders of Quebec. Father LeClercq, in writing about them in 1691, mentions several which can be identified:

This good religious [Frère Luc] laboured for fifteen months on many works, which he has left as so many marks of his zeal: the painting over the high altar of our Church and that of the chapel; he enriched the parish church [Notre-Dame-de-Québec] with a large painting of the Holy Family, that of the reverend Jesuit Fathers with an Assumption of the Blessed Virgin; and he completed that of the high altar, representing the Adoration of the Wise Men. The churches at Ange Gardien, Château-Richer, the Cote de Beaupré [*sic*], at Sainte-Famille on the Île d'Orléans and of the Hospital [Hôtel-Dieu, Quebec] were also indebted to him for works ... [5]

Father Charlevoix, who visited Quebec in 1720 when the fashionable Louis XIV taste favoured ornate elaboration and monumental conception, wrote that the great Recollet church with its carved altars and other decorations 'lacks nothing,' but was critical not only of some badly executed paintings hanging on the walls, but also others there by Frère Luc which he singled out for their dark shadows.[6]

Certain canvases now in Canada are unquestionably by Frère Luc and from these his style is apparent although the wear, tear, and dirt of centuries have much altered their appearance. His Assumption of the Virgin, (fig. 1), the signed and dated altarpiece in the Hôpital Général, and his Holy Family at Sainte-Famille church, Île d'Orléans, to which Le Clercq refers, were painted in Quebec. After returning

home, Frère Luc is said to have sent three further paintings to Canada. A Virgin and Child and a St Joachim and the Virgin are thought to have been gifts from Bishop Laval to Sainte-Anne de Beaupré. A second Assumption of the Virgin was an ex-voto offering to the Recollet church at Three Rivers, and later transferred to Saint-Philippe in that city.

The artist must naturally have considered the Assumption of the Virgin in the Hôpital Général his most important Canadian canvas since it was designed for his order's headquarters. In spite of the dull gloom of the chapel, it is still possible to decipher the vision of two angels bearing upward a rather heavy Madonna; one carries her sceptre and the other the star-studded halo symbolizing a spiritual queen. Two putti guard the empty tomb in a landscape where cliffs rise on one side while roses and a lily, symbols of purity, bloom on the other. The arrangement of the figure with the rose, the lily, and other elements echoes an Assumption by Frère Luc's old associate, Poussin. The dramatic and powerful rising figure, outlined against a burst of light, is faintly reminiscent of the imaginative *Vision of Ezekiel* or *Transfiguration* of Raphael's later years which Frère Luc must have seen in Rome.

In the Sainte-Anne de Beaupré canvases the figures are crisply illuminated as if by candlelight, and stand out like carved and painted statues; this lighting is similar to that used by artists of the school of Utrecht, particularly Honthorst and Georges de la Tour, the French painter who was allied with the group stylistically. Both were active when Frère Luc was a youth. His Three Rivers Assumption is later in spirit and faintly echoes the painter's old master, Simon Vouet. But Frère Luc's interests were eclectic and, as pointed out, all his many mannerisms have been borrowed from other artists. His figures are sometimes wooden and his groupings uninspired; these may be other qualities which Charlevoix disliked in addition to the gloomy black shadows he specifically mentioned.

Other canvases scattered throughout Quebec are suggested as by this artist but they lack signatures or precise documentation and are inconsistent stylistically with those already mentioned. *La France apportant la Foi aux Indiens de la Nouvelle-France* in the Ursuline Convent, Quebec, is one such canvas. The subject matter is Canadian, but the painting itself was almost certainly executed in France. It was partially repainted in the early nineteenth century, and guide-books of a hundred years ago declare that it was the work of a Franciscan in 1700. France, symbolized by the Queen Mother, Anne of Austria, shows a painting of New France's spiritual patrons to an Indian kneel-

ing on the shore of the broad St Lawrence, while a little mission sta-
tion in the distance is strangely reminiscent of that in the *Martyre* can-
vas. Another very competently painted and attractive canvas with
Canadian subject matter was once attributed to Frère Luc but almost
certainly also came from France. Now hanging in the Ursuline Con-
vent chapel in Quebec City, it pictures the Holy Family posed as a
group dressed in richly coloured robes with St Joseph presenting a Hu-
ron girl to the Virgin; the Indian child wears a medal given to con-
verts by the missionaries. Through a window is a glimpse of the St
Lawrence flowing past wigwams and campfires; it has been suggested
that the misty distant cliffs are either Capes Trinity and Eternity or
Cape Diamond itself. In a third canvas, in the Hôtel-Dieu, Quebec
one of the sisters cares for a sick man who is lying on a hospital bed.
The kneeling nun, (fig. 2), on discovering the nail and spear wounds,
realizes that she is tending the Lord Himself. Frère Luc's signature,
thought to be on it, is no longer visible.

One Canadian portrait which Frère Luc is supposed to have
painted is that of Talon already mentioned; another is of the austere
and aristocratic Bishop Laval which by tradition was painted in
France in 1671. Unfortunately modern research indicates that the ac-
tual painting is of nineteenth century origin although probably based
on an early engraving. It is quite different stylistically from the Talon
portrait. Talon is painted as an aristocratic dandy with curled wig and
elegant brocaded clothes, peering almost informally from a closely
cropped picture frame; the sense of light and spaciousness which sur-
rounds Laval is completely lacking.

Frère Luc's canvases are much more sophisticated than anything
previously seen in the colony and must have moulded tastes of church-
men and laity alike. Virtually every early Quebec painter marvelled
at and studied these and others ascribed to this artist. Such canvases
were in tune with Bishop Laval's lofty aspirations, since a high stand-
ard of church decoration was his ultimate goal.

Both Talon and Laval advocated education in the arts, envisioning
a strong, self-sufficient New France with many craftsmen skilled in the
various trades necessary to the colony's life. Laval founded an arts and
crafts school at a date popularly said to be 1668 at Saint-Joachim,
some thirty miles below Quebec in the vicinity of Sainte-Anne de
Beaupré, as a country branch of his new Quebec Seminary. Greek,
Latin, and classical studies were staples of the Seminary course; those
who were more attracted by practical work attended Saint-Joachim
until they reached the age of eighteen, and occasionally were even
older when they left. In this country setting, youths were taught cabi-

net-making, sculpture, painting, gilding for church decoration, masonry, and carpentry. Tailors, shoemakers, tool makers, locksmiths, and roofers also taught their crafts to the young people of the country. Agricultural instruction was given at an attached model farm. Two carpenters graduated in 1671 and 1672, and the study of sculpture and architecture was introduced by 1675.

Jacques Leblond de Latour was named head of the school almost immediately after his arrival in Canada during 1690. Leblond de Latour's father was a Bordeaux painter and writer, and he himself had trained as a painter, sculptor, and architect but unlike other Canadians had studied southern French styles. He carved candlesticks, an altar, a reredos, and other works for Canadian churches, and did portraits of Laval and his successor, Saint-Vallier. Assisted by pupils, Leblond de Latour ornamented the Quebec Seminary chapel with paintings and sculpture. A Saint in Glory was painted to celebrate St Pascal Baylon's canonization in 1691, for which the Recollet, Didace Pelletier, sat as a model. Leblond de Latour was ordained in 1706 and spent his later days as curé at Baie-Saint-Paul. The 'artist-priest' now had become almost a tradition in New France.

Bailly, an architect, and Fauchois, Genner, and Mallet, all sculptors, taught at the arts and crafts school. Mallet's association with Saint-Joachim was a particularly long one. Pierre Le Prévost, the school's curé, carved a statue for his own church when he was later appointed a parish priest.

The school was conducted along practical lines by undertaking actual assignments under the teacher's supervision. Students worked on construction of l'Ange Gardien church, and carved elaborate wooden decorations for the Sainte-Anne de Beaupré chapel; some of the ex-voto paintings still at Sainte-Anne's are possibly student work. The school decorated the Quebec Seminary chapel under Leblond de Latour's direction, an important assignment. Some years later La Poterie, in writing about the Seminary, described its chapel as forty feet long, having a high altar carved in the Corinthian style, and with many wall paintings surrounded by sculpture. The sculpture, painting, and gilding were entirely carried out by Saint-Joachim students.

Wood carvers and sculptors were legion in New France as compared to the painters. Both carving and sculpture required years of practice, and a long apprenticeship training was therefore preferable to more formal class instruction. It became customary for woodworkers to serve a seven-year apprenticeship to master craftsmen, and this new practice reduced the number of students at the school of arts and crafts. This was one reason for Saint-Joachim's decline. All classes ex-

cept those in agriculture were discontinued in 1705; thus ended the first Canadian experiment in art education.

Bishop Laval stepped down from his lofty position in 1685 because of ill health, but already his championing of art was bringing results. Jean Guyon, an *habitant's* son who had graduated from the Quebec Seminary, showed promise as a draughtsman and painter. The young man took minor orders in 1677, was ordained in 1683, and the next year was appointed Laval's secretary and a cathedral canon. He taught botany at the Seminary and painted minute water-colour studies of Quebec flora (formerly in the Quebec Seminary). Fifty years before, when Dr Cornut had published a book in Paris on Canadian plants, no one in the colony had been capable of preparing the illustrative sketches so the Jesuits had had to send dried specimens to France where the drawings were completed. Although her portrait was formerly attributed to Jacques Leblond de Latour, Guyon is now thought also to have painted Mother Juchereau de Saint-Ignace. This is one in the series of portraits of nuns executed in Canada during the seventeenth and eighteenth centuries, and is almost identical with another by Dessailliant de Richeterre (see p. 123). All these canvases have archaic characteristics, are naïve and almost harsh in their stark simplicity and lack of colour, and are particularly appropriate to these women who worked with remarkable single-mindedness for others. An early portrait of Mother Saint-Joseph sent from France to the Ursulines and later destroyed may originally have been the inspiration for this austere, unsophisticated series. Abbé Guyon went along with Bishop Laval to Paris, where he intended to study painting and sculpture. He died shortly after his arrival overseas without a chance to demonstrate what Canada's first native-born painter could really accomplish.

Laval lived in Quebec after retirement and died there in 1708. He had promoted the church vigorously and it was his reward during his old age to see it flowering in the colony. In their plans for decorating new church buildings, later churchmen followed his precepts, that they should be appropriate to the glory of God and reflect the beauty of surroundings, which was the aim of the régime of Louis XIV in France. The first Canadian canvases were painted to fulfil Laval's ideas. An atmosphere was being created which was favourable to the arts and an early eighteenth-century visitor to Quebec recalls that during lively evening discussions 'Sciences and the Fine Arts had their turn.' Canadians were learning to appreciate paintings.

2

Votive Painting in New France

Best loved of all early paintings from French Canada are the very human ex-votos scattered through country villages. Two we may single out as characteristic of many others in the group.

A painted wooden plaque entitled *Ex-voto des trois naufragés de Lévis* (fig. 3) is a picture of a terrifying shipwreck on the St Lawrence. Two young men, Jean-Baptiste Aucler and Louis Bouvier, were crossing from Lévis to Quebec at two o'clock in the morning of 17 June 1754, when their boat overturned and the three girls with them, Marthe Feuilleteau, Mra (*sic*) Chamar, and Marguerite Champagne, were tossed into the water. The artist has painted the catastrophe at the dramatic moment when St Anne appears in the sky and intervenes to assist the youths who sit astride the overturned boat and rescue one girl. Her two drowning companions struggle and stretch out their arms to the saint. The picture was given to the church at Sainte-Anne de Beaupré, which the artist has painted at the left on the distant horizon; there it has remained as a permanent reminder of the saint's goodness in saving the three young people. An inscription on the plaque documents the details.

A bush-worker, Dorval, was pinned to the ground by a tree which he had just felled; this incident is pictured on a second plaque, which may even date from as late as the nineteenth century. St Anne is again in the sky, and the lumberman's little dog trots away with a piece of bark in his mouth. Failing to free himself, Dorval had prayed to the saint for assistance in this lonely spot where there was no hope of a chance discovery by friends or relatives. He dipped the bark in his own blood, gave it to the dog, and sent the animal for help. There was great excitement in Tadoussac when the dog dropped the bloody shred at the feet of the first man he met. An alarmed rescue party followed the faithful servant to his master, who donated the picture to the shrine in gratitude for his miraculous release.

These ex-votos, both preserved at the shrine of Sainte-Anne de Beaupré, were paintings commissioned to fulfil religious vows. Others are scattered in religious institutions in the province of Quebec, the majority dating from the French colonial era. They were normally hung in church vestibules, where they were seen by the crowds of worshippers, who paused when entering or lingered before departing for home after the service. Those who had heard of the miraculous events commemorated by the ex-votos examined them with interest on many, many occasions, retold the incidents with relish, and discussed and gossiped about the affair at length.

The tales of the shipwreck and the bush-worker are but two in a long list of such dramatic stories. For example, in a painting commissioned by her husband, a member of Quebec's Conseil Souverain, the aristocratic Mme Rïverin, dressed in Parisian fashion, kneels with her three daughters and son in thanksgiving for rescue from another shipwreck in 1703. When a Quebec merchant, M. Roger, found that his ship had been miraculously extricated from dangerous ice on 6 February 1716, he gave 114 livres to Sainte-Anne de Beaupré for the saying of a solemn mass and the buying of a votive painting for the church in thanksgiving for divine intervention. A ship of another Quebec merchant, M. Juing, eluded three Dutch men-of-war in 1696, and an artist painted a huge canvas of the escape. The original has disappeared but it was replaced by a copy made by Antoine Plamondon in 1826 (at Sainte-Anne de Beaupré). A ship, *L'Aimable Marthe*, under the command of Captain Maurice Simonin, was saved from rocks in 1747 and an ex-voto deposited in Notre-Dame-des-Victoires church, Quebec; the usual vision of St Anne and the Virgin looms in the sky. Some ex-votos survive only in fragments. Others may be undiscovered. The earliest dated ex-voto found to date was executed in 1697 and is among the holdings of the Vaudreuil Museum. It was restored recently. In it, parents thank a saint, who appears dramatically in a cloud, for the recovery from illness of a tiny babe who lies tightly wrapped at their feet.

A lesser-known ex-voto at Sainte-Anne de Beaupré (fig. 4) was donated by a sea-captain, Charles Édouin, who commanded the barque *Sainte Anne* in 1709. That year M. de Subercase, Governor of Plaisance, Newfoundland, learned of English preparations to attack the French, and sent Father Gaulin, a Recollet priest, to report to Vaudreuil at Quebec on the situation. On the way, Édouin's *Sainte Anne* faced imminent disaster when a storm threatened the safety of all, but Father Gaulin prayed fervently on the deck (one sees him in prayer), and all were saved. Two years later Édouin and his crew at a solemn

mass promised a painting as a memento of their delivery and safe arrival at Quebec; the canvas (it is remotely possible that the artist was Dessailliant de Richeterre) was handed over to Sainte-Anne de Beaupré at another mass the next year. Father Gaulin, for his part, chose to contribute seventy livres as a personal thanks-offering for his miraculous deliverance.

Ex-votos tell thrilling stories taken from the simple faith of country folk. It seems appropriate that most were painted by native artists. They may have been untutored and inexperienced, have known nothing of draughtsmanship or perspective; their colours may have been crude – a red dress was simply red, a blue coat blue, and waves were basically green – but the artists had strong wills, were genuinely sincere, and were moved by their subjects. Their message is even more direct because there is no intrusion of non-essential subject matter in the telling of their story. Yet they follow a pattern, traditional from long repetition, of St Anne as a heavenly vision. The paintings in their own limited way are forceful living histories. As one writer has expressed it, they are 'as moving as children's fairy tales ... the memory of beautiful and distant dreams.'[1] Early Canadians must have found them very human documents. They are much more personal and alive than the austere official portraits or remote Baroque religious compositions. Here for the first time we find the local human touches sadly missing in the elaborate canvases of Frère Luc and other earlier Quebec painters.

Most Canadian ex-votos are anonymous although two early ones bear signatures. One of these, Frère Luc's Assumption of the Virgin, has already been described (see p. 10). Traces of the name Cardenat are on a sophisticated example in which Marie-Anne Robinau de Bécancour is presented to the Virgin by St Anne and kneels before her in a lace-trimmed dress. The little girl, whom the artist knows from life, and therefore paints as a human being in contrast to the more stereotyped Virgin and St Anne, is Baron de Portneuf's youngest daughter; she is fashionably dressed as becomes her father's high rank. Many other ex-votos are thought to have been painted by Paul Beaucourt, Dessailliant de Richeterre, and various Saint-Joachim school students.

A Guardian Angel (fig. 5), now in the Hôtel-Dieu, Quebec, is the most strikingly dramatic of all. It may have been painted by Dessailliant de Richeterre in 1707. A hospital nun has placed her little sister under the protection of the angel who stands guard over the frail girl. There is exaggerated power in this angel, shielding the helpless child with his powerful wings and strong hand as he stands with his great

muscular legs thrust forward in a seven-league boots stride. By contrast the powerful angel accentuates the sweet and helpless innocence of the tiny child, whose face is painted in fluid and tender brush strokes. This is one of the gentlest and most moving of all portraits from old Quebec.

Several early plaques and canvases which tell of the founding of religious houses are closely allied in their naïve spirit and execution to the ex-votos. Captain John Knox, an officer in the British forces occupying Quebec in 1759, described one he saw on a visit to the Hôtel-Dieu:

By an inscription I perceived it [the Hôtel-Dieu] was constructed in the year 1639 at the sole expense of Mary de Wignerod [*sic*] Duchess of Aiguillon; of whom I saw a tolerable portrait on her knees in a praying position; her Grace dedicated the house to St. Joseph, who is also patron of Canada.[2]

Two portraits apparently painted in the early eighteenth century were found recently in this institution's attic, and one is the kneeling duchess to which Knox referred. The other is her uncle, Cardinal Richelieu, who supplied funds to assist his niece in founding the hospital. The two figures may have been copied from cheap popular prints of the day. The landscape backgrounds are of particular interest. Behind the duchess is Quebec City, with its streets winding up the hill, church and convent spires dominating the Upper Town, and busy commerce in the river. No earlier oil painting of Quebec is known. An engraving in a map cartouche prepared by Bécart de Granville (see p. 22) in 1699 may have inspired this landscape. An Indian village appears behind the Cardinal. Some Indians canoe on a stream while others busy themselves on the banks where there are Indian houses resembling those sketched by Baron de Lahontan, a French visitor of the early eighteenth century. Ancienne Lorette near Quebec, to which the Hurons moved after their defeat by the Iroquois, was such an Indian village. On the basis that the style of the painting is similar to that in two signed canvases by Paul Beaucourt formerly at Cap-Santé church, they may possibly be his work. However, all interested in these earlier years must remember that firm documentation of painting and painters is so fragmentary that even *suggesting* a link between artists and the bulk of the canvases is highly dangerous.

Another late seventeenth-century or early eighteenth-century painting showing Christ watching over a ward in the Hôtel-Dieu hospital, Montreal (fig. 6), may appropriately be mentioned here. In its naïve style it differs little from many ex-votos. Its great modern inter-

est is as a record of the hospital interior, the beds with their green baize hangings and the nursing nuns, but in its day the vision of Christ bearing the cross served to comfort the sick in this ancient Montreal institution.

The ex-votos were, of course, part of a European tradition, which was exceedingly popular in France, Germany, Italy, Spain and other predominantly Catholic countries during the seventeenth and eighteenth centuries. Indeed occasionally artists still paint them. Just as the French Canadians in Quebec imitated customs of their homeland, so the Spanish colonists in Mexico imitated those of Spain; Spanish colonial ex-votos still survive in many old Mexican churches. The striking characteristic of the whole group, whether European or colonial, is the unusual uniformity of style in the universal language of folk art. These early Canadian examples have no particular style that would fit them into the development of sophisticated painting, disregard spatial depth and perspective completely, yet have a fresh and universal appeal. Isolated examples by gifted folk artists appear at irregular intervals throughout the whole range of Canadian painting; with all kinds of subjects, painted through the years by farmers, coal miners, housewives and many others, none of whom ever received an art lesson, they have maintained an approach which scarcely changes and is never lost.

3

Local Painters in New France

Two powerful personalities passed from the Canadian scene towards
the end of the seventeenth century with the retirement of Bishop La-
val and Count Frontenac's death at Quebec in 1698. They had di-
rected and promoted local development with unrelenting vigour.
Laval's successors took little interest in the colony; one did not set foot
on Canadian soil, and two others made only brief visits to Quebec.
France's interest in America indeed seemed on the wane. The great
immigration scheme commenced in the 1660s came to an end. Four or
five thousand settlers arrived during the first half of the eighteenth
century, but they crossed the ocean entirely on their own initiative.
Louis XIV resented the vast expenditures allocated for construction of
the Louisbourg fortress. Voltaire described Quebec as but a few acres
of snowy waste. The Jesuit missionary crusade was a ghost of its former
self. An opera which parodied the French-Canadian scramble for
wives was written in Paris where formerly poets had composed noble
verses eulogizing Christian martyrs in the wilderness.

The whole atmosphere of the colony was changing now that France
was leaving Canada more and more to her own devices. The colony
responded to the challenge in her own fashion. Real power passed
from the bishop to the local priests who were responsible for the
erection of many small parish churches along the St Lawrence. They
were decorated with the most elaborate wood carvings by native wood
carvers and sculptors until their ornamentation became Quebec's
highest form of artistic expression and the real glory of the eighteenth
century. Stepping from the rough pioneer environment into the
church, resplendent with its richly gilded interior, one truly sensed
most forcibly the entering of the House of God. Scattered paintings
discreetly hung on the walls accentuated the opulence. The Levas-
seurs, one of the great wood-carving families, began decorating

churches during these years. Fewer immigrant painters arrived from France, but several artists of Quebec and Montreal helped keep painting alive. Indeed pictures were so popular for church ornamentation during the building boom between 1700 and 1750 that the local men could not keep pace with demand, and nearly every ship from France brought another canvas for a new church.

Many of the emerging local painters had little or no formal academic training. They undertook their task simply with a will for creation and a desire to express their inner feelings in both portraits and religious canvases. Gradually such artists began working in many towns and villages throughout the colony. Art was losing its completely 'French' character and becoming more *canadien*.

A second arts and crafts workshop school in Montreal assisted in the spread of painting to centres other than Quebec. This new school, partially modelled on Saint-Joachim, operated from 1694 to 1706. The earlier school had had official government sponsorship but the one in Montreal, private in character, was established by the religious community of the Charon Brothers or the Hospitalers of St Joseph of the Cross. This community was the brain-child of Jean-François Charon, a prosperous Montreal merchant with whom Pierre Le Ber and Jean Fredin were associated as co-founders. A stone house and chapel, designed by Pierre Le Ber, served as a hospice for orphans, elderly people, and indigents. The arts and crafts school was housed in the hospice, supervised by two members of the community: one was a well-known sculptor, the elderly Charles Chaboillez, who retired there and who died in 1706; the other was Le Ber, who supervised apprentice painting. Le Ber died in 1707 and the arts and crafts project was discontinued. The community itself prospered briefly, then financial difficulties forced its closure. Its assets were taken over in 1747 for the Hôpital Général by Marguerite d'Youville, foundress of the Grey Nuns.

The Grey Nuns have preserved the paintings once owned by the Charon Brothers. Some very accomplished canvases are quite evidently of European origin, but other, more primitive ones were certainly painted locally. Two naïve works in which saints kneel while angels hover overhead are based on European traditions, and two strange visionary portraits of priests which arrest because of their great burning eyes are possibly by Pierre Le Ber himself. Le Ber, who belonged to a prominent Montreal family, was a cousin of Baron de Longueuil and a brother of Jeanne Le Ber, the famous recluse, whose embroidery made her known throughout New France. In 1697 Le Ber designed the chapel of St Anne near Montreal. He gave paintings to

the Hôpital Générale. The inventory of his estate after his death gives some idea of the equipment of a Canadian painter at the time:

8 drawers full of all kinds of colours, and 2 full of brushes and palette knives used for painting, and another drawer full of gum arabic; a little chest full of pots, brushes and other things used in painting; a little barrel of yellow ochre half full; a quarter barrel of white lead; another where there is about twenty pounds; an easel for painting; 4 barrels of lamp black; 4 canvases primed for painting of which 2 are on stretchers; another large primed canvas 8 feet wide ... 4 pictures representing the Holy Virgin, St. Therese and St. Paul.[1]

Pierre Le Ber's most famous painting is his posthumous portrait of Marguerite Bourgeoys (fig. 8) completed in Montreal after her death in January 1700. The artist undertook the work at the request of the sisters of her order; the commission was a difficult one, but '... the painter succeeded in completing his task, although even in death, the foundress of the Congregation of Notre Dame appeared for a moment to refuse the vanity of a portrait.'[2] This canvas has recently had the disfiguring layers of nineteenth-century paint cleaned away, so that it is now as it was when it left Le Ber's brush. It is a sad face with the hands clasped above the cross. The design is powerful in its austerity, the colours are restricted virtually to white, ochres, and blacks, and the whole has an emotional impact like the moving Pietà of Avignon in the Louvre. It is a masterpiece of early Canadian painting.

Less well known but of considerable historic interest is a painted pine altar still used by the Sisters of the Congregation at the St Gabriel Farmhouse, Montreal. The artist in delicate ochres, pinks, and grays has followed a design utilized by Jeanne Le Ber in making an embroidered altar cloth frontal. Vases filled with flowers, with birds fluttering around them, flank a motif related to the Cross of St Louis. The circumstantial evidence indicates that it was painted by Le Ber. Such painted altars are mentioned in early Quebec documents, but other examples are unknown.

Priests and nuns still numbered artists among their ranks in the changing artistic scene after 1700, but to them were added engineers, ex-soldiers and even the occasional professional artist. Many works were still religious in inspiration but there was also a sprinkling of canvases having no connection with the church. Some early secular paintings were portraits of leading citizens, government officials, army officers, seigneurs, and those few private individuals who could afford such luxuries; others were topographical sketches sent back to France so that people at home could picture the New World. Many secular

canvases, which were not guarded as jealously as the religious works, undoubtedly have been lost over the years. But not all private patronage went to local artists. Wealthier citizens visited France regularly and preferred sophisticated Parisian paintings to the more humble Canadian portraits. In France in 1751 Pierre Jouffroy painted Charles Duplessis, Provost-General, and Henri de Pontbriand, Bishop of Quebec, and sent the canvases to Canada.

The Hôtel-Dieu wards were crowded when Mother Maufils de Saint-Louis and several other sisters died while nursing the sick during a fever epidemic which struck Quebec during the winter of 1702-3. She had a 'considerable reputation as an artist' and some landscapes have been attributed to her. Charles Bécart de Granville et de Fonville who, like Mother Maufils, had been born in Quebec, was a second fever victim. Granville had served in the marine and had travelled abroad while with the ship *Bouffonne* . He returned to work as a professional engineer and map-maker at Quebec, preparing a view of the city which was engraved for a map cartouche in 1699; the engraving is pure topography with none of the spontaneity of the artist's original.

A famous water-colour sketch-book, the *Codex Canadensis*, completed about 1700, which was in the royal collection at Versailles until after the Revolution, was formerly thought to be the work of Granville. Its pages contain all manner of local studies – Indians, wild animals of Canada, birds (fig. 9), plants, even the stallion sent out by Louis to improve the strain of Canadian horses. The linear drawing is lively. Recent discoveries suggest that the accompanying text was written by Abbé Louis Nicolas, who had served as a Jesuit missionary in New France from 1667 to 1675 and then became a lay-worker. Since he could draw, it may be that he himself was the artist who painted the original *Codex Canadensis* and that the volume sent to the king was a copy transcribed from Nicolas's original sketches.

The engineer Verrier, a topographer of no mean ability, lived for years at Louisbourg on Cape Breton Island, where he went as a cartographer to design and supervise construction of buildings. His panoramic view of Louisbourg was sent back to Paris in 1731. The exaggerated heights of various towers resemble distortions in Granville's drawings of Quebec and endow the town with a nobility which it never possessed. A veritable rococo skyscraper towers over Louisbourg's hospital – an added dignity which no doubt impressed officials in the homeland. In the foreground stands a bewildering array of sailing ships, seeming confirmation of tales of the promised wealth of trade in the New World.

Verrier was a prominent Louisbourg citizen, who lived in a half-timber brick house on the Rue Royale where the cobbled street made a satisfactory sidewalk. His living-room was over twenty feet square and there were a large kitchen and two other rooms on the ground floor; at the rear were a wine cellar, a formal enclosed garden and a pool by a summer house. When this house site was excavated in 1958, the discovery of his surveyor's plumb bob provided a very personal link with the man. Verrier returned to France in 1745 after the first fall of Louisbourg.

While artistically of no great importance, Mother Maufils, Granville, and Verrier deserve mention for the secular notes introduced into their subject matter. As examples of the same trend in early eighteenth-century portraiture, there are three known secular portraits of Canadian officers by an anonymous artist. That of Chevalier Jean-Louis de la Corne, who died in Montreal, is starkly realistic with a gaping socket for one eye which was lost in the wars. The other two portraits, identical in style, are of the brothers Jean-Baptiste Hertel, Chevalier de Rouville (fig. 9), stern and resolute, and the more youthful and weaker looking François-Zacharie Hertel, Sieur de La Fresnière, both of whom were born in Three Rivers and served as officers in the king's colonial troops. They wear distinctive red and gold trappings over blue as prescribed for the regimental uniform, and on their heads sit proudly the curled wigs of the aristocrats. Noble likenesses were required, and these were produced without the softer refinements of a later and less austere period. Rouville, for example, had commanded a ruthless raiding party against Massachusetts and Crown Point early in the century, an age of tough personal heroism. When he was granted a seigniory near Montreal and awarded the coveted Order of St Louis in 1712, the new decoration was added to his portrait which had been finished earlier. The brothers never left New France so there is no possibility that these portraits were painted outside this country.

The best-known Canadian painter at the turn of the century was Michel Dessaillant de Richeterre, who probably graduated from Saint-Joachim. He was living in Montreal during 1701, and journeyed to Detroit in 1706 to paint a private altarpiece for the commander, Sieur de Cadillac. The altar was still owned by Cadillac when he died a quarter of a century later. Dessaillant returned from Detroit to Quebec to paint a portrait of a Hôtel-Dieu sister, in which he imitated Guyon's earlier work. Dessaillant may have been in Quebec as late as 1721. The ex-votos of Mme Riverin and her four children (see p. 15), the Guardian Angel (see p. 16), and the portrait of Abbé Joseph de La

Colombière, with some of the same fanaticism and visionary feeling of the portraits from the House of the Charon Brothers, have been attributed to him on rather shaky stylistic grounds.

Other artists of the period are known from records, but art historians have made a fruitless search for their canvases. One, Jean Berger, a colourful contemporary of Dessaillant, came to Canada as a young marine and received his discharge shortly after. Berger was imprisoned for counterfeiting playing-card money and after his release took a studio at Montreal. He was jailed a second time when he fought with the apothecary Claude Saint-Olive, and would have been released almost immediately if he had not foolishly composed a very ribald song ridiculing Canadian justice while still in his cell. In 1710 he was banished from New France as a troublemaker. His mishaps were almost as many as Pommier's.

Another marine, Paul Beaucourt, commenced working as a professional artist after his discharge in 1741. A Madonna and Saint Joseph, in Cap-Santé church until a score or more years ago, is his only signed and dated work. He also painted a Good Shepherd which formerly ornamented the chapel doors of the Quebec Seminary, and is said to have painted ex-votos. His son, François Malepart de Beaucourt, to whom he gave painting lessons, became one of Canada's first important native-born artists.

As had so often happened earlier, three priests in the later years of the French régime carried on old traditions, painting for relaxation and then using their canvases in their pastoral work. Jesuit Fathers Sébastien Rales and Pierre Laure both emigrated from France to serve in the Indian missions. Father Rales, while with the Abenakis, designed and built his own chapel at Norridgewock (Narantsouak) and painted pictures on the interior panelling. The chapel was burned by the English in 1705 but was rebuilt and redecorated. Father Laure served first at the Saguenay mission and then with the Micmacs and Maliseets of Acadia. An architect and amateur painter, he later erected a chapel at Chicoutimi, which he also decorated with his own paintings. He drew maps of the Saguenay River. Two of Father Laure's signed paintings, *Tableau de saint François-Xavier mourant près d'un port de mer* and a *Tableau de l'ange guidant l'enfant* were discovered at Tracadie on the north shore of New Brunswick where they had probably been sent in 1804. A note on the reverse states that they were painted in 1724 and 1725 at the Jesuit college, Quebec.

Father François who, like Frère Luc, belonged to the Recollet order, was a more accomplished painter of the same period. The old Varennes church account books note that he was commissioned to

paint a *Sainte Anne* in 1735, which the church still owns. He completed other canvases for the churches at Berthier-en-Bas and Saint-François-du-Lac. He had sent sketches of Eskimos to Paris, along with a covering letter dated 20 October 1732, now in the Colonial Archives in Paris, describing how he wanted to paint an Eskimo woman from Beauport in native costume:

As she has no longer her native clothing in which I should have wished to draw her, I had her draw a native Eskimo man and woman in their ordinary clothes. The poor woman is not very skilled either in drawing or sculpture.[3]

Father François's finest painting is an unsigned portrait of Father Crespel, a priest who had been shipwrecked on Anticosti Island and had written a well-known account of his experience. Crespel's genial air, kindly expression, and good humoured sensitivity are captured in a most accomplished portrait.

Though the eighteenth-century records are dotted with artists' names and titles of lost paintings, and few which survive can be stated definitely as by any known artists, some artistic comparisons can be made between the canvases associated with Abbé Pommier, Frère Luc, and Cardenat of the late seventeenth century and the work of the next century, which we have just been discussing. We find that the first group is a direct reflection of Continental French painting and the second is much more provincial in character. While these later paintings are less sophisticated and less ostentatious, what may seem a regression is actually a healthy development for it reflects the first attempt by local artists to paint the local scene as they personally felt it. These paintings must have had a wide local appeal. They are thus important as work which begins to be a native expression of the Canadian people. And yet all Canadian paintings of the French colonial period are tinged, to some extent, by the art of France, just as early Mexican painting is a reflection of the art of Spain and early painting along the Hudson River is a reflection of the art of Holland.

4

Early Painting in
British North America

Seventeenth- and eighteenth-century painting in the English settle-
ments of Newfoundland and Nova Scotia lagged far behind that in
French Canada. A few chance early visitors sketched along the eastern
seaboard just as the French explorer, Champlain, had sketched during
his travels. One was the Elizabethan adventurer John White, famous
for his views of Virginia and her Indian peoples. He went with Fro-
bisher to Baffin Island in 1577 and there made the earliest surviving
paintings done on Canadian territory. These unique water-colours,
now in the British Museum, picture the Eskimos (fig. 10). There are
studies of a man and woman, and a panorama with a group of Eski-
mos, some shooting arrows from a hilltop, others in kayaks, as an En-
glish boat invades their seclusion. Such paintings must have been ex-
amined with excited interest by Londoners anxious for wealth, trade,
and adventure.

The tardiness with which art developed in the English-speaking
communities can be readily understood. Nova Scotia was, after all, re-
ally no more than a scantily populated outpost of New England. The
great concentrations of English-speaking merchants, important
officials, and the portion of the English-American citizenry interested
in cultural and scholastic matters were in Boston or other cities now
within the United States. Newfoundland was completely dominated
by the cod fishing industry. Swarms of English fishermen, chiefly De-
von and Cornish men, visited the Grand Banks during the season and
at other times the coastal establishments were virtually ghost villages.
Great local fishing barons like Benjamin Lester, who could afford
the luxury of paintings, would not appear until the late eighteenth
century.

Religion also worked to the disadvantage of painting in the Protes-
tant English colonies. The Puritan revival left Americans strongly ico-

noclastic; they almost feared any kind of religious art. Frontier English churches and chapels were austerely simple, lacked carvings and painting, and contrasted sharply with the luxuriously decorated Catholic churches in New France.

One prominent painter visited Newfoundland briefly about 1690. Gerard Edema had been born in Holland where he studied under a painter of mountain scenery, A. Van Everdingen. He emigrated to England when he was eighteen, and quickly became successful by catering to the English merchants who liked to have landscapes of the countries where they traded. He sailed with their merchant ships to foreign parts like Norway and there made his sketches. He became a painter of the 'first rank' in England and his canvases even entered the Hampton Court collection before his unfortunate early death at Richmond, attributed to 'an inordinate love of the bottle.' He earned himself the title of 'Salvator Rosa of the North.'

Edema's chief patrons were the Duke of St Albans and Cornish and Devon merchants like Sir Richard Edgcumbe, a 'worthy' knight, who lived in the English homeports of the Newfoundland fishermen. During one season Edema accompanied the Grand Banks fishing fleets to America at Edgcumbe's suggestion. The summer was spent in wandering about Newfoundland, sketching rocky landscapes, waterfalls, and views 'full of the fantasy of the unknown' in which he delighted. These Newfoundland canvases of fishing stations with men in dories, storage barns, and racks of drying cod were expanded into larger canvases (fig. 11) after he returned home and sold 'at a first price to merchants' connected with the various establishments which he had visited. Edema's figure painting was bad, so a friend, Van Wyck, added the workmen. Looking at such straightforward representations now, we find it difficult to accept the term 'fantasy' for them, but it must be remembered that the very distance of the scene in itself probably did much to stir the imagination. No Edema paintings were on the American continent until recent years and this artist contributed no part to the Canadian art tradition, except that he painted the first landscapes of Newfoundland.

Two oil landscapes of Newfoundland fishing stations, unidentified as to artist but probably painted after 1700, were found recently in a private collection in Bath, England. Some later English painter apparently followed Edema's example, with the same English fleet owners in mind as prospective customers.

Nova Scotia's closest ties in the early eighteenth century were with Boston rather than England and her artistic traditions came from that city. Boston men traded at Digby and Annapolis Royal, and also car-

ried on a substantial contraband trade with Louisbourg from trading posts on the upper mainland. There were amateur New England artists in the colonial army of 1745 which conquered Louisbourg. When Halifax was established four years later, British troops poured into the area. Army topographers accompanied them, and they and their kind began the major rôle they would play in Canadian painting for over a century. A few minor figures worked in Nova Scotia before the Seven Years' War. John Hamilton, an officer in the British Army, was at Fort Edward in 1753 and at Fort Cumberland on the Chignecto Peninsula in 1755, and his matter-of-fact studies of those places eventually went with King George III's library to the British Museum. He also made topographical sketches of eastern Canada. J. H. Bastide, another officer, visited Louisbourg and Annapolis Royal, which he recorded in water-colour. An unidentified artist, probably a naval officer, visited Halifax in 1754 on the British ships *Norwich* and *Success* and painted a water-colour of the new city. Just before or after the outbreak of the Seven Years' War, Samuel Scott, an eminent English artist, accompanied a British squadron to America. A successful painter in both oil and water-colour, he depicted Annapolis Royal (fig. 12) and other American ports in the tradition of English marine artists of his time. He also did oil views of the eastern seaboard and of blazing fire-boats drifting down the St Lawrence River during the siege of Quebec in 1759.

Many early Haligonians turned to New England for their paintings. Youthful John Singleton Copley, who was to become the most important colonial American painter and idol of Massachusetts gentry, was accepting their portrait commissions by 1756. One patron was Chief Justice Jonathan Belcher, an English-born Harvard graduate who had been appointed to Nova Scotia in 1754. His father advised him during his youth 'not to marry too soon but well, to work hard, and to relax with his bass viol and flute.' He waited to marry until he was forty-six, chose a spouse of twenty-seven, and made a wedding trip to Boston where he commissioned Copley to paint portraits (now in the Beaverbrook Art Gallery, Fredericton) of himself and his bride. Thomas Ainslie, a merchant of Halifax, also was painted by Copley. Governor Campbell went to Boston only to find that the famous artist was not home so he returned without his picture. Captain Peter Traille, who wanted to be an artist, persuaded Copley to forward him a course for self-instruction; the ship carrying the packet of instructions was intercepted by Indians on the southern Nova Scotia coast, and the parcel was lost. Traille advised young Copley in October 1757 to visit the province in person because he would certainly secure some

good portrait commissions, but the Seven Years' War had broken out and the trip could not be made.

These are indeed feeble beginnings in painting throughout the Canadian part of British America. A stable and receptive climate would not spring up in the region until the next quarter-century with a large influx of colonists, local government officials, and garrison troops.

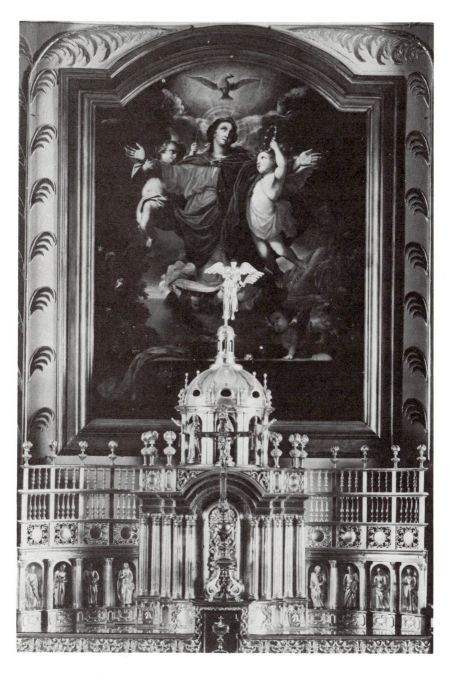

1 / Frère Luc (Claude François): *L'Assomption de la Vierge*, oil
81 x 62 inches (205.7 x 157.5 cm), 1671
Altarpiece in the Hôpital Général, Quebec

31

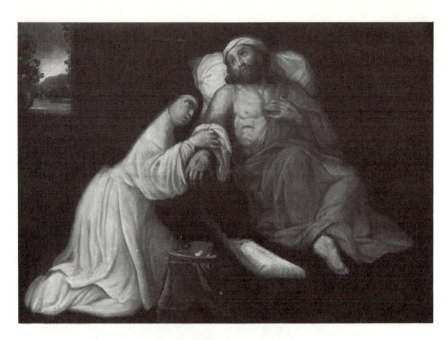

2 / Probably Frère Luc (Claude François):
Une Hospitalière soignant Notre Seigneur dans la personne d'un malade
oil, 39 x 55 inches (99 x 139.7 cm), undated, Hôtel-Dieu, Quebec

3 / *bottom* / Anonymous: *Ex-voto des trois naufragés de Lévis*, oil
12 3/4 x 20 1/2 inches (32.4 x 132.3 cm), 1754
The Museum, Sainte-Anne de Beaupré

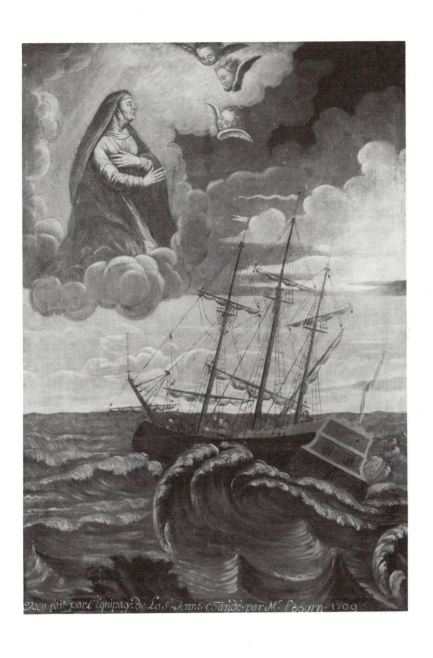

4 / Anonymous: *Ex-voto de Monsieur Édouin*, oil
64 x 44 inches (162.5 x 111.7 cm), 1712
Commemorative Chapel, Sainte-Anne de Beaupré

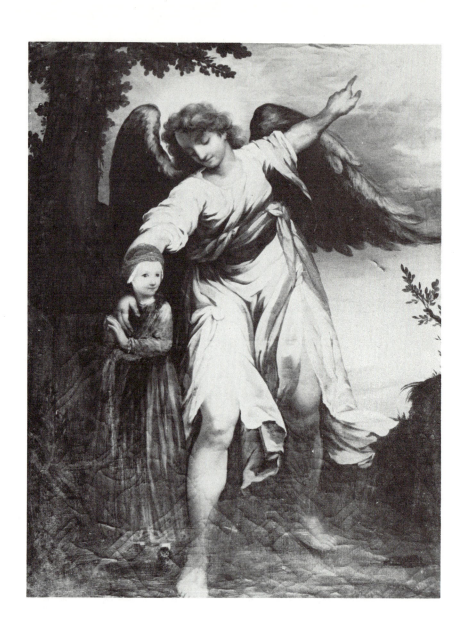

5 / Possibly Michel Dessailliant de Richeterre: *Ex-voto de l'Ange gardien*, oil
46 1/2 x 33 inches (118 x 83.8 cm), *c* 1707, Hôtel-Dieu, Quebec

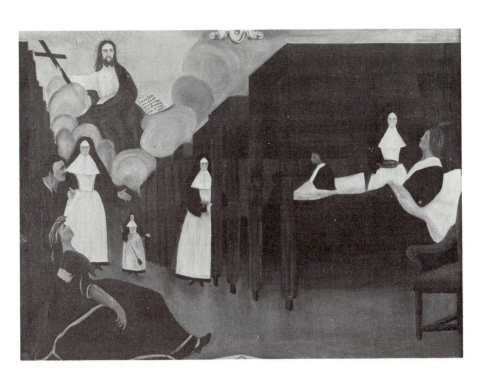

6 / Anonymous: 'Ward of the Hôtel-Dieu, Montreal,' oil
35 1/2 x 50 inches (90.2 x 127 cm), undated
Hôtel-Dieu, Montreal

7 / Anonymous: *Jean-Baptiste Hertel, Chevalier de Rouville* , oil
25 x 21 1/2 inches (63.5 x 54.6 cm), *c* 1710
McCord Museum, McGill University

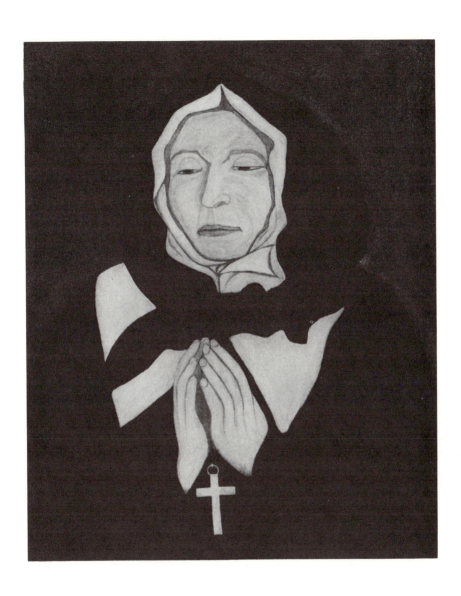

8 / Pierre Le Ber: *Marguerite Bourgeoys*, oil
24 1/2 x 19 1/2 inches (62.2 x 49.5 cm), 1700
Collection of the Sisters of the Congregation, Montreal

37

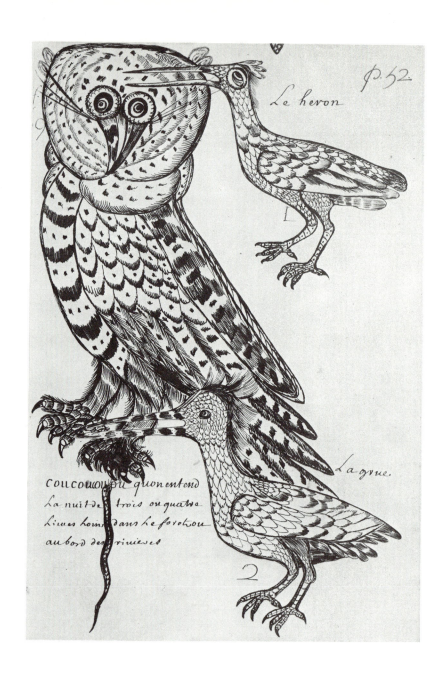

p.52

Le heron

L

La grue

coucouoouou quonentend
La nuit de trois ou quatre
Lieües loing dans le foret ou
au bord des rivieres

2

9 / Perhaps by Abbé Louis Nicholas: Bird studies from the *Codex Canadensis* w.c.
c 1700, Thomas Gilcrease Institute, Tulsa, Okla.

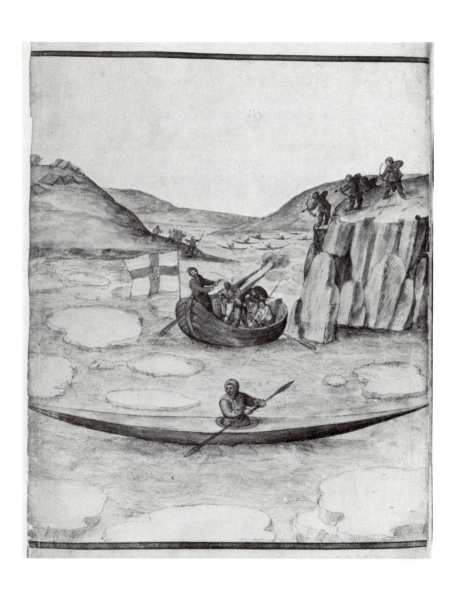

10 / John White: *Fight Between Frobisher and Eskimoes, Baffinland*, w.c.
12 1/2 x 10 1/2 inches (31.7 x 26.7 cm), 1577
British Museum

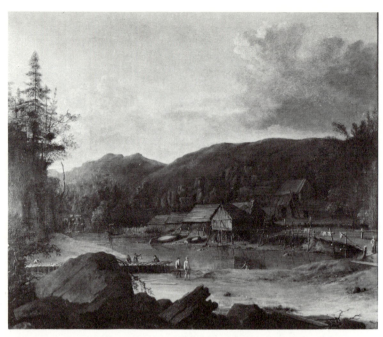

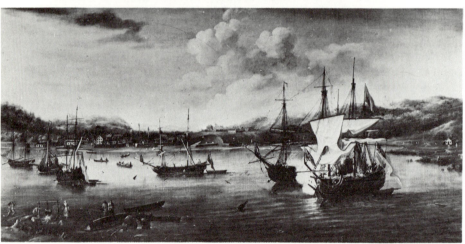

11 / Gerard Edema: *Fishing Station, Newfoundland*, oil
32 x 39 inches (81.3 x 99 cm), *c* 1690
Sigmund Samuel Collection, Royal Ontario Museum

12 / Samuel Scott: *Annapolis Royal*, Nova Scotia, oil
undated, private collection

Part Two
The English Colonial Period
1759-1867

5

The Aftermath of the
Seven Years' War

Grievous damage was suffered by buildings throughout New France during the Seven Years' War. Quebec itself was so shattered that the British Army's first task after occupying the city in 1759 was the clearing of the rubble-blocked streets. The Ursulines allowed the British commander to hold services in their undamaged chapel until some other building could be found for Protestant worship. All other Quebec churches were utterly ruined. General Wolfe, in issuing orders for razing outlying settlements, had commanded his soldiers to spare all churches, but many were damaged in spite of his instructions. The church building programme in the colony had come to a halt when war broke out. Painting ceased, awaiting more settled times.

This hiatus in French-Canadian art is an unfortunate contrast to progress in the English-speaking thirteen colonies, soon to become the United States. Their towns had suffered no damage. American merchants had prospered during the war and they revelled in new wealth after the coming of peace. The innumerable commissioned portraits mirror this well-being. The Loyalists would eventually bring some of this American artistic fervour to Canada, but meanwhile Nova Scotian merchants and officials continued to patronize John Singleton Copley.

The building and exquisite ornamentation of Quebec churches with delicate gilded pine carvings and paintings began again in the post-war years after the British had guaranteed the French the retention of their religious liberties, language, and customs. A priest remarked optimistically that 'those whom the war had ruined will find it yet possible to conserve the dear church of more happy days.' Reconstruction gathered momentum with the passing years and there was such widespread enthusiasm for this work that between the signing of the peace treaty which ceded Canada to the British and the year 1791,

no fewer than 39 new churches were built and 13 others repaired in what is now Quebec province. The old direct ties with France had been broken, but the familiar and much-loved styles in painting, wood carving, and sculpture of earlier years were retained by the builders even if they were growing old-fashioned.

British traditions in painting, architecture, and sculpture, however, from this time became increasingly more important in that area, where formerly French influence had dominated so completely. Many British Army men painted in water-colour, a technique they had learned in England. New immigrants from all over the British Isles also brought to many parts of what would eventually become Canada the art traditions of their homeland, just as the French had brought theirs during the previous century. Canada from the days of the Seven Years' War was richer artistically by a blending of the French and English artistic temperaments.

The curé of Quebec had written in his journal under date of 9 August 1759, that 'the Church of the Lower Town [Notre-Dame-des-Victoires] burned with 150 houses.' This was the first Quebec church chosen for reconstruction and the standing walls of the empty burned-out shell were incorporated into the new building, which was re-dedicated in 1765 only two years after the peace treaty. Thereafter, as under the old French régime, the church celebrated the feast days of St Genevieve and of Notre-Dame-des-Victoires in honour of earlier French victories over the English. Augustin Wolff's large *Annunciation* was painted for the new church and still hangs there. It is a rather dull and uninspired work, remarkable chiefly for its size, but possibly the first canvas painted in Canada for church use under the new English régime.

Augustin Wolff was a German who came to Canada as a paymaster to mercenary Brunswick troops attached to the British Army, and turned a hobby into his profession when he was discharged at Quebec. He was probably chosen to work at Notre-Dame-des-Victoires (1765-6) because no French-Canadian artist was available who could carry out the formidable task. Wolff painted other large religious canvases, and in 1767 a portrait of a lady primly dressed in a blue gown trimmed with lace. He then disappears from sight for a time, but twenty years later he advertised in the *Montreal Gazette* of 30 November 1787 that he painted carriages, coats-of-arms, cyphers, or would do any other similar work.

Jean-Antoine Aide-Créquy, whose ancestors were Quebec master masons, was the first French-Canadian painter to emerge after the war. He graduated from the Quebec Seminary, was ordained a parish

priest in 1773, and spent most of his religious life at Baie-Saint-Paul, Les Éboulements, and Île-aux-Coudres where he decorated churches with his own canvases. Aide-Créquy was delicate. His long hours of painting were said to have weakened his constitution and he died prematurely at the Hôtel-Dieu, Quebec. As was customary under such circumstances, he bequeathed one of his own canvases, depicting the Virgin holding the infant Jesus, to the institution which tended him in his last illness. His contemporaries remarked that he was not a Raphael but had a real aptitude for art.

Most intriguing of all Aide-Créquy canvases is *Saint Louis tenant la couronne d'épines* (fig. 14), painted in 1777 to honour Louis XVI's accession to the French throne three years earlier. St Louis stands posed in a marble hall like an actor imitating royalty. The canvas hung formerly in the Île-aux-Coudres church where Aide-Créquy was curé; it was discovered in a nearby garret during the present century, and now hangs in the episcopal palace of Chicoutimi. The theme of the painting is a subtle allegory in which the newly crowned French king becomes identified with St Louis by bearing in his hand the nails and crown of thorns that the saint normally carried, but these are simply transparent guises which do not really hide the monarch's identity. His flowing robes are like those of Louis XIV in an engraving of Rigaud's handsome portrait now in the Louvre. Aide-Créquy painted the canvas to express his continuing fealty to France and the French crown; it hung in his church as a reminder to parishioners of their racial origins, and yet he and they avoided all danger that the British could question their loyalty; if anyone raised such a question, it could be pointed out that the portrait honoured the patron saint of Île-aux-Coudres.

Most other canvases by this artist are free copies of prints or earlier paintings. His Annunciation in the Ursuline Convent, Quebec, was suggested by an Italian engraving. He copied Frère Luc's St Joachim and the Virgin at Sainte-Anne de Beaupré for the Saint-Joachim church in 1779. A Holy Family, also copied from another Frère Luc painting, was later so mutilated that when the church authorities asked Joseph Légaré to restore it, he ordered its destruction instead. A tondo of Saints Peter and Paul was burned during a fire at Baie-Saint-Paul church in the present century, but individual portraits of these two Fathers of the Church, very competently executed, have found their way into the Hôtel-Dieu collections at Quebec. They are very literal copies of engravings from paintings by Philippe de Champaigne.

Cheap prints in French-Canadian homes during the eighteenth

century kept alive memories of French origins just as did *Saint Louis tenant la couronne d'épines*. The Duc de La Rochefoucauld-Liancourt, writing his memoirs of a Canadian tour in 1795, told of pictures of the French royal family in many homes:

[After the French Revolution] in most of them [the dwellings between Montreal and Quebec] which stand along the road and where of consequence the death of the French king is known, you find his portrait, the print which represents him taking leave of his family, his execution, and his last will. All these prints are something venerable to Canadians, without impairing their attachment to the French.[1]

One supplier of prints of the French royal family was J. G. Hochstetter, the first Canadian engraver, who worked for the *Quebec Gazette* from 1791 to 1794, and prepared illustrations for *Le Magasin de Québec*. At least three different portrait engravings were sold by Hochstetter. One, that of Bishop Hubert, is familiar through a few surviving copies, but there are no known examples of a Marie Antoinette engraving. Such mementoes of the deceased French royal family did not embarrass the English authorities. Indeed the government of Upper Canada ordered public mourning on Louis XVI's death in 1793.

6

British Army Topographers
in Eastern Canada

The British Army, which inevitably had done much damage during the war years, would now expand the phase of painting in Canada which had made its tentative beginning in Nova Scotia. Many of the army officers were water-colour painters. They would provide a remarkable record of the local Canadian scene during the British colonial period which has been an unceasing source of delight and information to connoisseurs and collectors down through the years.

During the war itself, Wolfe's men painted views of the attacks on both Louisbourg and Quebec. These were not doodlings of effete junior officers. One of them was the aristocratic Marquis of Townshend, Wolfe's second-in-command, who painted a portrait of his chief (in the McCord Museum, McGill University) at their Île d'Orleans headquarters during the actual siege. (Townshend heartily disliked Wolfe, considered him an upstart and youthful prodigy, and in private caricatured both his amorous inclinations and his dictatorial and sometimes rather narrow-minded discipline. There were strained relations between the two when rumblings of these merciless and somewhat bawdy caricatures reached the man who was the butt of the horseplay.) Sketches by Wolfe's aide-de-camp, Hervey Smyth, showing troops scaling the Heights of Abraham and naval vessels operating in the St Lawrence, were engraved by Thomas Jeffreys of London and sold widely. Richard Short, purser of HMS *Orange*, made detailed drawings of Quebec buildings after the capitulation, and several historic and celebrated structures of the French régime are known only through Short's views. Earlier he had sketched Halifax buildings. These were forerunners of an impressive list of officer-artists who spread out into all parts of British North America.

In the eighteenth and nineteenth centuries officers still purchased their commissions, a luxury possible only to members of British noble

and county families. This group traditionally received a classical education. Their background was such that British officers considered themselves 'gentlemen' and continued their gentlemanly interests in the service. The disagreeable results of sheer boredom during peacetime service were kept in bounds by such diversions as gay regimental balls, parties, receptions, and St George's Day dinners with interminable toasts. Rare visits of a royal prince necessitated all-out revelry, but any visiting dignitary, royal birthday, or similar pretext was sufficient excuse for a diversion or celebration. Afternoons of fashionable tandem driving on the river ice were followed by evenings of whist. Hobbies, often related to the arts, were other excellent safety valves. Each major Canadian garrison centre, such as Halifax, Saint John, Quebec, Montreal, and Toronto, had its own theatre with a cast of officers, and many an 'honourable' prefixed to an actor's name denoted his noble birth. These theatres prospered despite the frowns of Lt-Col. John Graves Simcoe who, en route to Upper Canada, attended one performance in Quebec by the Fusiliers but refused to go again because he disapproved of officers 'being so employed.' Others wrote diaries, plays, or poetry. But landscape sketching was one of the most popular diversions. There seemed to be one officer in every detachment who painted as a hobby and continued it in Canada. On his tour of duty, lasting from a few months to three or four years, he observed and recorded and his precious bundle of sketches was under his arm when he sailed for service in another part of the Empire. Of his own efforts, Major Petley remarked in 1837: 'these sketches [of the Maritimes] were originally not intended for publication but merely done to while away some part of the idle hours of a soldier's life abroad.' Officers carried on their hobby during fishing expeditions, while accompanying elegantly dressed ladies to picnics at local beauty spots, or when travelling through the countryside.

British officers, when training at the Woolwich Military Academy, studied topographical drawing. Royal Engineers prepared maps and elevation plans, while Royal Artillerymen had to note landscape features. When the celebrated Paul Sandby, leading English water-colourist of his day, was a Woolwich instructor, he extended his course beyond the basic military needs to embrace very full instruction in water-colour landscape painting. Many young soldiers under his teaching blossomed into accomplished amateurs.

At least fifty British officers, serving in the four Atlantic provinces, Quebec, and Ontario, were competent water-colour topographers, while dozens of others were more pedestrian painters. Three of the most important were Thomas Davies, who painted intermittently from

1757 to 1812, George Heriot, working at the turn of the century, and J.P. Cockburn, in the 1820s and 1830s.

Thomas Davies' water-colours were virtually unknown until the mid-twentieth century. Historians had seen scattered examples in various collections but the discovery of a portfolio of Davies' Canadian and American views in the Earl of Derby's library sparked new interest. These paintings were pristine fresh, represented all phases of Davies' North American career, and prompted a new assessment and appreciation of his remarkable ability. A number were purchased for the National Gallery of Canada, giving Canadians a unique opportunity to appreciate them to the full.

Davies had studied under G. Massiot, Sandby's predecessor at Woolwich, then left for Halifax in 1757 on a bomb vessel. His commissioned rank was 'Lieutenant of Fireworks,' lowest in the Royal Artillery. Davies saw the surrender of Louisbourg and then hurried with a British force to burn the already abandoned Saint John River French settlements at Grimross and to re-build Fort Frederick where Saint John now stands. He was stationed later along the St Lawrence, saw action at Lake Champlain, served in the American Revolution, canoed down the French River from Lake Nipissing to Georgian Bay, and revisited Canada on several occasions, his last departure for England apparently being in 1790.

Some early Davies works, such as those done at Grimross, are very primitive. His St Lawrence River sketches and others of tributary streams, painted while on fishing trips in the 1780s, stimulate through their bright colours and linear patterns in which one layer of rock repeats another in an attractive rhythm. These full-blown water-colours are a contrast to the tinted drawings of so many other army artists. They have a distinctive and personal feeling. While they have an attractive naïve touch, their bold patterning carries great conviction. This earned for Davies the title of an 'eighteenth-century Rousseau.' Their individual importance is enhanced by careful and iconographically truthful draughtsmanship which does credit to a keen military eye. Every feature is correctly set out, even in early water-colours like that of Fort Frederick with its brew house operated for the ranks, an officer fishing while off duty, mulleins and other readily identifiable plants, and the intricately constructed fort. *Château-Richer* (National Gallery of Canada) has carefully drawn houses, backyards, cows, fishing nets along the shore, and a series of hills and valleys. Others picture Indians. In one, a village on the St Lawrence is peopled with painted braves wearing feathered head-dresses and displaying trophies of the hunt. Another shows a group clustering beside the waterfall

where Ottawa now stands (fig. 13). Colour is a real glory: many of the officers favoured muted tones, but Davies' paintings fairly sparkle. Brilliant reds and yellows accentuate luminous blues and greens as seen in the clear Canadian air. His English friends at home probably condemned him for gross exaggeration.

Davies made the inevitable pilgrimage to Niagara (fig. 15), whose grandeur haunted many English visitors. Dozens of army men sketched there. Their fascination with the Falls is summed up by Captain Henry Davis whose reactions, in a letter to a friend, move through a full range of romantic emotions:

For myself, though twice a visitor [in 1831 and 1847] with an interval of sixteen years, and on both occasions constantly at work with the pencil near and above the Falls, I could never divest myself of a nervous desire to complete hastily what I was occupied with, in order that I might get away from the awful and imposing scene, with its accompaniments of deafening noise, boiling, hissing spray, and blinding mist, incident on the fall of three thousand millions of cubic feet of water over a precipice of one hundred and sixty-five feet; as soon, however, as the sound of the mighty water was lost to my ears, I was all anxiety to return again to the spot. A friend, writing to me from Niagara, thus graphically expressed himself: 'I longed for you when I sat gazing at the mighty Falls. No words can express my feelings, while I sat in silent wonder, almost afraid to breathe, and beheld the flood rush fearless to the brink. Hour after hour passed, and still I gazed, and thought, and gazed again: I felt as if I had intruded on Nature's privacy, and yet I was unwilling to depart. At last, after looking at it from every point of view, I returned to rest at the Clifton Hotel. I could not sleep: my ears were open though my eyes were closed; the roar of the waters had not yet become familiar to me, and after the fruitless efforts of an hour or more, I got up and took my seat in the window that looked full on the untired cataract. Here, under the mild splendour of a full moon, I saw clouds of ascending mist go up to heaven, and could almost fancy it was Nature's incense offered up to Nature's God.'[1]

Two officer-surveyors, Davies' contemporaries, did well-known Canadian sketches. Colonel J. F. W. Des Barres, while living in Halifax between 1763 and 1773, prepared a famous set of eastern seaboard admiralty maps which he published in London as *The Atlantic Neptune*; this was embellished with several Nova Scotian views. James Peachey, attached to the Quebec office of Samuel Holland, Surveyor-General of Canada, worked along the St Lawrence following the American Revolution. He executed many Canadian water-colour views of historical interest and sketched the heart-rending scenes as the Loyalists made

their first encampments. In Peachey's charming water-colours the dramatic subject matter is overshadowed by a romantic air found in some late eighteenth-century paintings, a certain fluid treatment of the trees, with their branching mauve trunks silhouetted against a pervading flood of yellow light. This approach sets them apart from the usual topographical records.

George Heriot was the most distinguished water-colourist in Canada to work in the Sandby tradition. He lived in this country from 1791 to 1816, revelled in the local scene, and might have ended his days here but for a fierce row with Sir George Drummond, Administrator of Lower Canada. His Scottish father had sent him to Woolwich hoping that he would enter the army. His student sketch-books while he was studying there under Paul Sandby are filled with water-colours of Greenwich in quiet washes, and with innumerable monochrome studies which continually grope for the character of trees in an anatomical study of gnarled trunks forming a solid frame for the tenuous lines of branches and the delicate foliage.

When first posted to Canada, Heriot was actually a civilian official in the army paymaster's department and was named Postmaster-General of British North America later. From that time he was divorced completely from military life, and became one of that aloof band of English officials who guarded the homeland's interests abroad. There was a certain loneliness for these men. Relations with local French-speaking society were cordial but somewhat restrained both because of language barriers and through some slight lingering resentment against the intruders. Protocol was stiff, and diversions were necessary. Heriot's one distraction was the famous Baron's Club of Quebec, a kind of 'Pitt Club' of twenty-one carefully chosen Tory members. All-night celebrations honoured the election of seven new 'Barons' in 1807; by five in the morning the cost had reached a total of $1,250. Painting was a cheaper recreation.

Heriot's duties included inspection of all British North American post-offices. Travel was endless: to the Niagara frontier with stops at Kingston, to Quebec villages with their quaint parish churches, and to Nova Scotia and New Brunswick where fierce mosquitoes nearly triumphed over art. Heriot carried his leather-bound sketch book everywhere. He sketched the Prince's Lodge at Windsor, Nova Scotia, Fort Chippawa on the Niagara Frontier, in and around Quebec and Montreal, as well as points between. Heriot's paintings demonstrate his deep philosophical understanding of the landscape theories then being advanced by the most advanced Englishmen of his time. He wrote a book, *Travels through the Canadas*, in which he introduced many terms

then in vogue. 'Picturesque' he applied to scenes where tumbling waterfalls and rough unbridled nature asserted itself as in his *Falls of the Pokiok, St. John's River* (fig. 16). By contrast, 'serenity' described nature subdued and cultivated by the hand of man as in his *West View of Château Richer* (fig. 17), even though he could not resist introducing a 'picturesque' note in the ruined castle. 'Sublime' views were those in which breath-taking and awe-inspiring grandeur crushed man by its very sweep. Consistently Heriot achieved a jewel-like brilliancy through transparent washes with bright colour touches accentuated by rich darks. Pale blue or blue-green washes quietly silhouette and set back the distant hills. Sandby's thorough training is very evident.

The Royal Academy hung two of Heriot's Canadian views in 1797. Studies of *habitants*, his *Minuets of the Canadians* and *La Danse Ronde*, and others of Indian life were first published as aquatints in 1807 as book illustrations. Heriot mentioned that he had also painted a Venus and two cupids in oil, and an unsigned view of Quebec with a couple sleighing outside the walls in oils is almost certainly his work (at Royal Ontario Museum). Few English army officers worked in this medium.

Lieutenant-Surgeon Edward Walsh, Heriot's contemporary, was doctor to the troops on the Niagara, Detroit, and St Mary's River frontiers in 1803-5 when continual fear of American encroachment necessitated constant vigil. He made sketches at various posts. Great black clouds darken the air in one, a unique record of the now extinct passenger pigeons (fig. 18). Niagara pioneers described such flocks passing overhead for hours. Another sketch of muddy little York, Upper Canada's tiny capital, shows the first houses lining the single straggling street.

James Pattison Cockburn was another Sandby student. He graduated in 1793 and held the rank of lieutenant-colonel when posted to Quebec in 1827. A senior officer's duties were not onerous in peacetime. He supervised the Citadel's gun-drill but this daily routine was usually delegated to junior ranks. Cockburn often escorted ladies of the Governor-General's household to picnics at Montmorency; Lady Aylmer, the Governor's wife, was sometimes at these outings. In a letter to her English niece in 1831, she vividly described how Cockburn worked indefatigably at his art:

I have just forwarded to England for you a little book lately published here, of which the drawings are Engraved from the beautiful sketches taken from nature by Colonel Cockburn who commands the Artillery at Quebec, and who is one of the most accurate and Elegant Artists I have ever met; he has travelled much in all the countries we have seen, and in many where we have

not been, he has an immense and most Valuable collection of his own drawings in every part of the world he has travell'd over and some color'd from Nature. He continues (at his present age) to be indefatigable and his passion for the beauties of nature can only be gratified by his unceasing perseverance in delineating them. He is a very good Example of how much can be done by never losing one moment of precious time and I always think when I am looking at his surprising labors, that surely the same number of hours are not marked in his day and mine. He gets through so much, while I seem to do nothing.[2]

Quebec's and Ontario's waterfalls, gates, principal houses, the horse ferry to Lévis, a Fête-Dieu procession in the street, and other points of interest were not his only subjects, for Cockburn too made the inevitable trip to Niagara. He sketched on the way and studied the falls from every conceivable angle after arrival.

Heriot and Cockburn paintings differ considerably. Cockburn favoured pale ochre-greens with bright spots of colour and blue accents to achieve the depth of the outdoors. Rich autumn colouring never attracted him. His mauve-brown tree trunks were hurriedly painted and lack Heriot's love for the essential anatomy of trees. Only in his most carefully worked up paintings did Cockburn attempt to build solid effects by applying one wash over another. He seldom achieved the subtle atmospheric moods of which the Postmaster-General was capable. In contrast to Heriot, with his firm touch, tonal solidity, and judicious accents, Cockburn was a less deliberate worker. His more serious works, however, were accepted readily by art circles and two were exhibited in 1836 at the National Academy of Design in New York.

The famous Ackermann firm of London published two handsome sets of Cockburn's views of Quebec and Niagara dedicated respectively to William IV and Queen Victoria. In these he reached his artistic heights, and they are also superb examples of the print-maker's art. In one view, a summer party of Quebec gentry gaily picnics and promenades at Montmorency Falls; in another, officers and ladies mingle with the local populace on the frozen St Lawrence where wooden huts display flags and the cryptic signs 'Auberge' announce temporary taverns for a thirsty crowd.

Cockburn experimented with a *camera lucida*, a device used by Basil Hall and other visiting topographers. Through a pinhole this 'slow motion camera' projected a reverse view on a sheet of paper inserted into the back. The artist rapidly traced the salient features in pencil. This required considerable skill, but a practised hand could sketch landscapes and even slow-moving processions. Cockburn once drew a

'funeral procession passing down the street, with the officiating priests, acolytes, mourners and bearers carrying a small coffin' (fig. 19), using the *camera lucida*. On the basis of such pencil sketches, he painted his water-colours, of Quebec streets and similar subjects, at a more leisurely pace, reversing the *camera lucida* image to show the true view. One senses that this guide resulted in a much greater sense of deliberation and tightness than in those paintings of his which were drawn free-hand from nature.

Britain was thoroughly roused by the news of the Mackenzie-Papineau Rebellion. Reaction in England had been slower when the United States invaded Canada in 1812 at a time when the Mother Country was embroiled in a life-and-death European struggle. Now in 1837 there was vigorous action. Troops were rushed overland in midwinter from the quiet Maritimes. Others were despatched from Britain by the first available transports – but the fighting was over before they arrived, although they would spend several weary garrison years in a country which was outwardly quiet but emotionally much aroused.

A surprising number of artists in the garrison turned out many fine works during the three or four years following the rebellion. Sir Richard G.A. Levinge of the 43rd Monmouthshire Light Infantry was the most proficient, and his friend Sir J. B. Estcourt was another painter-officer in the same regiment. Levinge had previously painted regimental sleighing parties of officer-dandies leaving the Saint John barracks in sleighs emblazoned with illustrious family crests, or arriving at the home of a gentleman farmer in New Brunswick where the smoke rises straight into the sky on a frosty morning. He painted his officer companions of the 43rd Regiment and subsequently it was lithographed in London during 1837 as *Meeting of the Sleigh Club, at the Barracks ... St. John, New Brunswick*. Levigne wrote and illustrated *Echoes from the Backwoods* (1846), about his life in Canada. Another sleighing scene, for these officers loved to record their lighter moments, pictured *The Insolvent Subalterns*, high-spirited young officers driving through the Kingston streets; it was by the Royal Engineer E. Y. W. Henderson.

Captain Beauclerk sketched various actual rebellion skirmishes. G. R. Dartnell, surgeon-general for the British army in Canada, painted while on duty from 1836 to 1843 in such remote posts as Penetanguishene, Ontario. Colonel A. C. Mercer, a Woolwich man and hero of Waterloo, assisted in the New Brunswick-Maine boundary settlement on the east coast during the late 1830s, carrying his sketch-books throughout Nova Scotia, New Brunswick, and Prince Edward Island.

Fewer garrison officers sketched in the later years. Captain W. W.

Lyttleton handled water-colours superbly while serving in the Halifax garrison in the 1850s (fig. 20). W. O. Carlisle, last of the crew, remained in Canada to work on the strengthening of the Lévis forts after the withdrawal of most British troops in 1871. Carlisle travelled widely, published his sketches in the *Canadian Illustrated News*, and caricatured his army comrades in his *Recollections of Canada, Quebec*.

British Army officers, it must be admitted, were not a part of a developing Canadian tradition. They are a gratuitous bonus, but they did foster some local interest in water-colour painting. Most local citizens of the day, of course, saw prints of their paintings rather than the originals. As book illustrations in earlier years and as reprints today, they have over the years done much to form an impression of the earlier Canadian landscape. A lively contemporary interest in this historical landscape has brought about the return to Canada of hundreds of these water-colour sketches during the twentieth century; in themselves they now constitute a whole specialized field of study, particularly for innumerable avid antiquarian collectors. The Canadian Government paid a quite accidental tribute to all these British Army painters in 1885 when W. O. Carlisle's Canadian sketches were part of the Dominion's section of the Colonial and Indian Exhibition, London. It was a finale to a century of painting by army officers which by then had passed into history.

7

The Golden Age in Quebec:
The Beginning

A golden age of native painting was dawning in Quebec, Montreal, and the other villages and towns along the St Lawrence in the late eighteenth century. Abbé Gravé mentioned the new French-Canadian fashion for portraits in a letter written from the Quebec Seminary in 1788: 'The custom has come in Quebec to have oneself painted. The portrait of the curé is very lifelike. I have persuaded the old retired Bishop to have himself drawn. He is not so well ... ' Sitters were not only clergy but included secular members of the community – seigneurs, petty officials, and successful bourgeois.

This new age in French-Canadian painting achieved unprecedented heights and lasted for the extraordinarily long time span of seventy years. Its canvases have an attractiveness undreamed of by earlier artists, and insufficiently known to our present generation. Subjects are varied: unforgettable portraits, the first major Canadian landscapes, and sensitive religious works. Many canvases have been described as primitives, but their painters also demonstrate stronger aesthetic sensibilities; when they achieve greater sophistication, lingering traces of a naïve approach preclude any tendency to the banal or the sentimental. The whole cycle had two phases, artists of the first painting chiefly before 1800, and of the second from the 1820s to the 1850s. Before the Quebec painting of these years had run its course, three great art movements had swept across the world scene: the rococo, neo-classicism, and romanticism. These wider trends imprinted themselves in varying degress on Quebec painting, and the result is a stimulating variety of artistic approaches, which enriched the cycle as a whole.

Painters prospered in the 1780s as never before in Canada. François Baillairgé, an unusually successful business man, painted in Quebec after returning in 1781 from studies in Paris. Montreal had more vari-

ety since three well-known artists practised in that city: Canadian-born François Malepart de Beaucourt who had spent some years in Europe, Louis-Chrétien de Heer whose *canadien* 'in-laws' bickered with him constantly over his Protestant leanings, and the aristocratic Louis Dulongpré who had already been in Montreal for several years when he advertised portrait painting in 1794 and whose career would extend into the period of the second phase. William Berczy, Sr, had moved to the city by the end of the century. These five professional artists dominated the first phase of Canadian painting in this golden age, but various itinerants and lesser men also painted during these years when portraiture was commanding special attention throughout Quebec province.

Three of these painters had studied in Paris when fun-loving courtiers and aristocrats still demanded gay and carefree paintings. Boucher, who had painted delightful whimsies in which aristocrats cavorted as shepherds and shepherdesses, was now dead, and Fragonard, famous for his naughty *The Swing*, was older, but society, as mirrored in the pastels of Quentin de la Tour and Perroneau, the current favourites, was still light-hearted and mirthful. Most painters chose to ignore the sober warnings of *philosophes* who forecast the rise of the proletariat and the danger of revolution, for they still preferred the rococo spirit of the age of Louis XIV. The rococo styles had not the same creative vigour of former years but were still a mighty force, and Beaucourt and his Canadian artist associates carried back home from Paris memories of sophistication and lightness of heart. The rococo influence, synonymous with bright, lively and carefree painting, is accordingly evident in a few late eighteenth- and early nineteenth-century Quebec canvases. No Canadian artist visited France during the French Revolution or the Napoleonic age. Revolution and war did not completely cut off contact, however, for the social world still imitated Parisian fashions in clothes and hair styles. Reproductions of the latest French paintings may even have trickled into Canada, but knowledge of the Continental art scene was very much second hand. When students again crossed the Atlantic after Waterloo, a whole age of classical art had risen, flourished, and almost disappeared in a losing battle against that romantic and optimistic wave which was beginning to engulf Europe. Those Canadian artists who knew France after Waterloo became leaders in the second stage of Quebec's golden age of painting.

The golden age, with rare exceptions, was not one in which religious art was especially noteworthy. The artists' income from painting religious canvases for altarpieces and church walls was nevertheless probably larger than from portrait commissions since churches were

under construction on every side, and large ornamental paintings commanded substantial sums. The clergy specified traditional subjects and styles; artists responded with thinly disguised variants of earlier European works or outright copies after Raphael, Rubens, and Titian. Painters rarely stepped out of line and if they had done so would have invited rejection of their works. For this reason, eighteenth- and nineteenth-century religious painting in Canada has not interested art historians to the same extent as has portraiture, where more originality was in evidence. The commissioned paintings often bordered on commercial art, but artists still regarded themselves as craftsmen and would never turn down any possible income. Even leaders among them, according to their advertisements, were prepared to paint shop signs or stage scenery and fresco homes. The art-loving society was not sufficiently large to support many artists in affluence.

The break in direct contact with France during the Napoleonic wars left Canadians very much to their own resources at the crucial time when the demand for paintings was reaching unprecedented proportions. French-speaking artists responded to the challenge by creating a distinctive Canadian portrait style. In their new portraiture the rococo heritage was tempered by sober thoughts of revolution and war in Europe and threats of American invasion at home. It blends alert and lively touches with a trace of sadness, and a curious provincial naïveté with sophistication. The resulting portraits are among the glories of Canadian art. The whole rococo spirit is best typified by the refined portraits of M. (fig. 21) and Mme Trottier *dits* Desrivières by François Beaucourt. They reflect the life of the genteel pre-revolutionary French society as emulated by the more affluent French-Canadian seigneurial class. Beaucourt revelled in the play of colour and in laying bare both the human pride and the human weakness of his sitters. The wife, pouring tea for her guests, maintains the respectable air of a perfect hostess, while her gay husband carelessly risks the family estates and fortune at the gaming table. The costly samovar, the cup, the golden box, and Mme Trottier's jewellery reflect an age of elegance, grace, and serenity; the highlights and surface textures convert them into a still life composition which Chardin might have painted for its own sake. The inner spirit of these paintings parallels that in the work of William Dunlop, leader of the rococo movement in the United States. Beaucourt could have known Dunlop since he himself had maintained a studio in Philadelphia for a few months.

François Beaucourt received his first painting lessons from his father Paul Beaucourt. He left for serious study in Paris after the Seven Years' War and then moved on to work with Joseph Camagne in Bor-

deaux. There he married Camagne's sixteen-year-old daughter, Benoîte, in 1773. Historians in Bordeaux know even less about Camagne than about Beaucourt. While a student there, Beaucourt painted murals in religious institutions in and around the city. Then he and his young wife visited Russia, Germany, and other European countries before settling in Paris where they mixed with Fragonard's pupils and admirers. He returned home after an absence from Montreal of what some believe to be fifteen years, and later inserted an advertisement in the *Montreal Gazette* on 4 June 1792, describing his studies and the many types of painting he was prepared to undertake. It described him as a 'Member of the Academy of Painting, Sculpture, and Civil and Naval Architecture of Bordeaux' who had painted professionally in Paris, Petersburg, Nantz, and other European cities. He died in 1794, still a comparatively young man.

Beaucourt painted a sensual half-length portrait of his coloured servant, now known as *Portrait of a Negro Slave* (fig. 22), in 1786, at about the time of his return home. She sits erect, holding a bowl of tropical fruit, with a landscape dominated by a mountain peak as a background setting. The woman still lived in Montreal as an old lady in 1832. This is the earliest Canadian painting conceived purely in terms of picture-making and painterly qualities. The artist delighted himself in the play of light and shadow on the white blouse and the contrast in tones between it and the red-brown flesh and brown skirt; a red kerchief on the head echoes the pineapple's orange-red skin, and the cool blue sky makes the warm colours even richer. There is a sumptuous elegance in every brush stroke of the exotic fruit. In this painting, the artist consciously sought after an aesthetic rather than any didactic or literary response.

Beaucourt's portrait of the foundress of the Montreal Grey Nuns, Marguerite d'Youville, differs strikingly from the Trottier and Negress portraits. It had to be based on a somewhat crude posthumous portrait. He sensed the woman's pious devotion, reverently inclined her head, and suppressed colour, choosing sombre tones as appropriate to a religious atmosphere. A sagging and distorted shoulder and other weak points of draughtsmanship demonstrate how much Beaucourt needed a model.

The influence of his Parisian friends is indelibly stamped on Beaucourt's religious paintings. His greenish-blues and pinks are like those favoured by Fragonard's followers, as for example in the Virgin and Child formerly at Varennes. The Madonna, silhouetted against a dark background, clutches a cherub-like child who embraces her. She looks out with a radiant gaze, her idealized almond-shaped face

smooth, serene, and contemplative. A gentle sway of line throughout the composition is attuned to pre-revolutionary France's gentle rococo.

Beaucourt's larger canvases commissioned for churches have fared badly. Two, the *Marie, secours des Chrétiens* and the *Miracles de sainte Anne*, were burned in recent years. Fragments rescued from the former conform in colour and spirit to the Virgin and Child. Dirt hides much of the charm of four canvases completed for Varennes in 1793, but there is the same springing linear rhythm which fairly darts back and forth over the composition. They honour Saints Gregory, Augustin, Ambroise, and Jerome, the painting of the latter having been inspired by a painting, Pierre d'Ulin's *Vision de saint Jérôme*, now at Université Laval.

Practical François Baillairgé, who studied in London and Paris between 1778 and 1781 when rococo painting was still the vogue, scarcely allowed the age's frivolities to affect his work. Sculpture took precedence over his interest in painting because his family were wood-carvers and sculptors; his letters from Paris imply that he was determined to please his sculpture master, Jean-Baptiste Stouf, and make no reference to his painting teacher. Baillairgé's activities were diffuse. He conducted art classes for years, advertised the sale of altars, trade signs, sculptured coats of arms, niche statues, small Virgins, and the like. He even carved figureheads for Quebec ships. The family business of carving decorative ensembles for churches took up much of his time. Later he was appointed Treasurer of Quebec City. This 'universal man,' who loved music, the theatre, science, art, history, and the decorative arts, could have had little time to meditate over his paintings.

The half-length portrait of Dr Dénéchaud attributed to Baillairgé is an excellent psychological study: the doctor, with carefully combed hair, and a knowing, cunning, and even quizzical face, stands in simple dignity, highlighted against a gloomy background. Portraits of local ladies have quality, a poise and refinement which seems to be summed up in their dainty lace caps, but they lack the completely aristocratic bearing of Dulongpré's sitters. Baillairgé's decorations for the Quebec theatre, finished between 1784 and 1796, were presumably rococo carvings and paintings, but the building has long since disappeared. Many known canvases have religious themes but are so dulled that they now have little of the original impact. His small sketches for larger religious paintings have a livelier air. *La Résurrection* in Sainte-Famille Church, Île d'Orléans, painted from a water-colour study, where the figure of Christ floats up from the earth, echoes slightly the upward surge of Tiepolo, the great Italian rococo master.

Baillairgé even completed a series of twelve apostles inspired by Rubens, but virtually abandoned painting after 1804.

Baillairgé had shown an interest in the classical world, the style which gave a whole new look to painting of the Napoleonic age, and this results in a dualism in his work. His lost *Rape of Europa* was painted in seven days and like his rendition of *St Ambrose and Theodosius* drew its subject matter from antiquity. He drew a medallion portrait of his brother (fig. 23) whose clear bold outline would do credit to any neo-classical master. It echoes his interest in sculpture and has a smoothly rounded profile reminiscent of classical sculpture rather than the florid rococo age. Baillairgé left France before David returned from Rome, but he must have seen Benjamin West's neo-classical works in London.

Later eighteenth-century and early nineteenth-century neo-classicism, which so affected the European art of the time, was a way of thinking from which ideas spilled over onto the brushes of the painters. In the current preoccupation with the ancient world, artists, in painting interiors, provided them with the reproductions of Roman furniture and classical antiquities which were then the latest vogue in house decoration. French neo-classical canvases became larger and more magnificent, reflecting the glory of Imperial Rome and incidentally the Napoleonic Empire. Stylistically, painters and sculptors used the clear lines, soft rhythms, and open uncluttered spacing found in either the single classical figure or the antique frieze.

Philosophically, neo-classicism embraced the spirit of revolution and took real root only where there was dissatisfaction with the existing order. France regarded the 'establishment' as an oppressor, and her intellectuals, looking into the ancient world, discovered a democratic Utopia, which they wished to imitate by setting up their own ideal state. The style had strong appeal in the new American republic which was searching for established roots. Canadians, on the contrary, were indifferent to the new philosophy for the country was enjoying a period of unprecedented prosperity and growth in contrast to the disturbances of the Seven Years' War. The French Canadians were loyal to church and seigneur, since the British had guaranteed freedom for both. English Canadians looked forward to the potentialities of the new land. Revolution would be an unthinkable catastrophe for either. Most local painters had merely a superficial attraction to neo-classicism, and probably also failed to appreciate its real achievements as an art style for they had no opportunity to see the movement's important canvases at first hand. It is also characteristic of much Canadian art that once a style takes root, it lingers on long after it is superseded

by new styles in Europe. That happened in this instance. Plamondon was still very much aware of classicism in the 1830s.

William Berczy, Sr, from Saxony based his works on European traditions. He began imitating the neo-classicists after a trip to England in 1800 but grasped little of the movement's inner philosophy. Reared in Vienna, where his uncle was the German ambassador to the gayest of all European courts, he rebelled against entering the diplomatic service. Berczy attended Leipzig University and the Art Academy at Vienna, where his master demanded accurate drawing. Then he wandered through Central Europe. After he married Charlotte Alemande, a painter from Berne, the two passed five years in Italy where the husband painted refined water-colours of family groups, and then allegedly became drawing master to an English aristocrat's family. Their London friends were expatriate Germans, one of the circle being Johann Zoffany, favourite court painter to Queen Charlotte and George III. Berczy brought a party of German colonists to the United States in 1792 as the Marquis of Bath's land agent, quarrelled with the New York State authorities, and moved them to Markham Township outside Toronto. Thereafter he considered himself a Canadian, and shortly was painting portraits of Toronto's leading citizens.

Joseph Brant's portrait is one of Berczy's very early Canadian works. The two were friends. The great Indian leader, who had led the Six Nations from New York State to the Grand River grant below Brantford, was every inch the chieftain. Mrs John Graves Simcoe wrote after entertaining him at dinner:

He has a countenance expressive of art or cunning. He wore an English coat with handsome crimson blanket, lined with black, and trimmed with gold fringe, and wore a fur cap; round his neck he had a string of plaited sweet hay. It is a kind of grass which never loses its pleasant scent. The Indians are very fond of it. [1]

Berczy painted three pictures of Brant, a head in gouache, a low-keyed oil portrait in a classical oval, and a full-length portrait standing with his dog by the water's edge (fig. 24). Theatrical touches in this later version are in the spirit of Zoffany's portraits of the comic actor, Isaac Bickerstaffe, owned by the Garrick Club of London. A stage tableau of *Columbus and the Egg* by Berczy has similar theatrical touches: the curtain rises to disclose the Spanish king, his son, and a councillor, all confounded by Columbus who demonstrates his theories on the roundness of the world. An inquisitive and sceptical French-Canadian curé looks on. It is based on an earlier English engraving.

Litigation over title to the Markham lands took Berczy to England about 1800. The dispute was never settled and on returning to Canada he became a full-time professional painter. Montreal offered a more appreciative and larger clientele than Toronto. There indeed he had little real competition except from Louis Dulongpré who was both his landlord and a friend. Beaucourt was dead, Baillairgé had virtually stopped painting, and de Heer may also have been dead.

Berczy's undoubted masterpiece is his neo-classical *Woolsey Family* (fig. 26), painted during a visit to Quebec in 1808-9. His numerous letters back to his wife in Montreal describe the progress of the laborious undertaking. One by one each figure was carefully drawn, the outline transferred to the canvas, and then painted. The family group – the young master of the house, his mother, his charming wife with her babes, the younger brothers-in-law with their green velvet clothing, and his brother with a flute – is spread across the narrow stage of the room with the spaciousness and precision of a classical relief. The neo-classical mantel and Roman mosaic tile floor are emphasized. Through the window is a delicate landscape. Berczy charged ten pounds for each figure and painted the dog for nothing. The painting has an added importance as an early Canadian conversation piece in an age when the single-figure portrait was a general rule. Possibly Berczy had memories of Zoffany's group portraits of the English royal family or Jacques Louis David's *Portraits of Michel Gérard and His Family*.

Both Berczy and Dulongpré mingled with local leaders of society. Governor Prescott commissioned a water-colour portrait from the former which was a real triumph in prestige for the artist, but Berczy tore the paper just before its completion and had to redo the whole. Occasionally he visited the wealthy at their country houses. A judge and his wife near Quebec were astonished at an outline likeness drawn in a single day; the painting was completed later. Some orders were for life-sized oil busts, and others for miniatures on ivory. Berczy's best-known works are profile pastel portrait heads embodying the precision and clarity of classical or Wedgwood basalt medallions. Most subjects in this style were Montreal fur-traders, lawyers, civic leaders, and garrison officers.

Berczy undertook restoration of the large altarpiece still in the Ursuline Chapel, Quebec. His young son, William Jr, was his apprentice and both painted in backgrounds for his father's miniatures and copied part of the Ursuline canvas while his father carried out restoration. The nuns asked Berczy to undertake a further commission and he wrote to his wife that he would need her help:

The Ursulines have asked me for a work which I will do in Montreal; it is a medallion for the front of the altar where the large picture which I have just restored for them will be placed. This painting will represent a Descent from the Cross and is to be painted on silk, but it will be difficult for them to find a piece of material as good as your old white silk dress. I pray you to tell me in case you are willing to give me a piece of it, what is the greatest width so that I can judge if it is large enough. [2]

The question was delicately phrased. The artist had been absent from home for many more months than he had anticipated.

Other members of the Berczy family also painted. His wife taught art, and William Jr was almost as proficient as his father at miniatures, small water-colour portraits, and landscapes. In one of these, the curé blesses the fields as his flock accompany him (fig. 25). Amélie Panet, the son's wife and the daughter of a seigneur, had been her father-in-law's favourite pupil. Her landscapes and those of her husband are stylistically indistinguishable. Amélie and William Jr lived near Windsor until her father's death forced them to take over management of his seigneury. Berczy Sr bequeathed a series of historical paintings to his sons William Jr and Charles, an early Toronto postmaster. He died unexpectedly in 1813 while visiting the United States in search of a publisher for a book he had written on Canada.

Louis-Chrétien de Heer, another Quebec painter of this generation, was an Alsatian who had settled in Montreal by 1783; the documents of his marriage in the following year describe him as a master painter. During 1787 he painted portraits in Quebec in oil and pastel, landscapes, pictures of all kinds, and gave lessons in landscape painting. He advertised drawing lessons for young Montreal ladies and gentlemen in 1789 and his last known paintings are dated 1792.

The *Portrait de Monseigneur Hubert* painted at the Quebec episcopal palace is probably the Bishop's portrait to which Abbé Gravé referred in 1788 (see p. 56). This and a replica now in the Hôpital Général at Quebec (fig. 27) seem to be de Heer's most striking known works. It is a full-face composition, rigidly bisymmetrical, a kind of patterning which ignores all volume, all accidentals of light and shade or surrounding atmosphere, in great contrast to Beaucourt's airy style. The sitter's ecclesiastical robes enhance the decorative effect. The browns, blacks, and sombre mauves have a heavy quality, but there is a great majesty and dignity as befits the subject. De Heer strove continually for a pleasing pattern in all his pictures, and made particular use of red flashings for this purpose when he painted military men in uniform.

De Heer decorated churches as did other artists of his generation. One contract signed by himself and others undertaking decoration in the church of Saint-Charles (Bellechasse) must be typical of many of that period:

I the undersigned undertake to paint for the Church of St. Charles, 1) a canopy above the altar, the wooden supports of which I will gild in fine gold, the edging only, and will repaint the rest. 2) seven paintings shaped to fit the piers which I have seen; one representing Christ and the others six apostles. I will supply everything: paint and canvas. 3) a Holy Ghost above the sanctuary, also painted on canvas. 4) St. John the Baptist for the rear like the print which is there, and this for the price and sum of 18 Portuguese 864 *livres*. At St. Charles, 23 March 1789. I have received on account 9 Portuguese. I will deliver the work and put it into place myself during next June.

LOUIS DE HEER, *Painter* [3]

Louis Dulongpré's obituary states that he painted more than 3,500 oil and pastel portraits, an output scarcely attained by another Canadian painter. While his art grew out of rococo style, he was never able quite to equal such a painterly achievement as Beaucourt's sophisticated portraits of the Trottiers. Dulongpré was a conservative old gentleman, born at Saint-Denis, just outside Paris, who always wore the silver buckled slippers, knee breeches, and white powdered wig of the French Old Régime. He recalled how he studied in the best academies, presumably those of Paris, before going with the French marines to assist the Americans in their revolution. That same year, 1778, Baillairgé went to study in Europe. Dulongpré visited Albany before returning to France, met some young French-speaking Montrealers, and was persuaded to visit Canada. There the light-hearted kindliness of all he met struck a sympathetic note. He lingered on in Montreal and forgot France completely after marrying charming Marguerite Campeau in 1787.

Instruction in dancing, singing, and the harpsichord brought in a meagre income during Dulongpré's first years in Montreal. Then he branched out in November 1789, painted scenery for the local theatre and also worked as a producer under a contract in which he agreed to undertake many responsibilities:

[To] furnish to the society's theatre which will be set up in his house [presumably his large studio on Campeau St., Montreal], three complete stage sets, painted on canvas and representing a room, a wood and a street, together with the large curtain ... he will set up the stage and will furnish the

wood necessary for its construction as well as for the orchestra ... he will pay the musicians, and the wig maker, for the tickets, expenses of advertising, etc.[4]

On 10 April 1794, the *Quebec Gazette* printed Dulongpré's advertisement offering miniature or pastel portrait work to be carried out at Dillon's Hotel. This marked a new phase in his career. Art historians are sharply divided on whether he painted many well-known unsigned canvases, and his name has been associated with portraits which differ widely in style. There is no question about a few. *Madame Dragon* is known to be by Dulongpré. There is excellent documentation on others, such as several pastel portraits in the Chateau de Ramezay which were completed before 1800. Dulongpré's pastels developed stylistically out of the popular pastel portraits of pre-revolutionary France; many have survived despite the perishable nature of the medium. His hale, hearty, very jolly and very human oil painting of Mère Thérèse Coutlée (fig. 28) is signed on the reverse. She embroiders a sash of red felt, a type of cloth favoured as a trade article by the Indians. The brush work is broad and very vigorous even if a darkening of the colour has detracted from the original. His sitters also included Sir George-Étienne Cartier's ancestors, and Louis-Joseph Papineau's relatives. This courtly artist and the great patriot leader Papineau were close friends, and the chess set still survives with which he and Papineau passed long winter evenings in intellectual duelling when the artist visited Montebello seigneury.

Religious paintings and murals provided additional income for Dulongpré. He was commissioned by François Baillairgé to carry out certain work for him in 1799, presumably some type of decorative painting. After 1802 Joseph Morand, an apprentice, assisted in the completion of larger compositions. Dulongpré's most celebrated church painting was the ceiling decoration of old Notre-Dame, Montreal, destroyed during the 1820s, and said to have been compositions into which he introduced portraits of friends. One group which surrounded Saint-Roch even included a painting of his wife. Religious paintings occupied much time during his later life; he worked at Berthier-en-Bas in 1797-1800, Saint-Eustache in 1803-4, the Ursuline Convent in Three Rivers in 1807, and in various other churches; he concluded his career with his work at the church of Sainte-Croix (Lotbinière) in 1840-42.

Stylistically the portraits of Mme Dragon and Mère Coutlée have no apparent connection with another group, painted in the 1830s, which have a typical *canadien* air. Some authorities have attributed this group to Dulongpré and others to Roy-Audy (see p. 67). All of them,

in contrast to the freely brushed painting of Dulongpré, have virtually a porcelain-like finish. One of these minutely painted portraits (fig. 29) is of Mrs Charles Morrison, wife of the Montreal fur-trader. Her genteel, refined face has an almost wistful look. Like ladies in other portraits of the time, she wears the elaborate head-dress which tourists particularly mentioned in writing about Quebec.

A host of fascinating Quebec portraits from the late eighteenth or earlier nineteenth century are unsigned. One, the portrait of the fourth seigneur of the Rouville family of possibly 1810, has been traced recently to William Berczy, Sr. Another, of Abbé Duberon (Royal Ontario Museum), combines dignity and decorative elements in its black and white patterning enhanced by rich reds; painted in 1792 for Varennes church, it has been claimed for both Beaucourt and de Heer. There are portraits of women in Regency dress, some have rows of curls across the forehead like the hair styles in David's great canvases. There are smooth serene faces, and faces wrinkled with years of work. Such portraits, many of which are anonymous, lend even more variety to the artistic scene of their period.

This whole phase we have been discussing should be of the greatest interest to all lovers of Canadian painting, for in it our artists had gone beyond mere imitation of European prototypes to create paintings with a 'Canadian' character. It is art without close parallels. The un-tutored ex-voto painters of the eighteenth century's opening years were now superseded by a virile, more sophisticated, and more accomplished group. Their new painting is unique not just because Quebec was prosperous and the economic climate favoured artistic development; it is so chiefly because it evolved when Quebec painters, cut off by the French Revolution and Napoleonic Wars, were vigorously pursuing an almost solitary path as they worked out their own ideas. Yet during those years, trickling rumours of the rococo and neo-classical age gave a special piquancy to their paintings, so that they were also contemporary, lively, and attuned to the times. Near-isolation had its compensations.

8

The Golden Age in Quebec: Maturity

Quebec artists, building on the distinction achieved in the late eighteenth century, brought an exciting new vision into Canadian art during the golden age's full flowering. In the next century they painted dazzling portraits of beautiful ladies, dimpled children, austere politicians, and local celebrities, and landscapes both of the cities and of the countryside. The canvases which poured from studios in ever increasing numbers were not only more spectacular and elegant than those of the earlier generation, but grew in size to match the country's growing sophistication. Painting had a new vitality which matched a new character in Canadian life.

The leading artists of these years of great accomplishment between 1820 and 1850 lived in Quebec and thus restored to that city the prestige of being the country's artistic capital. Montreal, by contrast, had dominated painting in the 1790s. Légaré, first of the new generation, enlivened his daily routine by working as a part-time political agitator. Plamondon and Hamel, equally important, were such busy portrait painters that they had no time for sidelines. A fourth, Roy-Audy, was a primitive of extraordinary ability. Their united output made a powerful artistic impact.

An emotional and romantic spirit was beginning to modify Canadian painting. The romanticism of Europe was partially reaction against the classical world, an artificial world which had lived really only in the minds of philosophers. Classicism had been cold, it lacked intimate contact with man's real life and environment, and it was dying rapidly. Newly crystallizing attitudes in England and France counteracted its austere, aloof qualities. This new outlook was also partially reaction to the Napoleonic War, now that tensions could be released in a restless lively mood which was vaguely like that of the

'gay twenties' in this century. Writers and artists began to explore their own surroundings and their own inner feelings. Byron was a romantic poet; he was also a swash-buckling adventurer who, in fighting for Greek independence, lived the romantic life about which he wrote. English nature poets – Wordsworth, Keats, Shelley, and others – ruminated on birds, flowers, and nature. Alfred de Musset's poetry and prose had new qualities of personal emotion. Many well-known painters, stirred to romantic excesses, sought for new and vital directions in their art. Delacroix painted the stricken harem during the *Death of Sardanapalus* and a soul-stirring maiden, symbolic of France, leading her compatriots to victory in *Liberty on the Barricades* . Bonington's very rich colours roused emotions, and Turner became nostalgic when painting the *Fighting Téméraire* as she was towed into her last sunset, or charged his canvas with passion as the newly developed railway train rushed through the blustering storm.

Canadian paintings, like those in Europe, showed new personal touches, reflecting the painter's own emotions or his surroundings. Canadians for two centuries had considered themselves colonists, simply transplanted Englishmen or Frenchmen living away from home. They had regarded Canada as a place quite inferior to the homelands, which must take its standards of the beautiful and correct from Europe. Suddenly these colonials realized that they were living in something more than a mere puppet state of Europe, that they had a country of their own, an exciting country with exciting people; Canadian artists began to paint their own land and fellow citizens with a feeling of kinship to their subject matter and in the hope that others might share in the excitement of their discovery. This was one aspect of the romantic spirit. Légaré was the first native-born artist really to look at and paint the exhilarating Quebec landscape, while Plamondon and Hamel saw its people with a fresh eye, particularly its leaders and cultured hostesses. Plamondon tried to remain a classical painter, but even he could not entirely escape the new artistic impulses which led painters to seize on anything and everything for their subject matter.

Many recent events unrelated to art helped to strengthen this interest of Canadians in Canada. They had fought for their country during the American invasion of 1812-14, and had come to realize that they were fighting for something worthwhile. They were launching into ever-growing business ventures; Montreal merchants who had banded together as the North-West Company were seriously cutting into the Hudson's Bay Company fur trade revenues. Books describing Canada sold widely and encouraged Canadians to look more directly at themselves and their country. English visitors, in their best tradition, pub-

lished journals and diaries filled with their impressions of the New World. Francis Hall wrote *Travels through Canada and the United States in 1816 and 1817*, Captains Franklin and Ross described their Arctic trips in the 1820s, and Mrs Jameson wrote of her *Winter Studies and Summer Rambles in Canada* in 1838. Joseph Bouchette wrote and illustrated a book on Canada published during 1815, T. C. Haliburton wrote on Nova Scotia in 1823, and Christopher Atkinson on New Brunswick in 1842; dozens of similar books were either printed or planned. Many scientific advances were made in this new industrial age, minds were becoming more receptive to new ideas, and many old conventions were passing away; Canadians saw their country and its potential for development in a bolder and more adventurous spirit. Her artists were swept up in this new enthusiasm.

Youthful Joseph Légaré, who led in this revolutionary new way of picture-making, had been preoccupied with painting from his youngest days. His father was a man of substance, and some writers say that the son studied in Rome, Paris, and London. Another has declared that the governor at Quebec, impressed by his work, offered the young man free passage to Italy on a frigate, but that he declined. Politics was Legaré's second interest. Authorities regarded him as such a potentially dangerous political agitator because of his close association with the more radical French-Canadian elements that, when the 1837 Rebellion erupted, he was immediately arrested, but he was released after five days when his father guaranteed his good behaviour. Légaré supported Papineau for many years; he offered himself for the Assembly in the 1848 election, but was defeated. His prestige later rose to the point that he was appointed a Quebec Legislative Councillor in February 1855, a few months before his death.

Légaré was a versatile painter, turning out canvases of the most varied subject matter. As a young man he supplied Quebec churches with numerous religious paintings based on French originals. On the other hand he painted a portrait of the last Canadian Recollet, a kind and gentle *Frère Louis, dernier Récollet*, obviously for his own personal satisfaction. The frail old priest, after spending a lifetime in helping others, wanders with his stick along the grass-and-flower-lined path as he nears life's end. Delacroix can be seen as an influence in the quality of light in the painting, but Légaré toned down the contrasts instead of retaining the strong emotion and forced qualities found in the works of the leading French romanticists. An intimate portrait of Lady Aylmer, now in the Ursuline Convent, Quebec, is strikingly similar to numerous Plamondon paintings in its careful draughtsmanship, lighting, and aristocratic character. In contrast to his intimate portraits from life,

Légaré painted both a giant canvas of Queen Victoria copied from a work by Sully which he subsequently raffled, and a George III after Ramsay which he sold to the Quebec Legislative Council. He converted his studio next door to the Ursuline Convent into a picture gallery where visitors examined his collection of European canvases and where he sold his own paintings. During the 1848 election campaign he sold £357 worth of lottery tickets at £1 each, and raffled off thirty-one canvases which included portraits of Indians and bagpipe players, still life compositions, a landscape with a hypothetical monument to Wolfe (fig. 30), and a variety of religious paintings. He was so versatile that he even painted processional banners, and in 1832 decorated the new Théâtre Royal, Quebec.

Louis-Hubert Triaud, art teacher at the Ursuline Convent, helped Légaré in the theatre decorations. This Londoner of French parentage had emigrated to Canada in 1820, and is best known for a magnificent canvas of the Corpus Christi (Fête-Dieu) procession at Quebec (fig. 31), with the pervading light grey and pale yellows accenting its touches of rich colour.

Légaré is virtually the founder of Canadian landscape painting. Earlier artists and visitors had painted innumerable water-colour views, but no Canadian artist had regarded landscape as an end in itself. His innovation was recognized by his contemporaries but is usually overlooked in the present century. A visitor to Légaré's studio in 1833 wrote in the *Quebec Gazette* during the month of December about his delight at seeing the artist painting the 'charming and delightful scenery of his own beloved forest land':

He has emerged from the dusty and prozing society of vigil worn saints and other goodly canonized notables, to give his pencil a revel amid the fair and fresh of nature's loveliness; and he is now, as I love to see him, surrounded by heaps of mountains, and sunny valleys, and dear gray hills of his own country ... it has often excited my wonder that our native painters have not devoted some part of their time and study to the scenery of Canada – and to their shame be it spoken they have not; and truly they have neglected a field from which rare laurels will yet be won ... Old worn copies upon copies of European landscapes, or anything else, seem preferable to the rich and novel material which our picturesque land affords.

This columnist suggested that a 'fanciful' (or romantic) Canadian artist might eventually find many unique subjects:

Our winter views – breaking through the ice – Indian camps by night – the

mounted Sioux, Chief of the western wilderness, and the bivouacs on the Prairies – Hillock – and the chase of the buffalo – the council tent – the savage and his forest wigwam.

Krieghoff in Quebec and Kane as well as others in Toronto would shortly fulfil this prophecy.

Légaré's first real interest in landscape painting grew out of the Desjardins Collection which he housed in his studio. Abbé Desjardins and others had been so aghast at the wanton destruction of art during the French Revolution that they gathered numerous canvases from monastic houses and churches, principally in Paris, which they felt should be saved; advisers were incompetent and Desjardins secured only a very few if any great original works, some decided third-raters, and many copies. This collection was sent to Quebec where Légaré purchased much of it when it was auctioned in 1817, and he eventually restored many of the canvases. Among these purchases were numerous Italianate landscapes filled with Renaissance ruins in gentle decay; six were attributed to Salvator Rosa, the style's chief exponent, and others to Hubert Robert, Rosa de Tivoli, Huysmans, Poussin, and Richard Wilson. Even if the attributions were not always strictly correct, these canvases inspired Légaré to create Canadian landscapes of a similar type which he painted in the dull browns of the European prototype. His *Paysage au monument Wolfe* best illustrates the transformation from a European to a Canadian theme as he worked it out. Canadian pines snapped off in a summer storm replace Rosa's picturesque blasted pine trees and a statue to a local hero stands in place of one of Robert's classical monuments, while Indians lurking in the woods are substituted for shepherds and shepherdesses promenading beneath the trees in park land.

Légaré was described as Canada's first 'historical' painter when the Montreal Society for the Encouragement of Science and Art awarded him their 1828 medal for his canvas, which best illustrated the 'character of a fight between Hurons and Iroquois.' His depiction of the election scene at Château-Richer, with an excited concentration of voters in the village and stragglers enjoying themselves on the outskirts, is related to another Desjardins canvas by Adrien Van Ostade of a Dutch genre group.

But this artist's canvases went far beyond imitation of prototypes in their appeal to the eye and interesting content, even if a heavy hand imposed a certain restraint. Many pictured local scenes and events, such as a rock slide at Cape Diamond, when a gaping hole was left in the precipice above and shattered houses below. Innumerable water-

falls were painted with romantic picturesqueness – Montmorency, Saint-Férreol, Etchemin, Niagara, and others. Most dramatic of all is his large canvas of a night scene in Quebec during the cholera plague; the sorrowing priest at the cathedral door watches the death cart gathering the dead and dying from the darkened streets where smudge pots make a futile effort to purify the putrid air. Then he turned to Indians conferring chieftain's honours on Edmund Kean during the celebrated actor's visit to Quebec. Artistically, Légaré reached his greatest heights in a series of dramatic paintings of burning buildings and stark ruins inspired by the Saint-Roch fire of 1845. One canvas (fig. 32) is almost surrealistically modern with crumbling walls illuminated by weird cold moonlight on one side, and by glowing embers on the other. It is like a set for a great Wagnerian opera.

Talented, ambitious Antoine Plamondon, Légaré's pupil, was Quebec's second great master of these years. He had been an apprentice to the older man from the age of fifteen to twenty-one, and immediately after his release from training temporarily opened a studio in opposition to his old teacher. Bishop Descheneau sensed his talent, provided money for foreign study, and sent him to Paris in 1826 where he worked under Paulin Guérin, court painter to Charles X and pupil of the great classicist, David. Plamondon learned from Guérin the virtues of the classical painters' cool blue shadows, evenly distributed full light, quiet poses, and carefully drawn contours. He examined the paintings of Géricault, but had little sympathy for the great romantic's ways, yet could not entirely suppress certain newer tendencies; a blending of classicism and romanticism is quite evident in some of his later paintings. Young Plamondon supported the king during the Louis-Philippe uprisings which erupted four years after he reached Paris. His sympathies were with established order as represented by his favourite teacher, Guérin, rather than the revolutionary Géricault; when the monarchy fell, he hurried back to Quebec to commence his real life's work.

Plamondon's celebrated reputation chiefly rests on the portraits painted during the next two decades. His first real success was a study of the future genealogist, Cyprian Tanguay. The boy wears a Quebec Seminary scholar's uniform. The drawing and modelling carefully follow every contour, the figure is evenly lit, and the colour and pose are restrained. But voluptuous elegance pervades his portraits of Quebec society women. During the first ten years of his career he painted many full-face and so close up that they almost seem to squeeze from the picture frame, lifting themselves from their shadowy background to give an immediacy of presence. Madame Pelletier, of this period, is

a richly jewelled French-Canadian lady with an ornate hair style and fashionable clothes modelled on the current Paris and London fashions. Lady Aylmer, the Governor's wife, arrived in Quebec during 1831 and exclaimed about the excellence of the local dress which far exceeded her expectations. Plamondon and Hamel were patronized by the upper class French-speaking society in Quebec who saw their portraits on the walls as reinforcing their own importance; Krieghoff, by contrast, painted gentry at play and quaintly dressed *habitants* solely to amuse the affluent bourgeois. Ten years later Plamondon was to paint a series of portraits of young nuns of the Hôpital Général, Quebec (fig. 33), each with the serenity of those who seek the cloistered life. Several still hang in the halls of the institution. He received wide acclaim and was awarded the Quebec Literary and Historical Society's medal for his lost portrait of Zacharie Vincent, last pure-blooded Indian of Lorette, which Lord Durham then purchased as a tribute to Canadian artistic achievement.

Vincent, fascinated at seeing his features take shape under Plamondon's brush, painted at least a dozen different self-portraits in imitation (fig. 34). Plamondon is said to have given him advice, but throughout he remained a primitive, adding detail to detail with little regard for the final artistic effect. The Huron Indian went on to paint some highly coloured landscapes of Lorette now in the Quebec Museum, one of which is a free copy of a Kreighoff canvas.

Between 1837 and 1839 Plamondon painted fourteen pictures to be used as Stations of the Cross; each measured eight by five feet. They had been commissioned by Notre-Dame Church, Montreal, and then, to Plamondon's great consternation, the clergy rejected them as being too radical an innovation; sculptured crosses would be more suitable! The artist had poured all of his accumulated knowledge into the grandiose scheme. The challenge must have delighted Plamondon for it seemed like the great projects of his hero, David, undertaken under Napoleon. *The Kiss of Judas*, which comes from a Jacques Stella canvas, is much in David's mood, as are many others in the series. Not to be frustrated completely by the clergy's rejection, Plamondon exhibited the whole group in the anteroom of the Quebec Parliament Buildings, for an admission charge of 1/6. Then he returned them to storage in the Hôtel-Dieu, but when two years later he had to vacate the studio he wrote a letter to Notre-Dame in Montreal asking payment for the enormous moving costs. Six of the series are now in the Montreal Museum of Fine Arts.

The artist's portaits assumed new overtones when he introduced more space around his figures. Sometimes the sitters are silhouetted

against light spots on the background walls; occasionally he even introduced a landscape setting. Both devices were romantic conventions. A second Montreal medal was awarded to him in 1853 for *La Chasse aux tourtes* (fig. 35), where three young Quebec dandies pose triumphantly with their catch of pigeons spread out at the foot of a tree.

Plamondon was ambitious, restless, and quarrelsome, flitting from studio to studio. From his first studio on Rue Sainte-Famille, he moved to Rue des Jardins where many valuable canvases were burned in a fire. Later he was given a studio in the Parliament Buildings, possibly rent free because of his national prestige, and from there he moved into the Château Saint-Louis, the governor's residence, where at least one other artist, H. D. Thielcke, a portrait and miniature painter, had been given a studio in 1833. On another occasion a visitor was amazed during a visit to the Hôtel-Dieu in 1838 to find the celebrated Plamondon's studio in a hospital attic room; he described how he saw there recent copies of Raphael and Guérin canvases, and many portraits of private citizens.

Adulated, favoured by those with money to have their portraits painted, well known to Quebec society, Plamondon exploded into jealous and intolerant range whenever any new painter dared invade his Quebec preserve. He would pour forth a stream of vitriolic critical comment. He would go even further and castigate completely any painting which he personally disliked. As early as 1833 he wrote indignantly about an exhibition of paintings brought to Quebec for two weeks which included a *Bacchus and Ariadne* by Guido Reni. The editor of the *Quebec Mercury*, ruffled at his pomposity and caustic remarks, sarcastically pointed out his personal failings to Plamondon in the issue of 28 September 1833:

This travelled painter it seems can find no excellence but in himself. His vanity reminds us of a story of a Spanish singer who finding himself at the point of death exclaimed to those about him, 'ah, what a loss is the world about to sustain; but those poor angels who have hitherto sung praises in Heaven, how will they be mortified when I arrive and they are commanded to be silent, that Don Juan Cabossa may alone be heard in praise of the most high.' Should our painter travel on that road ... no doubt he expects on arriving at the end of his journey that Lucifer will order all his brimstone daubing imps to burn their brushes and their palettes, and appoint the renowned Ant. Plamondon, *Élève de Paulin Guérin de Paris*, sole painter to his black Majesty.

Several letters from Plamondon in an 1850 newspaper decry a rival and set down his own academic canons which had been absorbed

thirty years before in Paris and still ruled his hand. Good paintings, Plamondon pointed out, were those which instruct, edify, and ornament; bad works did none of these. Good paintings were well drawn and well composed with figures in appropriate attitudes. He declared that kings should be portrayed as grave and majestic and beggars always badly clothed. He stated further that portraits which were likenesses but were executed without art were good only for hanging in the kitchen and should never ornament a salon. One senses that he was personally assuming the role of defender of academic art as was Ingres in France. With this valedictory to his Quebec career, he retired from active painting in 1851 and moved first to a farm and later to the rectory at Neuville near Quebec to become the dean of painting in his native province. Yet for all his output and the quality of his work, he remained unknown in the rest of Canada. The art reviewer of Toronto's *Anglo-American Magazine* visited the Quebec Provincial Exhibition in Montreal during 1853 and found many paintings by 'the well-known hand of Duncan, Lock and Krieghoff' but he admitted that he had never heard of Plamondon, whose *'Chasse aux Tourtes* reflected great credit on him as a painter.'

Théophile Hamel by temperament was completely the antithesis of his old teacher, Plamondon. Hamel's self-portrait painted when he was twenty shows a gentle, sensitive youth seated in a landscape. A portrait of the poet Shelley as he muses on his verse is a similar romantic treatment. Hamel painted himself again about 1846 after returning from a four-year trip to Europe (fig. 36), this time as a dashing young man about town, standing among his canvases in his light-filled studio, a wholesome, attractive, and very personable young fellow, and a sophisticated romantic.

Plamondon gave Hamel a superb training as a draughtsman. Hamel had so often seen his teacher painting important men that he began himself to seek out the politicians, following them to Toronto, Montreal, and back to Quebec as the government met in various cities, painting them with ample space around the figure, often silhouetted against lighted backgrounds. Other patrons were the wives of the prosperous, the same group whom Plamondon had painted. Hamel experimented with other poses and light effects, but returned in later life to his earlier styles. One of his greatest accomplishments was the mellow, delicate three-quarter-length portrait of Mme Marc-Pascal de Sales Laterrière (fig. 37) of 1853 which is a marvel of refinement with its almost liquid flowing lines and sensitive expression. She stands erect, the drop of her gold neck chain echoing the lines of her body. The portrait personifies the mystery of womanhood. Occasionally Ha-

mel even introduced into backgrounds stage props such as drapery or library shelves, a convention also used by Roy-Audy; occasionally snatches of landscape gleam through an open window.

Young Hamel interrupted his early career to study in Europe at a time when his finances were so limited that before leaving Quebec he sought commissions for the copying of masterpieces in Europe. First he halted in London, and then went on to Naples and Rome where, according to his letters written home, he was a favourite dancing partner of the lovely ladies from Edinburgh, London, and Paris who were seeing the great world capitals while the young men of family were on the Grand Tour. He was seriously ill while attending the Academy of St Luke in Rome, but when he recovered he sketched the romantic Italian peasants and bandits in their colourful costumes. He toured Rome, Florence, and the adjoining Italian countryside, a joyful experience, and brought back to Canada pencil studies of Roman baths, the Fountain of Trevi, and the Temple of Fortuna. From Italy he went to Paris where he stayed just long enough to copy some Murillos, and then hurried to Antwerp where the greatest thrill of his whole European tour was his discovery of Rubens' rich colouring and the facile drawing technique of the Flemish masters. Later he copied Rubens' *Descent from the Cross*, the *Education of the Virgin*, and works by Van Dyck, Jordaens, and Coypel.

There is much more red and pink colouring in Hamel's own portraits after his study of the warm-toned Flemish paintings. His highly keyed flesh tints seem even more brilliant alongside the cool blue and grey shadows he sometimes painted to accent the richness. This play of warm and cool effects can be studied to best advantage in a handsome 1848 portrait of Judge Jean-Roch Rolland when he was living in Montreal: the Quebec chief justice had a decade earlier sentenced Papineau and his followers following the 1837 uprising. It must be remembered that when Delacroix and other leading Parisian romantic painters became similarly interested in warm tones, those they favoured paralleled Hamel's.

An impressive clientele awaited the young man's return from Europe. Sir Narcisse Belleau, destined to be Canada's prime minister for the two years preceding Confederation, was an early sitter. One politician and statesman after another passed through his studio in an unending stream: members of the Baldwin-Lafontaine ministry, speakers of the Legislative Council and Legislative Assembly, Lord Elgin in state uniform appropriately painted with the King's Bastion of the Citadel in the background, and other leaders of church and state. Hamel travelled even more than he had before going to Europe, working

not only in the cities which he had previously visited, but also in Kingston, Hamilton, and New York. His income was increased when engravers made prints from his portraits of the nation's most famous leaders. He had painted so many politicians that he must have sighed with relief when he turned from them to Mme de Sales Laterrière, to historical subjects like Jacques Cartier and Champlain, or even to a group portrait of three Indian chieftains leading a delegation to Quebec. Quite evidently his greatest joy came in painting children, whom he obviously loved and in whose portraits he had freedom to revive his youthful tendency for the unique and original approach. He painted groups of children, the families of various relatives, and a whimsical portrait of his nephew, Ernest Hamel. In the latter, the baby sits on a cushion playing with his toy horse: his pink skin and blond curls, and the rich colours in the setting, recall the Rubens palette which had so inspired the artist while in Europe.

Hamel had both an astounding technical facility and prodigious output. Stories persist of the speed with which he painted. Religious compositions were finished in two days, and portraits commenced at eight in the morning were completed by noon. At least two thousand are now scattered through Ontario and Quebec. His constitution was delicate, he allowed himself little time for relaxation, and understandably died as a comparatively young man of fifty-three.

Théophile Hamel trained a whole generation of Post-Confederation painters. Many had been his studio assistants. Napoléon Bourassa became not only a painter, but an author, teacher of painting, nationalist, and vociferous promoter of the arts. Unfortunately he belonged to an era when photography and a liking for detail presented new challenges which the painter had not yet learned to meet except by an attempt to turn out canvases of more life-like precision. This allowed little scope for innovation or invention, and hampered Bourassa in his work as it hampered so many others in the last half of the nineteenth century.

Ludger Ruelland, another Hamel pupil, lived in Lévis where he never had enough money to keep himself comfortably. He painted hundreds of gentle faces at from $15 to $20 each. Although they are portraits of great feeling and understanding, the public was never willing to pay him the price that even the most plebeian work could demand. Sometimes he taught to supplement his meagre earnings. Old Ruelland was finally forced to sell his furniture and sought refuge in a charitable institution.

Eugène Hamel, Théophile's nephew, spent the years from 1862 to 1867 in his uncle's studio at a time when the older man's paintings

were becoming sterotyped and lifeless through endless repetition of subject matter. Eugène studied for some years in Antwerp, Brussels, and Italy; even this failed to awaken a spark of true originality. The Franco-Prussian War drove him back to Canada, and he arrived just in time to take over the rôle of leading painter of Quebec politicians after his uncle's death.

Jean-Baptiste Roy-Audy, the fourth great painter of these years, was a woodworker's son and married the daughter of a master-forger. He was always the honest picture-maker whether painting the curé, bishop, or the pretty wives of village leaders, working in the methodical matter-of-fact manner of the artisan. This practical attitude so dominated his outlook that he seems to have painted quite without emotion a criminal named Adolphe Dewey in his jail cell, the day before he was hanged for having killed his wife. This portrait created something of a sensation, and the artist raffled it to a 'lucky' winner.

Unlike his three great contemporaries, Roy-Audy's artistic roots were in the generation of the late eighteenth century, since he had been taught by François Baillairgé when he was sixteen. He made many trips through Lower Canada to paint clients and died at Three Rivers on one of these journeys.

Roy-Audy's many religious paintings are usually variants on French prints or canvases in the Desjardins Collection. The most attractive were commissioned for Deschambault church, among which a Baptism of Christ was suggested by an engraving from a painting by Pierre Mignard.

His precise and faithful portraits, 'primitives' which lack the painterly touches of trained artists, are like maps of his sitters' features delineated with steel-engraving sharpness, for his artisan nature demanded the greatest exactitude. In fact it is in this sharpness and clarity that much of the fascination of Roy-Audy's work lies. He would never dream of attempting such subtleties as a search for volume by the seizing and dropping of a line where the light moulds the form. Paint surfaces are ivory-like and without a trace of brush strokes. Always he seeks to please the client by adding details to make the picture more attractive. Father Roque's portrait hanging in the Hôtel-Dieu, Montreal, is embellished with the priest's ivory crucifix, his breviary, and his steel-rimmed spectacles. In Monseigneur Rémy Gaulin, the cleric sits in his library with every leather-bound volume, row on row, painted meticulously. The artist's signature is inconspicuously placed among the titles of the books. Such canvases have the honest naïveté of the ex-votos, but Roy-Audy was a more experienced man than the earlier painters, and his work shows a surer sophistication.

A portrait of Mme François Poulin de Courval (fig. 38) is the ultimate achievement during the second quarter of the nineteenth century in combining refinement with charming naïveté. This is a curious work, for while the inscription on the reverse seems to have been written by Roy-Audy, the drawing of the hands of the sitter, the general stylistic treatment, and other features are quite different from those used in painting Father Roque just seven years earlier. The colour is wonderfully rich with warm facial tones, and the background drapery sparkles against the black dress and gray shawl. The little bonnet has a stiff bow, the lace is delicate, and there is great refinement in the lady's clutch of her handkerchief. Whether the artist is Roy-Audy or another, this is one of the finest Canadian naïve paintings.

Many years after other artists of this great age of Quebec painting were merely memories, old Antoine Plamondon still lived in Neuville, a symbol of past glories. Tired of quarrelling and apparently independent financially, he had retired from active painting in 1851 to become a gentleman farmer. Théophile Hamel had opened his Quebec studio almost immediately on Plamondon's departure – he would never have dared such an affront while the proud and touchy man was still active in the capital. The old artist painted intermittently during his remaining years, but seemingly with little creative interest since many of these later canvases are both sentimental and dull. His religious works degenerated into poorer and poorer copies. Portraits were painted from photographs, but the artist required colour notes describing the eyes and hair. Busts on stretchers measuring 4′ 5″ by 3′ 5″ cost $40, 3′ 4″ by 2′ 6″ $25, and small head and shoulder paintings 2′ 5″ by 2′ $18. Occasionally there is a flash of the old genius as in a study of a young apprentice walking along the shore of the St Lawrence playing a flute. Even an ambitious storm and shipwreck inspired by Vernet's *Port of Cherbourg*, owned by a relative, reflects his ability to paint the elements with power.

The Marquis of Lorne honoured Plamondon in 1880 by appointing him first vice-president of the Royal Canadian Academy. His diploma-work was deposited, a singularly beautiful study of apples and grapes in a white alabaster bowl (National Gallery of Canada; a replica is in the Art Gallery of Windsor) which seemed appropriate to his academic background, but he took no further interest in the new art organization. A newspaper editor noted when he died at the age of ninety-one that he was no longer part of the art community and that in fact many thought he had been dead for years. Thus the last member of an illustrious generation passed from the scene.

9

Along the Atlantic Seaboard

No significant resident artists painted in the Atlantic region until after 1800. English-speaking settlers had been there since the 1720s but they arrived in numbers only with the first great influx of Loyalists at Halifax, Annapolis, Saint John, and other centres throughout 1783. Eventually 35,000 of these people left the United States for Prince Edward Island and Nova Scotia, which then included New Brunswick – men and women who preferred cabins in a sparsely populated region as loyal British subjects to homes in the youthful republic with its new loyalties and new materialism. Many came from the colonial élite, the affluent educated upper classes. They represented a New England social stratum which for long had been interested in the arts. Wilderness hardships were a vivid contrast to their former way of living.

Famine threatened during the first year of the Loyalist settlement, but life changed rapidly. Primitive early shelters were replaced by large new houses built in imitation of those they had left. Schools were erected, a profitable shipbuilding and lumbering trade grew up, and population increased as British immigration accelerated. This rapid transformation may be readily visualized in the fact that four years after Loyalists first set foot on the rocky foreland where Saint John was destined to stand, Edward Barton's Bakery Shop near the Public Landing innovated the luxury of 'Breakfast rolls hot every morning at eight o'clock.' Green turtles for soup were brought from the West Indies that same year for the Recorder's dinner. By 1797, gentlemen could spend an evening at a county hotel with 'Nectarious liquor, Ambrosial Viands and Elysian Beds, entertainment for a Prince, and accommodation for an Emperor.' The straggling settlements were soon replaced by bustling provinces with their capitals at Halifax, Fredericton, and Charlottetown. Officials in the new capitals had their portraits painted to substantiate their prestige, and bare walls of fine new

houses required decoration. There was a growing demand for paintings.

Portraits were a first interest, as they had been in the United States. Indeed, prior to the Seven Years' War, affluent Haligonians had looked to Copley in Boston for their portraits. George MacCrea from Edinburgh painted oil portraits in Halifax from 1783 until 1802 when he returned to Scotland. The city's amateur chess, pencil, and brush club survived from 1787 to 1817 and was the first Canadian art organization. William Beastalt, a New England miniaturist, was evidently the earliest Saint John artist and was listed among the City Freemen in 1797. Beastalt had come from the United States, but virtually all other artists working in the Maritimes before the mid-nineteenth century were of British birth and worked in the British portrait or landscape tradition.

Robert Field, a well-known English portrait painter, was in Halifax from 1808 to 1816, giving art on the seaboard an impetus of tremendous significance. He had studied at the Royal Academy school in London about 1790, and was a friend of Benjamin West who succeeded Sir Joshua Reynolds as president of the Royal Academy. He knew Gilbert Stuart and his paintings, and indeed Field's portraits are sometimes attributed to Stuart, while his miniatures were in the best late eighteenth-century tradition.

Field caught a good likeness and had been a successful painter in Boston, Philadelphia, Baltimore, and Washington. His painting of Lady Croke at Halifax (National Gallery of Canada) must have pleased, for not only was it a good likeness but it reflected her beauty and the aristocratic bearing which befitted the wife of a colonial English judge. His American clientele between 1794 and 1808 had included Thomas Jefferson, third president of the United States, and Martha Washington who had ordered her own miniatures and several posthumous likenesses of the first president as gifts for relatives. His other American miniatures were of the governor of Maryland, doctors, army officers, and prosperous citizens. Field was a facile worker, whether painting large oil portraits, small water-colours, or miniatures on ivory. He even engraved plates from his own paintings, from those of Gilbert Stuart, and from other portraits. But he always painted the single figure; indeed this type of portrait was almost a rule in the Maritimes and throughout all Canada, with the conversation piece an exception until the 1840s. Probably few early painters felt sufficiently skilled to tackle complicated compositions, and few clients had the money to pay for elaborate group portraits.

An acute stage in long-strained relations between the United States

and England was reached in 1807 when Britain, pursuing her block-ade of France, demanded the right to search American vessels and in-troduced various restrictions on trade. Field's friends in the United States were members of the English and Scottish community, but his patrons were republicans. He seemed fearful of the future and moved to a more friendly Halifax. The Napoleonic Wars had breathed new life into the city since its busy port was a base for intensive naval oper-ations and it had a large garrison. There he mingled from the very first with both officials and the affluent society among whom he hoped to find his clientele. One patron was Sir John Wentworth, a New Hampshire Loyalist, who had been made governor and was intimate with the Duke of Kent until some coolness developed over the Duke's famous mistress, Mme Saint-Laurent. It was Wentworth who intro-duced Field to the Rockingham Club, a counterpart of Quebec's Baron's Club. Being an affable, socially minded bachelor, he quickly made friends. Three weeks after his arrival, he took a studio at Alex-ander Morrison's Book Shop where the city's aristocrats and intelli-gentsia commonly met. Portrait commissions came from such friends as Mr Justice Croke of the Vice-Admiralty court, Bishop Inglis (fig. 39), Governors Prevost and Sherbrooke, and Captain J. N. Inglefield.

The Rockingham Club commissioned full-length portraits of both Prevost and Sherbrooke. Field's debt to Sir Joshua Reynolds is obvious in the former. Sir George Prevost has the self-assured pose of Reynold's Lord Rodney in Buckingham Palace; there is the same dra-matic sky, the head is silhouetted against dark clouds, a striking burst of light falls on the trousers, and the romantic distance reminds us of the warrior's exploits. The portrait of Lord Rodney was exhibited at the Royal Academy in 1789, the year before Field entered its schools. He left England in 1794 and had seen little or no English painting of more recent date. For all their excellence, Field's portraits are painted by a stylistic follower, and lack the purposeful touch, the ability to cre-ate well-defined dark shadows, and the direct approach of Reynolds, his more powerful predecessor.

In Halifax the artist painted many head-and-shoulder portraits like those of Mrs Lawson and Mrs Gorham. Occasionally he reverted to miniature painting. Miniatures of Major Thomas King and his wife reflect the works of his contemporary, Conway, which Field had un-doubtedly seen. Place a Field portrait beside a Dulongpré painting of a Quebec lady and an essential difference becomes apparent. The Quebec artist subordinated his whole pictorial concept to sensual charm and grace; the Nova Scotian approached his art in a more ana-lytical northern frame of mind, as if he wished to lay bare the sitter's

inner character in a psychological analysis; his was a cerebral approach for he worked with a cold analytical light instead of through the intuitive reaction of the more Latin heart.

The Post-Napoleonic slump hit Halifax in 1816 and Field moved to Kingston, Jamaica, where he died of yellow fever. He had played the same rôle in Halifax which Frère Luc had in Quebec a century and a half earlier, and he left behind a large number of paintings high in quality which were an incentive to succeeding artists.

Joseph Comingo, who was born in Nova Scotia in 1784, was painting miniatures at Halifax in 1811 during the years when Field dominated the local scene. He visited Saint John in 1814, painting watercolour landscapes and accomplished miniatures, one of which is now in the New Brunswick Museum (fig. 40). The exceptional quality of this profile portrait prompts interesting speculation about where he learned to paint so expertly. Was he a student under Field, or had he gone abroad to study?

Another local artist, Gilbert Stuart Newton, was the twelfth child of the Collector of Customs in Halifax and a nephew of Gilbert Stuart. His artistic career was pursued entirely in England, although he had possibly studied with his uncle in Boston. Newton was elected to the dignified ranks of the Royal Academy, and visited Halifax once in his mature years.

No painter of equal stature replaced Field although one portrait painter might have gone as far if he had had equal opportunities during his youth. William Valentine arrived from England in 1818, advertised himself as a painter, and obtained much local patronage during the next thirty years. One story tells how Joseph Howe, discovering the artist working as a house painter on a scaffold, remonstrated with him on the waste of his talents. His attainments as a painter are evident in a monochrome study of the Rev. William Black (fig. 41) which is a marvel in its warm characterization, a quality so lacking in Field's austere aristocratic portraits. He reverted to humbler house painting whenever income from his canvases fell below the subsistence level. A detailed price list for his paintings was given in the Charlottetown *Royal Gazette* of 6 August 1833:

1 pound 10/ – for profiles in oil, 11″ x 13″: and three pounds for the same style in oil, 16 ″ x 19″: for ordinary portraits six pounds for 16″ x 19″: Ten pounds for three-quarter size 25″ x 30″: Fourteen pounds for kit-cat 28″ x 30″: Thirty pounds for half length 42″ x 56″.

He asked one hundred pounds for full-length portraits, but probably received no commissions for such ambitious works.

Valentine was searching for commissions throughout the eastern provinces by 1833. He took his cue from the itinerants and he visited such centres as Charlottetown that summer, and St John's, Newfoundland, the next year. When in England during 1838, he copied portraits by such men as Sir Thomas Lawrence; after his return his work had more facility and emulated certain mannerisms such as the suave brush work and reddish flesh tones which in their warmth and urbanity made Lawrence's fame unrivalled in England. Valentine's accentuation of his subjects' noses is a curious characteristic of his later years.

Occasionally Valentine painted historical subjects, once considered the highest art form, but his *King John Signing the Magna Carta* (Nova Scotia College of Art) has little real interest. He began working as a daguerreotypist in 1844, in order to supplement his low income. Many of his best paintings unfortunately were burned in a studio fire shortly before his death. When Valentine was buried in a local Halifax cemetery, Joseph Howe wrote and dedicated a poem to him as a respected Halifax citizen.

The intellectual pulse of the Maritimes quickened at a phenomenal rate during the second quarter of the nineteenth century. Liberalization was sweeping across the whole Western world, with the working classes rising against the Louis-Philippe régime in France, and the English forced to introduce industrial and political reforms. Locally the Halifax and Saint John Mechanics' Institutes played a remarkable role in liberal education. Saint John's young men flocked in such numbers to hear lectures on galvanism, steam engines, philosophical subjects, and even topics relating to architecture and painting, that Hopley's Circus at the Golden Ball Corner was taken over as a lecture hall. Many amateurs wanted to be artists. An appreciation of painting was developing among the new lumbering and shipping magnates who regarded a talent for painting or even an attempt at dabbling as a status symbol. A vogue for painted rooms soon came into being. One Annapolis Royal ship owner boarded an itinerant artist during a winter in the late 1840s. In return the man covered the host's living-room walls from floor to ceiling, including views picturing London and Queen Victoria at Windsor. These are almost like the contemporary but more sophisticated pictures of imaginary cities of antiquity painted by Thomas Cole south of the border. Full-length Micmac Indians on the end walls, and a Scottish piper playing at the owner's wedding, gave romantic local touches. Thomas Moran, a ship builder of St Martins, New Brunswick, sent his ships from the Bay of Fundy to all parts of the world. One brought an artist from Italy in the 1860s

who decorated Moran's house with flower swags in the high Italian fashion, and returned on the next Moran ship sailing to Italy.

Numerous art classes and art academies, which flourished in both Halifax and Saint John, reflected this new interest in painting. Mr and Mrs Berkley worked in Saint John during 1831, and a new teacher seemed to arrive each winter during the years beginning in 1838. Their names included Robert Foulis, Joseph and Mrs Toler, Mrs Handford, Mr Paley, and Mrs Blatch. Halifax had a similar quota. W. H. Jones of Boston taught painting at Dalhousie College in 1829-30, and with public co-operation arranged a large exhibition of both student work and locally owned paintings, modelling the project on a similar Boston show held a year or two earlier. The exhibit included a Copley canvas from a Halifax home, and some paintings seized as prize booty from an American ship on its way from France to Philadelphia during the War of 1812. George Thresher set up a Saint John Academy of Drawing and Painting in 1821 similar to others he had organized in New York, Philadelphia, and Montreal. He moved with his wife and son in 1829, to Charlottetown, where his wife taught painting under the lieutenant-governor's patronage and drew small views of local houses, while Thresher himself operated a sign and carriage shop and decorated churches. During his spare time in Charlottetown, he painted a canvas with an area of eighty square feet showing the British attacking Algiers on 26 August 1816. Other canvases painted there were also of marine subjects. Another Charlottetown artist, after 1841, was Mrs F. Bayfield, who held classes and painted competent water-colour flower studies.

Few of the visiting instructors had real ability. They were supposed principally to 'finish' young people in both painting and music. Mrs Charles Halford opened an academy for young ladies and gentlemen on her return to Saint John from New York, and advertised an incredible list of subjects which she was apparently quite prepared to teach:

Pianoforte	Painting on Glass	Crystallizing and Wax
Organ	Poomah Painting	Fruit
Spanish Guitar	Artificial Flowers	Bronzing
Singing and Accordian	Painting on Satin	Gilding
Drawing	Velvet Painting	Shell Work
Grecian Painting	Mezzotint Drawing	Fresco Painting
Painting on Copper	Marbling on Glass	Filagree
Enamel Painting	Art of Copying Wax	Transferring on Wood
Marble Painting	Flowers from Nature	

Occasional paintings of a primitive character by gifted but anonymous Maritime artists are found (fig. 42). W. H. Bartlett engravings of local views were avidly copied by amateurs: S. P. Stoddard, for example, copied in water-colour Bartlett's view of Judge Haliburton's house, at Windsor, Nova Scotia, in 1843. Michael Anderson, a Saint John cabinet maker, turned to painting in the 1830s. The New Brunswick Museum owns one of his strange visionary canvases in which Moses, supported by two Israelites, gazes with burning eyes at the promised land.

Dozens of itinerants were travelling throughout the Maritimes, as indeed they were on the move in other parts of Canada, painting innumerable portraits of quality. One, Thomas Macdonald, painted several water colour portraits in Fredericton from 1825 to 1837 (fig. 44). His *Mr. and Mrs. Guion and their son Wilmot* is an outstanding small Canadian primitive. It is a most human painting, with the father distracting the child with his watch while the mother dangles an apple.

John Poad Drake, a transient artist and inventor, painted for two or three years in the new romantic manner both at Halifax and at Charlottetown, attracting visitors to his studio by advertising his huge painting of Napoleon *en route* to St Helena on HMS *Bellerophon*, and then, while they were spell-bound by its magnificence, attempting like Légaré to sell his landscapes or take portrait commissions. His view of the Halifax harbour (fig. 43) has a brilliant Turner-like sunset which bursts over the harbour in strident yellows, orange, and red. Picturesque ships with their sails spread are vivid foils to the Micmac canoe in the immediate foreground. The painting is a romantic adventure in picture-making. Drake made a most unfortunate *faux pas* in Halifax when he quarrelled with the Chief Justice while painting that august person's life-sized portrait. The judge paid the fee in pennies wheeled in a barrow to the studio door. The painting, which still hangs in the Halifax Court House, is a monstrosity. Drake lived briefly in Montreal and Quebec before returning to England. Jacques Viger, the mayor of Montreal and himself a keen antiquarian, commissioned him in 1826 and 1827 to paint thirty-two sepia sketches of historic Montreal buildings and other monuments, which are now in the Archives of the Quebec Seminary. No Maritimer was capable of exploiting the potentialities which he introduced in landscape painting.

Thomas H. Wentworth was born in Connecticut but was reared by his Saint John uncle and worked both in the United States and in New Brunswick. He was principally a miniature painter, but also did a series in oil of Niagara Falls views, the ultimate in subject matter during the nineteenth century for those with romantic tastes. He sold

prints of these and also painted replicas in the Maritimes. He most nearly approached Drake's abilities in his romantic *View of the Great Conflagration ... City of Saint John* (fig. 45). Fires constantly swept the city, culminating in a most devastating blaze in 1877, and each time someone published a print illustrating the latest disaster. Wentworth's Saint John studio looked across the Market Square to Prince William Street where the 1839 fire took its greatest toll; from a grandstand seat in his studio window, Wentworth painted the wild scene, and then turned the painting over to the print makers. Its precise drawing of buildings is like that of architectural views of New York and Philadelphia of the time, and similar to J. Gillespie's painting of Toronto (see p. 110). In this instance, however, Wentworth added the emotional romantic excitement of spectacular roaring flames, with panic-stricken people salvaging their furniture. James Duncan in Montreal and Joseph Légaré in Quebec both had painted similar fire scenes.

Many leading Maritime artists from 1820 to 1850 painted topographical water-colours, resembling those of English army officers and professionals. W. R. Best's Newfoundland views of the late 1840s and 1850s were lithographed. J. E. Woolford, an army officer, was stationed successively in Halifax, Saint John, and Fredericton, where he lived on after being discharged from the army. His view of young bloods cavorting with their tandems on the ice of the Saint John River, with Fredericton's first little cathedral in the background (New Brunswick Museum), pleases precisely because of the exacting and lively drawing. Woolford canoed down Ontario's French River in the 1820s, sketching in water-colour as he went; these sketches, now preserved in the Toronto Public Libraries, are in grey wash with slight colour; their clearly defined contours resemble the technique of the trained army men.

William Eager painted in St John's, Newfoundland, from 1831 to 1834, when he published a landscape as a print. Then he moved to Halifax. Many of his other views of cities and towns in the Atlantic region were lithographed; Indians in the foregrounds added exotic touches. An important topical painting was his *Celebration on Halifax Common of the Coronation of Queen Victoria* (fig. 46). Eager died of pneumonia after falling through the ice of the Saint John River. George N. Smith, who edited a St Andrews, N.B., newspaper before opening an art school in Saint John, painted in the water-colour manner he had learned as a boy in England. His country houses, now in the New Brunswick Museum, are carefully painted, low-keyed studies with a free use of browns, ochres, and blues.

Publication of great semi-scientific series of prints of birds, insects,

flowers, and animals was a late eighteenth- and nineteenth-century phenomenon. They rolled off English, French, and American presses to satisfy the public's new interest in natural surroundings. John J. Audubon, the best-known American painter working for the print-makers in the mid-nineteenth century, searched for bird subjects on Grand Manan, along the Saint John River, and in Labrador. Many local artists with varying capabilities were doing the same thing, inland as well as in the Maritimes. Montreal society ladies painted birds, insects, and flowers for the adornment of their personal albums of verses. Amélie Panet and her husband, William Berczy, Jr, together with many local amateur and professional artists of the 1830s and 1840s, joined in painting such an album at the request of Jacques Viger, first mayor of Montreal. Many of these paintings are marvels of *trompe-l'oeil*, but Berczy's are outstanding. Agnes Chamberlin, a gifted Englishwoman in pioneer Ontario, devoted years to studies of local wildflowers, which she lithographed and hand-coloured in 1868 to illustrate a botanical manuscript by her aunt, Mrs C. P. Traill. Maria E. Miller of Halifax was not only the Maritimes' most celebrated botanical painter; her sketches are typical of what other genteel ladies in Saint John, Halifax, and other places were attempting but with less success. She had studied with Professor Jones at Dalhousie College and Mr L'Estrange, a miniaturist who taught flower, landscape, and figure painting during 1833-45. Then she opened her own drawing academy which was operated between 1830 and 1870. Titus Smith, a local botanist, supplied the scientific information for her botanical studies which were executed with the most exacting precision. Two series of Maria Miller prints of Nova Scotia wildflowers were published in 1840 and 1853 by a London firm which had many Nova Scotian interests and was said to have been headed by Samuel Cunard. A third set was proposed but never issued. Art in such a botanical series was one reflection of the local intellectual awakening in the Maritimes during the nineteenth century.

Life on the Atlantic seaboard was inextricably bound up with the sea and ships. Dining rooms of local shipping men were lined with paintings of their own sailing ships by artists who haunted the docksides wherever cargoes were unloaded or loaded – in distant Liverpool, Glasgow, Malta, or even Singapore. John O'Brien alone on the east coast achieved a reputation as a ship painter before Confederation. This Irish immigrant's son was born on a sailing ship *en route* from Cork to Halifax, and began to paint views of Halifax harbour in his early youth. The local merchants were so impressed by the boy's talents when they saw one of his ambitious oils, painted when he was

only eighteen, that they gathered money for his study in London and Paris. His sailing ships of the 1850s and 1860s breathe the very romance of the sea with rushing wind, stormy skies, and rising waves. He transformed his subjects as did the earlier Dutch artists. But the grey harmonious tones which he learned to use when abroad were gradually abandoned for his harsher earlier colours and conventional compositions. Quality deteriorated with the passing years and he became little better than a hack derelict in old age, painting popular local views for Haligonians on a mass production basis.

The Maritimes' earlier painters made magnificent beginnings, painting some superb canvases, but sufficient gifted followers, capable of building a strong, integrated school of art, failed to appear. Perhaps natural reserve worked against experimentation, for it must be remembered that many Maritimers were descended from Loyalists whose philosophy was the *status quo* rather than revolution. Perhaps also new scientific interests drained off the thrill of discovery to the neglect of art. The Maritimes moreover have always had a relatively small population from which to draw their artists, and these few have had only the most tenuous contacts with the fountainheads of art styles. Consequently much painting over the years tended to be conservative and uninspired.

10

Portraits for the Masses

Canadian shopkeepers, tradesmen, prosperous farmers, the rising middle and lower middle classes, like those of England and France, envied the aristocracy, officials, and bourgeois their portraits by Field, Plamondon, Beaucourt, and other celebrated artists. They coveted the smug satisfaction of seeing their own likenesses, together with those of their wives, children, mothers, and fathers, gazing down on the assembled family. Two ways were found by which they could imitate their more affluent neighbours: cheap black and white silhouettes, or more expensive profiles and miniatures which were also commissioned by the highest of the land but were still less expensive than large oil portraits. Many Canadians resorted to these economical expedients until they were replaced by photography.

Wandering silhouettists and miniature painters travelled from town to town throughout British North America, staying long enough to satisfy current needs in each centre. They left thousands of likenesses in the better homes of Quebec, Montreal and Toronto, Halifax, Charlottetown and Saint John, and in all intervening centres.

Silhouettes or black profile miniatures were named after Étienne de Silhouette who, when in charge of Louis xv's finances, was so economical that anything cheap and skimpy was dubbed with his name. They were either cut from black paper or drawn in pencil outline and painted in solid black. Occasionally touches of gold enlivened the features. Some were cut freehand with scissors, a few were drawn in outline by sight, but others were produced by mechanical means in a darkened room where a candle cast a shadow of the sitter on a transparent screen. The silhouettist made a life-sized tracing of the shadow on the reverse, which then was reduced to its proper proportions by a pantograph.

These itinerants are known from their newspaper advertisements.

William King, the earliest recorded silhouettist in the Maritimes, took six minutes to complete a picture. He visited Halifax and Newfoundland in 1806 with a mechanical box, then deserted his family in 1809, and disappeared to the southern United States. Mr Bouker advertised in Fredericton, N.B., and Cornwall, Ontario, during 1807. On 30 April he was staying at Mr Barret's Tavern in York (Toronto) but left shortly after to visit the Niagara district and later revisited Fredericton, Kingston, and other Ontario and Quebec centres. His silhouette of Alexander Wood, a York merchant, is still preserved in Toronto. Duplicate miniatures of better-known men such as a newspaper editor of St Andrews, N.B., were posted in Bouker's sample book so that he could show them to prospective clients.

Other silhouette cutters set up special exhibitions to attract business. Master Hanks showed his 'Papyrotemia Gallery of Paper Cuttings' at Toronto during July 1827, having previously shown it in England, Ireland, and the United States. His Canadian advertisements read as if he were of English birth since he was then on British territory, but the man was actually a former sign and portrait painter from the United States. Hanks cut a free silhouette for each paying visitor (fig. 47). He and his assistant, Reynolds, who touched up the silhouettes with bronze, worked in Halifax under Sir Peregrine Maitland's patronage.

Many prospering citizens, who could well indulge in status symbols of a more pretentious nature than the lowly silhouette, patronized the fifty or more itinerant miniature painters advertising between 1772 and 1840. Some local artists painted miniatures, but those mentioned here adopted a wanderer's life in catering to mass popular demand.

Portrait miniatures are of two kinds. The painted profile was merely a step removed from the silhouette; the features were hastily painted in water-colour, with the outlines sometimes produced by a machine. Other miniatures were true portraits in small size, usually three-quarters or full face, drawn free-hand on card or ivory, some minutely finished, but others done sketchily, like numerous examples by various artists who visited the Maritimes. Full-face miniatures required more time, care, and skill and brought a much higher fee than profiles. Even Antoine Plamondon deigned occasionally to accept a commission for a miniature of high quality.

John Ramage, a graduate of the Dublin School of Art in 1763, is the first recorded miniaturist in Canada. (There are in existence miniatures of French officials who were in Canada which date before the Seven Years' War, but probably most if not all of these were painted in France.) Ramage worked at Halifax from 1772 to 1774 before leav-

ing for Boston. There he both painted life-sized pastel portraits and worked as a practising goldsmith. Ramage joined the Independent Company of Irish Volunteers during the American Revolution and again was painting portraits in Halifax during 1776. He was in New York a second time from 1777 to 1794, working successfully as a miniaturist on ivory and much helped by George Washington's patronage. Financial and marital difficulties forced him to flee to Montreal where he applied in 1802 for a Loyalist land grant because of sickness and a long series of misfortunes. Ramage died at Montreal the following October; he was referred to in an obituary as a 'Limner being a wandering Portraitist.'

Many wandering artists visited Quebec, the prosperous seat of government. Henri Vanière was there as a profile painter in 1778, after five years of study in Europe and sixteen years' experience in other countries. His miniatures cost 7/- on paper or £1 on ivory. Ralph Ritchie painted miniatures during 1794, gave lessons to ladies and gentlemen in flower, arabesque, and landscape painting, and also painted houses, carriages, and signs. Jean Natte *dit* Marseille, his contemporary, was a part-time puppeteer; he painted pictures for the churches at Lauzon, Rivière-Ouelle, and Saint-Michel (Bellechasse). Mr Cromwell used a physiognatrace at the Freemasons' Hall in 1808, colouring his miniatures in oil, pastel, and water-colour. He gave evening readings and recitations, and acted in the local theatrical company. Mr Metcalf is known only from an 1809 advertisement in Quebec's *Le Spectateur* which states that during the previous six months he had produced a phenomenal 5,000 likenesses. He too used a physiognatrace. Mr Herve, who had made 35,000 profiles in Great Britain, took a room in the Hotel Malthrot in 1817, cutting black silhouettes for 25 cents or painting profiles for $4 and miniatures for $20.

J. H. Gillespie of London, Edinburgh, and Liverpool, was a profile miniaturist who moved from Halifax to Saint John in May 1830. According to an advertisement in the *New Brunswick Courier* of 6 November 1830, he had made 'upwards of 1,400 likenesses' of Haligonians, and these were but a fraction of the 30,000 satisfactory portraits which he had undertaken over a twenty-year period with his 'very curious and elegant apparatus.' He detained the sitter ten minutes and 'generally succeed[ed] in producing a strong resemblance.' Quick pencil sketches cost 25 cents but for $2 features and drapery would also be painted. Gillespie installed his apparatus in a rented painting room at Mr Nagel's house in Germain Street opposite Trinity Church. In his mechanical device he looked into a prism suspended at eye level, and there he saw the sitter's head as if projected on the drawing sheet, so that he could draw the profile more quickly and accurately.

More carefully painted portrait miniatures were usually full or three-quarters face. G. Schroeder of New York worked at Roscoe's Hotel, Montreal, before going on to Quebec during the winter of 1830-1. Earlier he had painted the portrait of the Duke of Richmond, that unfortunate governor-general who died of rabies from a fox-bite in eastern Ontario. Woodley of London was painting miniatures that same winter throughout Quebec, and evidently settled in Canada for he helped Légaré to decorate the new Théâtre Royal, Quebec. Samuel Palmer painted miniatures and large-scale portraits, even advertising the painting of corpses while he was in Saint John during 1833. From the Maritimes he wandered through the United States to Quebec and Montreal where his clientele was fashionable, although the man was improvident and often in debt. One of his finest canvases is the double portrait of a doctor's sons at the Jeffrey Hale Hospital, Quebec.

Enumeration of all these travelling artists would be repetitious. Few were native-born Canadians. Many came from the British Isles and landed in Halifax or Quebec, stayed for considerable periods and occasionally took up permanent Canadian residence. Many more were from the United States and remained for shorter periods. New Englanders went to the Maritimes by ship from Boston or Portland to Saint John or Halifax. Others from Vermont or New Hampshire crossed the border into Quebec. Those from the New York area came by the inland waterways to Montreal and on to Quebec, or sailed across Lake Ontario from Rochester to Toronto, or entered by the Niagara frontier, painting as they went, and gradually working their way to Toronto, Kingston, and other principal Ontario centres.

Miniature portraits and silhouettes deteriorated to a mass media commodity during the later 1820s and 1830s. Most sitters really just wanted a reasonable likeness, identical to those in 'respectable' neighbours' houses, for the flattering of their ego and the tickling of their fancy. Artistic quality was unimportant. A contributing factor in the degeneration was a mechanical device for profile tracing developed in Europe during the eighteenth century but probably not used in Canada until the nineteenth. But these machines were only one way of obtaining cheaper and better likenesses, which nineteenth-century Canadians could then place in presentation lockets or display as ever present reminders of friends and relatives, living and dead. The art had virtually ceased to exist by the mid-century.

The photographic technician replaced the silhouettist and miniaturist once that picture-making process was invented by the ingenious and persistent Frenchman, M. Daguerre, in 1839. The new device cre-

ated a tremendous sensation when publicly demonstrated in Paris that year. Within a few months, a Canadian, Joly de Lotbinière, made daguerreotypes in Athens. Amateurs in New York, Philadelphia, and Boston almost immediately also began experimentations in picture-taking. A photographer is said to have been at work in Quebec during October 1840. Daguerreotype studies were fairly common in metropolitan centres within a couple of years.

Replacement of the silhouettist and miniaturist by the photographer in Saint John, New Brunswick, is typical of what happened throughout the country. Clepham J. Clow, in introducing daguerreotypes in May 1842, offered to show specimens of his 'novel and highly interesting art' to those who had not previously seen such pictures. He had painted profile portraits in Halifax five years earlier. During the following summer there was sufficient light in the Commercial Hotel, Saint John, for picture taking from ten to three o'clock, and he obtained 'the exact resemblance and most accurate delineation of the features, and equal if not superior to the finest engravings.' He, like other miniature painters, on realizing that old methods could soon be obsolete, learned the new and still very novel process. Pictures in neat morocco cases cost $5, but Clow would still paint miniatures on ivory for more conservative tastes at from $5 to $20 each.

Thomas H. Wentworth, the local Saint John artist, had so much competition from visiting artists and photographers that he supplemented his income by selling cooking stoves in his studio. When he realized that miniature painting would probably cease because of photography, he studied the new art with Messrs Hodkinson and Butters (Americans) and converted his studio over James G. Melick's watch shop into a daguerrean gallery a few weeks after Clow's departure. He photographed and painted or sketched Saint John residents for the next three and a half years.

Miniature painters' advertisements disappear completely from newspapers after 1850. Instead one published a doggerel poem written by a homesick young immigrant in Saint John entitled 'Lines to Accompany a Daguerreotype' which he sent to his mother across the ocean. Editorial writers commented on and eulogized the depths of light and shade in many photographic works instead of commenting on the qualities of paintings. Victorians loved the truthful or 'speaking likeness' which faithfully reproduced every wrinkle and undulation of the skin, and the unconventional poses which were such a contrast to the stiff painted miniatures. No painter could compete with these aspects of photography. The painted miniature or silhouette already was scarcely more than a memory although amateurs exhibited water-colour miniatures at local agricultural exhibitions for a few more years.

Photography's direct influence on the painted portrait was eloquently expressed in *Le Journal de Québec*, 13 June 1865. The writer, drawing public attention to J. B. Wilkinson's work, pointed out that a painted portrait can reveal the personality of a sitter more truthfully than a photograph:

Since the appearance of photography, oil painting has been, so to speak, in its 'widowhood' and if one thinks about it, scarcely exists. Moreover many of the artists, in order to live, have been obliged to make themselves into photographic machines, that is to say, to lend the weight of their palette to a new process, clothing in colour that which has no life. In this ungrateful work, they lose all inspiration and all originality.

Fashion is a strange thing, often forcing men to pay more for a badly painted photograph than a good original painting. Now a photograph of the face, one must have the graciousness to say it, is not nature; it is not the truthful and reflective soul; it is simply a machine-forced immutability of a moment, with a mechanical stiffness and rigidity. Also there are faces which the photograph is powerless to portray, and which the clever painter alone can see.

We are aware also of the unfortunate pitfalls in which the photograph finds itself, particularly those of larger dimensions, where larger proportions are given to objects or parts of objects which are nearer the camera, and which disfigure particularly the nose and hands.

Encourage then the painter, above all when you want a large portrait, since you will get something better for the same price and for even less. Mr Wilkinson awaits you, he is excessively modest in his prices.

11

Krieghoff and Genre in Quebec

Everyone in Quebec recognized the artist, a slight little man who always wore a velvet suit and a round beaver hat. His eyes were bright and sharp, his wit was keen, and he told a story well. His friends were jolly, colourful roisterers, men about town, whose pranks reached every ear. Companions marvelled at his incredibly keen sight in the woods, for he could shoot game at a much greater distance than others. During evening celebrations at the neighbouring inn when the long and vigorous dancing had exhausted the musicians, the artist himself would jump on the platform and take over, playing on the violin, flute, guitar, or piano for his fun-loving set. Then in the morning when the sun lit the eastern horizon, he would be among the last of the revellers to leave for home with throbbing temples and slightly tipsy gait. Such was Cornelius Krieghoff, patronized by Lord Elgin and many British officers, and by gentlemen in the English-speaking communities of Montreal and Quebec who were his friends, during the 1850s and 1860s.

Numerous Quebec newspaper advertisements of A. J. Maxham & Co., an auction firm in which John Budden, Krieghoff's frequent companion, was a partner, heralded the sale of his paintings after the mid-century. One in April 1862 was held at Ross's new auction house, Rue Saint-Jean, where 100 Krieghoff canvases, including his *Merrymaking* (fig. 48) and *The Alchemist*, were offered. In contrast to these and other Krieghoff canvases at such sales, European paintings sold at the same time seem dull. At an auction on 23 December 1862, held in time to permit Christmas purchasing, 31 works were sold. There were small oils, of Indian basket sellers, beggarwomen, and other subjects, which measured 11″ x 9″. Larger canvases showed *habitants* leaving for and returning from market, Indians spearing salmon, and numerous autumn and winter landscapes. A large *Interior – Group of Canadians, Girl*

Making Straw Hats provides another glimpse of the local Quebecker. Many record every-day *habitant* life in and around Montreal and Quebec City. Krieghoff canvases incorporate significant gestures, witty touches, and very human qualities. They are genre with all its storytelling power. Religious, portrait, and landscape painters had shown the Quebec scene in earlier years. British army officers and Légaré had made tentative attempts at a genre approach. But Krieghoff was the first major painter in the province to exploit genre to the full. He introduced all its satirical, romantic, and narrative force.

Details of Krieghoff's early life are vague and often contradictory. He was born in Amsterdam in 1815, son of an expatriate German working there as a coffee house attendant. His mother was born in Ghent. The family lived in Düsseldorf in 1820 but moved to Schweinfurt in Bavaria where his father manufactured wallpaper. Young Cornelius probably studied in Düsseldorf; he copied paintings by such well-known Dusseldorf School artists as Hasenclever. He may have studied art and botany in Rotterdam, and knew Flemish and Dutch genre paintings. Some of his Canadian canvases echo Low Countries art, and outdoor winter scenes of habitants at Longueuil are closely related to Dutch winter views by Andreas Schelfhout and other Dutch artists of the 1830s which he seems to have copied. His early interiors and his later fishing scenes or paintings of farm life have the flavour of popular American genre. One notes parallels in the approaches of Richard Caton Woodville who studied in Düsseldorf, of F. W. Edmonds who exhibited in New York when Krieghoff was there in the late 1830s, and of the numerous Currier and Ives prints. Evidently Krieghoff made a youthful Bohemian tour of Germany, Austria, Italy, France, and Holland to examine art, during which he was described as an itinerant artist and musician.

This same Bohemian spirit prompted emigration to the United States. Krieghoff landed in 1836 in New York, where he enlisted for military service in wars against the Seminole Indians of Florida, although whether he was an artificer or a sergeant draughtsman is uncertain. He completed many sketches of campaign incidents which he gave to John Budden in Quebec, but they were burned in 1882. These sketches had been used in making replicas, now lost, for the American War Department. The artist's interest in Indians was first awakened in Florida. The Caughnawaga Indians gave him many subjects for his earlier Montreal work; he later painted the Lorette Indians of the Quebec district repeatedly.

Krieghoff's whole life was changed when he developed an interest in Canada after meeting in New York a young French-Canadian girl

from a village in the environs of Montreal. He fell madly in love with and married the captivating Émilie Gautier (*dite* Saintaguta). He was discharged from (or deserted) the American army in 1840, and established a painting studio in Rochester and possibly for a time in Buffalo. Reportedly he supplemented his income with work as a musician. Krieghoff made a trip to Paris late in 1844 to copy paintings in the Louvre under the tutelage of Michel-Martin Drölling. On returning to this continent, he may have lived briefly in Toronto but evidently was living with his wife and daughter at Longueuil across the St Lawrence River from Montreal before he established a home in Montreal in 1847 or 1848.

The artist's early subject matter was related to the local scene. Engravings after European artists may have had a powerful suggestion in determining his choices. Émilie, his wife, and their young daughter who was named after her mother, posed repeatedly. In *Winter Landscape* and *The Ice Bridge at Longueuil* (National Gallery of Canada), they sit in a *berline* while the driver halts the horse pulling the sleigh to chat with a neighbour. These, like the most interesting of the early paintings, depict *habitant* life. Some show card players in the living room. In others the curé walks into the house to find the family breaking Lent – the shamefaced wife shows her empty plate; she can't undo the harm, but the artist obviously has more sympathy with the hardworking family than has Father Brassard, the officious churchman with his gold-headed cane. An eavesdropping mother may be spying on a soldier making love to her daughter or an outraged husband return home to discover a red-coat flirting with his wife. But about all is an overtone of light-hearted good will.

During these same years Krieghoff developed his interest in Indian life. Their encampments became a favourite subject. In summer, families sit around summer camp fires as men smoke, women talk about their baskets of berries, and children play (fig. 49). In winter views, men drag loaded toboggans over snowy plains on the shore of the St Lawrence River with a distant silhouette of Mount Royal beyond.

Montreal was capricious in her public acclaim of artists. Some earlier painters had been well patronized, but this was still a city of hardworking merchants and traders with their thoughts very close to business. The revival of interest in painting was not to come until the sons and grandsons of these successful early business men amassed Canada's finest collection of masterpieces during the 1880s and 1890s. Krieghoff lived in a cramped two-room apartment near Beaver Hall Hill, and there are stories that after about 1850 he was forced to peddle paintings from door to door at from $5 to $10 each, searching for

possible buyers in the city's old commercial quarters. For a time he instructed at the select Misses Plimsoll's school where Martin Somerville, who painted Indians and genre remarkably like those of Krieghoff, taught drawing. Krieghoff evidently gleaned ideas from Somerville, who in 1847 or earlier was painting Indian women selling baskets and moccasins in snowy landscapes; these paintings can scarcely be distinguished from Krieghoff's of a few years later. In 1851 Krieghoff painted the dramatic *Hostelry of the White Inn by Moonlight* (National Gallery of Canada) which suggests several later famous inn scenes such as *Merrymaking* of 1860 and *J.-B. Jolifou, Aubergiste* of 1871.

The artist was prepared to do painting of any kind if it offered sustenance for his wife and daughter. He copied popular European prints. He painted a few portraits and pictures of houses of the well-to-do. The *Trophy Room* (Royal Ontario Museum) shows a British officer's souvenirs displayed around him in his Montreal quarters. There once existed a bar-room nude for which his wife is said to have posed. Eventually we are told that he painted signs for new banks and business houses around Place d'Armes. At one point Krieghoff referred Mr Pinhey, a cabinet minister of Bytown, to young Mr McGill, nephew of the university's founder, for an assessment of his artistic ability. He was attempting to secure a contract during 1849 to paint a new portrait of Queen Victoria as a replacement for two canvases damaged during the Rebellion Losses Bill riots. One of the damaged works had been Krieghoff's own copy of Hayter's famous canvas of the queen in her coronation robes; the other, by the English portrait painter, Partridge, still hangs in Canada's Houses of Parliament.

The current vogue for huge painted panoramas prompted another Montreal project. William Burr, an American, had visited Canada in 1848 to paint a giant diorama of the Great Lakes and the St Lawrence. When this great canvas was displayed in many cities, a spieler described significant historical and geographical features and a folk-singer delighted the audience with appropriate songs of the different districts. Other artists undertook similar projects. People flocked in to see their own and other countries through the medium of the panorama, and its popularity is a further evidence that men were very much aware of their own surroundings in this new age of enlightenment. James Duncan and Krieghoff decided to collaborate in painting their own series of panoramic canvases picturing Canada. Newspapers trumpeted the undertaking, but then the idea was evidently abandoned.

Krieghoff was building contacts in business and government circles when the capital was transferred to Toronto following the 1849 riots.

Thereafter his following in Montreal seems to have been smaller. He continued to sell canvases in the city, but looked to other markets and in that year first visited Quebec. He took paintings with him for sale. Returning in both 1851 and 1852, he painted local Quebec views. At some point he met John Budden, a Quebec *bon-vivant* and auctioneer who sold canvases for him. Reputedly the genial Budden visited him in Montreal and urged him to move permanently to Quebec. Krieghoff was persuaded to go there with his family. They shared Budden's bachelor home for several years.

Krieghoff threw himself eagerly into painting in the Quebec community which offered him an opportunity to support himself adequately if not luxuriously. His work flourished as never before. Winter scenes at Jean-Baptiste's Jolifou's hostelry, as the inn sign proclaims, were universally admired. They record the lively occasions when the artist's friends arranged sleighing parties to a country inn for a night of dancing, drinking, and revelry. Normally Krieghoff painted the party's end. In *Merrymaking*, most elaborate of all, 'a partying' man sits on the snowy steps and holds his head. One bandsman, still clowning happily, deafens a distracted woman by vigorously blowing his flute into her aching ears. A solicitous friend, in an unhappy state himself, with features suspiciously like those of the artist, half carries a fellow musician through the snow. Someone drops a homespun plaid blanket from the balcony for a lady's comfort on the city-bound journey. Jean-Baptiste, in a gay purple jacket, stands gallantly at his door to speed the departing guests, who have paid well for their evening's carousal. Detail after detail enriches the lively narrative.

The Horse Trader (fig. 50) is another light narrative. An indignant matriarch soundly berates the niggardly buyer for his mean and insulting offer. She screams that in fact it is a real swindle; her son stands quietly by, for nothing he could say would be as effective as her tirade. An equally popular story was *Bilking the Toll*, the old game of cheating the slow-moving peg-legged gate-keeper by driving through the toll gate without paying and then thumbing the nose in derision. Many versions of this sold for $80 each, a considerable sum in terms of relative dollar value.

Krieghoff dealt with a whole host of other Quebec subjects. In numerous pure landscapes he repeatedly pictured waterfalls tumbling dramatically into the St Lawrence against backdrops of brilliant autumn foliage. Others showed overpowering storm and cloud effects, with flashes of brilliant sun bursting through overcast skies to highlight the panorama. Krieghoff always caught the dramatic element in a subject, overlaying it with a decidedly romantic flavour. He was fasci-

nated with and seized the expressive gesture. Once having chosen his subject, he painted dispassionately and in the most exacting fashion. Critics remarked on the photographic exactitude and brilliant colour. But bowing to popular demand, he continued his Montreal custom of also copying European works by Landseer, Stanstead, and others.

Most paintings found ready sale in Quebec, particularly among English-speaking residents and British officers on overseas garrison duty. Many were sent home as souvenirs and 'Krieghoffs' come to light in country houses of old military families around Bath and other parts of England. Krieghoff's own circle in Quebec hung them on their walls, laughing at their own shortcomings as they reminisced about jolly expeditions. Descendants still own a large number. Particularly popular subjects were painted over and over again with but slight variations, yet they often vary in quality. Of course the artist also mass-produced numerous 'pot-boilers' in less than a day when he was short of money, for they sold quickly. Innumerable hunting scenes on the St Lawrence and the St Maurice and in the Eastern Townships sold well. Sometimes he pictured his friends; at other times he painted Indians in these settings. Known Krieghoff canvases number possibly a thousand, and many, many others have disappeared.

This artist's genre painting was to Canada what the works of such contemporaries as George Caleb Bingham and George Henry Durrie were to the United States. Robert C. Todd, however, painted in Quebec at an earlier date and with the same interests as Krieghoff, and catered to the same clientele – but was never as successful. Actually Todd emigrated to Quebec in 1835 and began work as a 'house, sign, carriage and ornamental painter.' Recommending himself for patronage when he first arrived, he boasted that he had previously worked for London and Edinburgh gentry and nobility. He advertised figure-carving and gilding as added accomplishments in 1841. That same year he took pity on young Antoine-Sébastien Falardeau and through his help fame and fortune eventually showered their blessings on the young *habitant*. Todd also taught at the Quebec Seminary. His name last appears in the Quebec Directory of 1853, the year Krieghoff arrived. From 1856 to 1865 Todd was in Toronto, poorly patronized, an unhappy and embittered man, who wrote when completing his 1861 census return: 'Toronto is too new and too poor to support an ornamental artist.'

Some Krieghoff paintings parallel Todd's subject matter. Todd's earliest known canvas, 1840, shows Wolfe's Cove (fig. 51) with its timber docks and the Sillery shore. It had been commissioned by a Glasgow merchant who imported lumber in his own ships from these

wharves. The lounging boys and the raftsman with his colourful tuque are genre-like figures of a type which Krieghoff put to better use when in 1859 he painted a large canvas of the same Wolfe's Cove district. Among Todd's best known and most appealing works are scenes of gentlemen racing their tandem teams or single horses against a background of the Montmorency Falls ice cone covered with merrymakers. Actually these are a series of horse portraits commissioned by Quebec gentlemen who wanted their favourite blue-bloods pictured in a pleasant setting. Obligingly, Todd painted one black thoroughbred's name, *Corbeau* (The Raven), on an ice block. Later he painted the same horse in a summer setting. The almost photographic detachment of these pictures resembles Krieghoff's objectivity, but many of Todd's canvases have a terse linear rhythm prompted by his training in design, which imparts an attractive primitive quality not found in his successor's works.

Three early Quebec paintings by Krieghoff picture Montmorency in winter, a subject which Todd had painted earlier. Krieghoff even painted one racehorse in summer as had Todd. Possibly Todd's work prompted Krieghoff to try his hand at similar subject matter, and when the competition became too keen the older man left the overcrowded field and moved to Toronto, where he vainly hoped for greener pastures. Todd's limited output may make him appear an insignificant forerunner, but he pioneered in the figured Quebec landscape before Krieghoff, and again, as with Somerville, Krieghoff seems merely to have picked up someone else's ideas and turned them to good advantage. It is too much to say that there could not have been a Krieghoff without Todd and Somerville, but it is safe to assert that Krieghoff would not have been as richly varied an artist without their example.

Naturally other less sophisticated artists around Quebec capitalized on Krieghoff's popularity by painting similiar subjects. Some of their works are signed; other unsigned examples are often mistaken for Krieghoff originals. G. H. Hughes, Alexandre-S. Giffard, and other artists imitated Krieghoff's winter subjects, although Giffard was more successful when he painted a sailing ship with the sweeping lines of a Japanese print. Cochrane made variants of Krieghoff canvases during the 1870s, and those in gouache were enlivened with opaque white. Joseph Dynes, a local photographer and copyist, painted versions of such popular subjects as *The Boys Go to Town* with gay young *habitants* driving sleds over country roads. When Krieghoff taught art in Mrs Brown's Quebec School for Young Ladies, his method of instruction was simply to have the class copy his own paintings: his former stu-

dents as old ladies still turned out 'Krieghoffs.' The twentieth-century popularity and sky-rocketing auction room prices of the artist's work have resulted in 'Krieghoff factories' in Paris and various Canadian cities. Innumerable works now attributed to him are not genuine, and even some authentic works painted hurriedly for quick sale have little real artistic interest. But the canvases on which the artist laboured as a work of love bear his individual and unmistakable touch.

Krieghoff supplemented his income with revenue from the print-makers. Four very popular canvases of Montreal streets, Indians, and *habitants* playing cards were lithographed by A. Borum of Munich during 1847, for which Krieghoff received between five and six hundred pounds. This series, dedicated to Lord Elgin, was published under his patronage. A Philadelphia firm produced prints of *Pour l'amour du bon Dieu* and *Va au Diable* – subject matter similar to studies of beggars which sold well in the United States. John Weals of London published *Passengers and Mail Crossing the River* and *Indian Chiefs* in 1860.

Krieghoff actively championed good prints for the home where all could enjoy their moral and cultural benefits. He protested to the Hon. A. T. Galt, Canadian Minister of Finance, about a purported 15 per cent duty to be levied on imported paintings, and when assured that original works entered Canada duty-free, he then raised the question of the duty on prints, remonstrating with Galt:

Why prints should be under another class as to become dutiable, it takes, I confess, another class of common sense than mine to understand. If books are entered free, prints should be too, more so perhaps, for in many portions of Canada ignorance is so rife, that by the eye only some little education is obtained: as to the better class of prints, dear always from copyright, etc., the more duty is charged the less good can come of it, both to the public and treasury. A good print has not been offered for sale here – a city like Quebec – for three years.

Nor can the plea for protection be advanced, worthless as that might be.

Something ought to be done to further art in the province. Our very normal schools, high schools etc are without able drawing masters, or collections of prints or ornaments. No wonder that our young men should be drunkards and our young girls flirts.

This is a matter of importance and we should not follow the low wake of United States indifference to the fine arts. To our leading men we must look for proper measures, as it is the duty of artists to bring the matter before their eyes.[1]

Krieghoff turned out paintings at an enormous rate during the late

1850s and early 1860s. He had reached a peak of his career and built up a large clientele because these canvases mirrored aspects of local life in a popular, attractive, and entertaining way. They were bought by the socially affluent who wanted to be amused. But the insatiable public demand seems to have exhausted the man. Krieghoff turned to the photographers, commissioning local firms to make photographic prints from his canvases. These were tinted in water-colour and sold to eager buyers. He left Quebec about 1864. Probably he first went to Paris where he is said to have sold a large plant herbarium and an enormous coin collection amassed in Quebec. There is some evidence that at this time his daughter went to Chicago after her husband's death. The father is rumoured to have followed her eventually but the evidence is inconclusive.

Several art organizations and societies claimed his membership. After exhibiting with the Toronto Society of Artists in 1847, he, Duncan, Somerville, and others organized a similar Montreal show. In 1867 he exhibited a canvas at the Paris World's Fair which was hung, strangely enough, with the impressive Canadian photographic display; competently painted Théophile Hamel canvases and 'promising' Bourassas were, on the other hand, in the main art gallery. That year of Confederation, his *Crossing the Mail at Quebec* was sold at Montreal for $160 while it was on exhibition at the Art Association.

During 1870 and 1871 Krieghoff was again in Quebec, and there attempted to resume the life of earlier years. He suffered a heart attack within months of returning to Chicago. After writing a letter to his old friend, John Budden, he got up from his desk, went to his room, and there a few minutes later his wife found him lying dead on his bed. His wife died in Denver, Colorado, in 1906 and his daughter in the same city in 1929. Krieghoff left no other descendants. To the last it could be said of him:

He loved the woods and that border land of the early settler. He loved our rivers and lakes, and he loved our Canadian winters. Lake St Charles, Lake Beauport, the Montmorenci, were his favourite resorts where he found material and drew inspiration for his brush. Quebec was always with him, for he loved the old rock and the life within it.[2]

Krieghoff's interests are echoed in work by two of his contemporaries. James Duncan had moved from Coleraine, Ireland, to Montreal seven years before Queen Victoria's accession. Like F. M. Bell-Smith, A. W. Holdstock, and others, he painted principally in water-colour, the very British medium, as did his younger associates. His more plodding

ways contrasted with Krieghoff's keen awareness of bourgeois taste and intense drive, but even earlier he had used *habitant* life around Bonsecours Market as the subject of sketches. Duncan was indeed the recorder *par excellence* of Montreal. His paintings ranged from the *Funeral of General d'Urbain, Commander of the British Forces in Canada* (fig. 52), slowly passing through the streets, to panoramic views of the city from both the river and the mountain. Many sketches were made into woodcuts for the *Illustrated London News* and others were published as prints for local sale. His numerous panoramic water-colours follow a formula: detailed drawing, warm autumn colouring in the foreground, receding blue distance, and a picture plane which falls back step by step. A classical urn or picturesque ruin often dignifies the foreground. Duncan had a youthful interest in late eighteenth-century classical revival paintings as best seen in the Quebec Museum's large panoramic view of Montreal; it has the delicate tonality of Richard Wilson and his friends and in oil in contrast to his numerous water-colours. Two other views in the Chateau de Râmezay picture every Montreal building including the new Bonsecours Market and other architectural marvels. His concession to new romantic tastes were some studies of Montreal fires (McCord Museum Collection), and introducing bustling crowds in street scenes.

A. W. Holdstock was both an art teacher and an artist, who came from Bath to Montreal in 1850 where he was employed by the National School. He painted in pastel, water-colour, and occasionally in oil, but in contrast to other English immigrants, he seemed to abandon his English background; his waterfalls with Indian canoes, wigwams, and autumn foliage are curiously like Krieghoff paintings.

12

Pre-Confederation Years in Ontario

Ontario's Pre-Confederation art is virtually an unexplored field. School children are told how Paul Kane crossed the Prairies and the Rockies, sketching Indians, and then returned to paint his canvases in Toronto. Historians know of other early Ontario painters but there are eloquent indications that much remains undiscovered, for a steady stream continuously comes to light of previously unknown mid-nineteenth-century paintings with genuine interest and merit. An intriguing rural agricultural scene (fig. 53) and a religious fantasy by Ebenezer Birrell, an immigrant from Scotland who lived at Pickering, Ontario, and portraits by Delos C. Bell of the Hamilton district, who was born in Ontario, were discovered a few weeks apart in 1964. Painting in Ontario had a slow start, but there was a sudden surge beginning in the 1830s, and a host of works, now unappreciated, gather dust in attics or hang in older homes. The field is obviously rich; the period is ripe for study. There are many recorded anecdotes about artists of these earlier years, but they stop short of any real knowledge or appreciation of the actual pictures.

In contrast to French Canada where church officials, seigneurs, and prosperous merchants demanded paintings, Colonel John Graves Simcoe, Upper Canada's first governor, was not inclined to cultural matters. Curiously enough, while United Empire Loyalists in the Maritimes maintained an interest in art, one is hard pressed to find it among those going to the Niagara River and upper St Lawrence settlements. Geographical isolation was one stumbling block; visiting artists landed at Halifax, Saint John, Quebec, or Montreal, but generally refused to make the long hard journey inland to the scattered Great Lakes settlements. Without numerous transient artists, it took much longer to popularize painting. Those venturesome artists who dared

travel farther inland found practical, hard-working settlers with little spare time for artistic, literary, or any other interests beyond their daily routine. Only five members responded when Simcoe summoned his first parliament to meet at Newark on the Niagara River in 1795; the rest were detained by harvesting which in their minds took precedence over state affairs. The great bulk of settlers were small-holding homesteaders of English or Scottish birth, formerly tenants or labourers, who had emigrated to create a better life in the wilderness, and were prepared to work from dawn to dusk at cattle raising, growing winter provisions, making their own butter, cheese, and yarn, and various other crafts.

Some asides in writings of the time allude obliquely to this lack of artistic interest. Francis Hall, touring America following the War of 1812, remarked how in going from the Province of Quebec to Ontario he found a great change in social manners and customs with the French bow replaced by a nod: ' 'tis like the growling salutation of a mastiff who has not quite leisure enough to turn and quarrel with you.' [1] Probably some eighteenth-century portraits of early residents at Hamilton were painted in the United States. Were competent artists not available in Ontario? The more debonair spirit in Quebec favoured artistic development. William Berczy, Sr, when he decided to paint professionally, abandoned his Toronto business interests for the more favourable artistic temperament and wider clientele of Montreal. Indeed, when Anna Jameson, wife of Upper Canada's chancellor, visited Toronto in 1836, she described it as a 'mean town,' condemned the windows designed by James Craig for the Anglican Cathedral, and felt out of place as a cultured English-woman and art critic. One may however question the fairness of her remarks, both because she was disturbed by marital difficulties and because her own sketches of Upper Canada demonstrate no particular talent.

Richard Coates, who emigrated from Yorkshire to Toronto in 1817, was a pioneer resident artist of the province, although he was preceded by Berczy and by Robert Irvine, who had painted the Toronto waterfront in 1814. Coates's father had been knighted, his mother was related to Sir Joshua Reynolds, and he himself served as a bandmaster in the Duke of Wellington's army at Waterloo. He had a many-sided career as a portrait and decorative painter, musician, choirmaster, and organ maker, and even built a small yacht on the Toronto waterfront. David Willson, a mystic religious leader, commissioned him both to paint decorative panels of *Peace* (fig. 54) and *Plenty* and to build an organ for his curious Sharon Temple just north of the city. The paintings have the naïve qualities of early Quebec ex-votos. Tiring of

the provincial capital, Coates operated a mill at Oakville and then retired in old age to a farm north of Lake Erie.

A few residents were notable exceptions to the local apathy in the arts. Charles Fothergill, like Baillairgé, was one of the 'universal' men of the time, a keen naturalist, painter, printer, and general promoter of all manner of intellectual pursuits. He was the first to propose an art gallery in Toronto when he advanced plans for an Art Lyceum in 1837. His own water-colour landscapes are very English in their mood. Shortly after arriving in Canada in 1817, he visited Rice Lake and there painted the local scenery. In these pictures he still saw the world to which he had emigrated as idealized, and painted delicate outlines for his buildings and trees with gentle colour washes. He ignored the cruder qualities of the landscape; this is what he, a starry-eyed newcomer looking forward to a better world, wanted to see in his future Canadian home. He still retained some of the reverie that marks landscapes of the classical age. What he painted is like some pleasant backdrop for a stage scene of paradise. Less than twenty years later, J. Gillespie and others were to awaken and see Ontario as it really was; they would then paint with a much more matter-of-fact eye.

The most tangible evidence of a new artistic interest was the organization of two short-lived Toronto art societies in 1834 and 1847. Their catalogues list the exhibiting artists, most of whom had lived in the province for only a few years. Naturally Charles Fothergill was one of these.

The 1834 Society of Artists and Amateurs of Toronto was chiefly promoted by John Howard, a local architect who taught art at Upper Canada College from 1833 to 1868. Captain Bonnycastle, the president, was a topographer in the Royal Engineers. He and seventeen associate members exhibited 196 works in the Parliament Buildings of the day near the waterfront. Unfortunately there were few visitors since the great cholera epidemic, which had prompted Légaré's painting, was raging in Toronto, and Howard personally had to make up much of the consequent deficit. Portraits in the show were painted by Samuel B. Waugh, John Linnen, Grove Gilbert, Nelson Cooke, and William Lockwood, several of whom had connections south of the border, and their style was probably based on current American painting. Fothergill exhibited flower and bird studies. Others sent many copies of European prints and painting. Landscapes by John Howard, James Hamilton, and young Paul Kane were copies of English and continental scenes, but Thomas Drury, Kane's old teacher, had painted both Niagara Falls and Lake George from nature.

Nelson Cooke was a young, well-known Toronto portrait painter

who exhibited in 1834 many copies such as *J. P. Kemble in the Rôle of Hamlet*, *Sir Walter Scott*, and *Magdalene* after Caracci. Three years later a local committee commissioned from him a portrait of Sir Francis Bond Head, the stubborn and autocratic Tory governor. Cooke's canvas was then sent to England to be used for the engraving of a portrait print; local sponsors expressed great pleasure at this turn of events since they were sure London connoisseurs would be delighted to see such an excellent Canadian painting. Although not in good condition, the canvas, now in the National Gallery of Canada, appears always to have been a lifeless thing. Head's friends, in an extra burst of zeal, requested permission to dedicate the new print to the youthful Victoria. Much aware of her governor's local unpopularity, the queen was pleased *not* to give her consent. First proof copies of the print arrived in Toronto during December 1837; less than a week later William Lyon Mackenzie marched on the city in his short-lived rebellion. Cooke soon left Canada (he was almost certainly an American by birth) to become a fashionable portrait painter at both Saratoga Springs and New York, and died in Boston at an advanced age; he was described then as a poet and artist.

The Mackenzie uprising is one indication of a change of character in Ontario life which corresponds to the intellectual awakening of the masses in the Maritimes. The Arcadia as seen by Fothergill had disappeared. Whereas Quebec painters changed from the classical to a romantic approach by showing an interest in the emotional qualities of light and colour, Toronto artists turned to their immediate surroundings and presented them in a much more objective way. Thomas Young, architect of King's College, is best known from his topographical prints. John Gillespie painted a detailed view of King Street (fig. 55) at the same time. In it he exulted in *progress* in the same way as American artists did in paintings of cities south of the border. New antiquarian writings like Scadding's *Toronto of Old*, with their precise and detailed descriptions of buildings, paralleled in literature what Young was doing in paint.

James Hamilton, a pioneer Ontario landscape painter who participated in the first exhibition, worked both in oil and water-colour. He left England to assume the post of accountant with the Bank of Upper Canada, and lived in a cottage which stood until the 1950s at Yonge and Wellesley Streets but was then in the Toronto suburbs. Trees surrounded his home, and he delighted in painting distant city scapes with foreground trees in soft atmospheric greys, grey greens, and sometimes mauves (fig. 56). His objective approach and interest in atmosphere harmonize with the inquiring spirit of those years, yet

Hamilton's paintings, whether in oil or water-colour, reflect stylistically his English origin. He might well have become a very significant artist if he had turned professional, but he preferred to remain a 'Sunday painter,' moved to London, Ontario, there promoting such schemes as tollroads, and painted extensively only after retirement.

Feelings were so bitter about the first art society's financial losses that it was not revived until 1847 as the Toronto Society of Arts. All its members were professionals; they proposed holding annual exhibitions of paintings, sculpture, modelling, and other works, and arranged a first show in the city hall, which still stands as part of the St Lawrence Market. The society dedicated itself to promotion of local art education, the members declaring that the Fine Arts 'will contribute to the reputation, character and dignity of the province'; they proposed the importation of antique casts to 'form an effective school for study of the human figure and to provide the cultivation of pure taste in various applications of design.' Puritanical Toronto would not tolerate nude models for another half-century.

Portraits still held an honoured place in the 1847 exhibition. Their numbers indicate the principal source of artists' income. Shows were indeed overbalanced by the many portraits: as late as 1854 the *Anglo-American Magazine* still complained that there were too many in Toronto exhibitions. Nelson Cooke, then living in Saratoga, John Linnen, and S. B. Waugh were represented in 1847; new names were those of E. McGregor, A. Bradish, whose portrait of Lord Metcalfe is well known, and Mr Tinsley. Cornelius Krieghoff, only recently moved to Montreal, sent a mother and daughter group and genre canvases copied from European works. Hoppner Meyer showed miniatures, and George Theodore Berthon, portraits. Paul Kane was represented by his first Indian paintings, and John G. Howard had views of a *Cedar Swamp* and *Niagara Falls* drawn with a *camera lucida*.

The two most significant new portrait painters were Meyer and Berthon. Meyer came from a well-known German artistic family of London, England, and had first visited Canada in 1832 to paint attractive water-colours of pretty young Quebec ladies. One small painting is unfinished; the lovely girl's mother ordered the work discontinued immediately when she discovered the young artist quite understandably kissing the model. Meyer seemingly returned to England, but by 1840 was back in Toronto where he worked for more than twenty years for a clientele which included the Governor-General, Lord Sydenham, several chief justices, and leading provincial citizens. His standard water-colour portraits measured eight by ten inches but he also executed miniatures on ivory, did pencil drawings, and engravings.

George Theodore Berthon was to Toronto society what Plamondon and Hamel were to that of Quebec. His father, René Théodore Berthon, had been a court painter to Napoleon, living in Vienna. He had studied in Paris where he saw the paintings of his father's celebrated friend, David. This classical master's influence appears in such Berthon paintings as the pastel study of youthful *Edward Caudell Barber*, with its clear, precise, classically oriented draughtsmanship, and cool blue shadows. He had taught French and drawing to Sir Robert Peel's daughters in England during 1827, and exhibited portraits at the Royal Academy between 1835 and 1837. Some have suggested that he met Hoppner Meyer in London before leaving for Toronto in 1840.

Judiciary, Tory politicians, and prominent Toronto members of the ruling Family Compact clique all became patrons of Berthon. His account books disclose that in 1867 he painted 29 portraits for which he received $1710, not a miserly sum in those days but he was supporting six sons and six daughters. His finest judicial portraits are in Osgoode Hall. When he was painting Sir John Beverley Robinson, he made a small version (fig. 57) for the judge himself at the same time as the monumental life-sized canvas, and then went on to paint both Sir John's three daughters grouped together, and his daughter-in-law by herself. The portraits of the ladies have somewhat the look of the suave idyllic English fashion plates of the time. Berthon was aloof and isolated, regarding himself as Toronto's select painter and a step above other local artists. He exhibited at three Ontario Society of Artists shows in the 1870s, was awarded a gold medal at the Philadelphia Centennial Exhibition in 1876, and was named a charter member of the Royal Canadian Academy in 1880, but as he didn't bother depositing a diploma-painting he failed to qualify.

Kingston had achieved distinction as the capital of Canada early in the 1840s. William Sawyer moved there in 1850, feeling that there were still opportunities for painting portraits of its august citizens. Besides, politicians no longer flocked to his birthplace, Montreal, following the burning of its Parliament Buildings in 1849. In Kingston he painted several portraits of Sir John A. Macdonald and of various mayors (Kingston City Hall), and occasionally travelled to Ottawa to execute commissions. His portraits grew more and more detailed and meticulous as photography rivalled painting and popular taste demanded ever greater exactitude.

The public had only sporadic opportunities to see exhibitions of painting. A few travelling shows of inferior European canvases were taken from town to town by virtual side-show barkers who charged a small admission fee for visits, but the principal place to see local paint-

ing between 1847 and Confederation was at the annual Upper Canada Agricultural Society exhibitions. These were patterned on a similar New York State society. Early Ontario shows were held in the Lake Ontario ports of Toronto, Hamilton, Kingston, Brockville, and Cobourg, all of which could easily be reached by steamer. London was host only after the railway line was extended there in 1854. The society's fairs continue today in Toronto as the Canadian National Exhibition. Many local painters competed. J. W. L. Forster, who became a prominent portrait painter, has described visiting other Toronto studios while an apprentice to J. W. Bridgman in the Confederation years, and many of those he saw were tastefully decorated with provincial and county fair prize cards, as artistic trophies and for advertisement.[2]

Art exhibitions at these agricultural fairs were regarded for more than a century as a record of Ontario's artistic progress and, in the earlier years, as an opportunity for local citizens to see good painting in a province where there were no other galleries. The Agricultural Society show had feeble beginnings; at the 1848 Cobourg exhibition works of 'fine art were very meagre, as, from the state of the weather and other causes might have been expected.' However the next year at Kingston 'paintings, drawings and other works of art were highly spoken of by those who professed their ability to judge.' The first really comprehensive report of an exhibition, written by Henry Youle Hind in 1852, offered pertinent comments on the state of provincial art. It pointed out that a larger number of artists would have to exhibit if public taste was to be improved:

[M]ediocrity of a large proportion of the contributions evincing that unconsciousness of what is real excellence, which must prevail in a country where there are no Galleries of Art or Schools of Design, was fully redeemed in other portions ... The dissemination of an interest in the subject evinced by this list [of exhibitors] is the best part of the case, and we believe that it only needs the formation of a School of Design to elicit works of art as creditable to Canadian ability as were the more practical departments of the Fair ... We must conclude this notice ... by suggesting to those artists who are not in the habit of exhibiting on these occasions, that although a shed at the Agricultural Show can never be a Gallery of Art, it will be the best opportunity the bulk of the population have for acquiring correct ideas upon the subject; a consideration beyond the value of the prizes should therefore induce them to contribute something upon each occasion to raise the standard of taste, and elicit among the thousands before whom they are displayed, the power and enthusiasm which is only dormant, not dead. The quality of the exhibition in this

department must be greatly raised, before a stranger can be referred to it as a criterion of the progress the Fine Arts have made in this country.[3]

Early exhibition buildings were indeed primitive. A T-shaped structure at Toronto in 1852 was better than its predecessors, but paintings placed on tables and screens were juxtaposed among a jumble of wax flowers, false teeth, boxes of cigars, boas, fur caps, and innumerable other articles. The judges completely missed William G. R. Hind's two oil paintings. Amateur and professional divisions were established that year, but many curious anomalies required rectification, for dentures in the 1856 Fine Arts prize list had to be shifted later to a more appropriate department. Additional artists exhibited when buildings of a permanent nature were erected, although Berthon and others ostracized the show. Hamilton's Crystal Palace, opened by the Prince of Wales, later Edward VII, during his memorable Canadian tour of 1860, contained the first room built especially for an art gallery in Canada:

54′ wide and 64′ long, reserved especially for the exhibition of works of art. Three of its sides are close-boarded and the light admitted through the centre of the roof by a lantern light extending the whole length; the glass is frosted or obscured in order to diffuse the light.[4]

These exhibitions mirror Ontario's tastes and standards after the mid-century. There were Victorian still-life paintings, water-colours of flowers and birds, and both landscapes and genre with sentimental titles. 'Historical' painting received much attention. A discourse on historical painting delivered by Sir Joshua Reynolds when the Royal Academy was formed had crystallized thought on this branch of art. Connoisseurs and critics alike felt these paintings should mirror soul-stirring romantic episodes from Canadian history just as Alexander Muir's 'The Maple Leaf Forever' did in song, and be a local reflection of Benjamin West's *Death of Wolfe*, Trumbull's *Surrender of Cornwallis at Yorktown*, or the huge canvases of Napoleonic exploits so popular in France before Waterloo. Judges refused Paul Kane the prize in 1852 since he had entered a painting of contemporary Indian life and manners which they felt was not strictly historical. They hoped he would re-consider such subjects:

[I]t was clearly a misapprehension of the nature of the subject matter required, and not a want of power, which occasioned this disappointment – we shall hope to see, upon a future occasion, that the spirit stirring incidents of

the last war, and the great events which have marked the social progress and constitutional history of the country, have found their fitting expositor in the first native artist of Canada.[5]

Paul Kane had already a considerable reputation, as is suggested by the reference to him as the first native artist of Canada; but he was not actually Canadian by birth, and the writer of this report seems to have had no knowledge of earlier contributions to Canadian painting in other provinces. The judges added that since 'historical painting is the highest branch of art, we must remark that the prizes offered are wholly insufficient to tempt an artist capable of executing such a subject to sacrifice time which might be given to easier and more remunerative employment.' Historical division prize-winners were Alexander Davidson, a Hamilton portrait and landscape painter who exhibited from 1859 to 1875, Robert Whale, Richard Baigent, and W. N. Cresswell. The classification was altered in 1866 to 'historical or genre'; tastes were changing and becoming more liberal.

The portraits in 1852 were severely criticized by a man who found that size was no guarantee of excellence:

Portrait painting was very abundantly but very indifferently represented. It by no means follows that a very young artist who can catch a tolerable likeness, and has overcome the first difficulties of the brush, can deal with a full-sized portrait. Forgetfulness of this fact produced some sad examples of vaulting ambition which o'erleaps itself. The portraits were too large, and their defects were more glaring than their merits. A pleasing likeness by Mr. George Reid [of Hamilton], and a portrait in full profile by Mr. Griffith, of much expression, although the colouring and especially the background, were far more pleasing, were, with the two Indian portraits [by Paul Kane], which gained the first and second prizes, the only exceptions we remarked. [6]

James B. Wandesford consistently won prizes during the early 1850s in the water-colour portrait, landscape, and flower studies classes. His slight but pretty paintings appealed to public taste. Wandesford, born in Scotland, had settled near Goderich on Lake Huron, operated a saw mill, and painted miniatures on ivory. When the mill failed he became a full-time water-colour portrait painter, scattering his works throughout Oxford, Kent, and the adjoining counties. At Eldon House, London, is a large collection of his Victorian beauties with their hair hanging in ringlets and painted with little depth of character. He worked from photographs if the subject was unavailable. An unsigned portrait of Colonel Thomas Talbot, the aris-

tocratic bachelor and country squire of Talbotville on Lake Erie, is a more serious work and is thought to be by Wandesford. He later became an itinerant in New York State and eventually went to California during the gold rush.

The whole artistic scene began to change rapidly after the mid-century with the coming of aggressive English immigrant artists destined to be professionals or semi-professionals who exhibited almost immediately on arrival, but their real influence was felt only after 1867 (see chapter 16). W. N. Cresswell had an English county family background and, after settling near Seaforth in 1855, divided his time between fishing, painting, and encouraging art students. Daniel Fowler settled on Amherst Island as a farmer in 1843. James and John Griffiths, T. Mower Martin, and J. R. Rolph were also among the newcomers. Captain Caddy, when discharged from the army, remained in the Hamilton-Niagara district to sketch mill and river scenes. All these men worked in the English style and since they were the first considerable body of resident artists to make an impact, the Ontario tradition may be said to spring from their art.

Robert R. Whale, whose Canadian career stretched well into the Confederation years, was of necessity resourceful and adaptable in making a living, for only fashionable artists like Berthon could confidently expect a steady income from painting. He had gone up from his native Cornwall to study Sir Joshua Reynolds' paintings in London, and as an old man painted his granddaughter down among the roses in a pose which faintly reflects Reynolds' portraiture. The styles of Constable and Gainsborough are also constantly reechoed in his canvases of Brant County roads and streams. Portraits were losing their great popularity in England by the time Whale finished his studies, so in 1852 he emigrated to Burford near Brantford; his brother followed.

Whale painted some of the local prosperous farmers and merchants of Elgin, Brant, and Wentworth counties, but business was not good. He turned his talents to creating a panorama illustrating the Indian Mutiny of 1864. This was exhibited in many Western Ontario villages and towns, with the admission price of sixpence including a harrowing narrative of horrors perpetrated by natives on suffering British soldiers. The show was like a combined horror movie, television thriller, and news documentary. His views of Dundas, Hamilton (fig. 58), and other towns embody new objective and realistic overtones consistent with changing public taste; some were made into prints, while others were copied and recopied in oil for local citizens. Whale's popular *Panoramic View of Niagara Falls with a Michigan Central Railway Train*, repeated over and over again, attracted widespread attention because it

combined the romantic element of the great falls with pride in the new railways which heralded a wealthier age. The artist, his brother, and two sons produced slightly varying replicas of this painting over a thirty-year period.

Each autumn Robert Whale and his brother drove their horse and buggy piled high with paintings to the railway station. The crates were destined for the provincial agricultural exhibitions. There were many works so that the artists could enter all possible categories; they needed the prize money. Some other artists resented their aggressive ways and grumbled that the Whales monopolized all the awards. The brother later moved to Brantford where he made a living by painting scenes and designs on railway drinking fountains.

Whale visited New England once, saw Hudson River School paintings, and sketched the mountains of New Hampshire. He painted his own version (National Gallery of Canada) of Asher B. Durand's *Kindred Spirits*, but made his focal point a deer standing on a projecting rock instead of Durand's poet and painter. In this he could not resist reverting to more romantic trends. He even painted another fantasy canvas in which nude maidens surrounded by oaks bathe in the Grand River (National Gallery of Canada).

The careers of these painters of 1867, such as Whale, show that many were diverted from their ambition to be portrait painters. But most of those working in Ontario, whether in portraits or in landscape, were following the dominant English style. A few independent and important figures like Paul Kane were exceptions. He and like-minded painters would make an impact with their paintings of the romantic Northwest, an area far removed from English landscape in appearance and from traditional English reactions.

13

The Lure of the West

Joseph Howe declared at Halifax in 1851 that 'many in this room will live to hear the whistle of the steam engine in the passes of the Rocky Mountains, and to make the journey from Halifax to the Pacific in five or six days.' English-speaking Canadians, looking westward, envisaged a potential empire. George Brown, editor of the Toronto *Globe,* repeatedly pointed out Ontario's obvious interest in the Northwest. He maintained that Toronto, as a growing commercial centre, must look beyond the province since even then Ontario farmlands were almost completely settled, and the logical place for future expansion would be the Prairies.

Ontario's citizens were made vitally aware of that somewhat mysterious region through numerous paintings by Toronto artists. Kane, Hind, Armstrong, and Verner all were lured to the Prairies and the Rockies beyond, and painted the west before railways made it an open book. The romantic aura conjured up by Indians and the unknown spaces worked like a powerful magnet. Buffalo herds, plains Indians, and wild mountain scenery were exciting beyond the wildest stretch of the imagination. The Canadian Indian had always been of interest to artists. Légaré had painted hunters lurking in the forest, and both Plamondon and Hamel on occasion had used Indians as subject matter. But when later artists painted the natives, they were following the spirit of the age in an even wider sense. French philosophers, for example, corresponded with American generals about aborigines, eulogizing the Indians because of what they considered their pure spirit and ideal existence when uncontaminated by the softening effects of so-called higher civilizations; the Americans harshly replied that they had no such fanciful illusions. In eastern Canada, lecturers at the Halifax and Saint John's Mechanics' Institutes discussed the 'red man,' and Abraham Gesner of the latter city already was collecting Indian artifacts for his museum.

Two pioneer painters, Rindisbacher and Warre, were in the west before the better-known Paul Kane left on his momentous trip to the Pacific in the 1840s. Peter Rindisbacher was a Swiss immigrant who arrived at the Red River Settlement just ten years after the Earl of Selkirk's Highlanders had founded the colony in 1811. Rindisbacher's companions travelled by the same hazardous route as the Scottish immigrants, threading Davis Strait, landing on the western shores of Hudson Bay, and then suffering incredible hardships in travelling by waterways and portages to Fort Garry. North-West Company fur traders, Métis, and Indians all resented the newcomers, for a farm population would result in a shift in the economy from furs to agriculture. Rindisbacher, little more than a boy, was a good draughtsman and sketched in water-colour both the curious Eskimos in their kayaks and his companions carrying their heavy bundles across the portages near Nelson House.

Money was scarce, and the young artist during his first years in the west painted meticulous water-colours with the outline of the figures and the application of paint so precise that they may be mistaken readily for prints. Sales of these to traders and visitors at Fort Garry supplemented his parents' income. The Reverend John West, chaplain to the Hudson's Bay Company at Red River, sent some back to England. Others were painted for Bulger, the commander at Fort Garry (fig. 59). Most pictured Indian life or huge transport canoes with top-hatted fur-trade officials travelling through the west. A few were of buffalo hunts on the plains. Soldiers at Red River purchased several virtually identical paintings which showed British Army officers and Indians outside various palisaded western forts. Several pictures were lithographed in England during 1824 and 1825. Relatively few Red River settlers could afford pictures, so Rindisbacher sought a somewhat larger clientele by moving to St Louis in 1829 where he painted Indians and prairie scenes until his early death.

Captain Henry Warre's lithographic views, *Sketches in North America and the Oregon Territory*, were based on monochrome studies highlighted by opaque whites, which were completed during a secret fact-finding mission to investigate American encroachment on the western lands of the Hudson's Bay Company.

President Polk's 1845 election cry of 'Fifty-Four-Forty or Fight' had stung the British into action. That same year Warre journeyed westward with Sir George Simpson and the Hudon's Bay Company traders to the mountains, and then continued on to the Pacific with a fellow-officer. Despite Warre's efforts, England lost Oregon and much of British Columbia, but eastern Canada realized the necessity of taking a genuine interest in the whole region if all was not to be lost.

Paintings by eastern artists were one part of the necessary stimulation of interest in the west. The end result of this activity was the retention of British Columbia as a part of British North America.

Paul Kane proved to be the giant among the western painters. His nostalgic interest in Indians dated back to his boyhood years when his father brought him from their Irish home at Mallow, County Cork, to Toronto, where he saw his first Indians. He reminisced later about those youthful days:

I had been accustomed to see hundreds of Indians about my native village, then Little York, muddy and dirty, just struggling into existence, now the City of Toronto, bursting forth in all its energy and commercial strength. But the face of the red man is now no longer seen ... To me the wild woods were not altogether unknown, and the Indians [of the west] but recalled the old friends with whom I had associated in my childhood.[1]

Kane's painting was encouraged by Thomas Drury, art master of the new Upper Canada College. His first job was painting scroll ornaments on chairs and the like at Wilson Conger's furniture factory in Toronto. In his spare time, both in Toronto and in Cobourg where he went later, he painted local citizens. These are pedestrian Canadian portraits of the time. He also painted some landscapes. He had aspirations of becoming a full-time professional painter.

After two years at Cobourg, a more adventurous life began for Kane when in 1836 he crossed to Detroit. His intention was to travel to Europe for study, with William Bowman and Samuel Waugh as companions, but on meeting them he found that Bowman had just married and the trip was cancelled. It is rumoured that for the next few years Kane was a penniless wanderer, forced to paint portraits of river boat captains in lieu of passage money. Then he established a studio in Mobile, Alabama, where he earned sufficient money as a portraitist to finally set out alone in 1841 for Marseilles. He frequented 'humble lodgings as he wandered from Paris to London and other northern cities, and to Geneva, Florence, Venice, Rome and Naples.' The young Canadian studied by copying masterpieces, and brought home, after another period in Mobile, madonnas after Raphael and Murillo, and a copy of Basato's Pope Gregory XVI. They are a strange contrast to his later painting.

Kane was swept up in the exhilaration of westward advance which was sweeping the United States. Artists were bringing back views of the new American territories. Tales circulated of how Catlin had been painting the western Indians since 1832, and in 1841 these were

verified by his book which described how 'the history and customs of … such a people, preserved by pictorial illustrations, are themes worthy of a lifetime of one man, and nothing short of the loss of my life, shall prevent me from visiting their country and of becoming their historian.'[2] Kane echoed Catlin's statement in a preface to his own book which set out his motivations in travelling west:

I determined to devote whatever talents and proficiency I possessed to the painting of a series of pictures illustrative of the North American Indians and scenery … The principal object in my undertaking was to sketch pictures of the principal chiefs, and their original costumes, to illustrate their manners and customs, and to represent the scenery of an almost unknown country.[3]

His Indian portraits show a familiarity with those of Catlin. Almost certainly he had met the American artist, and had seen his paintings which were being displayed at the Egyptian Hall, Picadilly, when Kane was in London. Of like inspiration to him were the works of John Mix Stanley whom he had met earlier in Detroit and in whose *Buffalo Hunt* of 1845 are the atmospheric skies and noble horses of Kane's later paintings of prairie Indian life.

After only a few days in Toronto, Kane, fired with ambition to paint the western Indians and unknown scenery, set out on 17 June 1845, to cross the continent. He took 'no companion but my portfolio and box of paints, my gun, and a stock of ammunition,' and set off on the most direct route to Lake Simcoe. During the first summer he sketched Ojibwa chief Mani-tow-Wah-Bay (fig. 60) while camping with the Manitoulin Island and Mackinac tribes. The chief was a reluctant model:

He anxiously inquired what I wanted the likeness for. In order to induce him to sit, I told him that they [Kane's sketches] were going home to his great mother, the Queen. He said that he had heard of her, and was very desirous of seeing her, and that had he the time and means, he would pay her a visit. It pleased him much that his second self would have an opportunity of seeing her. He told me, with much pride, that he had been a successful warrior, and had taken nine scalps in his warfare. He was very fond of liquor, and, when under its influence, was one of the most violent and unmanageable among them.[4]

The local Hudson's Bay Company factor at Sault Ste Marie advised Kane to follow Warre's example and go west with Sir George Simpson. That winter he showed his first Indian paintings to Simpson

in Montreal, and received permission to accompany the spring fleet. He had great difficulty in catching up to the brigade of twenty-foot birch bark canoes on Lake Superior, because he was late in reaching the rendezvous and it went on without him. Later he sketched the men portaging at rapids and paddling through the lakes. He visited Fort Garry, sketched the Swampy Cree Indians at Norway House, made colourful studies of Plains Indian life, and of the huge buffalo herds around Fort Edmonton which filled the air with suffocating dust. Crossing the mountains was an exhausting ordeal. He wintered among the Pacific coast tribes (fig. 61), and returned to Toronto only in the autumn of 1848 bringing with him a collection of Indian souvenirs later sold to the Hon. George W. Allan of Toronto. In addition, he had made five hundred sketches, subject matter for canvases during the next quarter-century.

His western scenes, exhibited in Brockville at the Upper Canada Agricultural Exhibition of 1851, created a sensation. The artist, present in person, was singled out as a celebrity. In discussing one painting with an interested group he explained that he was the man sitting in the dog-sled. Reviewers described the works in full detail. At that time Kane was bending every effort to paint a series of many canvases illustrating the 'scenery and Indian life of the great northwest,' a virtual 'kaleidoscope of the unknown.' One hundred, completed by 1852, were exhibited both in Canada and in London where some were even shown to the Royal family at Buckingham Palace. The artist wanted them to remain in Canada as a unit, and his wish was realized when Mr Allan bought them. (They were later purchased by Sir Edmond Osler and donated to the Royal Ontario Museum, Toronto, where they are now housed.) In gratitude, Kane dedicated his book to Mr Allan. Fourteen additional canvases were commissioned by Sir George Simpson.

Kane addressed a petition to the Canadian Legislature in 1850, in which he described his western trip and his sketches. His introductory preamble included a request for financial assistance in publishing his journal. The Legislature refused an outright cash payment, but instead voted £500 to purchase twelve paintings. The House Committe, in recommending this, gave him commendation:

Mr. Kane is a native of the City of Toronto, of whom his native city may be proud, as an artist of the first merit. They deemed it their duty to visit his studio, and were highly gratified by the inspection of the splendid paintings and collection of curiosities shown them by that gentleman, illustrative of the remote and interesting parts of our Continent which he had visited during his peregrinations.[5]

Kane delayed repeatedly in delivering the canvases. The Legislature, in refusing a second request for publishing assistance, remained adamant that its only help would be purchase of works. The twelve were finally handed over in 1856. Eleven survive in the National Gallery of Canada.

Kane's is a romantic and idealized world. He painted the grass of the wildest regions trimmed like an English green sward. Trading boats descending the Saskatchewan River have the dignity of Roman galleys (fig. 62) and buffalo hunts are like wonderful tableaux on some gigantic stage. His lithe graceful horses in one painting are known to have been modelled on those in an Italian engraving. The stiffly posed warrior chieftains have a noble bearing. Sometimes he used focusing light and at other times decorative sky effects which echo those in seascapes of the Low Countries. His personal romantic nature, which was consistent with the spirit of the age, influenced his more highly finished canvases, but in his small oil sketches, his pencil notes in sketch-books, or his water-colour studies, all of which were finished with great speed, the scenes are more truthfully set down, and some of these have more appeal to contemporary taste than the highly finished canvases. The *Landing of Columbus* stands apart from the western series. In this hypothetical view, as three Spanish galleons approach the shore the woods on every side are alive with Indians. Possibly Kane painted this when the judges had refused him the 'Historical Prize' in 1852.

In 1853 Kane married Henrietta Clench, an amateur artist whom he first met in Cobourg. They built a house on Wellesley Street, Toronto, which is still standing and which is marked by a plaque; Kane's later years, spent here, were marred by weak eyesight which he insisted was due to snow glare in Switzerland.

Frederick Verner saw Kane from afar with the romantic eyes of a boyish worshipper. Unconsciously he patterned his own life on that of the better-known artist, and after Kane's death was himself the leading painter of Canadian Indians. Verner recalled knocking on Kane's door when a boy, possibly in 1850; it opened a crack, the youth requested painting lessons, and the door closed quickly without comment. They were friends in later years, and Verner painted Kane's portrait (Royal Ontario Museum). Verner's father was the school principal at Sheridan, Ontario, and he studied art at Heatherly's and the South Kensington Art Schools in London. His life has incidents in it almost as adventurous and romantic as Kane's, for when he finished art school in London, the Red Shirt Regiment, a legion of foreign volunteers similar to the Spanish Loyalist Corps, was assembling in Eng-

land for the purpose of assisting Garibaldi in the liberation of Italy. This was an irresistible lure, and Verner fought for three years in Italy before returning home to become a professional painter.

The artist established his first studio in Toronto, where he painted some early landscapes like *The Toronto Waterfront*. He travelled to the northwest on numerous occasions, periodically visited England, lived for some years in Windsor, Ontario, and whenever times were bad worked for the Notman photographic firm as a painter of photographs. Throughout, Indian life and the prairies provided much of his subject matter. He painted many buffalo studies in characteristic browns, greens, buff, and mauve, both in oil and in water-colour. Some are virtually epic dramas: a herd stampedes as a fire drives prairie chickens and all other wildlife before it (fig. 63). Seemingly he was determined to record these animals before persistent organized hunting extinguished the species. As early as 1840, 1,210 carts and 620 hunters engaged in the annual buffalo hunt, and such depredation continued for years. Scenes of camps and canoeing were a second love. His paintings may be small water-colours or large oils, in one of which the 'red men' halt on a canoe trip to gamble. Over and over again birchbark canoes emerge romantically from the mists or are etched against sunsets on Rainy River or the Lake of the Woods. Every Ontario exhibition had its quota of Verner paintings. Writers in 1873 pronounced him the best-known Ontario painter, and his slight change of subject matter at an Ontario Society of Artists exhibition of that time was remarked upon by one critic:

Mr. Verner surprised us this year by the complete alteration of style which a visit to Philadelphia or some other influence brought about. But whatever it may have been that has wrought it, we honestly say that we do not regret the change. His eternal devotion to the Red Men was becoming tiresome. Now, besides some exceptionally hazy buffaloes and one sketch of Tepees, he eschews the Far West altogether.[6]

Even then commentators were beginning to extol the narrative qualities so admired by later nineteenth-century English and Canadian academicians. Verner exhibited a painting with a ship under full sail entitled *Homeward Bound*, and the reviewer's description provides a good example of sentimental Victorian reaction to the story seen as implicit in the canvas:

Prominent among the oil paintings was a large sea-piece by Mr. Verner showing a large vessel in full sail under a stiff breeze making her last tack for

port. The catalogue gives the title 'Homeward Bound' which tells the story at once. The idea conveyed is that of a labour accomplished, of difficulties and dangers overcome, of the welcome haven reached at last, and of rest and recompense fairly earned. A poetic glamour is thrown around a commonplace incident of commerce which compels the spectator to linger musingly in front of the canvas. The effect is heightened by the evening sun, which having also performed its appointed task, is sinking to rest also 'homeward bound' to its couch beneath the sea, on whose waves its horizontal rays cast a weird and ruddy glow. The sentiment is similar to that conveyed in Turner's well-known 'Fightin' Téméraire' though there the subject is more poetical.[7]

Verner painted one remarkable series of twelve Indian portraits. He attended the 1875 treaty-signing ceremonies at Winnipeg when chieftains and others of the Chippewa and Swampy Cree tribes ceded 100,000 square miles for settlement. These portraits are the negation of Kane's works. Instead of noble and proud savages, Verner painted shy and timid aborigines hiding in their own world, gazing out at the new strange ways engulfing them. He achieved a remarkable effect with subdued gloomy faces made vivid by phosphorescent red and blue paint which looms out of the murky darkness. The artist refused to sell this series and bequeathed it to relatives. Some of them still remain in private hands.

As an old, old man, Verner lived with a bachelor-nephew in London, England. He spent his later days painting water-colours of Burnham Beeches and Hampstead Heath in the style of an earlier generation.

William Armstrong also painted in the Northwest when only the hardiest souls ventured into the isolated prairie and mountain wilderness. As a railway engineer for the transcontinental Canadian Pacific, he was one of those who brought the age to a close. He worked on both the English and the Irish railways before emigrating in 1850, and the Toronto Directory lists him as an 'artist and civil engineer' at the time of his arrival. For no fewer than twenty-six years he was drawing master at the Toronto Normal School, probably having been hired when William G. R. Hind left. Like Kane and Verner, he exhibited widely in Ontario, sent paintings to Montreal in 1865, and participated in both Ontario Society of Artists and Royal Canadian Academy exhibitions from their inception. One early painting shows Indians lingering on the Toronto railway station platform. He took great pride in his water-colour of the arrival of the Prince of Wales in Toronto by boat from Kingston in 1860, while guns boom a salute and enormous crowds await the royal visitor on shore (fig. 64). It is remarkable for

the lateral sweep of the compositional lines; these dart back and forth so that the lines of the ships and their booms are picked up by the lines of the water and of the crowds on shore. The Prince honoured Armstrong by buying his first version for $50; a Torontonian commissioned a replica for $40 but died before delivery, and the next year Armstrong was offering the painting for $30. The artist met the Prince of Wales and the Duke of Newcastle, who purchased Indian sketches measuring 7½ inches by 10 inches, a size which he normally sold for $3. He worked at times as a photographer, selling bush scenes and Indian prints to British officers for their souvenir albums at $1.50 each or 75 cents in quantity. Strangley enough, the Canadian government displayed photographs of Armstrong and Krieghoff paintings rather than originals at the 1865 Dublin Exhibition.

The artist was drawn to the west primarily by his work as a railway engineer. He painted on these trips. Water-colours of Lake Superior were exhibited in 1862, and impressive panoramas of the Indians on Manitoulin Island seem to date from the same time. The *Canadian Illustrated News* published his sketches of troops going to the Riel Rebellion in 1870. On the way, Armstrong halted to paint monumental water-colours of Fort William with the great rocky promontory towering over Indian houses in the foreground. He also painted the Plains and Foothills Indians, and like Verner lived to see the 'old west' pass away.

The Pacific coast had its own particular lure in those pre-Confederation years. Vancouver Island's first legislature met in 1856 at Victoria, a former Hudson's Bay Company fort. False rumours of gold earlier had disturbed the sleepy little community on the mainland, but in 1858 the stories were true. Men began treking up the Fraser River, first in an unobtrusive trickle, and then in a veritable deluge. Long lines of miners came from California along with adventurers and others from every corner of the globe. They travelled to New Westminster, Hope, and even farther up. One man discovered the famous Cariboo gold fields in 1860 when he recovered a quarter-pound of gold from a single panning. Six thousand miners had arrived by 1862, and a new mainland colony of British Columbia was founded. The British navy and marines arrived to maintain law, order, and the British Crown, and to survey the new colony. R. C. Mayne, Edward Panter-Downes, and other naval surveyors and topographers sketched during their western tour of duty, and at the same time civilian artists arrived to record these stirring events.

Restless William G. R. Hind was the most important of the new painters, and at the same time he introduced into Canada a Pre-Ra-

phaelite note from the currently fashionable English style. This artist worked in practically every Canadian province. His brother, Henry Youle Hind, geologist, explorer, and author, had protested that at the Upper Canada provincial exhibition of 1852, William's oils *Waiting for the Bat* and *Reading the News* could not be seen because they had been thrust into a corner. William resigned as an art teacher in Toronto, visited England, and returned in time to be appointed by Henry as official artist to the Hind Labrador Exploring Expedition of 1860; the artist-brother's pencil sketches and highly finished water-colour paintings were incorporated as illustrations in the report. They contain factual details of the Indians met and precise documentation of their clothing, tools, and other artifacts. But they also romanticize the wilderness rivers and mountains, and the fierce Naskapi oarsmen guiding a canoe down rapids or portaging supplies; the wild faces of the Indians compel the attention, and the whole composition is made more dramatic by the rushing water curving around the bases of dark and forbidding mountains. Strangest of all illustrations is *The Winding Sheet*, where Indians set a body adrift on a northern lake. A maiden holds the sheet draped in elegant folds, while a dog gazes into the distant sunset; here is the nostalgia for death as found in the paintings of Dante Gabriel Rossetti which Hind probably saw on his English visit. These imaginary compositions based on tales by Indian guides are a vivid contrast to the more factual renderings executed from the actual objects.

Labrador had whetted William Hind's appetite for adventure. Gold fever was sweeping the continent, and he promptly joined forty-four young Torontonians and others from eastern Canada, the 'Overlanders of '62' who travelled to the Cariboo by way of Fort Garry and Edmonton. An English party who had purchased railway tickets to the mining strikes joined the Overlanders when they found they had been swindled since the railway ended at St Louis. The whole party travelled by steamer up the Red River to Fort Garry, bought Red River carts, oxen, and horses, and started overland following the old fur traders' trails. Hind sketched constantly after leaving Fort Garry. His amazingly detailed water-colours and oils (in the McCord Museum, Montreal, and the British Columbia Provincial Archives, Victoria) show the dismantling of carts before ferrying the Assiniboine, the hostile Indians, pemmican-making, and a charging buffalo of which he remarked, 'I rather like the cussed thing.' Fort Edmonton held a dance in their honour to the music of fiddles, a welcome interlude before the most gruelling part of the journey. Horses and cattle staggered through muskeg and over windfalls on the

Upper Saskatchewan River and then emerged into the mountain valleys where travelling was somewhat easier. Hind was ostracized for several days and travelled alone when he made himself objectionable to the others. Lives were lost in mountain streams. Food was scarce. The party reached the Cariboo late in October, and the only woman with them gave birth to a child the day of their arrival. Hind painted Chinese panning for gold at the abandoned China Bar along the Fraser and a tavern interior at Lillooet (fig. 65) with its 'heterogeneous collection of men, these miners, Englishmen (staunch Royalists), *Americans* (Republicans), Frenchmen, very numerous, Germans in abundance, Italians, several Hungarians, Poles, Danes, Swedes, Spaniards, Mexicans, and Chinese.' They were a hard-drinking, roistering, cursing lot, both toughs and the homesick beardless youths hiding loneliness with their swaggering airs.

In those paintings, where he detailed every blade of grass and carefully rendered each stone, and in his numerous self-portraits, Hind reflected the Pre-Raphaelite ideology. Holman Hunt, for example, was attempting to rival daguerreotypes; he 'multiplied incident and minute delineations of specific forms in his pictures and laid it down as a rule that the amount of such incident and the number of specific forms minutely delineated must be held the measure of a picture's truth.'[8] With the possible exception of a few painters who were strictly portrait men, Hind was the only Canadian who adhered to Hunt's advice.

Some Overlanders stayed in the Cariboo but Hind and others continued on to Victoria. There he painted Indians searching for shell fish on the tidal flats, advertised as a professional artist, and painted the new tavern sign for the 'Prince of Wales.' He and a Mr Tomlinson collaborated on a large oil showing the Alexandria Suspension Bridge, 'the first of a series commissioned by a gentleman who would shortly proceed to England to lecture, and the picture speaks for our native talent.'[9]

Hind painted oxen drawing Red River carts (fig. 66) and farm scenes in Fort Garry during 1869 and 1870. Late in 1870 he began working for the Intercolonial Railway in Shediac, New Brunswick, and spent his later years as a railway draughtsman in that province and Nova Scotia. His work provided him with opportunity to sketch the docks, village streets, country roads, and local life in Pictou, Shediac, and other railway centres. He often visited his brother at Windsor, Nova Scotia, and when he died in Sussex, the local paper said that he was 'well informed, a good talker while inclined to be uncommunicative, fond of sports, and with a tendency to artistic matters; he had many friends by his grand and occasionally eccentric habits.'

The gold rush attracted other artists who came to reap a living from men who were harvesting over two million dollars a year in Cariboo gold. Edward M. Richardson, who came west as a surveyor on the American Great Northern Railway, was the son of a London sculptor and a student of Sir George Hayter. He sculptured and erected an eighteen-foot high monument in Victoria in May 1863, and then sketched the Indian burial ground at Tenase Lake in the Cariboo and scenes around Victoria (fig. 67) which have an almost oriental touch. W. S. Hatton came from Toronto to paint panoramic views of the feverish gold-mining activity at Lillooet, Parsonville, and other centres in 1863 and 1864. Frederick Whymper, brother of a famous Alpine artist, worked as an artist with the Western Union Telegraph Company expedition, then constructing a line between the western United States and Alaska.

Quebec painters, unlike those of Ontario, were relatively uninterested in the Northwest. A large exhibition by Frances Anne Hopkins at the Art Association of Montreal in 1870 was apparently the province's first real introduction to paintings of the region. Mrs Hopkins was the daughter of Admiral Beechy, the Arctic explorer, and granddaughter of Sir William Beechy, the London portrait painter. She married Sir George Simpson's private secretary, and moved to Montreal in 1858. This gentle Englishwoman sketched as she and her husband travelled with the Governor of the Hudson's Bay Company in the fur trade canoes during the 1860s and 1870s; in her large illustrative canvases she sought more to report the truth of what she saw, as did C. W. Jefferys in a later age, than to portray subtle atmospheric or aesthetic effects, and she did indeed graphically record the trade activities – the great fleets of canoes and the busy life at the company's forts.

Even a number of English artists, such as Edward Roper and illustrators sent out by magazines like the *Illustrated London News*, were intrigued with the western scene, as is evident in *A Settler's Home near Carberry, Assiniboia*. However, they generally arrived after the building of the railway, when it was easier to visit the pioneer settlements on the prairie.

Mrs Hopkins' reporting was done just before the railway age began. The eastern and western ends of the Canadian Pacific met at Eagle Pass in the Rockies on 7 November 1885. There Donald A. Smith, later Lord Strathcona, drove home the iron spike which completed the thin steel band that stretched across Canada from Atlantic to Pacific. Sir William Van Horne declared that 'this last spike will be just as

good an iron spike as any on the road.' and, characteristic of the changing years, photographers rather than artists recorded the ceremony. Six months later the first passenger train travelled from Montreal to Vancouver over this, the world's longest railway. It was a far cry from Sir George Simpson's epoch-making twelve-week journey across the continent during 1841. Settlers poured in and the philosophical concept of the proud and noble Indian which had moved Kane and his artist friends soon faded away. The ideal was finally dispelled during the angry 1870 and 1885 uprisings when the last Indian stands were made against westward expansion. Romantic scenes made familiar to easterners through paintings by Kane and others would soon be replaced by the west of the ranchers and the cowboys.

14

The Last Frozen Barrier

The search for the fabulous Northwest Passage had drawn adventurers to the Canadian Arctic since the fifteenth century. The most sustained effort to discover its secrets was a series of expeditions fitted out when England's navy was freed from guarding the homeland against Napoleon. British sailors on these voyages underwent fantastic hardships and displayed incredible personal heroism, but their officers were nevertheless able to make a record of Canada's last unknown spaces in water-colour. It parallels the British army topographers' record of eastern Canada.

Sir John Ross's expeditions in 1818 and 1829, Captain Parry's in 1821, and Sir George Back's in 1836, were a first wave. Ross and Back both painted, and their original sketches all went directly from the Arctic to England; only a relatively small number have trickled back to this continent. There are few in Canada outside of those in public collections.

Sir George Back was the most important Arctic topographer from the Canadian viewpoint. He had a long association with this country, and his sketch-books in the Public Archives of Canada make a first-hand study of his painting readily possible. He accompanied Sir John Franklin during the discovery of the Coppermine River in 1819 on an overland expedition from Hudson Bay. In 1825-7 he returned with Franklin to the Arctic seaboard east of the Mackenzie River, and he commanded his own ship in the north during 1836. His best-known sketches were those on the expedition of 1825-7. The party, having first made a diversion to Niagara Falls, travelled overland from the Great Lakes, following the fur traders' routes across Manitoba and northern Saskatchewan to reach the Mackenzie River which they descended to its mouth. They then struck eastward along the Arctic

coast. On the way, using a *camera lucida*, Back sketched every aspect of the landscape which caught his eye: forest fires, dangerous rapids, spectacular rock formations, and tents pitched on a rocky northern inlet where his party met a dangerous polar bear. Later he painted numerous replicas. His sketch-books faintly resemble those of George Heriot in their attempt to catch basic lines of the landscape and in the colour washes. Sometimes he had only time for rough pencil outlines and the colour notes were added by hand; at other times he carefully finished the page in water-colour. Franklin used these as aquatint illustrations in his official report.[1] Back made more detailed studies for his own satisfaction (fig. 68).

Many of Back's associates painted water-colours. John Richardson, a naturalist, published sketches of Arctic wildlife. Lieutenant Robert Hood on the trip overland from Hudson Bay in 1819, emaciated beyond belief, was killed by an Indian who already was living on the flesh of other murdered expedition members, but his minutely rendered and mood-filled water-colours of scenery, birds, and animals were saved (fig. 69). E. P. Kendall, an artist with Back in 1829, later prepared lithographic views of New Brunswick scenery. Captain Ross, a companion of Franklin and Back on the Coppermine and Mackenzie rivers, returned with his uncle, Sir John Ross, to draw and paint Eskimos and their igloos during the 1829-33 search for the Northwest passage.[2]

William Smyth was first lieutenant to Back when he commanded the *Terror* which mapped the Arctic in 1836-7; Smyth sketched the views used in the official report.[3] This adventurer had already crossed South America from the Pacific to the Atlantic by going over the Andes and descending the Amazon. During the Arctic winter, he superintended a school for sailors, and produced plays for the 'Royal Arctic Theatre' as entertainment for the crew. This theatrical tradition continued for many years on ships wintering in the Arctic. Smyth was particularly intrigued in his sketching by the great rings of icebergs towering over the ship, and by the men outside at their daily work.

Sir John Franklin, most famous English seaman of his day, optimistically left England for the Arctic with the *Erebus* and *Terror* in May 1845. His was to be a supreme effort at discovery. The heavily laden ships, awkward with their iron reinforcement against winter ice, could be managed only with the greatest difficulty. Two years passed without word of the expedition, and concern developed into alarm. The British Parliament was finally stung into action. Queen Victoria herself was solicitous for her famous admiral, and the anxious Lady

Franklin fitted out a rescue ship at her own expense. No fewer than forty-two separate expeditions searched for Franklin over a twelve-year period. Twenty-one thousand miles of coast were covered. The great tragic drama gripped British imagination as had nothing Canadian heretofore. Many Franklin search vessels wintered in the Arctic, and officers shipped back a flood of sketches to England.

Lieutenant William Browne of Dublin typifies the naval officer-painters among the Franklin search parties. He visited the Arctic with Captain Ross on HMS *Enterprise* in 1848-9 and returned the next year with Captain Austin. During the Arctic winter, he painted backdrops for the 'Royal Arctic Theatre' plays. In England he assisted artists working on the Arctic panorama at Burford's Leicester Square Theatre where various gigantic topical views attracted many London visitors. Captain Snow was one of them before himself commanding an Arctic search vessel in 1850. So effective and lifelike was Browne's huge painting that Snow, when he was recounting his northern experiences, could say that he had seen the spot near Leopold Island which Browne had illustrated and had recognized every detail:

As we neared the shore, the whole features of the place came fresh upon me, so truthful is the representation given of them by Lieut. Browne in Burford's Panorama. I could not mistake, and, I almost fancied that I was again in London, viewing the artistic sketch, but for certain undeniable facts in the temperature and aspect of the ice which banished such an idea.[4]

Snow's own Arctic sketches, lithographed for his book, described his expedition.

The Arctic even attracted Americans. William Bradford, from Fairhaven near New Bedford, Massachusetts, a village long associated with the sea and sailing ships, made studies each summer in Labrador from 1861 to 1890. At home in Fairhaven, he painted the most spectacular Arctic canvases, some of which illustrate the Franklin search (fig. 70). Sparkling light effects on the snow, with the brilliance enhanced by the clear air and a dramatic presentation, made them famous throughout England and the United States; those who saw them at the American National Academy, the Boston Athenaeum, and the Royal Academy in London were mesmerized.

Admiral Sir Edward Augustus Inglefield was descended from a naval officer who had served in Halifax early in the nineteenth century. He himself commanded Lady Franklin's steam yacht, the *Isabel*, in a search for her husband. His diversion during the Arctic hunting for traces of the *Erebus* and *Terror* was a music box which Lady Franklin

had given him, and as a reciprocal gesture he presented her with his own sketch of the *Isabel*. Alfred Lord Tennyson, after hearing his eloquent speeches on his return to England, admitted that he felt there was little left in life but to have an Arctic inlet or river named after him. On the voyage, Inglefield carefully painted many delicately toned water-colours, which seem almost inappropriate for the harsh north.

When Inglefield was received by Queen Victoria at Windsor Castle in November 1853, a maid of honour noted how the queen looked at his paintings:

Captain Inglefield came here this afternoon, and brought all his drawings and sketches of the Arctic scenery; quite beautiful and wonderfully clever; enormous for sketches, some of them 3 feet long and 18 or 20 inches wide, and though slight, not too rough, and with the most pleasing air and truthfulness about them. They were all arranged in the corridor, for the Queen to see after lunch, and we took the liberty of examining them till she came. He was there himself and explained them to her, an intelligent, active looking youngish man, with very dark hair and eyes; he is one of the very few who are still sanguine about poor Franklin. It was awful to see how slight and small the ship (not a very large one in reality), looked among the gigantic icebergs and in the 'pack.'[5]

Inglefield lived in Halifax during 1878 and 1879 as Vice-Admiral commanding the North American and West Indian Fleet of the British Navy. He visited Rideau Hall, Ottawa, where Princess Louise drew his portrait, and when he exhibited his own water-colours at the Nova Scotia Provincial Exhibition of 1879 he was awarded a first prize.

Canadians actually had little personal contact with these Arctic voyages. The ships sailed directly from England, and few called at east coast ports; no Canadian commanded an expedition. Instead they read accounts of what was taking place in local newspapers, in the *Illustrated London News*, and other periodicals. One of Captain May's Arctic scenes was exhibited at the first Royal Canadian Academy Exhibition in 1880. When Ross published his book, a Newfoundland sea captain was the only Canadian subscriber; in contrast, the Lord Mayor of London ordered fifty-seven copies. The Arctic saga so stirred England that enterprising individuals made coloured magic lantern views of the expeditions to satisfy public craving. George Baxter, at the height of the excitement over Franklin, published a popular coloured print which exaggerated the romantic aspects of the north by showing

incredible ice mountains, spectacular aurora borealis, and sailors in hand-to-hand combat with giant polar bears. Many of the prints in the mass media had similar romantic overtones, which matched the drama in the expedition accounts and the public imagination, even though the original sketches were much more faithful and prosaic records of the north.

Arctic paintings by British naval officers symbolize, in a sense, the last vigour of colonialism in the Canadian art scene. By now politicians were thinking in terms of a great, self-sufficient Canada. Canadian painters, although they would continue to be influenced by artistic developments abroad, would, after proclamation of the new Dominion in 1867, participate personally in all phases of national art, just as Canadians were assuming responsibility in every other aspect of the country's life.

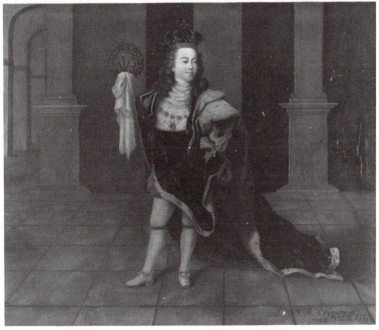

13 / Thomas Davies: *View of the Great Falls on the Outavaius River*, w.c.
13 5/8 x 20 1/4 inches (34.6 x 51.4 cm), undated
National Gallery of Canada

14 / Jean-Antoine Aide-Créquy: *Saint Louis tenant la couronne d'épines*, oil
62 x 73 inches (157.5 x 185.4 cm), 1777
Archibishop's Palace, Chicoutimi

137

15 / Thomas Davies: *Niagara Falls (From Above)*, w.c.
13 1/2 x 20 3/4 inches (34.3 x 52.7 cm), *c* 1766
The New-York Historical Society, New York

16 / George Heriot: *Falls of the Pokiok, St. John's River*, w.c.
9 1/2 x 13 1/2 inches (24.1 x 34.3 cm), undated
Sigmund Samuel Collection, Royal Ontario Museum

138

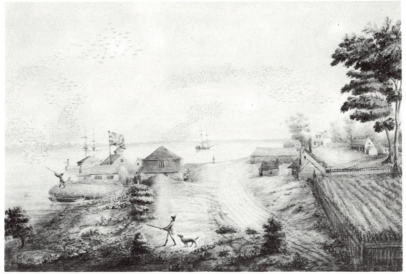

17 / George Heriot: *West View of Château-Richer*, w.c.
8 1/2 x 12 3/4 inches (21.6 x 32.4 cm), undated
National Gallery of Canada

18 / Edward Walsh: *Old Fort with the Migration of Wild Pigeons in Spring*, w.c.
9 x 13 1/2 inches (22.9 x 34.3 cm), 1804
Sigmund Samuel Collection, Royal Ontario Museum

19 / James P. Cockburn: *Ste Famille Street with a Funeral Procession*, w.c.
10 5/8 x 14 1/4 inches (26.7 x 36.8 cm), undated
Sigmund Samuel Collection, Royal Ontario Museum

20 / W.W. Lyttleton: *The House of the Honourable James McNab*, w.c.
11 1/2 x 19 1/2 inches (29.2 x 49.5 cm), undated
Nova Scotia Provincial Museum, Halifax

140

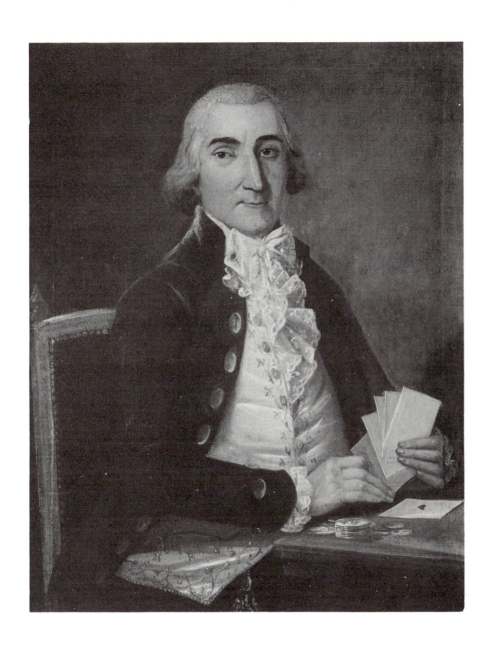

21 / François Malepart de Beaucourt: *Eustache-Ignace Trottier dit Desrivières*, oil
31 x 25 1/2 inches (78.7 x 64.8 cm), 1793
Quebec Museum

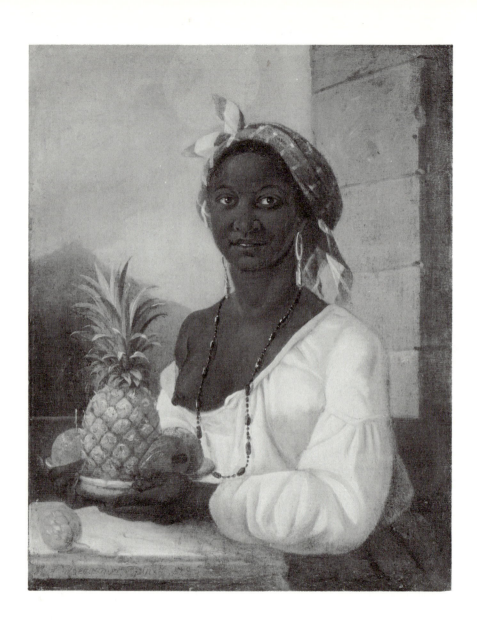

22 / François Malepart de Beaucourt: *Portrait of a Negro Slave*, oil
28 3/4 x 23 1/2 inches (73 x 59.7 cm), 1786
McCord Museum, McGill University

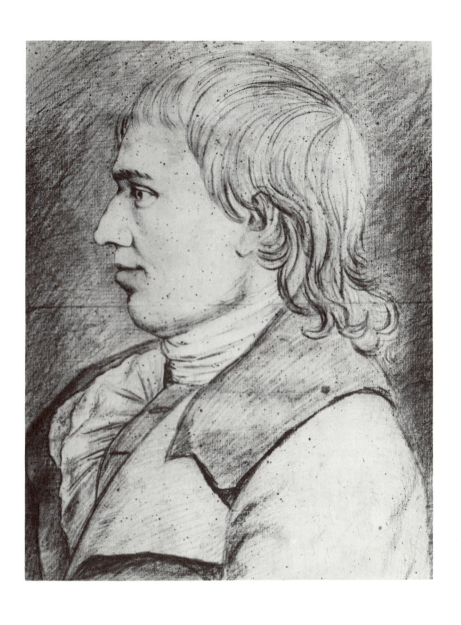

23 / François Baillairgé: *Pierre-Florent Baillairgé*, drawing in sanguine
16 x 15 3/4 inches (40.6 x 40 cm), undated
Quebec Seminary

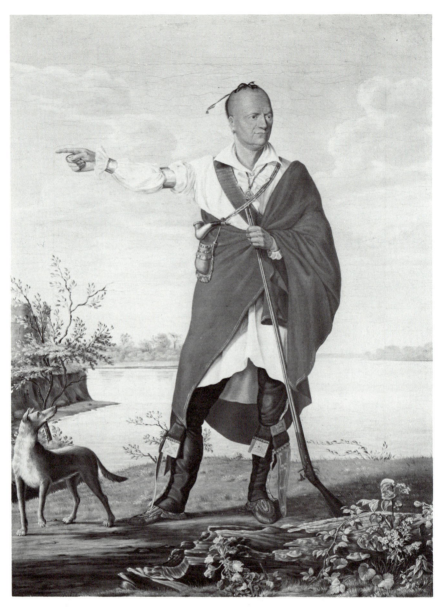

24 / William Berczy, Sr: *Portrait of Joseph Brant*, oil
24 x 18 inches (60.7 x 45.7 cm), undated
National Gallery of Canada

25 / *opposite, top* / William Berczy, Jr: *Harvest Festival*, w.c.
7 9/16 x 9 13/16 inches (19.2 x 24.9 cm) undated
National Gallery of Canada

144

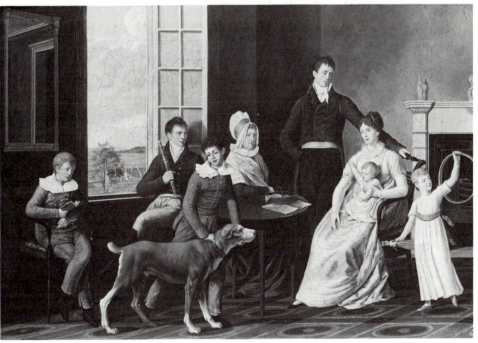

26 / William Berczy, Sr: *The Woolsey Family*, oil
23 3/4 x 34 1/4 inches (60.3 x 87 cm), 1809
National Gallery of Canada

145

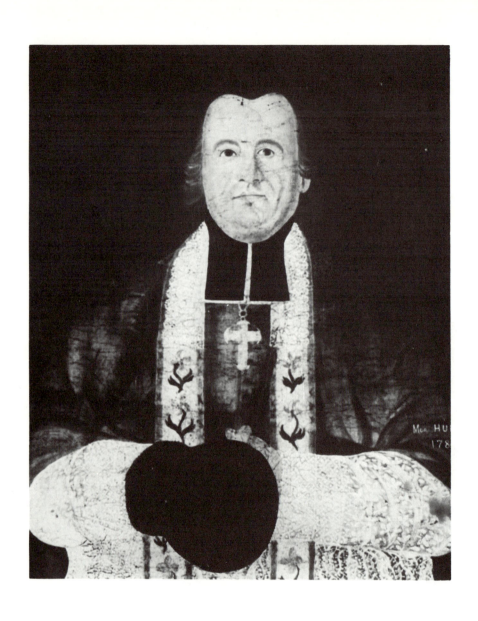

27 / Louis-Chrétien de Heer: *Portrait de Monseigneur Hubert*, oil
31 1/2 x 28 inches (80 x 71.1 cm), 1786
Hôpital Général, Quebec

146

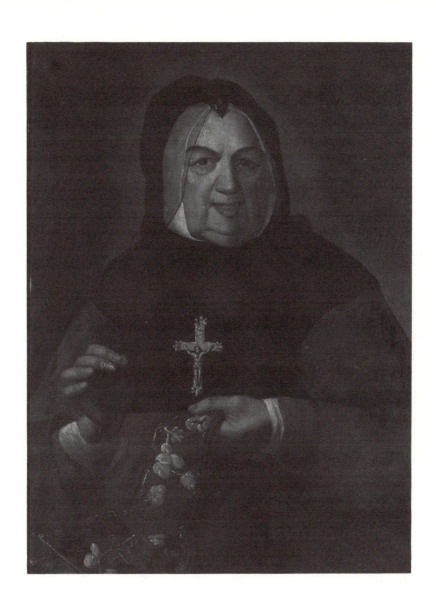

28 / Louis Dulongpré: *La Mère Thérèse Geneviève Coutlée*, oil
30 x 23 inches (76.2 x 58.4 cm), undated
Motherhouse of the Grey Nuns, Montreal

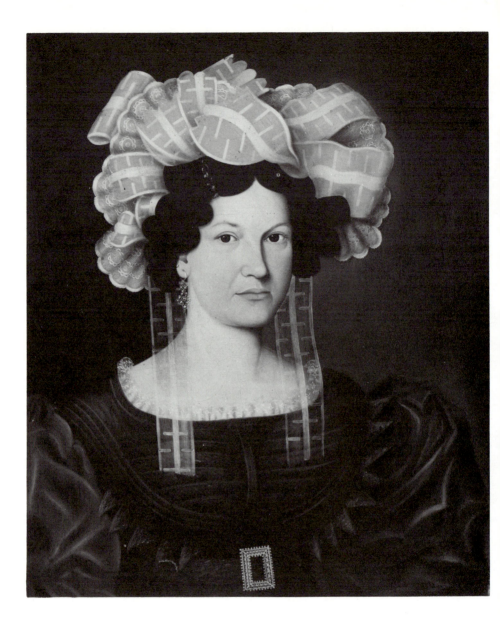

29 / Anonymous: *Mrs. Charles Morrison*
oil, 31 1/2 x 27 1/2 inches (80 x 69.9 cm), undated
National Gallery of Canada

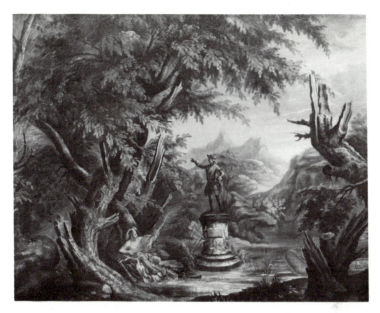

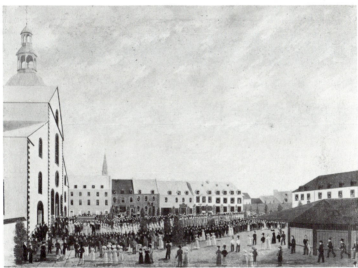

30 / Joseph Légaré: *Paysage au monument Wolfe*, oil
52 x 69 1/4 inches (132 x 175.9 cm), undated
Quebec Museum

31 / Louis-Hubert Triaud: *La Procession de la Fête-Dieu à Québec*, oil
30 1/2 x 42 inches (77.5 x 106.7 cm), 1821
Ursuline Convent, Quebec

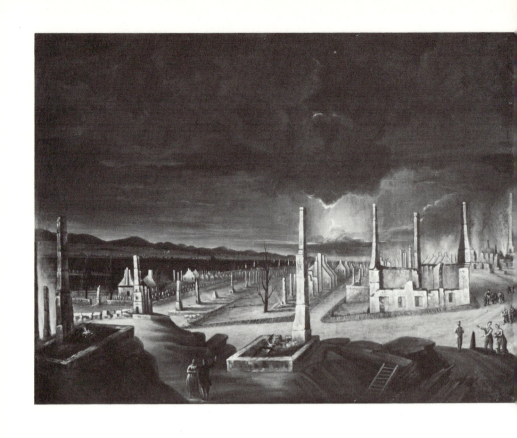

32 / Joseph Légaré: *Les Ruines après l'incendie du Faubourg Saint-Roch (May 28, 1845)*
oil, 37 1/2 x 49 1/2 inches (95.3 x 125.7 cm), undated
Art Gallery of Ontario

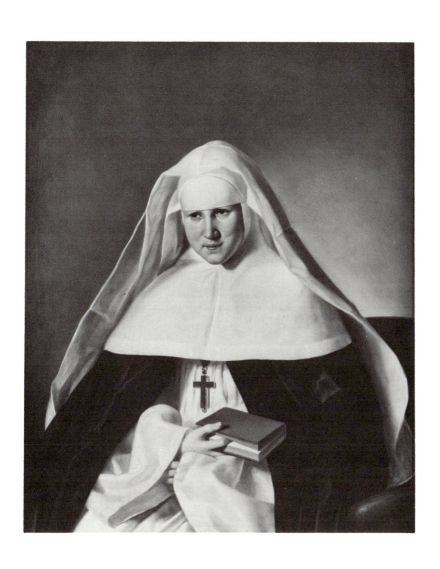

33 / Antoine Plamondon: *Soeur Sainte-Anne*, oil
35 x 28 inches (88.9 x 71.1 cm), 1841
Hôpital Général, Québec

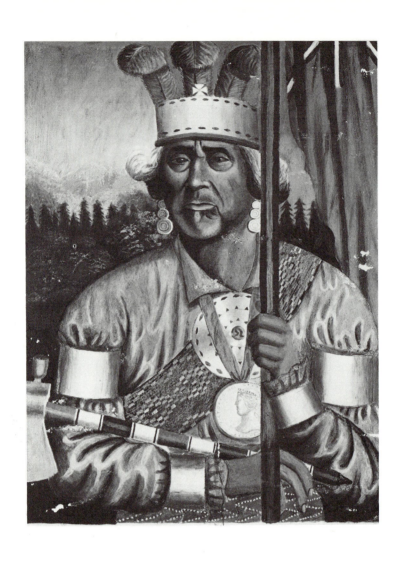

34 / Zacharie Vincent: *Self-portrait*, oil
29 1/2 x 22 inches (74.9 x 55.9 cm), undated
Château de Ramezay Museum, Montreal

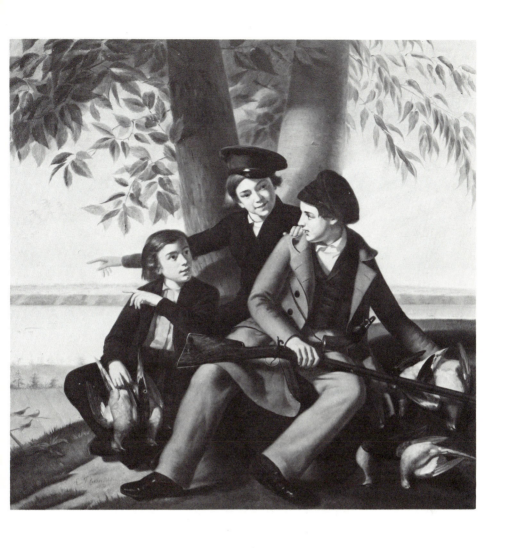

35 / Antoine Plamondon: *La Chasse aux tourtes*, oil
72 1/2 x 72 inches (184.1 x 182.9 cm), 1853
Art Gallery of Ontario

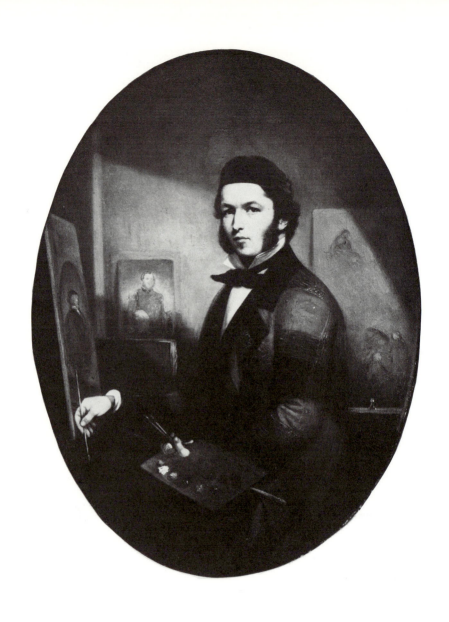

36 / Théophile Hamel: *Self-portrait*, oil
19 1/2 x 15 inches (49.5 x 38.1 cm) (oval), 1842
Quebec Museum

154

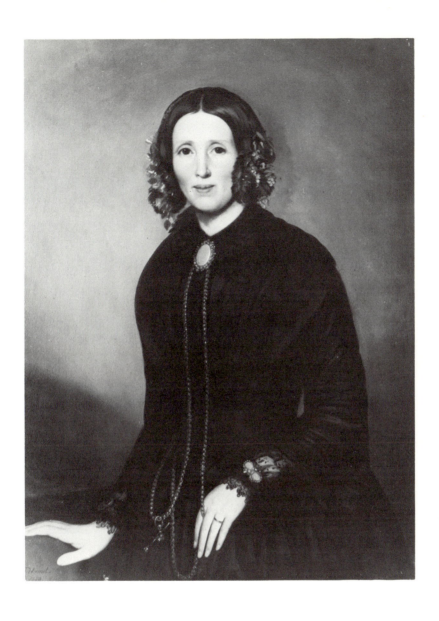

37 / Théophile Hamel: *Portrait of Mme Marc-Pascal de Sales Laterrière*, oil
37 x 29 inches (94 x 73.7 cm), 1853
Archbishop's Palace, Chicoutimi

155

38 / Attributed to Jean-Baptiste Roy-Audy: *Madame François Poulin de Courval*, oil
29 x 25 inches (73.7 x 63.5 cm), 1843
Quebec Museum

39 / Robert Field: *Charles Inglis, First Bishop of Nova Scotia*, oil
42 1/4 x 34 1/4 inches (107.3 x 87 cm), 1810
The National Portrait Gallery, London

40 / Joseph Comingo: Unidentified portrait, enamel on porcelain
3 1/4 x 2 9/16 inches (8.3 x 6.5 cm), 1815
New Brunswick Museum, Saint John

41 / William Valentine: *Reverend William Black,* oil
12 x 10 inches (30.5 x 25.4 cm), 1827
Mrs H. Connors, Halifax

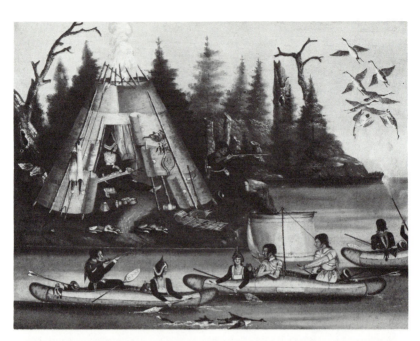

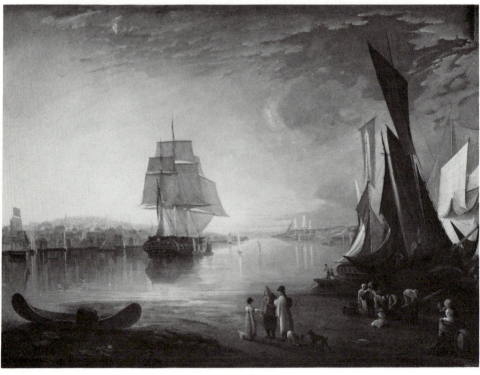

MISS ELIZA JANE McNALLY

42 / *opposite, top* / Anonymous: *Micmac Indians*, oil
18 x 24 inches (45.7 x 61 cm), *c* 1820-30
National Gallery of Canada

43 / *opposite, bottom* / John Poad Drake: *View of Halifax Harbour*, oil
53 1/4 x 73 1/2 inches (135.3 x 186.7 cm)
c 1820, National Gallery of Canada

44 / *above* / Thomas MacDonald: *Miss Eliza Jane McNally*, w.c.
9 1/2 x 7 1/2 inches (24.1 x 19 cm), 1833
private collection

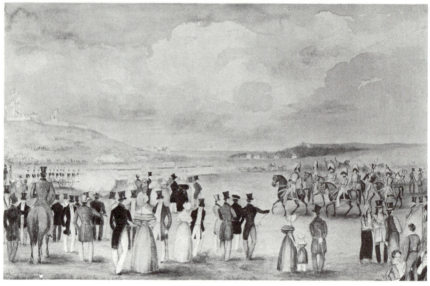

45 / Thomas Wentworth *View of the Great Conflagration ... City of Saint John*
engraving, 1839, New Brunswick Museum, Saint John

46 / William Eager: *Celebration on Halifax Common of the
Coronation of Queen Victoria, 28th June 1838*, w.c.
8 3/4 x 13 15/16 inches (22.2 x 35.4 cm), undated
Sigmund Samuel Collection, Royal Ontario Museum

47 / Jarvis F. Hankes: *J.B. Uniacke*, black paper touched with bronze
10 x 7 1/4 inches (25.4 x 18.4 cm), undated
Nova Scotia Museum, Halifax

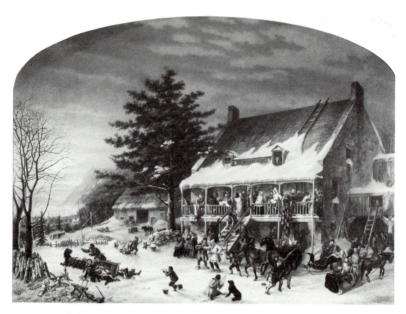

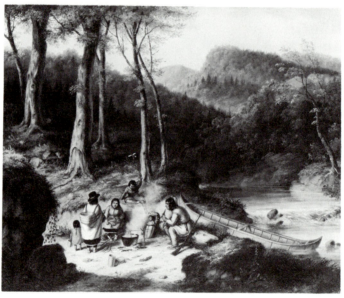

48 / Cornelius Krieghoff: *Merrymaking*
oil, 34 1/2 x 48 inches (87.6 x 121.9 cm), 1860
Beaverbrook Art Gallery, Fredericton

49 / Cornelius Krieghoff: *Indian Encampment at a Portage*, oil
28 1/4 x 33 inches (71.8 x 83.8 cm), 1850
Sigmund Samuel Collection, Royal Ontario Museum

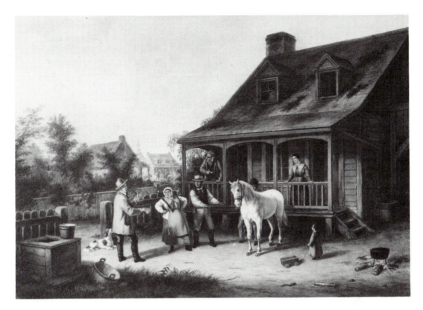

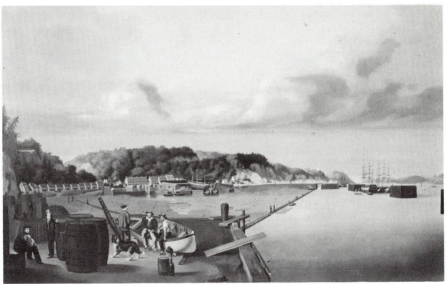

50 / Cornelius Krieghoff: *The Horse Trader*, oil
14 x 20 inches (35.6 x 50.8 cm), 1871
J. Blair MacAulay, Winnipeg

51 / Robert C. Todd, *Wolfe's Cove*, oil
29 1/4 x 47 1/2 inches (74.3 x 120.7 cm), 1840
Sir John Gilmour, Liverpool, England

165

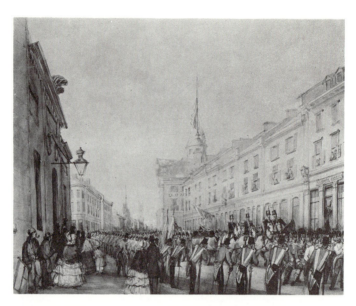

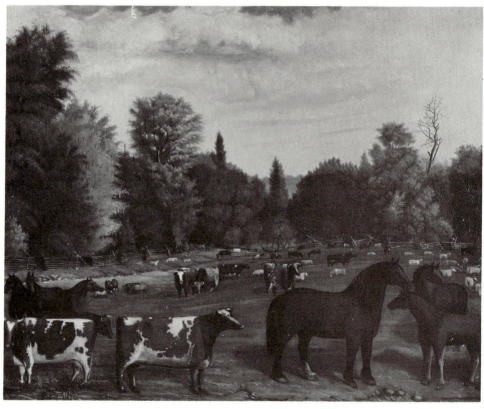

166

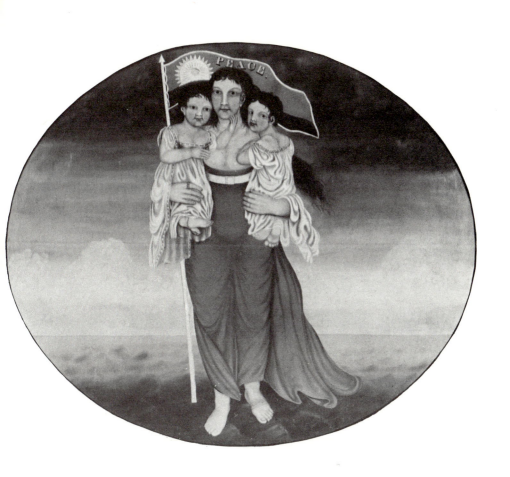

52 / *opposite, top* / James Duncan: *Funeral of General d'Urbain*, w.c.
18 x 21 inches (45.7 x 53.3 cm), 1847
McCord Museum, McGill University

53 / *opposite, bottom* / Ebenezer Birrell: *Good Friends*, oil
23 x 28 inches (58.4 x 71.1 cm), undated
Art Gallery of Hamilton

54 / *above* / Richard Coates: *Peace*
oil, 48 x 54 inches (121.9 x 137.1 cm), before 1828
Sharon Temple, Sharon, Ontario

167

55 / John Gillespie: *View of King Street, Toronto*
showing the old Jail and Court House, oil
11 x 22 inches (27.9 x 55.9 cm), undated
Sigmund Samuel Collection, Royal Ontario Museum

56 / James Hamilton: *London, Canada West*, oil
10 x 14 inches (25.4 x 35.6 cm), 1840
John Ross Robertson Collection, Metropolitan Toronto Library

168

57 / George Theodore Berthon: *Sir John Beverley Robinson*, oil
24 x 18 inches (60.9 x 45.7 cm), undated
National Gallery of Canada

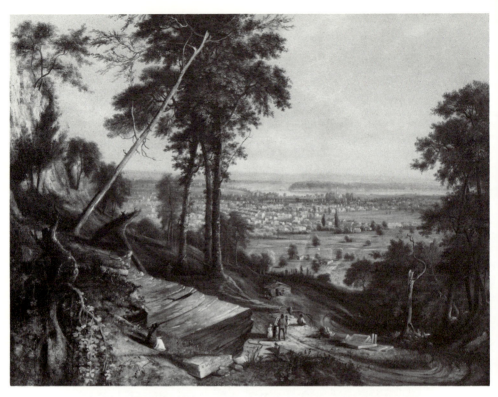

Captain Bulger, Governor of Ossiniboia, and the Chiefs & Warriors of the Chippewa Tribe of Red Lake, in Council in the Colony House, in Fort Douglas, May 22nd 1823.

170

58 *opposite, top* / Robert R. Whale: *View of Hamilton*, oil
35 3/4 x 47 1/2 inches (95.9 x 120.7 cm), 1853
National Gallery of Canada

59 / *opposite, bottom* / Peter Rindisbacher: *Captain Bulger, Governor of Assiniboia*
and the Chiefs and Warriors of the Chippewa Tribe at Red Lake, w.c.
8 1/2 x 11 3/4 inches (21.6 x 29.8 cm), 1823
McCord Museum, McGill University

60 / *above* / Paul Kane: *Ojibway chief 'Mani-tow-wah-bay' or 'He-Devil'*, oil
11 3/4 x 8 7/8 inches (29.8 x 22.5 cm), 1845
Glenbow Foundation, Calgary

171

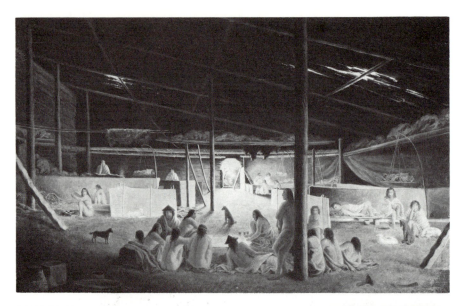

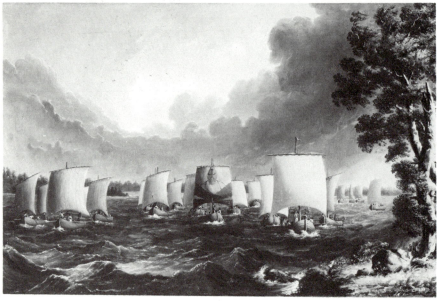

61 / Paul Kane: *Interior of a Winter Lodge of the Clallams* , oil
18 1/2 x 29 1/4 inches (47 x 74.3 cm)
National Gallery of Canada

62 / Paul Kane: *Brigade of Boats*, oil
18 x 29 inches (45.7 x 73.6 cm), undated
Royal Ontario Museum

172

63 / Frederick A. Verner: *The Buffalo Stampede*, oil
35 3/4 x 60 inches (90.8 x 152.4 cm), 1882
E. E. Poole Estate, Edmonton

64 / William Armstrong: *Arrival of the Prince of Wales at Toronto*, w.c.
13 1/4 x 22 3/4 inches (33.7 x 57.8 cm), 1860
National Gallery of Canada

65 / William G.R. Hind: *Bar in Mining Camp*, w.c.
10 x 14 inches (25.4 x 35.6 cm), 1862
McCord Museum, McGill University

66 / William G.R. Hind: *Oxen with Red River Cart*, oil
12 x 18 inches (30.5 x 45.7 cm), *c* 1870
D.T. Hind, Erindale

174

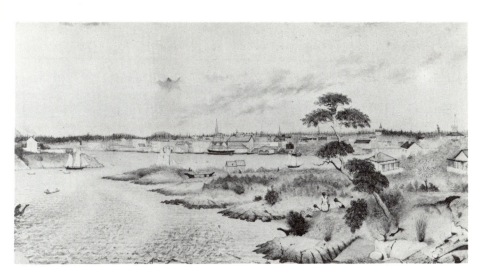

67 / Edward M. Richardson: *Victoria*, w.c.
6 x 13 1/2 inches (15.2 x 34.3 cm), 1864
Provincial Archives, Victoria, B.C.

68 / Sir George Back: *Winter View of Fort Franklin*, w.c.
5 x 8 inches (12.7 x 20.3 cm), 1825-6
Public Archives of Canada, Ottawa

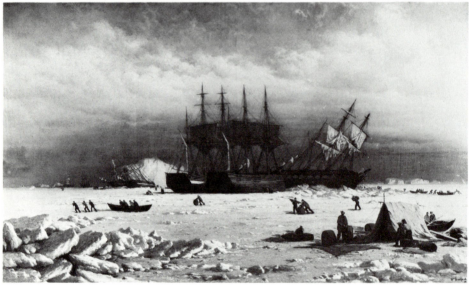

69 / Robert Hood: *A Canoe of the Northern Land Expedition Chasing Reindeer, Little Marten Lake, Northwest Territories*
10 x 15 inches (25.4 x 38.1 cm), 1820
Public Archives of Canada, Ottawa

70 / William Bradford: *The English Arctic Expedition in Search of Franklin*, oil
42 x 72 inches (106.7 x 182.9 cm), 1861-7
Glenbow Foundation, Calgary

176

Part Three
The New Dominion
1867-1910

15

Art in the New Dominion

The politicians were proud, even gleeful, at bringing about Canada's Confederation, but the event created scarcely a ripple of interest among the artists. Many county towns honoured the new Dominion's birth by civic ceremonies, military parades, and reviews, while smaller communities celebrated with sporting afternoons – yachting, racing, and a grand finale of catching the greased pig. But no art shows were arranged for the occasion. Even the word 'Canada' is noticeably absent from the 1867 or 1868 catalogues of the Art Association of Montreal's annual exhibitions. This, Canada's largest art organization of the time, had been founded in 1860 to serve the growing city's needs. In these years Canadian artists exhibited more scenes of England and the Continent than of Ontario and Quebec.

One possible exception to this artistic apathy towards Confederation was the Canadian Society of Artists. While there are stories that it was organized earlier, the act of incorporation was passed by the Quebec legislature only in 1870. The artists specifically named in it were C. J. Way, O. R. Jacobi, A. Vogt, and A. Edson, but the first president was probably John Bell-Smith, newly arrived from London, where he had been secretary-treasurer of the Institute of Fine Arts Gallery. The society seems to have faded away completely after its second exhibition in 1870. On that occasion Adolphe Vogt's paintings of *Niagara Falls* and the breathtaking *Approaching Storm* received most of the glory in the critical reviews. Indeed, the commentators seem to have been justified. Today Vogt's oils (fig. 71) still catch the eye, as does one that depicts a girl with sheep in a landscape bathed in orange by the setting sun. No artist in Canada had to that time attempted canvases so striking in their romantic exploitation of dramatic effects.

There is, understandably, a variegated pattern in Canadian painting during the Post-Confederation years, for the new Dominion's

painters had widely diverging backgrounds. Several of the more prominent exhibitors were either British-born or sons of British emigrants; they lived in Montreal and Toronto apart from a few scattered throughout other Ontario towns. Most French-speaking painters of Quebec City and Montreal were Canadians by birth, and built their careers on portraiture and church decoration; these two activities, as Napoléon Bourassa remarked, would provide artists with an adequate living. The occasional artist had trickled in from the United States, Germany, France, and even Italy. Younger native-born Canadians, and others who had arrived from overseas when children and thus considered themselves truly Canadian, went abroad to study; they returned with widely differing ideas about painting depending on whether they admired the French, English, or American schools. A multiplicity of styles inevitably led to confusion.

No seriously considered philosophical objectives were available to give direction in the development of painting between the date of Confederation and the century's end. Romanticism of an earlier generation was dying, and most artists lacked conviction when they turned to the older romantic themes. Painting 'to please the public' became their first thought, for the public was able to dictate what the artist should do, a situation which would be reversed in the twentieth century. The artists evidently succeeded in pleasing; their pictures sold even if they were not always satisfied with the prices paid for their works. In Victorian parlours a heterogeneous array of pictures plastered upon the walls matched the confusion of stuffed birds, ornate figurines, and other bric-a-brac.

To sweeping statements there are always exceptions, and such a superficial dismissal of all painting during the 1860s to 1880s is not entirely fair. An increasing interest in objective reality had manifested itself for some years. This was not the realism of Courbet, in which he tried to lay bare the true meaning of humanity; rather it was a precise clear reflection of the world. The paintings of these artists show objects with great clarity and detail, but unlike earlier minute works, those of this new generation were painted with almost scientific precision. Their vision owes much to the camera, which in itself was one expression of the new, mechanically oriented era. A few Montreal-based artists painted the most significant of these canvases. John A. Fraser and Henry Sandham who, with several other artists, worked for the Notman photographic studios, travelled to Quebec's Eastern Townships and other rural regions, and Fraser's *Mount Orford and the Owl's Head from Lake Memphramagog* (National Gallery of Canada) of 1870 is widely cited as typical of the new approach. In seeking wilder Canadian

terrain as subject matter, Fraser and his friends were beginning a fashion which would reach its fullest expression in the Group of Seven. Otto Jacobi abandoned his Germanic accents during that same year, 1870, to experiment with realistic truthfulness in painting river, rocks, and trees in a *Canadian Autumn* (Montreal Museum of Fine Arts). Even Allan Edson, two years earlier, had tried the same approach but with subtler atmospheric effects in his *Canadian River Scene.* Basically these men set down highly romantic views, but their objective and detailed 'photographic vision' treatment makes their work something more than simply 'romantic' art. No broadly based national style emerged in those years, but in these landscapes one does find 'Canadian' qualities which are such that one would not readily feel that they were by painters of any other country.

Often the mood of clear objectivity and purposeful direction in English-speaking Canada at that time seems to have overwhelmed deep contemplation and to have made much art of the period appear spiritually sterile. The sense of purpose asserted itself most vocally in the growing Canadian cities. They began to bustle with immigrants seeking an easier existence. A 'get-ahead' feeling was in the air. The 1876 Philadelphia Exhibition, organized for America's 'self-glorification over her century's progress,' caused Canadians to mutter about their own advancement. A pragmatic materialism and commercialism permeated the whole fabric of Canadian life. An educationist, addressing a teachers' group at Brantford in 1877 on 'The Age in Which We Live,' sounded a warning:

The present is utilitarian in the strictest sense of the word: all things seem to be valued for what they will actually bring in the market of life; for the stamp, in fact, which they bear upon their face. This utilitarianism is seen in all departments of human knowledge and social life. It is equally discernible in learning, in the arts, in literature, in politics.[1]

In 1893, J. G. Bourinot put the matter bluntly when he wrote that the 'tendency of the age is to become rich fast.'[2]

Most artists approached painting in this spirit. Art organizations were formed for sales promotion; one observer remarked that at the first Ontario Society of Artists exhibition in 1873 'everything bids fair, we understand, to make the effort a success financially,' but hoped that money was not the painters' only aim. Purchasers attending the 1887 Royal Canadian Academy Exhibition paid out a total of $5,500 for canvases. Artists sought to increase their personal prestige and promote sales by loudly advertising the various art societies in which they

had membership, their celebrated teachers, and the gold medals won at international exhibitions. They tried to capture public imagination by illustrating popular literary themes, and painted for exhibitions in larger and larger formats to focus attention on their canvases. Technically the quality was good, but for every work of lasting merit they painted a host of others mediocre in subject and treatment.

The Ontario Society of Artists was the first great Post-Confederation art organization, founded at a time when there was a new outburst of activity across the province. The tradition is that John A. Fraser, a former member of the Canadian Society of Artists and already a producing artist of distinction, mourned Montreal's ways after moving to Toronto, and missed in particular the excitement of gatherings of artists. He proposed a new Toronto organization as an antidote to his own loneliness. Daniel Fowler, whom he respected, was consulted. James Spooner, Toronto's leading art dealer, commented freely and favourably on the proposal, just as he gave free advice on the merits and deficiencies of many paintings: Spooner combined a tobacco shop and dog kennels with his gallery. George Gilbert, the other Toronto critic, also urged the plan's adoption. The final organizational meeting was attended by Charles S. Millard, T. Mower Martin, James Hoch, Marmaduke Matthews, J. W. Bridgman, and R. F. Gagen; they drafted a constitution and elected Fraser first vice-president. Early presidents were invariably chosen from among art patrons, a custom which had obvious financial advantages. The Hon. G. W. Allan, Kane's sponsor, served in 1889.

The society's first exhibition opened in April 1873, at the new Notman and Fraser Photographic Gallery where the King Edward Hotel now stands. The 'large' room – it measured thirty by fifty feet – had the most approved lighting, and the première was attended by both press and members of an Art Union organized to support the artists through sales promotion schemes. Three hundred paintings hung in several tiers. The president in his lengthy opening speech deplored the fact that Canadian artists were forced to send their best paintings to the United States because local residents would rarely pay more than framing costs. He discussed the unsympathetic settings for paintings which the inadequate old agricultural society shows provided, since good and bad paintings were there hung indiscriminately 'in conjunction with crushes and wonderful worsted work.' He asserted that the annual government donation of $4,000 in prizes was largely wasted as an aid to artists. That night the public spent $3,935 on paintings.

Notman and Fraser of Toronto was a branch of the William Notman photographic firm of Montreal whose artistic and ingenious set-

tings for photographs made their name synonymous with quality, and indirectly encouraged the spread of painting through Canada. The firm's prestige was enhanced when they were appointed 'Photographers to the Queen,' and their pictures became so popular that other branches were established in Ottawa, Saint John, Halifax, and even in some American cities. Some of the studio artists touched up and coloured the photographs. Others painted backgrounds for montages – composite photographs so elaborate that in one of them 1,200 figures had been separately posed and the studio technicians required two years to assemble them into a finished group. Some retouchers – the Fraser brothers, Henry Sandham, and others – were outstanding artists in their own right, and mixed with other local painters to build an artistic climate among men of related interests. A similar painting milieu grew up in other cities as regular employees moved from city to city wherever the firm's needs dictated. Sandham, for example, directed the Saint John office in 1880. Notman's also employed a part-time, shifting group of junior apprentices and older painters; the more experienced of these worked only when sales of their own paintings were few. Notman artists were always ready and willing to help younger men with painting problems. The firm's Toronto studio was virtually the country's leading art school, and it brought a new spirit into Canadian painting which was paralleled, a half-century later, in the commercial studios of Toronto's 'Grip,' several of whose employees became Group of Seven members. Photographic painting was pedestrian and laborious. These artists turned their leisure into more creative work.

The Marquis of Lorne and his young wife, Princess Louise, daughter of Queen Victoria, moved into Rideau Hall during 1878. The new Governor-General, ambitious and with literary tastes, was determined to transform Canada's intellectual life, although his imagination went no further than a feeling that he should recreate little replicas of British cultural organizations in the new Dominion. It was very much a part of the overwhelming spirit of 'Empire' of that age. The Princess liked to paint and was happiest in Canada when sketching. This had its difficulties. She was forced to invent an uncomfortable mosquito helmet which she wore when painting water-colours during the long hours while the men fished for New Brunswick salmon on the Restigouche River. The First Lady actually preferred Bermuda to Canada for 'health reasons,' much to her royal mother's annoyance.

Lorne wanted a grander academy of meritorious painters, sculptors, and architects than the parochial Ontario Society of Artists, and a Royal Society for writers and intellectuals. His predecessor, Lord Duf-

ferin, had patronized the Ontario Society of Artists and even joined the professionals in their club rooms on sketching evenings. L. R. O'Brien, the society's vice-president, requested continuing vice-regal patronage when calling on the new governor in February 1879. Lorne, in accepting, proposed the establishment of a Royal Canadian Academy of Arts similar to England's august academy, and mentioned this pet scheme again when opening the annual Art Association of Montreal exhibition. At a second meeting with O'Brien he proposed that the Canadian Academy should institute a National Gallery which would be initiated by diploma-paintings; the Academy would also hold annual exhibitions alternately in Ottawa, Halifax, Saint John, Montreal, and Toronto, and would establish art schools for the advancement of painting and improvement of design.

The new academy was born in a 'marvellous amount of bitterness and bad language; half the artists are ready just now to choke the other half with their paint brushes.'[3] Suave, diplomatic O'Brien calmed ruffled tempers and was named the society's first president as his reward. Fourteen of the Ontario Society of Artists and four Montrealers were the charter members. The next year, by Queen Victoria's command, 'Royal' was prefixed officially to 'Canadian Academy of Arts.'

The first exhibition was held in Ottawa just thirteen months after Lorne's original proposal. A crush of six hundred guests at the opening included cabinet ministers, senators, members of Parliament, and leading citizens. A military band in the corridors added a touch of pomp. The academicians themselves were overlooked completely, but were probably an unobtrusive group since a decade later some reporter described them as a 'scrubby' lot except for debonair Dickson Patterson, the Academy Beau Brummel. There was a confusion of 594 paintings and sketches chosen by a Committe of Academicians. Lorne, paying more than lip service to his new toy, purchased for Queen Victoria paintings by Homer Watson, A. Godson, John A. Fraser, and Lucius O'Brien, which still hang in Windsor Castle. O'Brien, as president, received the special honour of a sale of three works to the Queen. Not only was this a gesture to his position in the organization, but it repaid him for his diplomatic manoeuvring during the organization of the Academy.

The Marquis of Lorne realized that O'Brien was ideally suited to be the first Academy president. He was a Canadian by birth, when few other local artists were not immigrants. O'Brien's father, an English colonel with a 'respectable' background, was the founder of Shanty Bay north of Lake Simcoe. The son had attended the emi-

nently suitable Upper Canada College, the one local equivalent to an English public school, and there his paintings were displayed on graduation day. When living on Spadina Avenue in Toronto at the age of twenty-four, he had advertised himself as an artist, but prudently returned to more practical land surveying for many years. His watercolours and oils in many exhibitions after 1870 have the firmness and decision of a practised hand. Sketch-books record his wanderings on railway surveys and even a trip with his brother who was a missionary conducting a crusade among the Indians of the Foothills. O'Brien was familiar with contemporary American art. When he painted Indians in a canoe (fig. 72), there is a similarity to the work of George Caleb Bingham. *Sunrise on the Saguenay* (fig. 73), his Academy diploma-work, may be construed as an echo of the grandiose light effects Albert Bierstadt and others developed south of the border, or as a glow of divine approval shining on the British Empire. His great Citadel at Quebec bathed in radiant light (Royal Collection, Windsor Castle) echoed O'Brien's personal loyalty to the Crown. O'Brien received many honours as vice-president of the Ontario Society of Artists and president of the Royal Canadian Academy, such as a joint exhibition with Verner at the Burlington Galleries, London, in 1882, inclusion in the Colonial and Indian Exhibition in 1886, and prizes at the Chicago World's Fair of 1893.

To improve Canadian art generally, each Academician as a condition of membership was pledged to donate free time to student instruction. The Academy co-operated in the operation of art classes for some years in Montreal, Toronto, and Ottawa. Art schools, however, had previously been established in several Canadian cities and gave rise to institutions still in vigorous operation today.

New vitality was given to the Canadian art world immediately after Confederation when the École des Arts et Manufactures was founded in Montreal. Abbé Chabert initiated classes there on 1 January 1871. He had come to Canada from France four years earlier. During the interim he taught in Ottawa and lived briefly at the Quebec Seminary where he left behind as a gift a neat little painting of a rabbit. Chabert could model a clay head almost instantaneously. Although he was beloved by his students, outsiders quarreled heatedly over his methods. Lord Dufferin praised him, and paintings from his school were exhibited at the Colonial and Indian Exhibition, London, in 1886. Much of the early school's work has been carried on more recently by the very lively École du Meuble, which was set up as a separate institution in 1935 after having originated in 1930 as part of the École Technique de Montréal. Quebec's École des Arts et Métiers

opened two years after the school in Montreal; when the province assumed its operation in 1921 it was enlarged and renamed the École des Beaux-Arts. Montreal, not to be outdone in the see-saw battle, persuaded provincial authorities in 1922 to institute a similar school in that city during the next year.

Dr Egerton Ryerson had attempted to start an art school in Toronto during 1849, but could find no competent teachers and the scheme was abandoned. Not until 1876 was one finally instituted under the auspices of the Ontario Society of Artists. Publicity about the new Royal Canadian Academy's aims sparked fresh interest in the Toronto school and it was described at length in an article in the 15 May 1880 issue of the *Canadian Illustrated News*, for which students prepared illustrations. George Reid and James Kerr-Lawson were awarded silver medals for their proficiency that year. Instruction was carried on during mornings and afternoons in a single room. Many students were 'amateurs,' but classes improved their paintings to a point where they were far better, said the article, than those numerous 'summer resort amateurs' who filled sketch-books with nature studies which they then distributed to all their hotel acquaintances. Untrained amateur paintings by these summer sketchers were 'blottesque if they are bold, skinny if cautious, false in any case.' Strangely enough, people loved them. The author hoped that art school graduates would not be 'among the still more abominable flood of aesthetic decorators who flood the country with bad art in the shape of plaques, platters, screens, carved woodwork and sham oyster shells decorated with correct high art subjects – storks as a rule.' He also asserted that Ontario School of Art students at least knew how to draw – accurate draughtsmanship was still an artistic essential. This school moved first to the Toronto Normal School in 1882, was given new quarters and renamed the Ontario School of Art and Design in the 1890s, and is today the Ontario College of Art with its own building adjoining the Art Gallery of Ontario.

In opening the 1881 Royal Canadian Academy Exhibition in Halifax, the Marquis of Lorne referred to the need for a local art school. The cause was taken up by George Harvey, a recently arrived Devonshire landscape painter, and two powerful allies, the Hon. A. G. Jones and his artist daughter, Mrs Bannerman. Another supporter was Mrs Anna Leonowens who had taught the royal Siamese children and corresponded with the king after her return to Halifax. A gigantic exhibition for raising funds was held at the Province House in Halifax in 1887. There were paintings, antiques, historical souvenirs, relics of the Duke of Kent's stay in Nova Scotia, and even Mrs Leonowens' letters

from the King of Siam. Admission receipts initiated the Victoria School of Art and Design with George Harvey as first principal.

The Owens Art Institution of Saint John was incorporated in 1884, just one year after Robert Harris began to give art classes in Montreal. Owens, who had died a few days before the proclamation of Confederation, had left an estate earmarked for the initiation of the Saint John project which included an art gallery and adjoining school under John Hammond's direction. The school opened with twenty pupils in 1885, but a year later had grown to a phenomenal 114. Its eventual transfer to the Mount Allison University campus at Sackville N.B., left Saint John without any fine art centre.

These, Canada's principal art societies and schools in the immediate Post-Confederation years, demonstrate the growth of a substantial corporate life around art and artists. Yet organizations do not necessarily make painters or reflect actual accomplishments. Only the paintings themselves can tell us what this age of materialism really meant for the art world.

16

The British Tradition
at Confederation

Hundreds of immigrant ships cleared British ports for Canada in the 1850s and 1860s. Side by side on their crowded decks were English and Scottish country folk preparing to homestead and Irish farm workers and labourers. There was even a quota of young business and professional men, and also a number of artists. Many of the better Canadian paintings from the earliest Confederation years were by these newly arrived Britishers. They were most proficient as water-colourists, and when they worked in oil, few seemed happy in the heavier medium.

The water-colour tradition which these immigrants brought to Canada was a justly celebrated one. English painting of appealing brightness and clear colouring had reached a peak by the early nine-teenth century in the sketches of Turner, Crome, Bonington, Prout, Varley, and a host of others:

[They had] the daring freshness of a spring morning – the passing shower – the gay partial gleam of April sunshine – and the fresh vivid colouring of the broken foreground – all these features in the ever-varying face of Nature can be represented by the painters in water-colour with ... a day-like brilliance of truth, which we will not say *cannot* be produced in oil painting, but which we have never yet witnessed.[1]

Benjamin West expressed a similar preference when he advised Constable to aim for brightness in his skies, and then proceeded to talk about tonal values which would give a pleasing glow through the whole landscape.

The newly arrived artists had undergone a long and vigorous art training and were expert technicians. Daniel Fowler, John A. Fraser, and F. M. Bell-Smith, the leading English-born painters in Canada,

were superb craftsmen whose work inspired and influenced many younger artists in Ontario.

Daniel Fowler stands in the forefront. He was a gentle little bearded man who wore a skull cap and had 'delicate sharp features and high voice – quite remarkable for one who roughed it as a pioneer for so many years.'[2] Robert Gagen, a friend and contemporary, once said his paintings were so popular that dealers 'quarreled over them like dogs over a bone.' Today they still have an irresistible brilliance of colour.

Fowler spent three years as an apprentice to the well-known J. D. Harding, a London water-colourist and draughtsman. Harding, who had studied with Samuel Prout, painted at times in his teacher's style, but his hues intensified through the years. Fowler left Harding, toured Switzerland, France, Germany, and Italy, and settled in London in 1834 at the very peak of English water-colour painting. A promising career was opening when doctors warned him that he must adopt a new open-air life in Canada because he was threatened with tuberculosis. His journal describes how he fell in love with and purchased a home on Amherst Island near Kingston, although not before being sorely tempted to settle in either the Niagara or the Brantford districts because of their decidedly English character. He became an industrious farmer and did not touch a brush for fifteen years.

A trip to England in 1858 reawakened Fowler's love of painting. He turned to Canadian subjects, but he looked at them with the eye of an English-trained artist. His scenes are remarkably varied, sometimes coming from his pioneer farm – his team and wagon (fig. 74), his wheelbarrow, or woodland glades bathed in the clear Ontario sunshine. These farm subjects differed little from similar English subjects, except for a clearer light. At other times he painted dead fowl and game with remarkable realism. Fowler's diploma-painting of hares has faded, but a water-colour of ducks (Art Gallery of Ontario) radiates warmth with its brilliant reds and greens, inspired at least in part by Harding. Again, he would choose grapes, apples, and red sumach leaves painted with the same rich elegance. *Hollyhocks* (National Gallery of Canada), now much faded, was considered by the artist as his masterpiece; it won a coveted Philadelphia World's Fair medal. Fowler was also capable of subtle greys. Occasionally he painted little genre studies of romping children, or gentle, almost mystical, intimate glimpses of woodland flowers and moss. Always there is a gentleness of subject matter, and a gentle touch, and these are still present later when he became aware of the potentialities of broken colour for achieving magic brilliance. He applied clear yellows, oranges, vermi-

lion, and greens in fresh brush strokes, so that his landscapes resemble those of Gauguin without his ever having heard of that French bohemian. Fowler always drew a precise pencil outline and applied his paint directly as did Constable. He achieved a glowing result, whereas, in contrast, later English artists in Canada scumbled and washed their colours, blurring lines in an attempt at atmospheric mistiness, which resulted in effects quite foreign to the clear Canadian light.

All his fellow artists respected Fowler, and he was ungrudgingly named a foundation member of the Ontario Society of Artists and a charter member of the Royal Canadian Academy. He had even been mentioned for the Academy presidency. Prizes were awarded over many years both at home and in world expositions. He was widely mourned when he died, an octogenarian, from an accidental fall in his Amherst Island pioneer home.

James Griffiths of London admired Fowler and the two exchanged paintings. Their art backgrounds were very different: Griffiths and his brother John had both trained as china decorators in the Staffordshire Minton works, when dishes elaborated with lush fruit and flower arabesques were fashionable. John emigrated to London, Ontario, in 1854 where he painted china and worked as a photographer, and eventually was made principal of a local art school established in 1876 as a branch of the Ontario School of Art in Toronto. All the while he lived in style on the dwindling family fortune. James emigrated a year after his brother but lived more modestly, working as a sheriff's clerk and as a semi-professional 'Sunday' painter on weekends. Many of his fruit and flower water-colours on paper are virtual replicas of china decorations. His oils are less exciting than his water-colours, yet one small oil painting of flowers was so highly regarded that it was awarded an honourable mention at the Chicago World's Fair.

John A. Fraser, although equally proficient in oils, was one man who posed some threat to Fowler's pre-eminent position as a Canadian water-colourist. He and his family had emigrated about 1860 to Stanstead in Quebec's Eastern Townships after his father's strong Chartist views had led to the failure of his London business. John Fraser had studied for two years in London at the Royal Academy Schools under F. W. Topham, a member of the New Society of Painters in Water-Colour, and under Richard Redgrave, an ornamental art and design man. He began work at Notman's Montreal studio almost immediately after his arrival in Canada, and his brother William soon joined the firm. Later John moved to Ottawa and finally to Toronto, where he was a business partner of Notman until he went to the United States in 1883.

Fraser was a master of tone, and preferred broad and simple compositions. At one time he might choose a field of daisies drenched by the sun, overlooking the sea, for a water-colour; at another he might paint a panoramic landscape at Fort William (fig. 75). In the latter picture a stair leads up to the Indian mission station, with the rocky headland and glowing yellow sky breaking through summer storm clouds. His Rocky Mountain landscapes are grandiose, their hues undimmed. He combined genre with atmospheric effects in *Shot at Dawn* (National Gallery of Canada), in which hunters shoot ducks near Lake Scugog. This canvas was commended in an early Ontario Society of Artists exhibition, but was then lost for many years.

As leading Notman artist, Fraser exerted considerable influence over younger men in the firm, among them Horatio Walker, George Reid, and Ernest Thompson-Seton. The oil landscapes of Henry Sandham, his Montreal-born brother-in-law, echo Fraser's approach (fig. 76). Curiously enough, Sandham sometimes turned to good account his commercial work at Notman's. The firm successfuly photographed snowshoe clubs, separately posing each member and then tastefully arranging the prints into a group. Sandham painted many backgrounds as appropriate settings for the sportsmen, and then went one step further to apply them to his serious art. He turned a group of snowshoers into a genre study in his well-known *Hunters Returning with their Spoils* (National Gallery of Canada).

The third great English-born water-colourist in Canada was F. M. Bell-Smith. He and his artist-father arrived immediately before the Confederation proclamation was read. He loved people, and even in his paintings of pure landscape the human element never seems far away. Bell-Smith had a great interest in subtle atmospheric effects. He used cool broad washes of blues, blue-greens, and greens to great advantage; for example, in one painting a greenish haze hangs over the cricket field as the Gooderham family plays in the 1870s. But his colouring changed during the years, and in later life, although he still presented atmospheric hazes of the gentle blues and greys of summer, he emulated such artists as Boudin by using pink and mauve accents which add magic to sunny but quietly toned beaches.

Strangely, Bell-Smith's love of delicate refined colour was almost totally restricted to his water-colours. His painting of little girls leaving school in London, Ontario, is virtually a black and white monochrome. His famous oil of crowds of Torontonians on King Street near Yonge (fig. 77), might readily be mistaken for a Piccadilly Corner in London, heart of Empire, and has overtones of sombre tonality so often found in the 'brown '90s.'

Bell-Smith's sketches of day-to-day news events were published in the *Canadian Illustrated News* of the 1870s. Current affairs had always fascinated him and when Sir John Thompson, Canadian Prime Minister, died of a heart attack while attending a state dinner in Windsor Castle, Bell-Smith was chosen by the federal government to paint a memorial canvas. Several oil studies of the queen from life were painted at Windsor for this purpose, with Brown and the Indian servants pictured in the background. His interest in his queen drew him also to the Diamond Jubilee ceremonies; water-colours of Victoria as she showed herself to her people on the state ride along the Mall, into Trafalgar Square, and down Whitehall, are like a finale to this phase of Bell-Smith's career.

The great sailing fleets fascinated E. J. Russell when he arrived in Saint John from the Isle of Wight. His father had been both an art critic in Soho and Sir Thomas Lawrence's close friend. Soon Russell's 'anatomical' studies of the local sailing ships were blanketing New Brunswick. Saint John ship owners still own many and others are in the New Brunswick Museum. Russell's occasional exotic atmospheric notes turn some of them into compositions with feeling. He painted until the 1890s when steam was replacing sail in Saint John harbour.

There were many other immigrant painters. Harlow White homesteaded on a Muskoka farm and did small local water-colours until he returned to England where he painted Windsor Castle and other English views. C. M. Manly studied in London and in Dublin before settling in Toronto and painting rural scenes. George Ackermann taught art at the Brockville Deaf and Dumb Institute (he was probably deaf and dumb himself) and painted most attractive naïve topographical water-colours. One is of a local militia rally near Brockville in 1869, with relatives and lady friends picnicing along the roadside in a holiday mood; others show Picton's main street with bustling farmer folk, or the activity about the harbour of that pioneer Ontario town.

Such commendable British-school water-colours by Canadians failed to inspire any great outpouring of work which might be called a local development. True, exhibitions were studded for years with amateur daubs, but since fashion demanded more exciting pictures, gifted and ambitious professional artists turned to either narrative genre or grandiose landscapes in oil. Probably many artists felt that oil was a more appropriate medium for capturing the rugged Canadian scenery. Thus water-colour, often gentle, occasionally more strident, but always tasteful, fell into a decline as an art form, although in recent years this phase of nineteenth-century Canadian art has been looked at with new interest and appreciation.

17

A New Search for Canada

Confederation had inaugurated a broader concept of British North America; it would no longer be a group of small colonial communities, but a great new expanding nation. A sense of this growth, of the potentialities in nationhood, of how wild and picturesque mountains and sea coasts could exhilarate visitors and of the unique indigenous costumes of various regions, finally came to the artists and gripped their artistic imagination. These artists were a restless crew, always on the move, searching out new sketching grounds wherever expediency or fancy took them. First they examined the wonders of the four founding provinces. Soon they would see a vast dominion being welded together as the lines of steel from east and west linked the Maritimes to the Prairies and to the Pacific.

Some of the wandering artists, like the brilliant Allan Edson of Montreal, or Lucius O'Brien, F. A. Verner, T. Mower Martin, and Marmaduke Matthews, all of Toronto, were freelance professionals. C. J. Way was a professional artist who seemingly had no roots, for he kept popping up in various parts of Canada, in England, or in Switzerland. William Cresswell of Seaforth, Ontario, and other isolated painters, were also among the travellers. Many Notman photographer-artists joined the roving band.

The expanding geographical range of the sketching grounds can be plotted from year to year by checking the titles of exhibited paintings. The outlook was still restricted in 1867, for paintings at the Montreal exhibition of the Society of Canadian Artists were principally landscapes of Mount Royal, Montreal suburbs, and Toronto's Don Valley. But Otto Jacobi and C. J. Way had gone down the St Lawrence as far as the Saguenay, and Way even had gone to the Adirondacks. Some very active Montrealers looked to the Eastern Townships. Whale travelled there and to Quebec during the autumn of 1867. Cresswell vis-

ited Lake Megantic, and Edson, Ottawa. The principal sketching grounds during the next few years were the St Lawrence and Ottawa River valleys, the Eastern Townships of Quebec, and naturally Niagara Falls.

Torontonians were first introduced to paintings of the Atlantic seaboard when John Hammond exhibited a view of Portland, Maine, in 1874 and Verner showed one of Labrador the next year. Robert Gagen in 1876 painted an Atlantic seascape of waves breaking over wild romantic rocks. It was a subject he often repeated later. By 1878 a sizable group of Nova Scotian and New Brunswick views were on record. The Art Association of Montreal honoured Canadian artists in 1880 by organizing an exhibition which included a dozen maritime scenes, chiefly by Lucius O'Brien, John A. Fraser, and Henry Sandham. When the Royal Canadian Academy met in Halifax the next year, many academicians from Montreal and Toronto not only established a personal *rapport* with eastern artists, but had a chance to see this attractive sketching country at first hand.

O'Brien generated much interest in 1882 with the illustrations in an ambitious double volume of *Picturesque Canada*. A veritable army of specially commissioned artists painted views in all parts of the country, and these were then made into woodcuts. Some were subsequently painted into canvases. Fraser was intrigued by the natural phenomenon of Percé Rock (fig. 78), and Sandham by a style of life which he found such a contrast to that in Ontario and Quebec. O'Brien himself did many canvases; his trip to northern Ontario was a pleasant interlude during which he alternated between sketching and fishing. John A. Fraser, Henry Sandham, William Raphael, Robert Harris, and other Canadians assisted in the volumes. O'Brien felt that not enough Canadian artists were available to complete the huge undertaking, and so hired some Americans to assist. They were chiefly professional newspaper illustrators who had worked on the similar volume *Picturesque America*, and even earlier had been reporter-artists on the Civil War front. Canadians grumbled about the high-handed way in which O'Brien produced illustrations for his volumes, and in fact some artists whom he had ignored made an attempt to produce a rival volume. Yet the ambitious *Picturesque Canada* made available to public and artists alike the first great series of locally produced Canadian scenes, and it came at a time when nationalism was being aroused on all sides.

Generally speaking, these artists were working in a broader geographical sphere than had landscape painters of previous decades before artistic interest shifted from a local to an enlarged national scene.

At the same time many painted in a realistic manner, even if they combined with this realism romantic elements – a breaking storm, a remarkable sunset, rugged cliffs, wild waves. Thus, while their subjects were often dramatic, most artists painted them with pictorial truthfulness rather than with forced effects, as had Légaré.

Local painters shared with American painters two new developments which were changing the appearance of their landscapes. During the quarter-century following Confederation, an appreciation of the way light could achieve sparkle and luminosity was combined with an exploitation of recently discovered brilliant coal-tar colours. Allan Edson from Stanbridge, Quebec, who had studied in the British Isles and in Paris, made full use of both. Fraser, of the younger generation, in addition to O'Brien and Vogt was interested in light effects, although all three were more conservative in the use of the newer colours. To appreciate the introduction of luminosity and new interest in light, place Edson's paintings beside a Légaré oil or even a Henry Martin water-colour: the difference is startling. The example of the old school is, in spite of its other merits, dull, wooden, and solid in its gloom, lacking all sense of the light which imparts inner life; the new painting has gaiety emanating from the very heart of the picture. Edson painted glowing shadows beneath leafy foliage and sunshine filtering through onto youthful fishermen (fig. 79). A brilliant mountain sunset, vividly and garishly red in fiery new pigment, dominates a canvas now in the Edmonton Art Gallery. In *Giant Falls* (Montreal Museum of Fine Arts), patches of white foaming torrent and mysterious blues and strange warm colours in the foliage are painted with all the detail loved by the generation but subordinated to the general pattern.

These innovations in light effects were recognized and appreciated even in their own day. An enthusiastic review of the 1881 Royal Canadian Academy stated that Fraser's sketch of Percé was pleasing because of its purity of colour. The reviewer then went on to describe O'Brien's Quebec view (see p. 185): '[This is] undoubtedly one of the finest pictures in the exhibition, full of light, rich in colour, admirable in tone, with great breadth of effect, yet marked attention to detail, a picture to linger over and admire more and more each day.'

Foreign influences, particularly German landscape painting of a few years earlier, were also modifying style. Three well-known German painters had settled in Montreal – Otto Jacobi, William Raphael, and Adolphe Vogt. Jacobi went from Europe to New York to paint portraits, and after a short stay came to Quebec in 1860 for the specific purpose of painting a presentation canvas of Shawinigan Falls for the Prince of Wales; he remained in Canada, painting the waterfalls,

autumn foliage, and blue hazes (fig. 80) over and over again in both oil and water-colour. Occasionally he moved from romantic shrubbery, trees, and water to more specific subject matter, as in his *Parliament Buildings, Ottawa* of 1866. Raphael, a Berlin Academy student, introduced genre to add interest to his landscapes. He painted Canadian sleighing scenes in a freer manner than Krieghoff, striking studies of *habitants* during winter and summer outside Montreal's Bonsecours Market (fig. 81) and of wild winter storms and wolves which seem as if they could be taken out of contemporary European prints. Vogt's dramatic skies embellished his paintings of horses (see p.179) and sheep where the animals themselves are treated much as they would be by France's greatest animal painter, Rosa Bonheur.

Few Canadians, unlike Americans, studied in Germany. Franklin Brownell had been there, but he was an American for whom Canada was an adopted country. Canadians, however, eagerly examined numerous American canvases, and many painters south of the border felt that the Berlin approach symbolized all that was most effective in contemporary painting. The German influence was thus very real in Canada, although second-hand. Quite obviously O'Brien was familiar with paintings of the celebrated German-American, Albert Bierstadt, who had studied at Düsseldorf; O'Brien's diploma-painting, *Sunrise on the Saguenay* combines dramatic light effects with romantic grandiose cliffs in a way characteristic of Bierstadt's Rocky Mountain paintings. Bierstadt's landscapes were the American sensation of their day. Each of his new elaborate works he announced by a banner stretched across the New York streets. Verner's *The Buffalo Stampede* (fig. 63), with its over-elaborate romanticism, owes much to the Germans.

Canadian painters were familiarizing themselves, too, with the last hey-day of Hudson River School landscapes south of the border. George Inness and John Frederick Kensett were still at the height of popularity. Thomas Moran's works were sought after, as well as Winslow Homer's paintings of the Atlantic seaboard. Canadians travelled to see these developments in the United States for themselves. Homer Watson visited George Inness; George Reid, William Edwin Atkinson, W. W. Alexander, and Owen Staples all studied with Thomas Eakins. Some American paintings even hung in Canadian exhibitions. A. F. Bellows' canvases, to cite one instance, were in the Art Association of Montreal exhibitions of the 1870s. American art magazines circulated freely in the Dominion. Two Canadians, the eccentric misogynist Henri Perré, and Marmaduke Matthews, penetrated regularly well within the United States on painting trips. Perré in particular learned much from late Hudson River School painting. He spent several sum-

mers in Pennsylvania and came back with river landscapes filled with the gentle nostalgia of the woodcuts in the *Aldine Magazine* published in New York. Some of these appealing oils, hidden away in private Canadian collections, have a glowing pearly-grey luminosity of sky which is reflected in the water. On another occasion, Perré sketched along the Intercolonial Railway between Montreal and the Maritimes. Allan Edson and his friends crossed into Vermont and New Hampshire during summer jaunts to Quebec's southern border. Marmaduke Matthews painted along the Lehigh Railway in 1876, while Fraser and Sandham maintained a lively interest in the Boston scene.

The landscape of France made little impression on the wandering crew of landscape painters, although French styles would soon make themselves felt in Canada in genre. English landscapes still continued to play some part in Canadian painting. The latest English works were often on view; in Montreal during 1870 there was a large exhibition by J. E. Herring, W. Shayer, Birket Foster, C. Stansfield, and a half-dozen other Royal Academy members. English-speaking Canadians continued to spend time in England during their years abroad. Marmaduke Matthews, despite his American interests, remained English to the very core as a painter, and never forgot his great English water-colour teacher, T. M. Richardson of Oxford.

Canadian artists were open to the continual stimulation of trying out the new ideas they were observing. Everywhere these landscape painters, with a broad awareness of what was happening in the United States, England, and Germany, themselves seemed on the verge of making promising discoveries. Just as often, however, they fell short of carrying their experimentation to genuine and striking conclusions. It was an age of exciting possibilities, but the results often seem disappointing.

These men were faced with the greatest challenge to their painting skill in 1885. By that time they had been prepared for new fields to conquer through all their preliminary skirmishes with landscapes in the Maritimes, picturesque Quebec, northern Ontario, and other areas; they had discovered the techniques of dynamic, light-impregnated realism, and had a familiarity with developments in foreign landscape. This ultimate test came when they were given the opportunity to paint the Rockies after the completion of the Canadian Pacific Railway.

The artistic generation which followed Kane had been tempted westward while the railway was still under construction. T. Mower Martin, after painting the Toronto railway station, had gone to Lake Superior in 1881. A. F. Loemans of Hamilton had travelled to Manitoba in the next year. James Smith was painting Lake Superior in

1883, and William Cresswell had gone to Colorado by the American railways. During 1883 and 1884, John C. Forbes and the geologist A. P. Coleman penetrated the Rocky Mountains and exhibited their paintings at the Royal Canadian Academy. But it was not until 1886, the year after completion of rail, that the western mountains really burst upon the public awareness through paintings.

Sir William Van Horne of Montreal, the greatest of all Canada's art collectors, inaugurated an unusual promotional scheme when he decided that the Canadian Pacific should scatter paintings of the Rockies throughout eastern Canada. He was interested in art, and saw an opportunity both to help the artists and to promote his railway. Some years earlier the president of the Lackawanna and Delaware Railway had commissioned George Inness to paint scenery along its new line as an advertisement for its scenic attractions. Sir William, in a similar scheme, apparently offered the artists free transportation and possibly their expenses to paint scenery along that section of the railway which pierced the mountains.

Views of the mountains thus began to appear frequently in Academy and other exhibitions. During 1886, Bell-Smith, William Cruikshank, Coleman, Robert Harris, and Forbes all painted the west. Two years later, Mower Martin, Marmaduke Matthews, O'Brien, and Forshaw Day had joined the group. Martin became virtually sidetracked from the mountains, with their natural wonders (fig. 82), by the picturesque Indian villages similar to those which had attracted Kane, and he played luminous sunset skies against totem poles and native houses. Matthews and Bell-Smith each spent ten consecutive summers sketching along the railway. Bell-Smith's view of Mount Hurd was reproduced unwittingly on a Canadian ten-cent postage stamp in 1928. Edson ventured west one summer. Percy Woodcock and John Hammond made the journey towards the end of the era.

John Hammond was persuaded by Van Horne to promote the newly inaugurated connections by which the Canadian Pacific steamers from Vancouver met the P&O liners from the Orient. By this connection English and European tourists could travel around the world, with the Canadian firm providing a major link. Hammond made a sketching tour through the Japanese countryside; his paintings were designed to lure tourists to the newly opened East.

While currents and cross-currents of style were swaying these eastern painters who were ranging over all British North America, a few resident artists in the vast west were pioneering in quiet isolation. They received but little attention, their paintings were not exhibited in the

east, and publicity was stolen from these virtually forgotten local men by the more vigorous easterners. Yet they deserve a word, for they attempted to create an indigenous western art in a milieu which was then very barren.

Lionel M. Stephenson, of an English county family, brought his wife and three children to Winnipeg in 1885. He arrived at the Red River settlement when the district was alive with soldiers sent to suppress the second Riel uprising. Stephenson painted hundreds of views of Upper and Lower Fort Garry with an eye to the souvenir trade; these travelled eastward in soldiers' kit bags. Most were without merit, for the artist merely made copies of earlier sketches, even adding the earlier dates, but Stephenson set himself to more serious work when this profitable business ended.

Frank Lynn, whose technical accomplishments were greater than those of Stephenson, was advertising as a Winnipeg artist by 1875. Many of his oils seem to recall earlier days of Red River carts, Indian tepees, and the fort as it was in previous years. He operated a grocery store in 1885, but his obituary described him as a pioneer Winnipeg newspaper man who was also known for his paintings.

Periodically other artists came to Winnipeg but soon moved on because of lack of patronage. Mildred Peel painted portraits in the city in 1883. She later went to Paris with her famous brother, Paul, and finally married Ontario's former premier, Sir George Ross.

Father Émile Petitot, a missionary on the Mackenzie River from 1862 to 1882, had a remarkable life story. This French Oblate was the first priest assigned to the natives living north of the Arctic Circle, and in this little known region he painted and studied geography, ethnology, and linguistics. He decorated his tiny mission chapels along the Mackenzie with his own naïve murals, and then while visiting St Albert Monastery near Edmonton painted a view of Fort Edmonton, the old trading post which stood on the site of the present Alberta Legislative Buildings. He made his own brushes from animal fur. His paints, after he had exhausted his supply imported from France, were natural ochres with fish oil as a medium. Yet Petitot's simple paintings are far from pedestrian, as may be seen in the admirable sense of rhythm in the eroding bank below Fort Edmonton. At other times he copied brilliant chromolithographs of a religious character with attractive floral borders; two are still in St Albert. Numerous engravings were prepared from his countless sketches of Eskimos and Indians as illustrations for his reminiscences published after his return to France.

Vancouver was merely the terminus of the Canadian Pacific when H. Tomtu Roberts arrived about 1886. This Welshman must have

had incredible optimism to dare advertise as an artist; one wonders where he could expect to find patrons. Small oil landscapes in the Vancouver City Museum picture tall Douglas firs still growing on Granville Street. He loved landscapes with atmospheric effects: on grey days, for example, he could obtain greater illusion of depth by sharp foreground against vague distances. Roberts was capable of greater development, but this frontier was too remote a place to provide him with artistic stimulus.

In contrast to Vancouver, painters had worked in Victoria from the 1850s. Wives of early English officials spent much time as amateur artists and through their efforts the Island Arts and Crafts Society was long regarded as a centre for painters. But when young Thomas Bamford, graduate of the Liverpool School of Art, settled there in 1882, no local artist was thought worthy of inclusion in Canadian exhibitions of consequence. His very English water-colours of local homes and scenery were painted with meticulous precision. Later he exhibited with the Ontario Society of Artists.

By the 1890s the vitality of the eastern landscape painters who had set out to paint in various parts of Canada was waning. Some had died, others had left Canada, and all were aging. Theirs had been a unique artistic opportunity because they had for the first time experienced the impact of all Canada. W. A. Sherwood, writing on 'A National Spirit in Art' in 1894, pointed out that in their search for material they had penetrated the sub-arctic northern forests, the farthest western mountains, and over and beyond the Rockies into British Columbia. Their paintings had appeared side by side with pastoral pictures from Ontario and Quebec, and marine subjects of New Brunswick and Nova Scotia. A birchbark canoe and an evening scene on the Mimico marshes might adorn the walls of a prairie home, 'whilst weird and lonely mountain pictures, with distant Kamloops, or the blue Lake Louise, or Mount Sir Donald, hung beside a view of St. John's Harbour, showing the vessels bathed in the evening's faded light, may find a cherished resting place in the parlors of Toronto or Montreal art patrons. Thus in a most material way is the landscape painter furthering patriotic sentiments.'[1]

No doubt the motivation of the artists was less conscious, but it was of the same order as that of the Group of Seven during the twentieth century. Yet, as Harriet Ford wrote in 1894, though the painting of 'Canadian subjects' is a worthy ambition it does not necessarily make a Canadian school.[2] This is a deeper, more profound thing of the spirit, and such an objective would come only with an artistic ripening which requires time. That time had not yet come in Canada.

18

The Dignity of Labour

Wyatt Eaton, son of the mayor of Phillipsburg, Quebec, was overwhelmed when he saw Millet's *Woman with a Lamp*. For him this was the only worth-while painting at a large Paris exhibition he visited when studying at the École des Beaux-Arts under Gérôme. That summer of 1873 he visited Barbizon in the French countryside where Millet, Diaz, and their friends had entered into art history by painting peasants in rural open-air settings; their canvases had created a minor sensation in the art world. The elderly Millet still lived on the edge of the village. In the autumn, Eaton returned to spend many pleasant hours with the painter of *The Angelus* and *The Gleaners*, the man who praised the hands of work as more beautiful than the delicate hands of the idler, the simplicity and austerity of Poussin as preferable to Titian's over-elaboration, and who sensed the drama of the toiler in repose. To Millet, the most noble and dignified man was the honest labourer, and he was typified by a farm worker. Eaton met Millet in Paris a second time shortly before his death, and when the Canadian returned home, he was still profoundly impressed by the Barbizon school.

Eaton continued to show an interest in the Millet tradition, both by painting Canadian women harvesters (fig. 84) and by introducing Barbizon theories to Montreal. But he could catch a remarkable likeness in paint as well, and a lucrative New York success in portraiture drew him away from both Canada and the Barbizon tradition. His early death cut short a career which held out genuine promise of phenomenal achievements.

The Barbizon tradition found its greatest Canadian expression in paintings by Horatio Walker and Homer Watson. They lived curiously parallel lives.

Homer Watson came to Toronto as an art student in 1874, the very

year in which Eaton had last met Millet. He was to be an artist who would paint with a love of Canada which permeated his whole being. Yet in spirit these paintings would be closely allied to the Barbizon tradition, although Watson knew absolutely nothing of what its French exponents were doing until well on in life. Rather the lad had heard the older folk in his native Doon, a hamlet in the Grand River valley of Ontario, talk about the struggling pioneers whom they had known – the men, to them heroes, who tamed the virgin wilderness and built neat prosperous homesteads. This was Watson's world, a settled valley where aboriginal trees still dotted the landscape, and where even a few pioneer log houses still stood. His thoughts never strayed far from this setting and its people.

Indulgent relatives purchased a first paint box for the orphaned boy who worked to support a widowed mother, and his guardian, with the thrifty pioneer's respect for learning, advanced a small allowance from his meagre patrimony for Watson to study in Toronto. Watson wrote later of his necessarily restricted outlook as a youth:

I did not know enough to have Paris or Rome in mind; I felt Toronto which [I] had visited once two years before, had all I needed and my first look at a collection of pictures was when I visited the normal school to see the collection of old masters there.[1]

Unfortunately these 'masterpieces' were but poor copies.

Horatio Walker of Listowel came to Toronto the same year as Watson. His father was a lumberman who periodically delivered logs to Wolfe's Cove, and on his twelfth birthday the boy was taken there as a treat. At Quebec he saw colourful *habitants*, Indians in canoes which even at that late date were piled high with the annual catch of furs, and many famous historical sites which he had discovered first in his reading. Pages from Parkman suddenly came alive. Walker later would paint Quebec *habitants* with complete dedication but would retain a sense of the picturesque so that, while superficially he seemed to work in the Millet manner, he would lay relatively little stress on the deeper sociological message of the dignity of labour.

Walker's artistic career began when he painted an Orange Lodge banner; he had already been singled out locally as a coming artist. He and Watson both entered Toronto's artistic life when they began work at Notman's studios; there they met the intelligent and sympathetic John A. Fraser and Henry Sandham. Walker drew miniatures under Fraser's tutelage, and was instructed in painting by Robert F. Gagen, another employee, who came from Seaforth which was not far from

Listowel. He received advice from gracious Lucius O'Brien, and the eccentric old Henri Perré who was then living in rooms over the new Ontario Society of Artists gallery. Perré was still indulging a 'gastronomic love' for shrimps developed when he had lived in the southern United States. Watson and Walker left Toronto in 1876 after two years spent in its limited art circle. Their paths were to cross periodically, and they held each other in mutual regard. Watson visited Walker's home on the Île d'Orléans where he and Clarence Gagnon were the only two artists allowed to paint freely on Walker's 'exclusive' sketching reserve.

Horatio Walker sought greener fields in New York during 1878. There he studied, read, and painted unrelentingly. He was very much aware of Millet's 'cry of the earth' and a spiritual kinship with the countryside developed during a six-month walking tour down the St Lawrence from L'Épiphanie near Montreal to Quebec City. On this remarkable pilgrimage of 1880 he visited country folk in their homes, smoked their *tabac canadien*, slept in barns at night, observed the rural ways, and always was sketching, sketching. Walker was a superb draughtsman. His studies of cattle and pigs, of *habitants* and their wives, of homes, barns, and daily life, are masterpieces of intimate sketching. He was particularly fascinated with swine and innumerable early canvases, such as *Swine Herd and Pigs*, show this interest. *The Prodigal Son* is a much more ambitious work.

Success came during the 1880s. Soon Walker was a member of the National Academy of Design, the Society of American Artists, and the Royal Institute of Painters in Water-Colour. He travelled extensively in Europe. Gold medals and other honours showered down from art juries of various world's fairs. Major American galleries purchased his works. Prices soared until he was one of the generation's highest paid artists; as late as 1922 a George Inness canvas was auctioned for $400 while one of a similar size by Walker sold for $3500.

Walker established his reputation with his early *Python and Boar, Ave Maria* (fig. 85), and *Hauling Logs – Winter*. His major inspiration was the rural Quebecker as typified in *Ploughing – The First Gleam*, a well-known canvas in the Quebec Museum, or in *Oxen Ploughing*. First he built a summer home on the Île d'Orléans and wintered in New York. Later he built a year-round home at the island's westerly end, and was known unofficially as the *grand seigneur* of Sainte-Pétronille. From here the noble rise of Quebec dominated the distant sky line. Walker became a complete francophile, continually emphasizing a French branch in his ancestry, not caring to speak English, and considering most Ontario people, particularly the politicians, as barbarians. He

lived surrounded by rare Japanese water lilies and his beloved peonies. He honoured simple country virtues by entertaining elderly, roughly clad *habitant* grandmothers at dinner in the Château Frontenac, defering to them as to royalty. The old man, a conservative, painted 'the thing as I see it,' and preferred an old-fashioned surrey to the new-fangled motor car. Younger folk were then a continuous irritation because they didn't stand in awe of his genius, and he was even more bellicose in his outbursts if 'any young sprig of an artist in a motor car dared to drive over his precious preserve painting his sacrosant Island.'

Many touches in Walker's paintings are reminiscent of Corot's trees, and of subjects by Troyon, Mauve, and Millet. Millet's peasants were always bent and sad from the drudgery of farm work, but in Walker's paintings there are many lively hues and bright faces of happy country folk. A woman in red blouse and blue skirt beams at her turkeys or contentedly puts bread in the outdoor oven. A team halts momentarily as the farmer stands in humble devotion at a country shrine, the woodcutters are busily at work, and the farmer tills his soil from morn till dusk. One critic, reviewing the Canadian Art Club exhibition of 1908 hung in the old Toronto assize court behind No. 1 Police Station, wrote that the 'magical maestro of a past age' painted 'Homeric oxen and massive field horses whose anatomy not even Rosa Bonheur could have surpassed.' His tones lightened with old age, but the spirit and subject matter of his art remained constant. The artists's whole life may be summed up in a kind of self-valedictory which records his devotion to the country life:

The pastoral life of the people of our countryside, the noble work of the Habitant, the magnificent panoramas which surround him, the different aspects of our seasons, the calm of our mornings and the serenity of our evenings, the movement of ebb and flow of our tides which I have observed on the shores of my island which truly is the sacred temple of the muses and a gift of the gods to men: such are the preferred subjects of my paintings. I have passed the greatest part of my life in trying to paint the poetry, the easy joys, the hard daily work of rural life, the sylvan beauty in which is spent the peaceable life of the habitant, the gesture of the wood cutter and the ploughman, the bright colours of sunrise and sunset, the song of the cock, the daily tasks of the farmyard, all the activity which goes on from morning to evening, in the neighbourhood of the barn.[2]

In this same spirit, and possibly closer in both technique and subject matter to the Barbizon school, were some early paintings by Suzor-Coté; being of French extraction, he may have been more

closely allied by natural disposition to Millet's philosophy than was Walker. In Suzor-Coté paintings, such as a small, privately owned oil of a peasant hoeing, the only essential difference from Millet is in the less experienced handling of pigment by the young Canadian, and in the more impressionistic approach which forecast his future interests. In his later years, instead of genre studies of the villagers, we have from Suzor-Coté character portraits such as M. and Mme Cyr (Montreal Museum of Fine Arts), painted in the broken colour of another age.

Homer Watson painted the rural environment of an industrious and thrifty farm people rather than the Ontario farmer himself. His early interpretation of landscape evidently originated in little pastoral woodcuts published by American art magazines such as the *Aldine* which reflected late Hudson River School paintings. These woodcuts, which illustrate the well-being and prosperity of American life, unwittingly tended to exaggerate sky effects because of the wood-engraving process. Watson was himself always interested in sky effects, as seen in hundreds of his little pen and ink studies of the Grand River valley.

A further advance from his inheritance allowed Watson a visit to the Art Students League and many New York galleries in 1876. There was a significant trip to the studio of George Inness; the older man encouraged the young Canadian and he in turn must have been impressed by the overpowering skies and vistas of nature in all moods in Inness' paintings. They deepened his absorption with transient out-of-doors effects. While sketching along the Susquehanna and Hudson rivers and in the Adirondacks on his homeward trip, he echoed some of Inness' atmospheric effects; his tonal colouring and subject matter are very close to the landscapes of A. H. Wyant, particularly the latter's *The Valley of the Mohawks*, now in the Metropolitan Museum of Art, New York.

Watson's studio was from the first in Doon, and there he made his permanent home. Other early paintings done there were based on his American tour, but some were frankly and unashamedly wildly romantic, even to picturesque mills, rushing streams and menacing cliffs replete with Victorian sentiment. His elaborate *The Pioneer Mill* was bought during the first Royal Canadian Academy *vernissage* by the Marquis of Lorne for the Windsor Castle collection, and Queen Victoria was so pleased that she ordered further canvases. Sceptics at Doon were silenced by the local boy's success. *After the Rain* (fig. 83) was a superb early painting embodying a factual and realistic approach in vogue during Watson's younger years. It pictures the Doon countryside to which he always returned. James Spooner, the somewhat ec-

centric art critic and dealer, his champion, auctioned his canvases in his gallery and wrote long letters of advice, both wise and unwise. He pleaded with the young artist not to alter his subject matter, to think for himself and pay less attention to others, and then went on to recommend that Homer remove a sun from a landscape.

Oscar Wilde visited Toronto in the early 1880s; there he was most impressed by Watson's work and proclaimed his discovery of a new 'Canadian Constable.' The 'Constable' label was to follow the artist like a haunting refrain. Wilde obviously had intended the remark as a compliment: he was genuinely impressed by Watson, evidently visited Doon, and commissioned a painting for himself about which he later spoke in highest praise. He introduced Watson to Whistler at the London Chelsea Club and declared over dinner that 'This is my find in America. Mr. Watson is the Canadian Constable and Barbizon without ever having seen Barbizon.' By way of rebuttal later, Watson protested that he had never seen a Constable painting until 1887 but admitted that he once imitated Constable in *The Flood Gate* (fig. 88). And indeed, while he may have been unconsciously influenced by Wilde's statement, for this critic's judgment carried much weight, many of Watson's paintings are closer to Inness, Daubigny, Diaz, and some of the Barbizons.

By the mid-1880s, Watson was aware of his inadequate training and unhappy about the 1886 canvases in which his streams have Ruisdael mannerisms. However, his paintings were so well received by London critics at the Colonial and Indian Exhibition that he and his wife left for the first of several trips to England. His new friends there were Sir George Clausen and E. J. Gregory, and he spent much time with his old Canadian companion, J. Kerr-Lawson. The latter painted his portrait, which he humourously remarked made him 'look as if ye were drunk.' Etching was popular; Watson studied with Whistler, and bought his etching table which still remains in the family home. After his return to Canada in 1890, his paintings show a change; the detail of the earlier paintings has been replaced by greater solidarity and simplicity and by a more unified movement of form and composition, as in *The Lone Cattle Shed* and *The Gravel Pit*.

Watson achieved an overnight popularity at the end of the century with those enlightened Montreal collectors who were amassing a truly incredible collection of fine paintings, for Watson's own great gods of style were among the Dutch and Barbizon artists patronized by the Montrealers. *Log Cutting in the Woods* won the Art Association of Montreal prize in 1893 and was bought by Lord Strathcona. James Ross followed with purchases, patronage, and friendship. Years later, he

took Watson and his wife on a cruise around Cape Breton and the Nova Scotia mainland where *The Wreckers* (Mount Royal Club, Montreal) and *The Smugglers* (Beaverbrook Art Gallery) were conceived.

Now at full maturity, Watson began to search for deeper meaning and new concepts, for he felt that his earlier paintings were merely transitory studies of nature's varied moods. Out of his nostalgia for the pioneering past, he conceived an epic cycle illustrating the transformation of the virgin wilderness into *The Land of Thrift* as he knew it. In this monumental concept, those heroic Pennsylvania settlers who first opened Waterloo County arrive in their Conestoga wagons, cut the virgin forest, haul logs to the saw mill, stump the fields, break the soil, and build the pioneer log houses under the shelter of giant protecting oaks.

Affluence permitted Watson to build a new studio where he painted a frieze around the wall in which he paid homage to his art heroes. Their names are spelled out in bold letters and beside each name Watson painted small landscapes in the various masters' styles. A Ruisdael-like landscape flanks this artist's name, and a Turner-like painting is reminiscent of the Turner sky in a landscape which won Watson a World's Fair medal. Others honoured are Constable, Gainsborough, Daubigny, Diaz, Rosa, Ruisseau, Corot, Millet, and Lepage. A new large picture gallery in the house was intended to be hung permanently with paintings for the enjoyment of the community.

Edmund Morris, Walker, Watson, and others decided to collaborate in the creation of a market in Canada for native canvases rather than Dutch imports, and in the public exhibition of good Canadian paintings. The outcome was the Canadian Art Club, of which Watson was president for the first four years. Other members included Morrice, Williamson, Brymner, Cullen, and Suzor-Coté. They did not regard themselves as belonging to a common school, but rather as individuals co-operating for mutual benefit. The Club stirred up much interest during its eight years of life. A successful exhibition held overseas in 1911 made an impact on the British public which compared favourably with that of Wembley in 1938 where Group of Seven canvases were enthusiastically acclaimed.

As president of the Royal Canadian Academy from 1918 to 1921, Watson reiterated the importance of subject matter. Both he and Walker scorned paintings of pots and pans: they were mere colour notes and no substitute for more noble themes. He also quarreled with abstract and non-objective tendencies.

Watson the aged patriarch kept on painting even though sometimes lonely in his deafness, never quite reconciled to his wife's death,

and uneasy at losing most of his savings in the 1930 stock market crash. A car purchased in 1923 permitted sketching in the whole Doon region. Later came a long-desired trip to the Rockies. The modern world passed him by, but he bent his efforts to formulate a new and more highly impressionistic landscape technique. Always, however, the woodland continued to hold his interest.

Trees are the first of all the beauties with which the Lord has embroidered this old earth, and I look for types away from the tree butchers, storms, hydro, and telephone wires and axes – all destroy. They have a hard time. I must save them to show what a beast man is sometimes.[3]

The artist of Doon may never quite have realized that as a young man he added a new unity and sense of order to Canadian landscape painting. Moods of nature were sharply focused in a three-dimensional sense as well as in surface patterns under his brush. He had caught the brooding quality of Ontario woodlands whereas other less perceptive Canadians felt it only as the blurred pastiches of European painting. He, as it were, pioneered in seeing the Canadian landscape as Canada, and in that limited sense was a forerunner of the Group of Seven whom he admired even if he quarreled with their lack of refinement. Finally, as a mature man, he brought more monumental themes into Canadian painting. Like Walker, Watson wrote an epitaph which sums up his life-long struggle to portray nature.

There is at the bottom of each artistic conscience a love for the land of their birth. It is said art knows no country but belongs to the world. This may be true of pictures, but great artists are no more cosmopolitan than great writers, and no immortal work has been done which has not as one of its promptings for its creation a feeling its creator had of having roots in his native land and being a product of its soil.[4]

Carl Ahrens, a close friend of Watson and also a painter of trees in the Grand River valley, died in 1936, the same year as his friend Watson. Suzor-Coté died in 1937. The very next year Walker died, the same age as Watson. All belonged to a generation then nearly forgotten. They had lived to see new and radical developments in Canadian art undreamed of in their own most creative years, when they had given their devotion to Canadian country people and the Canadian rural scene as it had first been glimpsed in Wyatt Eaton's early canvases.

19

French Academic Influences

'The French school rules the Art of Europe' declared J. W. L. Forster in Toronto during the 1890s. Sherwood, writing about late nineteenth-century painting, noted that prior to 1876 English influences had commanded the American scene but that at the Chicago Exposition in 1893, when 1,154 American paintings were on exhibition, all but about a hundred could have appropriately borne a French master's name on their gold frames.[1] The Parisian academies and art schools during the late nineteenth century were the mecca of every enterprising young Canadian artist. They crossed the Atlantic to join other young people from the United States, England, every continental country, and even the Orient. The horde of students lived in left bank tenement rooms reached by seemingly endless flights of stairs. Many lived a bohemian night life in the cafés. They congregated by day at the state-operated École des Beaux-Arts, at Julian's, Colarossi's, or a dozen other private academies set up to accommodate the overflow. After drawing and painting for long hours, they had an occasional momentary criticism from celebrated painters of the world's art capital. They advertised their prowess when they returned home, boasting that they had been instructed by various famous artists, and were respectfully stared at by less fortunate fellow professionals who had managed to receive only a provincial training.

Canadian pioneers in the new fashion for French academic study were Robert Harris of Charlottetown, William Brymner of Ottawa, and Wyatt Eaton. The fashion was taken up by many in Canada and a wave of young students arrived in Paris. There they found that Americans, first attracted to France by the nostalgic sentiment of Corot, had already been congregating for a number of years. Shortly after the first Canadians arrived in Paris, Paul Peel, Blair Bruce, and many others

joined the group, which in 1893 numbered no fewer than twenty-five. They found a completely different art from the Barbizon humility of a quarter-century earlier; it was an art with new 'strength, dash, materialism and modernism.'

Figure pieces and narrative genre had become both commercial and fashionable successes. The walls of the French salons from which wealthy Americans purchased freely were covered with great canvases of heart-rending partings, deeds of noble warriors, or any other appealing romantic or sentimental incidents. Each was painted in the greatest detail, so brittle and exact as to stand scrutiny within a few inches. Brymner was appalled and shocked the year he arrived in Paris to be informed that student candidates for the celebrated *Grand Prix de Rome* scholarship had to paint a competition canvas, five by six feet, on this text: *C. Augustus Commanded the body of Alexander to be taken from its Tomb and when they had done so he placed a Crown of Laurels on his head and covered him with flowers.* 'Corpses, corpses, corpses,' he moaned, 'how the French love them!' But this was only one of the popular subject areas. The same Brymner was ecstatic with the paintings in the Universal Exposition by Bonheur and Meissonier in which each vein in the horse's legs and each wrinkle in the rider's boot were carefully painted. He and his Parisian companions in turn imitated these universally admired potentates of the academies. It is partly from these French influences that a sizable quota of unwieldy, sentimental narrative figure pieces dominated the Royal Canadian Academy and other Canadian exhibitions until the close of the century.

Brymner had his way paid to Paris as an assistant to help install the Canadian exhibition at the 1878 Universal Exposition. He rented two small sixth-floor rooms on the Rue des Écoles at $5.37 a month and ate in side-street cafés where a fine meal of beef stew cost seven cents and there was no tip. He stayed on in France, probably to study architecture, and filled several sketch-books with architectural studies. When he decided to study painting he did not feel sufficiently advanced for the academies, so he spent three preliminary months in drawing 'heads and hands and feet and bodies' for a M. Pinet. He entered Julian's in October and, like every other newcomer, gave a 'Punch' treat all round rather than risk a severe hazing. Twenty-odd students, including one American girl, worked from a disreputable model who posed for fifty minutes at a stretch, and whose appearance was improved when minus his clothes. For this privilege, Brymner paid $5 a month for afternoon attendance only. However at first he and ten others worked from complicated casts, as was the custom for students beginning academic study; they did not feel ready to work

from the live model. Some of his friends spent mornings at the Beaux-Arts where Cabanel and Gérôme appeared weekly, but they declared that there they received little real criticism. At Julian's, Jules Lefebvre and Boulanger discussed the meticulously drawn studies one morning each week, but since Brymner normally attended only in the afternoons, many weeks passed before he saw them. The academic routine was a rigid process of careful drawing and shading before the student painted the studies in thick opaque whites and thinner blacks. A whole series of Suzor-Coté oil studies from the nude painted a few years later and still preserved in Montreal demonstrate how painstaking and repetitious the process was. Brymner stayed in Paris for six years, achieving a remarkable facility in the precise and approved drawing and painting of the nude (fig. 86). Before he left, Carolus-Duran praised him for his proficiency.

Finished canvases were sent back by Brymner to Ottawa for sale and exhibition before he had actually finished his training. In one 1884 shipment were *Playfellows, The Cups Which Cheer,* and *A Wreath of Flowers.* The last of these was exhibited with the Canadian paintings at South Kensington in London during 1886; there it was warmly praised by critics and was deposited by Brymner as his diploma-piece on election to the Royal Canadian Academy that same year. While he was still in Paris, his father Douglas Brymner, the Dominion Archivist, advised his son to take a practical point of view about paintings which would sell well in Canada: the public must be pleased or it would not buy. He declared that all artists were happy with the young man's work, but urged him to remember the value of narrative subjects:

It would be well to take now some work with a story interest. I think you could not do better than to set to work at *Dora* – such a story with quotations from Tennyson ... would take, I think. Make one of the best paintings of, say, a girl, and simply call it *a girl,* nobody, a few at best, would care about it. But call it *Mignon Aspiring* or *Esmerelda,* a much worse work than *a girl* would sell. Some little domestic genre pieces, or some touch of humour, with a taking title, or something like *Enoch Arden Watching his Wife,* anything that people can fix a story on would be good policy ... There must be some *human interest* to attract those who know little about the technique.[2]

John C. Forbes had learned a decade earlier the value of appealing to Victorian sentiment when he sent to the 1876 Philadelphia Exhibition his *Beware, I know a Maiden fair to see: Take Care – Longfellow.* The elder Brymner at the same time demanded high standards from his son and urged that he should set for himself the loftiest goals, for through his

painting he must 'be able to take [his] seat alongside of the best ... It is all very well for Caesar to prefer being the first man in a village to being the second man in Rome ... '[3] He insisted that his son must have more than mere village distinction. Brymner became particularly noted for good craftsmanship, and in turn always demanded the best from his students.

On his return home in 1886, he replaced Robert Harris as head of the Art Association of Montreal classes. There he taught many of Montreal's best-known early twentieth-century artists and emphasized careful draughtsmanship as a prerequisite for any prospective painter. He long continued painting in the academic style, and in fact a nude in the National Gallery of Canada dated as late as 1915 reflects this approach. However, contact with Maurice Cullen and others gradually modified his style in later life. This newer freedom of technique is most apparent in the filmy brush work and delicate colouring of *The Vaughan Sisters* (fig. 87). The old tight disciplines were broken, and his later landscapes are almost impressionistic.

Charlottetown considered Robert Harris a prodigy in the 1870s. His father had moved there from his birthplace at Conway, Wales, when Robert was six years old. His thought of a surveying career was replaced completely by his growing ambitions in art after his mother had encouraged him and a trip to the English galleries in 1867 had opened his eyes to the world of painting. Harris's training was sporadic. He would work and save money, go to art school until this was spent, and then begin all over again. He set up for a year as a portrait painter in Boston. Then came study at the Slade School during 1877 under Alphonse Legros, and from London he went on to Paris and the Atelier Bonnat in the same year that Brymner first went to France. Harris thereafter had a phenomenal rise to fame. In Toronto, he joined the Ontario Society of Artists in 1879 and the next year was honoured by election as its vice-president and was named a founder-member of the new Academy. He made enough money in Toronto to visit the Roman and Florentine galleries in 1882.

The Dominion Government commissioned *The Fathers of Confederation* from Harris on his return from Italy. The original was burned in 1917 with the Houses of Parliament in Ottawa; only the cartoon and three trial sketches survive – one an out-of-doors study and the other two interiors. Two are loosely composed, but Harris chose finally to follow a more academic version, with static and carefully balanced grouping. He spent two years on the undertaking. Some praised it. Others like Checkley, an Ottawa artist and Harris's most devastating critic, declared that he had missed a triumphant moment. Douglas Brymner passed Checkley's comments on to his son in Paris:

[N]ever was a splendid chance more stupidly thrown away. It was not only done quickly and bears every mark of haste, the drawing is bad, the lights are confused as if the light from each photograph used for the likenesses was transferred to the canvas without regard to the general effect. A man who seeks only to make money by the exercise of his art and has no enthusiasm for the Art itself is doomed to failure, no matter how brilliant his talents may be. He may do work to please the ignorant and unthinking and may live upon reputation of what he *can* do, but he will never be anything but a *pot-boiler maker*.[4]

Petty jealousies may lie behind this criticism, but certainly Harris's paintings vary considerably in quality. Financially he was most successful, yet many of his commissioned portraits throughout the Dominion are very competent but official and consequently uninspired, dull, and repetitious. In contrast, some unpretentious self-portraits and studies of his family are rendered with great simplicity and have particular merit. Harris was in fact capable of notable achievements. His *Sir Oliver Mowat* in the Ontario Legislative Buildings is superb, in spite of its somewhat grandiose conception, particularly when compared to some of the portraits by his contemporaries. *Harmony* (National Gallery of Canada), a genre study of his sister-in-law playing the organ, painted in 1879, is sensitive and the muted colours do not diminish the feeling for the theme; even so it has little of the exotic appeal which this subject could be given, as demonstrated by paintings of Thomas Eakins or Mrs Frances Jones Bannerman of Halifax (Archives of Nova Scotia). The human qualities in *A Meeting of the School Trustees* (fig. 89) have been beloved by young and old throughout the years who examine the quizzical, sceptical Scottish pioneers of Prince Edward Island interrogating the sincere and very young rural school teacher. Some large genre works – such as *On the Shore of the St Lawrence,* where a woman and her lover, life-sized, meet beside a beached row boat – are trite, banal, over-ambitious in format, and deserve the dust which they now collect in art gallery basements.

Gifted young Paul Peel from London, Ontario, belonged to the same generation. Genre came to him naturally. Before leaving home for London, England, he painted what seems more like genre than the conventional portrait: a girl, clad in riding habit, stands in front of her home and holds a pony. He first went to the Royal Academy School in London in 1881 and then to the École des Beaux-Arts in Paris. He became a willing expatriate, married a Danish student, and returned to Canada only occasionally for sales promotion. In the French countryside during the summer of 1882 he painted several small canvases of

his young wife, enveloped by sunlight, at one time sitting on a hillside and at another feeding pigeons in a courtyard; they demonstrate an extraordinary facility and even a lushness in the handling of paint which would soon win him fame.

Peel ultimately achieved a style remarkable for deep rich colouring, and always with a suave urbanity which the contemporary taste adored. A famous series in this mood, *The Tired Model* (Art Gallery of Ontario), *A Venetian Bather* (National Gallery of Canada), and *After the Bath* (Art Gallery of Ontario), were all painted in his Paris studio (fig. 90). He here defied the puritanical Canadian taboo against the nude; his native countrymen were ecstatic when *After the Bath* won a medal at the French Salon. Sarah Bernhardt tried to buy the famous canvas but found it was too expensive. The work was sold in Hungary, but years later returned to a private collection and thence to the provincial gallery in Peel's native Ontario. The life-sized oil sketch study for this interesting work has also come back to this country. Many Peel canvases were sold at a Copenhagen art shop, where Queen Alexandra purchased examples when in her native city. Canadians had high hopes that this native son would enter the celebrated ranks of internationally famous artists, but were cheated by Peel's early death.

Blair Bruce was another European by adoption. He went to Julian's in 1881, married a Swedish heiress, and lived in Rome before finally moving to Gotland Island in Sweden. His few Canadian themes, such as *The Phantom Hunter* (fig. 91), have literary suggestions quite acceptable to the French academicians. Less ambitious portraits are also in the academic manner of the day, but small Roman nocturnes have a delicacy of mood. In later years his paintings of sunsets over northern seas and groups of bathers, of which many were bequeathed to the Art Gallery of Hamilton, became ever larger. He could not entirely resist the influence of Impressionism in his lightness of colour, but these late works lose their impact by over-ostentation.

George Reid, an Ontario farm boy from Huron County whose first contact with art was a visit to William Cresswell's studio, became one of the best-known Canadian genre painters of his generation. His career was so long that it is difficult to reconcile his Royal Ontario Museum murals of the 1930s, his genre of nearly half a century earlier, and his historical and landscape painting of the intervening years. He received his first instruction from the Notman artists and teachers at the old Ontario School of Art and Design in Toronto, then studied under Thomas Eakins in Philadelphia; a powerful self-portrait done at this time demonstrates his youthful decisiveness. Paul Peel himself ushered Reid and his young bride into the Parisian art scene in 1888.

Boulanger at the Julian had just died. Peel declared that Benjamin Constant, who had replaced him, was the most enlightened teacher in Paris. The three Canadians enrolled under Constant, and astonished fellow-students by using an oil sketch technique to wash in their entire painting rather than first preparing the usual elaborate tonal studies. Eakins and Constant both favoured this method (it appears in the study for Peel's *After the Bath*).

Reid took a studio the next year in the Toronto Arcade. He felt ready to meet the world as a 'finished' artist. Reid had always thought of himself as a Canadian, but other students who went to Paris had difficulty in re-orienting themselves to Canadian themes, since their work abroad had no Canadian content. Brymner's *With Dolly at the Sabot-Maker's* (National Gallery of Canada), in which a little girl approaches a cobbler to mend her doll's shoe, is as French as the old man admiring his antiques in Suzor-Coté's *Le Connaisseur* (private collection). There is nothing particularly local in Robert Harris's portrait of *Mary Morison* (Beaverbrook Art Gallery) whom Burns made famous with his poem, but *A Meeting of the School Trustees* was a return to the local scene. George Reid, on the other hand, always represented Canadian scenes even when he was abroad. When painting a Canadian lumbering scene in Paris, he hired Parisian workmen to pose along the Seine as Canadians would have done. *Mortgaging the Homestead* (National Gallery of Canada) and *Family Prayer* (Victoria University), painted in Toronto, echo the country life he had known as a boy. The autobiographical *Forbidden Fruit* (fig. 92) recalls stolen hours in the hay mow. *Toronto Water Front, July 1886* (Metropolitan Toronto Library) is filled with the light of Venetian canvases translated into the local setting. Later he painted Canadian historical scenes in a genre manner allied to that favoured by many Quebec artists; Suzor-Coté, for example, had used it in the well-known *La Mort de Montcalm*.

Canada sent a very large exhibition of paintings to the 1886 Colonial and Indian Exhibition in London. In fact more Canadian artists were represented there than artists of all other British colonial states combined. Before the show returned home, Sir Charles Tupper, Canadian Commissioner to the exhibition, asked J. E. Hodgson, RA, a leading professor of the Royal Academy Schools, to prepare an objective report on this dominion's art. Hodgson knew none of the visiting artists personally and so had no preconceived ideas. He was astonished at how completely they were dominated by Parisian academic teaching.

[I]t has been rather a shock to me to observe in the Canadian pictures such evident traces of French influence; not the influence of the great French

painters, Gérôme, Meissonier, Ingres and Flandrin, &c., but of the rank and file of mediocrity, the influence, to speak plainly, of a school which is daily becoming more debased, which is substituting pedantic rules for the freedom of nature – which is shutting out from us the clear bright air of heaven, and stifling us with the smoke and dust of studios.[5]

R. A. M. Stevenson, reviewing the same show in the *Magazine of Art*, was equally impressed that 'the Canadians have not been slow to take advantages of European, and more especially of French, sentiments and traditions. This influence is easily seen in figure work ...'[6] He even felt that 'while walking among the Canadian pictures at the Colonial Exhibition, you can fancy yourself in a good European art gallery ...'[7] Obviously Canadian artists were losing any sense of identity with the country of their origin which had such unique and individual characteristics. Hodgson concluded his report by exclaiming that he 'should like to see Canadian art Canadian to the backbone ...'[8]

There were other men who were not quite so dedicated to the French academies but who can be most readily discussed with the more thoroughly trained Paris painters. The eccentric old bachelor, William Cruikshank, who was furious when some kindly intentioned ladies on one occasion tried to tidy his unruly study, was undoubtedly one of the greatest yet least appreciated nineteenth-century painters in Canada. A nephew of the famous illustrator George Cruikshank, he was born in Scotland but spent his youth in Canada. His training was truly rigid even in that generation: two years at the Royal Scottish Academy, a period at the Royal Academy in London under Leighton, Millais, and others, and a stretch in Paris working under the popular historical painter of the Napoleon III régime, Yvon, who had his own academy. For long years he was an illustrator for *Cassels*, the *London Graphic, Scribner's,* and the *Saint Nicholas Magazine.* As a drawing-teacher at the Toronto art school he was a rigid disciplinarian and rather frightened his students, but beneath his gruffness was much kindness.

Changing fashions has tended to overlook the genuinely high quality of Cruikshank's paintings. His best works were not always his large canvases; teaching was too demanding for him to excel in these. He was a superb draughtsman and an amazing technician, and when he turned to portraits, like *Anne Cruikshank* (fig. 93), he painted more than a simple character study; he added an imaginative still life grouping with admirable tonal sense and an alluring sparkle of colour. He had, of course, studied painting with the great Pre-Raphaelite masters interested in photographic realism, and he is as much a product of En-

glish schools as of French academies. Late in life Cruikshank turned to purely Canadian subjects. He caught the pioneer spirit in *Breaking A Road* (fig. 94), in which oxen haul a sleigh through a snow-blocked trail; the painting here has a new freedom of brushwork not found earlier.

Artists throughout Canada were painting genre at the century's end. Charles Caleb Ward of Saint John, N.B., who studied in London before Paris became fashionable and then worked alternately in Boston and his native city, turned out innumerable small highly finished genre. He loved circus scenes, children playing under the trees, and men in lively discussion over their bottle of port. Franklin Brownell's paintings of school boys differed little stylistically from those of George Reid, but then the vivid sunshine of the West Indies revolutionized the subject matter and light of his canvases; his paintings of natives with their brilliant handkerchiefs and red pottery were thereafter highpoints of his production. Like Reid, he evolved late in life into a rather prosaic landscape painter when fashion changed to favour new subject matter for which he had no feeling. Margaret Campbell McPherson of St John's, Newfoundland, studied with Courtois in Paris; she lived in that city and exhibited both genre and flower studies in the Salon and other shows from 1894. Sophie Pemberton of Victoria, B.C., was one of a dwindling stream of students who went to London, and was lured from there to Julian's. Friends and relatives posed in the Pemberton Woods during her summers on Vancouver Island, and many other works completed in Victoria were exhibited in the Canadian and English academies and the Paris Salon beginning in 1893.

Genre, either whimsical, classical, or of indigenous narrative subjects, became so fashionable that anyone ambitious for international reputation was forced to exhibit works of this kind. A sprinkling had been found in the Royal Canadian Academy of 1882 with Frances M. Jones Bannerman's *A Breton Peasant Woman Spinning*, Mrs Schreiber's *After Tea* and *Springfield on the Credit* (fig. 95), Brymner's *An Unwelcome Guest*, and others. But at the 1893 Chicago World Columbian Exposition, not more than a half dozen of nearly four hundred paintings illustrated in the catalogue were other than large-format genre. Canadians had to follow the trend. These grandiose, elaborate, highly finished works naturally were expensive. As early as 1893 Cruikshank complained about the fashion for larger and larger canvases since he himself was forced to paint more impressive works if he wanted to make sales. But this did not alter his opinion of what was good: 'Canadians won't bother to look at anything small, and anything like crisp constructive drawing makes them uneasy. But I have decided to

do what I know, without being influenced by the opinion of a lot of farmers who can hardly be trusted to go to bed without attempting to blow out the gas.'[9] But sales eventually became fewer and fewer for all Canadian artists as they increased their prices for these large canvases, which after all had little real artistic content. Cruikshank complained once more in 1898 about the ignorance of artistic values which in Canada had given 'an artist-status to a lot of them who have never made a special study of anything, know all about everything, and are a lot more authoritative than the whole Academy of France.'[10]

Numerous medals awarded at the Buffalo Pan-American Exhibition in 1901, to which Canada sent many paintings, demonstrate changing tastes. Gold medals went to Brymner, Harris, and Bruce, all of whom were French-trained, and a fourth to Homer Watson, who was much more of a home product. Lesser awards included some to the old guard as well, but others went to a new generation – to Maurice Cullen, James Wilson Morrice, and John Hammond. Change was coming with the change of century.

20

Contrasts in Quebec

Progressive, vital painting was the exception rather than the rule in French Canada during the later nineteenth century. Stagnation, lack of inspiration, and repetition of religious subjects where either creativity or startling innovation was unwelcome, could be found on all sides. Absence of innovation in the Quebec art scene should cause no real surprise. It was not just that creativity had been stifled by the uninformed dictates of laymen; the artists themselves were acutely aware of fabulous reputations which had been built solidly on superior copying. Old Antoine Plamondon copied Renaissance and Baroque paintings throughout his lifetime, and no one thought the less of him for it. Théophile Hamel and others did the same. Many were celebrated artists.

Chevalier Antoine-Sébastien Falardeau's incredible success story was built entirely on a career as a copyist. This poor *habitant* boy from Cap-Santé had run away to the 'distant' city of Quebec because he had dreamed of being an artist. Robert Todd employed the boy in his shop and with others was responsible for sending him to Italy in 1846 for study. Falardeau's life was thereafter a most romantic tale. Sick, unpopular, and disheartened during his first years in Europe, he found his paintings singled out one evening in an exhibition by the Duke of Parma. This was the turning point. Falardeau married a niece of the pope, and bought a Florentine Renaissance palace where he entertained in splendour the Empress of Russia and other crowned heads and aristocrats who came to admire his paintings. When he returned home to sell canvases in Quebec, his progress was like that of a royal visitor. The celebrated expatriate was widely mourned when he was killed by being thrown from his horse while taking a morning canter. Yet, as an artist, he was merely a professional copyist.

By contrast, Ozias Leduc lived hidden away in the little village of

Saint-Hilaire, virtually an unknown recluse. The aesthetic value of his canvases cannot be measured by the modesty of his surroundings. He had painted small still life canvases, portraits, and landscapes in oil since the 1880s in a studio that he had built with his own hands. Luigi Cappello, an Italian painter who worked primarily as a church decorator throughout the province, had introduced Leduc to painting, and later he was associated with a fellow Quebecker, Adolphe Rho. Leduc was forced to earn his living from decorative painting, for which he produced exquisite cartoons in pencil, but his small canvases were painted almost entirely for his personal satisfaction and they found no sale among collectors at that time.

Leduc's still life paintings best demonstrate his true measure as an artist. The most astonishing and most mystical of Canadian painters, Leduc chose the humblest subjects – the *habitant's* plain meal lit by elusive candlelight, onions, apples on a plate, or a jug with two eggs made mysterious by daylight from a distant window. He bathed his subjects with a reverent light, caressing each object lovingly with his brush, and building a silken texture which tantalizes the eye. A peak of sensitivity is reached in a little canvas in which three apples sit on the corner of an old pine table. This he gave to his famous disciple, Paul-Émile Borduas. Few artists have honoured a humble subject with such devotion. Leduc was a man of modest wants who created universal beauty out of simple things.

Several of Leduc's paintings, *Le phrénologiste* (private collection), *Les livres et la loupe* (private collection), and a Chardin-like grouping of his sketch-box with letters (fig. 96), all have qualities similar to the *trompe-l'oeil* of William Harnett and his Boston associates in the 1880s. The fashion manifested itself in Ontario; *Music* (fig. 97) by J. R. Seavey is an excellent Canadian example of painting in this mood. But Leduc had other qualities not found in these American works or those of Seavey: his curious enveloping light and his sensual textured surfaces. His touch has something of Chardin's, his abiding love of the objects themselves sets him down more firmly apart from the others; he strives to raise his subject matter to an unusual dignity and has no interest in quick or sensational effects.

The qualities in Leduc's portraits are identical to those in his early still life canvases, for he stood equally in awe and respect of God's simplest handiwork and of man, the greatest of His creations. His intimate portraits – when he gazes into the face of a little lad, or paints a sensitive study of a young musician (fig. 98), or yet again the quiet and dignified *Portrait de Madame Lebrun* (private collection) – are marvels of gentle and familiar portraiture. The artist wanted to paint portraits

professionally but was discouraged from attempting further commissions than these simple old-fashioned studies whose great virtue completely escaped the sitters' slight comprehension of art.

Only once did Leduc venture to travel abroad. The lure of Paris was irresistible, and he accompanied Suzor-Coté overseas in 1897. There he was particularly interested in the paintings of three minor Impressionists of whom Le Sidaner was the best known. Leduc returned, still a humble and simple man, unimpressed by the great academic canvases, the turmoil, arguments, and excitement of those who advocated new trends, and, it would seem, by the great masterpieces of the past. He recommenced painting, still an isolated individualist, still following his own personal vision. Changes are solely in his surface technique, which gradually evolved as in his much repainted *Pommes vertes* (National Gallery of Canada). This took many months to complete, and his brush strokes were laid down in a way which he felt would achieve the atmospheric effect he sensed in Impressionism. Broken strokes are more apparent in certain later paintings. He introduced more colour into his occasional later portraits, even daring a clear yellow-green background, or painting rich red clerical vestments completely alien to his soft greys, blues, and dull red-browns of earlier years. Landscapes provided his fullest satisfaction with the passing years. He preferred the out-of-doors during the mysterious evening hour: *L'heure mauve,* a canvas which he kept hanging on his studio wall, *Fin du jour* (private collection), *Neige dorée* (National Gallery of Canada), and *Le cumulus bleu* (Beaverbrook Art Gallery). The diffuse light, which plays tricks on the mind, creates a strange, other-worldly atmosphere that echoes his contemplative mood.

Leduc's principal income was from church decoration. He attempted to follow the methods of Maurice Denis and Georges Desvalliers of L'Atelier d'Art Sacré, believing profoundly like these men that symbolism was all-important. The decorations for the Archbishop's Palace in Sherbrooke are a masterpiece painted as if God's mysterious, all-powerful workings overawed the whole. Paul-Émile Borduas, who had first felt the impact of painting when he saw Leduc's decorations in Saint-Hilaire church, assisted in these later days. Leduc treated Borduas as he would have treated any other sensitive youth, imparting his own philosophy built during a lifetime of contemplation and quiet living. He preached a spirit of humility in creating new expressions of feeling, a reverent devotion to one's craft, and the potential power of the brush as a means of expressing inner feeling. These attitudes later bore fruit for they were an emotional stimulus in Borduas's own unique experimentation, and thus indirectly encouraged new developments in the French-Canadian art scene during the 1940s and 1950s.

The authorities of Montreal's Notre-Dame employed Leduc to decorate the new baptistry ceiling in 1926. Earlier its clergy had shown a lively interest in training young people as artists when they built Sacré-Coeur Chapel. A group of Abbé Chabert's students at the École des Arts et Manufactures were sent to Europe by the church authorities to work on paintings for the new chapel and thereby benefit by an overseas art training. Ludger Larose and J. C. Franchère sailed in December 1890, and each painted three canvases under an École des Beaux-Arts professor in Paris. Larose then copied old masters in Rome. Charles Gill, Henri Beau, and Joseph Saint-Charles, who had studied briefly in Paris, followed in the next two years. Their chapel paintings, in the French academic tradition, have clear, precise drawing, with careful light-and-shadow studies. They brought back for the new Notre-Dame chapel copies of Lebrun canvases and others painted in a Giottoesque manner.

Notre-Dame's enlightened gesture in sponsoring young Quebec painters in Europe did not bring the returns which one might reasonably expect. Their rigid academic assignments abroad stifled much of their creativity. Beau, who had shown great promise well before 1900 as a landscape painter in the style of the Impressionists, returned to paint grandiose historical compositions; some others continued as church decorators. During the years around the turn of the century these individuals occasionally would turn to landscape or still life for their own personal satisfaction. Charles Gill's painting of a fisherman's catch (fig. 99) is in the sober browns of the '90s, but a silver sheen on the scales demonstrates that he had another and livelier feeling for beauty. Like Beau and Charles Huot (fig. 100), he paid homage to Quebec's past. He and Larose could catch similar aesthetic effects in the rare canvas.

The most personal Quebec artist early in the twentieth century was Father Arthur Guindon of Montreal who abandoned his teaching career because of deafness and then devoted his increased leisure to poetry and painting. Guindon passed his summers at Lac-des-Deux-Montagnes, where the local folk-lore so fascinated him that he painted a series of canvases illustrating various regional tales. Quite evidently he was familiar with the early Surrealistic paintings of Hieronymus Bosch which he may have known from his student days in Paris; his *Le Génie du Lac-des-Deux-Montagnes* is the finest painting in the Bosch tradition executed by a Canadian, and at the same time virtually unknown. Like so many other Surrealists, Guindon pursued a solitary and personal path, painting Canadian folk-lore in a timeless tradition which could be dated as easily from the sixteenth as from the early twentieth century.

Another typical approach to painting, in a completely different vein, was that of Henri Julien, a genial companion at supper parties, and a family man who adored his trim little wife and his large family – there were eighteen of them. A complete contrast to everything Ozias Leduc represented, he gave a hundred men pleasure in his own light-hearted way for every one who had seen a Leduc painting. Indeed his sole desire was to give pleasure and interest to others. Julien was an extrovert, beloved of extroverts; Leduc was an introvert and made his appeal primarily to the introspective.

Julien began his career as one of the Canadian newspaper and periodical illustrators who flourished in the brief decades before the photo-engravers wiped out the profession. He is one of the greatest in the generation of F. M. Bell-Smith and Arthur Heming in Ontario, and of Gascon, Arthur Racey, and half a dozen others in Quebec. Young Julien's first big assignment was to document the suppression of the liquor trade among the Métis on the prairies by the North-West Mounted Police during 1874. A life of newspaper work followed. His earlier sketches appeared in the *Canadian Illustrated News* and other Desbarats Press publications. He had a warm affection for the firm; his father worked for the company as a printer, and he himself was apprenticed to it at an early age.

Popular imagination coupled Julien's name with the *By-Town Coons*. Here he caricatured in the guise of a minstrel show the actors in Ottawa's great parliamentary drama as it unfolded year by year. Julien had a gift for characterization, and worked from 1888 as a political cartoonist for Sir Hugh Graham and then Lord Atholstan, publishers of the *Montreal Star*. J. W. Bengough of Toronto was the only Canadian cartoonist who approached him in popular appeal. Each year Julien moved to Ottawa when the House of Commons opened, and after the daily session went to his tiny room in the Russell Hotel to create diverting impressions of the day's highlight for the newspaper. He literally worked against the clock, drawing until the dreaded morning hour when the alarm rang to warn him of his deadline and the need to get the cartoon aboard the Montreal train. Sir Wilfrid Laurier reappears constantly through this steady stream of humour. A slight figure with coat tails flying and a delicate poise, he was the principal parliamentary actor. Stolid old Sir Richard Cartwright in the background dozed through debates and the perennial but inevitable Hon. Richard Scott, spider webs decorating his creaking figure and his flute, was the most inert of all figures in the great By-Town Coon Minstrel Show.

Leisure time was always at a premium, but Julien occasionally

fished at Sainte-Rose north of Montreal, and there he painted his fellow fishermen and incidents of *habitant* life. Many of his *habitant* characterizations were freely executed pencil drawings, with a few others in water-colour or oil. They show the village auctioneer holding up a rooster which he is offering to the crowd, or the exciting life in the sugar bush where the collection of the sap in buckets is followed by boiling and sugaring off. People meet in lighter moments at country dances or race their sleighs on bright Sunday afternoons.

Finally, Julien illustrated many publications about French-Canadian folk life. Some reproduced werewolf legends, and others a variety of country superstitions. The Quebec Museum's *Ghost Canoe* is probably his best known larger canvas. Vignettes of life, whether superstitions, local customs, or Ottawa parliamentary life, always fascinated him.

Julien's income as a cartoonist and illustrator was never large and he drove himself unmercifully. He returned to Montreal a weakened man following the parliamentary session of 1908 during which he had suffered from influenza. There, in his old grey stone house on St Denis Street, he plunged into the vast amount of work necessary for the forthcoming Quebec Tercentenary. Unable to drive himself further, he collapsed and died of a heart attack on a Montreal street.

This artist's popular drawings, water-colours, and oils created an image of Quebec widespread through Canada, an image of quaint folk customs and superstitions, of a country people who were likeable yet slightly backward and out of touch with reality and current life. Other artists strengthened this image: Krieghoff in his various canvases, Massicotte with his illustrations and paintings, Georges Delfosse in canvases of the Quebec countryside, and Gagnon, Suzor-Coté, A. Y. Jackson, and others. All sought for the picturesque and quaint elements in Quebec life as their subject matter. Such an impression of Quebec still colours the thinking of many Canadians outside the province. Regrettably, Ozias Leduc's canvases are difficult to see, both because of their small number and the fact that they are so appreciated by the present generation of connoisseurs that most are now hidden in private collections; as a result they have not been able to serve as a counter-balance. Canada at large has had a very few recent years to build a different concept of French Canada as an area where great aesthetic sensibilities underlie a varied artistic output. Other and vital concepts have come to be recognized more widely only with a revolution in thought within Quebec itself, during and since the Second World War. The process still continues.

21

Painting as an Aesthetic Experience

The taste of the Canadian public as the nineteenth century neared its end was generally undiscerning and spiritless. Montreal was overrun with expensive, muddy brown paintings, many of them imported from Holland, which the affluent bought avidly. Less prosperous citizens aped their wealthier neighbours and bought cheaper yet equally tired works by minor luminaries. Toronto followed Montreal's lead. Mary Ellen Dignam, regarded as the Queen City's art connoisseur and herself a painter, headed the Canadian Women's Art Association. This organization, dedicated to improvement of public taste, sponsored an exhibition by Mauve and other Dutch artists whose imported canvases are now deservedly forgotten. Her own birch trees were as brown and foreign to the true Canadian character as the imports which she so much admired.

Grandiose genre by academicians were the most discussed of local paintings. They were so lifeless that some wag ascribed them to the 'fossil school.' More vital works in these exhibitions were floored, skyed, or rejected. The situation never quite descended as far as in England where famous Royal Academicians hid their entries under sheets as closely guarded secrets until the annual opening at Burlington House; they wanted to overawe the reviewers solely through the uniqueness of their ideas, and could not afford to let another artist steal their themes. They took up a gamut of sensational or merely intriguing subjects. Most nineteenth-century art critics omitted any attempt at a judgment in terms of aesthetic feeling; they themselves uniformly lacked connoisseurship and merely reflected public sentiment. One critic in 1873, to take an example, wrote that J. C. Forbes was a young and very deservedly popular portrait painter and that his picture of a young lady was not only a portrait but a picture and better a story; in his opinion it was the most valuable work in the exhibition.

On the other hand when T. Mower Martin in 1880 exhibited a water-colour in which he had attempted atmospheric effects, he was assailed with bitter sarcasm:

The Toronto Waterworks in the evening shows up in a misty manner and the day must have been foggy when the idea was conceived. If the intention was to show the building in its beauty – if it has any – the mist should not have been thrown around it, otherwise if it was only wanted to give the observer a faint conception of what it is like, the artist has accomplished his object.[1]

Yet the spirit which prompted Mower Martin thus to give expression to some of his own feelings as to what constituted real art would bring about a whole new philosophical approach and new direction to Canadian painting in the 'modern' age from which we have not yet emerged. Canadian artists were ready for a violent reaction against the current demands of art patrons for paintings such as *they* wanted; many of them, and especially a few perceptive ones, objected that the public's preference for tasteless, dead figurative works permitted little opportunity to satisfy their own aesthetic aspirations. They became tired of their rôle as paid servants, as did many artists throughout the Western world; they were prepared to stand on their own feet and become creative individuals.

Thus some Canadian artists were quite willing to follow certain European trends which led them completely away from academic positions and from the lethargy into which they saw the nation's art descending. Laymen did not give up their dominance quietly. An ever-increasing and often loud complaint would rise over the next three-quarters of a century: 'I can't understand it!' Yet the cry became less and less effective as artists turned their attention elsewhere. The exceptions were the numerous official portrait painters who would undertake commissions primarily to catch an excellent likeness and possibly even to ennoble the sitter, and the landscape and marine artists who found their rôle of 'servant-artist' profitable (it is, indeed, difficult to describe many of these as artists). The subservient artist remained among many respected leading Canadian painters, but was largely replaced by the 'artist-dictator.'

The first revolutionary influence was the 'art for art's sake' theories of Whistler and associated aesthetes in France: out of them, in turn, would come a concept of art as dictated by the artist's own personal sensibilities – the twentieth-century concept. The second of the new influences was the combined impact of Impressionism and Post-Impressionism.

James Wilson Morrice was the leading practitioner of an art form related to a combination of these various trends. Maurice Cullen, his close associates, and ultimately certain Group of Seven painters would be closely allied to Impressionism and Post-Impressionism.

James McNeil Whistler, expatriate American, at times haunting London of the Chelsea Embankment and at other times Paris, preached a new philosophy in which he demonstrated that painting was primarily the creation of aesthetic feeling through compositions of shapes and tonal arrangements. He even challenged Ruskin in a sensational libel action, about one of his own pictures, which was tried by the English law courts in 1878. Whistler and his group, Aubrey Beardsley of the *Yellow Book*, Oscar Wilde, and various bohemian intellectuals fomented in London a powerful new philosophy of pure aestheticism in art. Whistler became the most disruptive force in the placid art world of England.

John Hammond went to Europe about 1885 to investigate Whistler's theories. This Montreal-born man was a wanderer by nature. By the age of thirty he had fought in the Fenian raids, spent two years hunting gold in New Zealand, crossed Canada with the first successful railway survey party to penetrate the Rockies, and worked in Toronto as a Notman artist. Canadian art historians have never mentioned him as a revolutionary, yet after heading the Owens Art Institution at Saint John, New Brunswick, for a year or two, he left for study with Whistler in Holland. He was perhaps the first Canadian not only to come in contact with 'the Butterfly' but to be, at the same time, sympathetic to his approach. Perhaps Whistler's interest in oriental and particularly Japanese prints turned Hammond's thoughts to the East, for he later fought in the Chinese Boxer Rebellion and painted in Japan (see p.198).

Many of Hammond's paintings became a search for tone, which reflected his interest in Whistler. Later, he directed the Owens Institution intermittently and followed it to the Mount Allison University campus. Loving the Saint John fogs, he returned repeatedly to paint fishing boats, their hulls looming out of peasoupers while their sails reflect the yellows, pinks, oranges, and reds of sunset (fig. 101). These canvases are purely studies in subtle variations of tone and colour.

The work of Harry Rosenberg (a contemporary Halifax painter) was very similar in spirit to that of Hammond, except that he preferred blues and greys, colour schemes also favoured by Whistler. Rosenberg was originally from New Jersey and during his two years of study in Venice he and Whistler lived in the same house. He moved in 1897 to Halifax, where he was principal of the Victoria School of Art and

Design for ten years. From his home in Dartmouth (his wife was a local girl), he looked across the harbour with its sailing ships to the distant city of Halifax. Many canvases record the scene, mere shimmers of blue with an occasional sail in the mists, and a dark line of oil slick giving a certain solidity to the whole. His paintings are aesthetic adventures built on tonal harmonies and subtle, almost sinuous line.

Unfortunately both Hammond and Rosenberg worked in comparative isolation and had little or no opportunity either to expound such theories to other painters or to themselves gain new insight into subsequent discoveries. They reached a static point in their own development. The local art world was unappreciative of their innovations, and they were unable either to penetrate into the wider Canadian community and so influence painting on a national scale, or in fact to build and develop further along the lines on which they had started.

James Wilson Morrice was able to reap the fruits denied the Maritimers. Yet it seems illogical that this man with his wealthy Montreal background should overthrow all the conventions which a staunch Presbyterian upbringing might have dictated, and become one of the world's outstanding early twentieth-century artists. His youthful sketching was mildly countenanced by his family as a passing childish whimsy. Signs of real revolt against his rationalist upbringing first appeared while he was studying law at the University of Toronto. Classmates described his aloofness, his taciturn ways which mellowed with drink, and his independent spirit which he proclaimed by playing the flute in the University cloisters much to their annoyance. The notes from the treasured flute became more and more doleful as he imbibed progressively during the evening, and it was silenced only when in a pawn shop while he awaited a cheque from home.

Morrice sailed for Europe about 1890. William Scott, the Montreal art dealer, had advised him that he would profit by working overseas, and Sir William Van Horne spoke glowingly to his father of his artistic abilities. Thereafter his life was completely devoted to painting; fifteen years later his family was reconciled to his decision when the French Government and Parisian connoisseurs began to buy his canvases. Three even found their way into the Hermitage Museum collection at Leningrad. William Ogilvie, one of the earliest Montrealers to show an interest in him as an artist, began to buy his paintings. Toronto was another matter; Morrice even begrudged sending works to the 1911 Canadian Art Club exhibition held in that city, for, as he wrote to his friend Edmund Morris, the secretary, he had a low opinion of the city's tastes:

I am doubtful about the advisability of sending pictures to Toronto. Nothing is sold (except to one excellent friend, MacTavish), nobody understands them – and it involves great expense. I have not the slightest desire to improve the taste of the Canadian public.[2]

His first European teacher was the aged Barbizon painter, Henri Harpignies, and in Morrice's early work the delicate and slightly varied olive green tones, with spots of colour in scattered figures throughout the landscapes, follow the master's manner. Then he discovered Whistler; he visited Dordecht, Holland, in 1892 where Whistler was painting and learned from him the use of large simple colour areas and low-hued tonal harmonies. These are sombre effects, but he discovered light during two early visits to Venice, first when he went with Maurice Cullen in the 1890s and then alone in 1904. On all sides was Venetian sunshine and the delicate pastel shades of the old palace walls; the sad Whistlerian notes were permanently forgotten. On the northern French coast during several visits he discovered the soft and delicate beauty and the light which Boudin loved. He developed along more and more personal lines, but always kept a relationship between his own painting and the evolving French styles.

The many years in Paris never completely remoulded Morrice into a Frenchman. He always remained the expatriate Canadian, and it took him years to master the French language. His friends were the colourful English-speaking world of the café Chat Blanc in Montparnasse. Whistler, idol of the English aesthetes, was a periodic visitor there. This English group admired him just as the French admired Puvis de Chavannes, and Morrice equally looked up to both of them. The Americans Prendergast, Robert Henri, and Henry Glackens came to the café each evening when they were in Paris. Charles Conder, the Australian fan painter, was a particular friend of Morrice. Among the group were some writers. Somerset Maugham and Arnold Bennett in their novels have each drawn word-pictures evidently based on the Canadian, describing his bald head and hooked nose, and how he sat in his corner drinking glass after glass of whiskey or absinthe until he became uproariously drunk. Then, emboldened by liquor, he would take out his tiny sketch-box and stubby brush and scrub away at incredibly beautiful oil studies the size of a cigar box lid.

Hundreds of these little sketches accumulated over the years. Some were painted in Paris parks or along the Saint-Malo seacoast on sunny afternoons; others recorded visits to the circus or trips into the suburban countryside where models posed in the open air as was then the custom. There are sketches on shipboard while he was travelling back

to Montreal, and many of Canadian winters, of Venice, the North African coast, and dozens of other haunts. Selected studies were enlarged into canvases during industrious mornings in his Quai des Grands-Augustins studio facing the Seine book stalls, for steady work was necessary to prepare a yearly quota of entries for the Société Nouvelle and other exhibitions.

Léa Cadoret, Morrice's favourite model, reigned supreme as presiding hostess in the studio. Later she found him a more comfortable studio farther down the Seine. Her faithfulness is touching. Morrice would disappear suddenly, she would receive postcards as the only indication of his whereabouts, and always she would be waiting for him on his return.

There were annual trips to Canada until his parents' death. Before 1900 he began sketching the Canadian winter, painting horses and cabs waiting for their fares on Quebec streets, the Upper Town, horses hauling cordwood along country roads (fig. 102), floating river ice, and the Quebec to Lévis ferry. Sometimes he sat in the café opposite Notre-Dame-des-Victoires church in Quebec's Lower Town, sketching as if in the Chat Blanc. Morrice wanted to go with Edmund Morris to paint the western Canadian Indians but never found the time. These trips back to Canada were not necessarily happy reunions. The Montreal Establishment of that era was only intermittently amused by its wayward son, and his most congenial companions were Brymner, Cullen, and his old dealer, William Scott.

Morrice often used a heavy impasto during the earlier European years, but began to experiment with heavily painted areas as a foil to thinly glazed portions. Gradually he achieved a thin painting technique in which the surface textures are like delicate raw silk, and have similar tactile qualities (fig. 103). He abhorred the academicians implacably, and searched constantly for new emotional feeling by which to achieve a more powerful impact and experience through paint. Seeing a Cézanne exhibition about 1910, he judged it highly:

Fine work, almost criminally fine. I once disliked some of his pictures, but now I like them all. His is the savage work that one would expect to come from Americans – but it is always France that produces anything emphatic in art.[3]

Then he discovered Matisse, and to appreciate his art more fully, Morrice deliberately spent the following two winters in Algiers where he knew Matisse was painting. Morrice planned that they should meet as if by pure chance, and each evening therafter they discussed every-

thing except painting while Matisse matched in mineral water the tumbler after tumbler of pure whiskey which was set in front of Morrice. His painting gradually assumed resemblances to that of Matisse yet he refused to move into a Paris studio in the building where Matisse lived. Later he visited Trinidad and Cuba where he found the same lush green which had intrigued him in his early days of painting in the French countryside under Harpignies. His palette also became richer with the tropical opulence of the West Indies – the brilliant blue skies, and the oranges, pinks, purples, and reds which he observed. This Post-Impressionist colouring echoes Van Gogh and Gauguin, but it is greatly softened to retain the refinement, sensibility and delicate 'sensual' feeling which was characteristic of his painting.

Morrice found the war years trying. He had to give up his normal café life in Paris. His health began to fail and the doctors entirely forbade absinthe. He and Léa went to Algiers early in 1923, and Albert Marquet has described his sadness when she left for France without him. That spring he painted some softly scumbled water-colours, seen and admired by Robert Pilot and Edwin Holgate when they visited him in North Africa. Thereafter he did little painting. His return journey to Paris was interrupted by a sudden illness in Montreux. Soon he had recovered sufficiently to be off again to North Africa, visiting Léa on the way in a house which he had purchased for her in southern France. A second seizure in Tunis late in January 1924 proved fatal, but his death had been announced in Paris newspapers some months earlier. To the very end an air of mystery surrounded Canada's first great modernist.

Morrice's Canadian paintings find some reflection in the canvases of Kathleen Morris of another generation. Both subject matter and techniques are similar, and textured snow has the warmish tones of Morrice which contrast vividly with the cold blues and dazzling whites of Cullen and some others. Morrice himself admired Edmund Morris. This respect was not based on his Indian head pastels; Morris was not at all the same man when he turned to landscapes in oil. His *Quebec Terrace* (Poole Foundation, Edmonton) has delicate beauty and sensitivity, his early pastorals have a low-keyed tonal harmony which even Whistler would have admired, and at least one pastel study of a girl has the softly textured beauty of a Morrice painting.

Other Canadians of the time, minor when compared to the giant Morrice, reflect in varying degrees an appreciation of the sensitivity, tactile surfaces, and other 'painterly' approaches which seem to ally them with the art for art's sake school. J. M. Barnsley, in his soft nocturnes of the 1880s painted in French villages along the Seine, dis-

played certain Whistler qualities although at other times he seems to have looked at the painting of Boudin. F. M. Bell-Smith and Clarence Gagnon both discovered the delicacy of Boudin and Morrice when painting at coastal spas, the one on the Isle of Wight and the other along the French Channel beaches.

John Russell, who admired Morrice as 'a man with a splendid sense of colour and artistic quality, the best product that ever struck Paris from Canada,' went to Paris in 1905 and for a time his goal was an identical search for delicate pure sensual beauty. Morrice, on the other hand, petulantly inquired in 1909, 'Who is Russell? I have never seen any of his works in Paris.' He would have found them to be paintings of regattas and other beach scenes with nuances of pinks and greys. Russell was a pragmatist; he declared that the country where he made his living was the flag which he adhered to, and since he was then living in France, the tricolour was the largest flag.[4] Two years later he complained about the new Parisian fads and grumbled that 'smelly food is going to result from it all.' In reaction to Cubism, he reverted to slick realism.

Russell's skilfully painted sensuous nudes at the Canadian National Exhibition of 1927 were the cause of an unprecedented sensation in Toronto. By then he had completely abandoned his earlier style of pastel shades and slight tonal variations and instead adopted figurative realism. News reports, editorials, and dozens and dozens of letters appeared in the newspapers. Puritanical Toronto shuddered. One unmarried lady school teacher, visiting the art gallery, had to make a hasty exit when she found scarcely another woman there. Attendance skyrocketed; it had been 61,000 the year before, but reached an unprecedented 158,888 in 1927. Russell was always vociferous and controversial. He moved to Toronto and a studio exhibition of nudes created another but lesser sensation. A. Y. Jackson wrathfully denounced him when he dared to dub Canadian painting 'provincial.' Russell failed to live up to his promise, but during the early years of the century he was one of the few Canadian painters who was really aware of tonal beauty.

Laura Muntz Lyall likewise failed to accomplish all that her Parisian study promised, but her early mother and child compositions went beyond mere narrative in their unsurpassed subtleties and freedom of brushwork.

French Impressionism proved to be even more potent as a weapon against dull Salon painting than had the theories of Whistler. Its exponents began with a scientific study of light and *plein air*. They analysed

light in terms of the pure spectrum and were soundly berated when their revolutionary work achieved a more vivid, more colourful, and an infinitely more exciting 'impression' which played on the emotions as other contemporary paintings could never do.

Newfoundland-born Maurice Cullen, the first Canadian to exploit Impressionism, influenced a whole generation of his fellow Canadians. He began in business in Montreal, but had no interest in it and in 1888 left to study sculpture in Paris. This he soon abandoned for painting. After graduation he remained in Europe, painting first at Pont-Aven and Le Pouldu where Gauguin and his friends had been working two years earlier, and in fact painting from a different angle the same house which appears in one of Gauguin's canvases. A comparison of Cullen's crisp vermilion strokes and other characteristic techniques in this painting with those in Gauguin canvases points to the Canadian's familiarity with the French artist's work. Then Cullen went on to Sisley's home town of Moret, and to Giverny where Monet was making radical experiments in the painting of light. In Europe he made a close friend of Morrice, and the two painted together in Brittany, Venice, and Quebec. Whistler and Henri Rousseau were other European companions. Periodically he saw his older compatriot, William Brymner. There were five Cullen canvases in the 1894 Salon. He was elected the next year to the Société Nationale des Beaux-Arts at the same time as Sir John Lavery and Le Sidaner; Degas and Whistler were already members.

In spite of a rapidly growing reputation in France, Cullen returned in 1895 to Canada, where Monet's pictures continued to inspire him. His acceptance at home was to be slow and difficult. First he painted the wintry Canadian landscape; these pictures were bitterly condemned, not only because of his new approach in painting, but because official publicists disliked any suggestion that Canada should be regarded as a land of snows. *Logging in Winter, Beaupré* (fig. 104) was one of the earliest canvases in this country to make use of the Impressionist discoveries. Cullen recognized that cast shadows on snow were blue since the snow reflected the blue sky. Where the sunlight fell directly on the snow, he built up a gleaming light impasto. The public denounced him for his false colouring, yet he dared to oppose the popular concept and many other painters followed in the same vein. He had opened men's eyes to see snow in its manifold colours as it really is. These have been recognized not only by every subsequent major artist, but by every nature lover who, with Cullen's searching eye, finds 'Nature as a large book, with most of the pages still uncut.'

Before the end of the century Cullen began painting his second

great series of Canadian landscapes – Montreal on winter nights.
They poured out steadily during the next dozen or more years. Old
houses on Craig Street have lighted windows, cabs wait for their fares
along Dominion Square (fig. 105), and the neutral silhouettes of great
buildings bulk as faint outlines against the night sky. Sometimes the
pale moon rises while a faint afterglow still warms the western sky.
The whole series is low-keyed, but built up with brush strokes of great
vibrancy and richness for the city lights. He paints as an Impressionist,
but instead of loading his canvas with unmixed pure pigment in
Monet's manner, he fuses the various colours into a tonal harmony.

Cullen sold enough canvases to undertake a second overseas trip in
1900. Two years were spent in visiting his old haunts in Paris, Britta-
ny, and Holland and then he ventured further into North Africa.
There the sun's brilliance on the desert sands suggested a new, lighter
pigmentation. Yellow and ochre of sand became his favourite colours,
and after returning to Canada he painted snow on cloudy days in
ochre tones, and, in a monumental canvas of 1905, golden reflections
of the setting sun light Cape Diamond. Cullen continued to explore
the Canadian scene, visited Newfoundland, painted the St Lawrence
ice floes jostling ships in winter, and men harvesting ice as mist rises
from their new cuttings. The measure of his acceptance was that in
one year, 1925, his Montreal dealer turned over to him $11,000 from
the sale of his paintings. After 1912 Cullen and his friend Brymner of-
ten painted at Lac Tremblant. They were much together at Cullen's
Chambly cottage where he passed his summers, and it was in this
country retreat that he died.

Cullen moulded the thinking of his own generation of painters,
young men like his step-son, Robert Pilot, and the general public who
perceived through him new colour qualities in the Canadian winter
landscape. A. Y. Jackson, as a young Montreal revolutionary, was in-
spired by his work and has told how Cullen was a powerful stimulant
to the Group of Seven. Jackson himself worked as an Impressionist in
Italy, Lismer's early *Guide's Camp* (National Gallery of Canada) is
pure Monet, and J. E. H. MacDonald's *Tracks and Traffic* (Art Gallery
of Ontario) probably owes much to Cullen in its yellows, red, and
mauves.

W. H. Clapp of Montreal first studied under Brymner but went to
Paris when Pointillism was beginning to supersede Impressionism. He
returned to Montreal a few years after the turn of the century and
proceeded to paint landscapes of Sainte-Famille and other Quebec
districts. He experimented by using brilliant splashes of unbroken col-
our, and stylistically he falls between Impressionism and Pointillism.

Montreal laughed. One critic only, Laberge, appreciated what he was trying to do. Clapp, unable to withstand the opposition, went to study light in Jamaica and other southern places, and eventually moved to Oakland, California, where he headed its art gallery and seemingly abandoned his revolutionary techniques.

Aurèle de Foy Suzor-Coté, from little Arthabaska in rural Quebec, introduced the Impressionist style to his French-speaking compatriots. Suzor-Coté's first introduction to painting was as an assistant to Maxime Rousseau in decorating the local Arthabaska church. It was a traditional way for young Quebeckers to commence an art career. Then he and Joseph Saint-Charles went to Paris together and began art study in 1890, although Suzor-Coté had also had musical aspirations. Morrice and Suzor-Coté both registered at the Académie Julian in the same year; Morrice left a few days later when he was the butt of some student horse play, a not uncommon incident at this particular school. Suzor-Coté, on the other hand, faithfully served the dicta of his instructors for four years and went on to the Académie Colarossi and the École des Beaux-Arts. His early paintings are tight, carefully painted, and academic, as when he painted his student room in Paris or made figure studies. Even certain early landscapes show stylization.

The young Arthabaskan did not return to Canada permanently until 1908, and in the meantime he had discovered *plein air* painting. His early Impressionist canvases are very different from another type of formalized painting, such as *Les coteaux de Senlis* (Quebec Museum) of about 1907, picturing the countryside near Paris; they are directly and freshly painted but usually neither distinguished nor inspired in composition. On the other hand, a canvas in the National Gallery of Canada painted on the Normandy coast about 1908 has all the qualities of Sisley. The blue channel gleams, the whitewashed walls of a church and its hamlet are radiant, and in the foreground hedges and grass are alive with colour as only the Impressionists would paint them.

Suzor-Coté, like Cullen, painted winter snows on his return to Canada and introduced Impressionism to the French-speaking community. He preferred open streams whose blue water contrasted with the vari-hued snow on the bank. His small, directly painted landscapes are superb (fig. 107). Larger canvases may lack the same individual character, for sometimes when the subject is not uniquely Canadian he forgot the crisp Canadian air and gave an overlay of French haze, as for example, when farmers plough in Quebec just as the artist had seen farmers ploughing overseas. His interest in the *habitant* was abiding and among his most distinguished portraits are those of old Mme

Cyr of Arthabaska, and of her husband smoking his pipe (Montreal Museum of Fine Arts). His more ambitious later historical studies include *La mort de Montcalm*. Pastel studies of nudes and of fashionable ladies posed in the sun are brilliant in execution but remain slight in conception.

Clarence-A. Gagnon painted the sunny winter landscape of Baie-Saint-Paul on the lower St Lawrence after 1900 (fig. 106). He had a freshness of technique which closely approached Impressionism particularly in the early years of his career but which never quite reached it. His love of the *habitants* was passionate and intense, and he painted them at work or play with a background of quiet villages or the rural Quebec hillsides. The colour is brilliant; a meticulous technician, he even purchased a marble palette for grinding his own colours to achieve greater intensity. His earlier interest in picture making was a purely artistic venture; the subject matter became more picturesque at the time when the seductive romance of the simple peasant folk and their gaily painted houses lured him into illustration. His colour plates for *Le Grand Silence Blanc* and *Maria Chapdelaine* are intricate classics whose technical excellence far surpasses anything similar achieved by Canadians.

Impressionist and Post-Impressionist influence tempered works by lesser-known Canadians. It lifted their canvases out of dull mediocrity to transform them into glowing gems. Toronto-born Helen McNicoll is a case in point. After study under Brymner in Montreal, she went to London's Slade School of Art and then to St Ives in 1906 for work with A. Talmage. She died at an untimely early age in 1915. Her career was opening as a painter of figures set in landscapes filled with sheer sparkling sunshine.

These pioneer experimenters broke the academic hold over Canadian painting, although only after much bitterness and recrimination. Edmond Dyonnet, for years secretary of the Royal Canadian Academy, writing as late as 1913 about newer developments in art, could still regard the Impressionists as mere novelty seekers:

[N]o French-Canadian painter fortunately has dreamed of following in their folly those despisers of art [i.e., the Impressionists] who have undertaken the mission of denying beauty and proscribing truth. Cubists and Futurists may go by. Our country is too young not to be attracted by novelty, but it has enough native good sense not to allow itself to be made a fool of, or to take the grin of a monkey for the smile of a woman.[5]

Yet Morrice, Cullen, and others had created a climate receptive to radical change, had brightened the art scene, had given it a sense of meaning, and had prepared for future developments. Time after time since Confederation optimism and promise had been in the air but results had never seemed to match the promise. Now these men had opened the way for new concepts, and there would be achievement to reward the many efforts of the past.

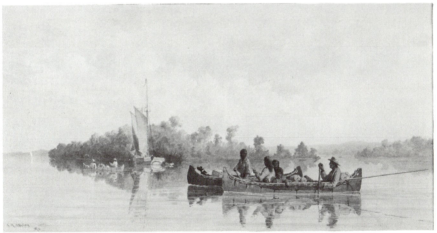

71 / Adolphe Vogt: *Coming Storm During Harvesting,* oil
38 1/4 x 66 inches (97.2 x 167.6 cm), 1870
Art Gallery of Windsor

72 / Lucius O'Brien: *Fishing Party Returning Home,* w.c.
9 1/2 x 18 inches (24.1 x 45.7 cm), 1874
Mrs Percy Band, Toronto

239

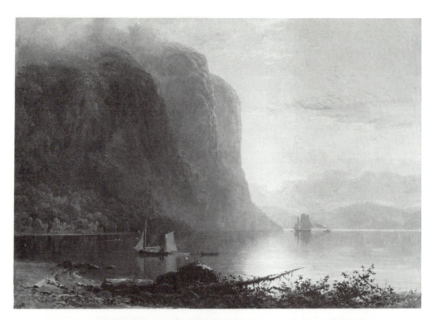

73 / Lucius O'Brien: *Sunrise on the Saguenay*
oil, 34 1/2 x 49 1/2 inches (87.6 x 125.7 cm), 1880
National Gallery of Canada

74 / Daniel Fowler: *Horses with Wagon*
w.c., 9 1/4 x 13 1/4 inches (23.5 x 33.7 cm), 1873
Miss M. Griffiths, Ottawa

240

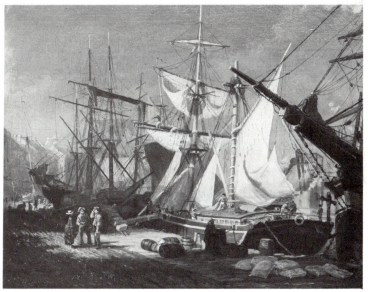

75 / John A. Fraser: *The Ferry at the Mission, Fort William*, w.c.
10 3/4 x 17 1/2 inches (27.3 x 44.5 cm), 1883
Mr and Mrs Jules Loeb, Toronto

76 / Henry Sandham: *Montreal Harbour*, oil
17 1/2 x 22 inches (44.5 x 55.9 cm), 1865
private collection

77 / F.M. Bell-Smith: *Lights of a City Street*
oil, 52 1/4 x 78 3/4 inches (132.7 x 200 cm), 1884
The Robert Simpson Company, Toronto

78 / John A. Fraser: *Percé Rock*, oil
25 x 60 inches (63.5 x 152.4 cm), undated
Metropolitan Toronto Library

79 / Allan Edson: *Trout Stream in the Forest*
oil 23 1/2 x 18 1/4 inches (59.7 x 46.4 cm), *c* 1880
National Gallery of Canada

243

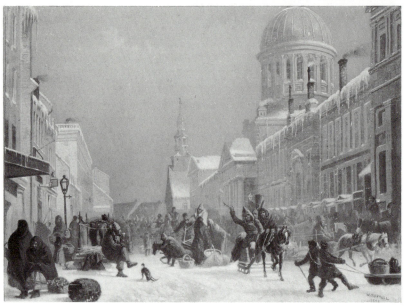

81 / *bottom* / William Raphael: *Bonsecours Market*, oil
12 x 16 inches (30.5 x 40.6 cm), 1880
Peter Winkworth, Montreal

80 / *opposite, top* / Otto Jacobi: *St. Anne River*, oil
20 1/2 x 40 1/2 inches (52 x 102.9 cm), 1865
Estate of C.M. MacAllister, Ottawa

82 / *above*/ T. Mower Martin: *Interior of the Great Illecillewaet Glacier*, w.c.
19 5/8 x 13 5/8 inches (49.8 x 34.6 cm), undated
Glenbow Foundation, Calgary

245

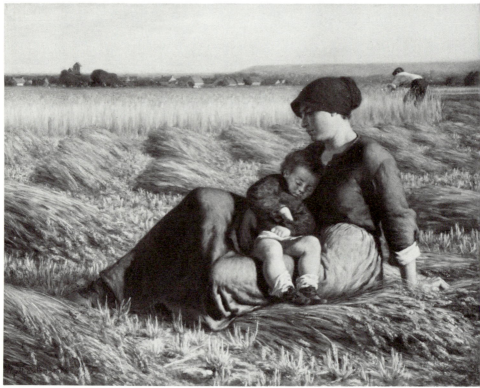

246

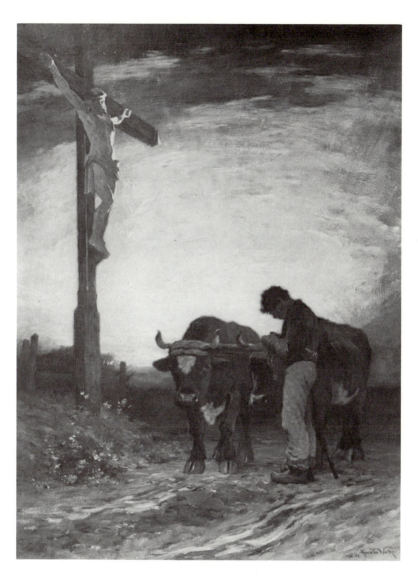

83 / *opposite, top* / Homer Watson: *After the Rain*, oil
32 x 49 1/2 inches (81.3 x 125.7 cm), 1883
Beaverbrook Art Gallery, Fredericton

84 / *opposite, bottom* / Wyatt Eaton: *The Harvest Field* , oil
35 1/2 x 46 1/2 inches (90.2 x 118.1 cm), 1884
Montreal Museum of Fine Arts

85 / *above* / Horatio Walker: *Ave Maria*
oil, 46 x 34 inches (116.8 x 86.4 cm), undated
Art Gallery of Hamilton

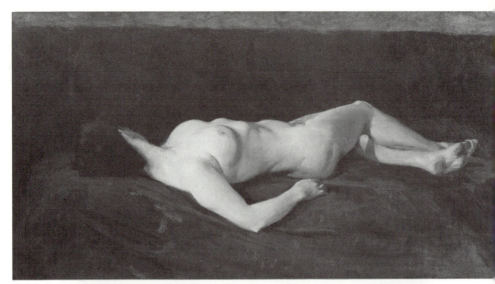

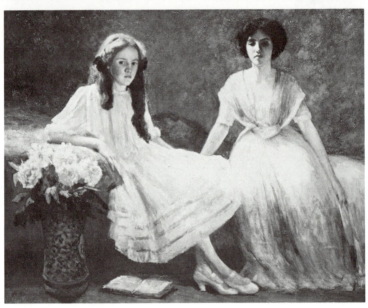

86 / William Brymner: *Reclining Figure*, oil
18 1/4 x 34 3/16 inches (46.4 x 86.8 cm), undated
Montreal Museum of Fine Arts

87 / William Brymner: *The Vaughan Sisters*, oil
40 x 50 1/2 inches (101.6 x 128.3 cm), 1910
Art Gallery of Hamilton

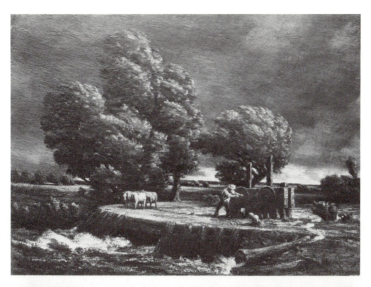

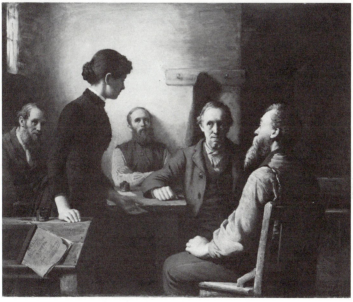

88 / Homer Watson: *The Flood Gate*, oil
32 1/2 x 46 3/4 inches (82.6 x 118.7 cm), 1900
National Gallery of Canada

89 / Robert Harris: *A Meeting of the School Trustees*, oil
39 1/4 x 48 1/2 inches (99.7 x 123.1 cm), 1886
National Gallery of Canada

249

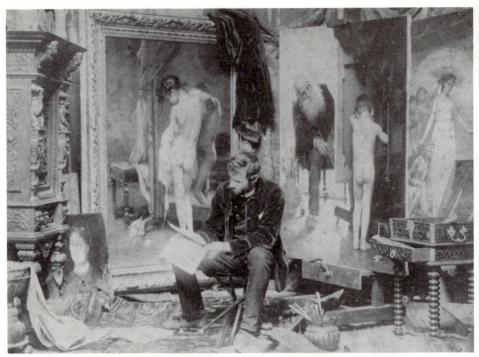

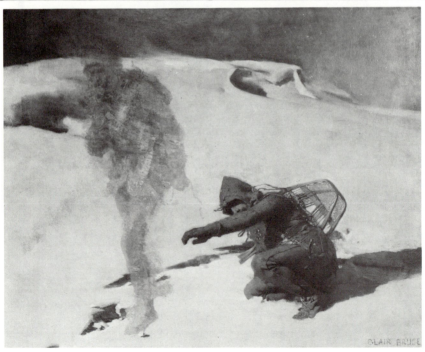

250

90 / *opposite, top* / View of the interior of Paul Peel's studio in Paris, France, 1889

91 / *opposite, bottom* / Blair Bruce: *The Phantom Hunter*, oil
59 1/2 x 75 1/4 inches (151.1 x 191.1 cm), undated
Art Gallery of Hamilton

92 / *above* / George Reid: *Forbidden Fruit*, oil
30 5/8 x 48 inches (77.8 x 121.9 cm), 1889
Art Gallery of Hamilton

251

93 / William Cruikshank: *Anne Cruikshank*
oil, 38 3/4 x 35 1/2 inches (98.4 x 90.1 cm), undated
Art Gallery of Ontario

252

94 / William Cruikshank: *Breaking A Road*, oil
35 x 68 inches (88.9 x 172.7 cm), 1894
National Gallery of Canada

95 / Charlotte M. Schreiber: *Springfield on the Credit*, oil
32 x 42 7/8 inches (81.5 x 108.9 cm), 1875
Mr and Mrs Fred Schaeffer, Thornhill

96 / Ozias Leduc: *Still Life*, oil
14 3/4 x 11 1/2 inches (37.5 x 29.2 cm), 1892
D. McLeish, Toronto

254

97 / Julian R. Seavey: *Music*
oil, 36 x 22 inches (91.4 x 55.9 cm), 1890
National Gallery of Canada

255

98 / Ozias Leduc: *Le musicien*, oil
20 x 22 inches (50.8 x 55.9 cm), 1892-9
M. and Mme Édouard Clerk

99 / Charles Gill: *Still Life*, oil
18 x 24 1/2 inches (45.7 x 62.2 cm), 1895
M. and Mme Maurice Corbeil, Montreal

256

100 / Charles Huot: *La Bataille des Plaines d'Abraham*, oil
16 x 22 1/2 inches (40.6 x 57.1 cm), undated
M. and Mme Maurice Corbeil, Montreal

101 / John Hammond: *Saint John Harbour*, oil
42 x 59 1/2 inches (106.7 x 151.1 cm), 1895
Owens Museum, Mount Allison University

257

102 / James Wilson Morrice: *The Woodpile, Sainte-Anne*, oil
17 1/4 x 25 1/4 inches (43.8 x 64.1 cm), undated
M. and Mme Maurice Corbeil, Montreal

103 / James Wilson Morrice: *On Shipboard*, oil
15 x 23 inches (38.1 x 58.4 cm), *c* 1900-3
H. Heward Stikeman, QC, Montreal

258

104 / Maurice Cullen: *Logging in Winter, Beaupré*, oil
25 1/4 x 33 1/2 inches (64.1 x 85 cm), 1896
Art Gallery of Hamilton

105 / Maurice Cullen: *Dominion Square, Montreal*, oil
32 1/2 x 40 1/4 inches (82.6 x 102.2 cm), undated
Beaverbrook Art Gallery, Fredericton

106 / Clarence Gagnon: *Spring Thaw*, oil
24 x 32 inches (61 x 81.3 cm)
Vancouver Art Gallery

107 / A. de F. Suzor-Coté: *Spring Landscape, Arthabaska*, oil
32 x 40 inches (81.3 x 101.6 cm), 1921
McGill University

Part Four
Nationalism and Internationalism
after 1910

22

Nationalism and the 'Group'

Nationalism is pointed to now as a laudable and unique feature inherent in paintings by the Group of Seven. Yet when these artists struck out in a new Canadian style, Toronto critics in particular were so indignant that an observer could but assume they had been personally insulted. The seven young revolutionaries had decided to paint 'Canada,' and they were evolving an approach, startlingly different from that of earlier artists, which they felt was appropriate to the Canadian scene. It was based on the landscape of Algonquin Park and the Georgian Bay area as first discovered through Tom Thomson's fresh little oil sketches: the bare Precambrian rock, the wide skies, lonely lakes and rivers, the sinuous dark pines, and the autumn colouring of the maples. All these were characteristic of the solitary northland, but critics and many other Canadians could see nothing typical of an emerging nation in such subject matter. An 'intellectual' closed circle of associates understood the meaning inherent in their probings. But the daily press during and long after the First World War published reams of bitter denunciation and invective about the decadent ideas which future Group members were spreading in their paintings and which most columnists felt were an affront to common decency.

Reaction to this incredible flood of adverse publicity and controversial bickering built up the prestige of both the Group of Seven and their associate, Tom Thomson, who died before the formation of the Group itself. Public discussion reached such a height that many Canadians soon began to assume that the new movement's paintings were the country's first and only real artistic achievement. Everything earlier tended to be forgotten or castigated as traditional and old-fashioned. The massive criticism moreover forced the emerging artists to close ranks in self-defence, and the spirit required to fend off attacks generated an extraordinary amount of personal loyalty among them.

No evaluation of the movement's real worth or of its shortcomings was possible during the aroused emotions of the twenties; a more objective analysis can now be made, but a final judgment will be possible only when personal feelings and involvement and an extraordinary worship of the artists no longer colour critical thinking.

A search for something 'Canadian' in painting had actually been the objective of several Toronto painters since the 1890s. W. A. Sherwood had published a long article on 'A National Spirit in Art'[1] in 1894. J. E. H. MacDonald, the senior member of the Group of Seven, declared in 1925 that the real origin of the new movement could be traced back to a much earlier period:

Men like Reid, Jefferys, and Fred Brigden, Arthur Goode, Conacher, Plaskett and others had their places as pioneers and encouragers. The Art League and its annual publications, the Graphic Arts Club, with its Canadian evenings (like the fellows all singing Sid Howard's canoe songs ranged like canoe-men on the benches), the visiting evenings we used to have at different artists' studios, to make half-hour compositions on Canadian subjects, with one chosen as critic for the evening. There was a real stirring of Canadian ideals. Old Cruikshank, for instance, with his *Breaking A Road*, was a more direct Canadian influence among us than Kreighoff, and Reid's City Hall Murals [painted in 1897-99 at his own expense to promote mural painting in Canada] meant much to us. Dave Thomson's name also comes to me as one of the local heroes. His pen drawings in the Art League Calendar, and his water-colours of Algonquin Park and Scarboro Bluffs, were landmarks to us. Dave was a real Canadian, but he got switched off the tracks in a Boston lithographing house, and there he uses his talents on Remington calendars and such like. But he married a French-Canadian wife and I have no doubt that the Canadian in him is not quite dead.[2]

The Toronto Art Students League mentioned by MacDonald, to which he briefly belonged, originated as a sketch club in 1886; members worked from the model in winter and out of doors from nature during the summer months, as did the French Impressionists. The club later adopted its more pretentious name. An active founding member was Robert Holmes whose love of Canadian wildflowers prompted a remarkable series of water-colours now preserved in the Art Gallery of Ontario (fig. 109). He taught at the Ontario College of Art during the First World War, where he continually and with great emphasis proclaimed that Canadian artists should use *Canadian material only* as their subject matter. William Cruikshank, also mentioned by MacDonald, enlivened the proceedings of the Club with his 'caustic dry Scot's wit'

of a not always kindly character. C. M. Manly, who organized the composition classes, spent much time sketching with Fred Brigden in many parts of Canada. Members of the League explored the Toronto district by foot on Saturday afternoons and Sundays, visiting the Don Valley, Scarborough, High Park, Port Credit, and Richmond Hill. Occasionally they strayed to Queenston and during summer vacations even as far as Quebec and the Maritimes. Many of their sketches were reproduced in the Toronto Art League Calendars, now eagerly sought by collectors, which were published annually from 1893 to 1904 under Charles W. Jefferys' supervision.

Jefferys was one of the League's pioneer disciples of Canadianism and declared vehemently that 'It is inevitable that a country with such marked physical characteristics as Canada possesses should impress itself forcefully upon our artists.' At first his subject matter was found in the Toronto ravines and suburbs, set down in quiet colours and muted tonal relationships. Then in 1907 he made the first of several annual visits to the Prairies, where he found the Qu'Appelle Valley particularly fascinating. His more brilliantly keyed canvases, *Western Sunlight, Lost Mountain Lake* (Fig. 108) and *Prairie Trail* (Art Gallery of Ontario), were painted from sketches made on these trips. He sought to discover the western landscape's real nature – its distant horizons, the repetition of horizontal lines, subtle variations of colour in the foliage, and the clearness of the atmosphere. Later Jefferys would preach the gospel of spruce and pine as a theme for Canadian painters. His vivid interpretations of the Prairies and his landscapes of other parts of Canada must have acted as powerful stimuli to members of the Group of Seven.

The Group of Seven movement passed through three phases. During the first, future members were training themselves to be artists in far-ranging places. Gradually they assembled in Toronto as their principal centre of activity, each bringing individual creative strengths. In 1914 they moved into the Studio Building: this new status initiated a second phase, during which they were able to spend long periods in creative painting. War interrupted, but they resumed their sketching in the north after 1918; two years later the first Group show was organized to place their best works on public view. It is difficult to determine the precise date when this second phase ended and the third phase appeared, but scattering of interest and loss of the earlier cohesive spirit became apparent in the 1920s. Some painters began to concentrate on more personal work; there was less 'club' spirit and a turning to more individual initiative. The third stage was well under way when the Group held its last exhibition in 1931. The Group disbanded

formally in 1933, and the Canadian Group of painters was organized to replace it.

Tom Thomson acted as an inspirational catalyst for the Group philosophy which in turn echoed the earlier efforts of Jefferys, Reid, and their circle. Little in his early life prophesied this hidden power. From youth he had always liked music but he did not take up painting until he joined his brother as a photo-engraver in a Seattle commercial art studio during 1901. There he studied art magazines and made his first tentative gropings as a designer and water-colourist. Thomson returned to Ontario and in 1905 was working in Toronto, where he began sketching in pencil, oil, and water-colour. An oil dated 1908, of a woman dressed in white picking roses in a garden, completely lacks the design and striking colour of his later landscapes; his commercial designs were the stylized leaf and stem motifs of the prevalent *Art Nouveau* which dictated certain mannerisms in his early landscapes, although these lessened with the passing years. His painting assumed new purpose and direction at about the time he joined the art department of a commercial firm popularly known as 'Grip' which had earlier become famous for its publication of J. W. Bengough cartoons. The supervisor, A. H. Robson, was most sympathetic to artists.

J. E. H. MacDonald had worked for the Grip firm from 1895 to 1903 and rejoined it in 1907, just a year before Thomson was to paint his early garden canvas. MacDonald's parents were Canadian, and he had studied at the Central Ontario School of Art and Design in Toronto under William Cruikshank and George Reid, and had served for a time as an apprentice with the Toronto Lithographing Company. Tall, spare, and of a sympathetic disposition, he served his art with devotion and intense honesty, and conserved his frail strength whenever possible so that he could throw himself with more vigour into his painting. His two other great loves were writing poetry and reading Whitman and Thoreau during sketching trips. Indeed the poetic overtones which are evident in his painting are like echoes of his literary interests, a quality not found in any of his associates' canvases. MacDonald and Thomson became fast friends at Grip, where they met Lismer, Varley (only briefly a firm employee), Johnston, and that great craftsman, Carmichael. This was a spirited, cohesive group of employees. MacDonald tells us that 'there was a lot of fun in general, and a healthy humility about art, even in "the bronc" [Lismer] himself, the darndest bronc you every saw.' By 1910 the Grip staff were sketching on Lake Scugog and in those villages ringing Toronto where the topography appealed to the instincts of the landscape painter.

Thomson's small brown and grey sketches of Lake Scugog are still honest and plodding, but all these men were developing the genuine love and understanding of the Canadian landscape which was necessary for successful and individualistic interpretation.

Ben Jackson, an avid northerner and fellow-employee at Grip, urged Thomson to visit Algonquin Park, and in May 1912 the two travelled there. Later that summer Thomson canoed with W. S. Broadhead through the Mississagi Provincial Forest Reserve. This was Thomson's real introduction to the Ontario northland, and he wrote to a friend describing the exhilaration of the scenery. It had prompted him to make innumerable sketches and to record the whole trip on roll after roll of photographic film; all these souvenirs except for two rolls of film were lost when their canoe capsized in a rapids almost at the end of their journey, and he was plunged into despair. The following winter he painted his first studio canvases – low-keyed shoreline views. Thomson's annual routine thereafter was to sketch in summer and paint larger canvases during the winter.

Broadhead was responsible not only for introducing Thomson to the northland, but for suggesting that Fred Brigden and his father should visit his old friend Arthur Lismer in Sheffield while they were touring England. The Brigdens spoke with such optimism about Canada's future that Lismer decided to emigrate to Toronto. He arrived early in 1911 with $5 in his pocket. The gregarious Lismer joined the Grip firm and became a close friend of Thomson and a member of the Arts and Letters Club where Lawren Harris played an active rôle. The Group were coming together.

Thomson's enthusiastic account of sketching in the northland fascinated Lismer, who as a newcomer found all these new surroundings something of an adventure. In September 1913 he went to Georgian Bay at the invitation of Dr James MacCallum, a Toronto ophthalmologist who had little academic knowledge of art but who was fascinated by Thomson's brilliant little sketches. So deeply did he feel the northland's message as painted by this group of friends that he became their patron during their years of experimentation. Lismer sketched during this first visit to the MacCallum cottage at Go-Home Bay. Many of his early paintings are in the broken colours of the Impressionists, the pristine pigments unmixed on the palette, and these create a glowing tapestry. He achieved an effect of sunlight in his *The Guide's Home, Algonquin*, 1914 (National Gallery of Canada), by painting in this manner; by using a similar technique in another canvas, the autumn hillside becomes radiant with red sumach and the blue lake shimmers in the distance. Lismer soon abandoned this almost pointil-

list manner, moving first into fauve-like experimental painting with bizarre chromatic harmonies. This was a logical development, since the Group worked during the autumn when the brilliant splashes of yellow, orange, and red of the hardwoods accented the green-blacks of the evergreens. By 1920 Lismer was beginning to develop more decorative designing in his paintings.

F. H. Varley followed Lismer to Toronto in the late summer of 1912. Both were from Sheffield and both had graduated from the Sheffield School of Fine Arts. Varley had a mop of red hair which, as Lismer put it , 'burned like a smouldering torch on top of a head that seemed to have been hacked out with a blunt hatchet,' and the colour was the symbol of his fiery nature. He respected his ancestor, John Varley, the noted nineteenth-century English water-colourist; he admired Turner, and, like him, always sought to 'come to grips with nature.' With meagre earnings and his father's help, Varley had financed his years of boisterous study in Antwerp at a school which was to look back upon two red-headed students of note: some years later tales circulated about Varley, but no one remembered Vincent Van Gogh. Varley's London days had been financially difficult, but two characteristics persisted throughout his various changes of fortune: his vision of paint as a vehicle to express aesthetic feeling, and an innate sensitivity which enabled him to discover hidden life and form in his surroundings.

Thomson was Varley's first Toronto companion. They walked together on Centre Island opposite the waterfront on many weekends during 1913, and at the end of the day returned to Thomson's room where the host entered and switched on the electric light with a highly placed kick. Their art experiences had been vastly different: Thomson had had a commercial art training and Varley a European background of fine art instruction. Though they talked exhaustively about painting, they never sketched together, and the weekend jaunts were abandoned the next year when Thomson and A. Y. Jackson shared quarters in the Studio Building.

Dr MacCallum apparently introduced Tom Thomson to Lawren Harris late in 1913, although there is evidence to support a meeting between the two a year earlier in J. E. H. MacDonald's studio. Harris had many contacts in the art world, but was never active in the commercial field. As a boy in Brantford, he drew constantly before attending St Andrew's College near Toronto with his brother. The two high-spirited lads kept school authorities in a constant turmoil with their pranks. His first year of academic study at the University of Toronto convinced Professor A. T. DeLury that Harris's true bent was paint-

ing, and on his advice Mrs Harris allowed her son to begin taking art classes. A Berlin school was chosen because his young uncle was studying there. From 1904 to 1907 Harris received a Germanically thorough training. He worked for two years at the studios during the morning with pencil, charcoal, and water-colour, sketched in the Berlin slums during the afternoon, and was back at the studio for figure work in the evenings. Another two years were devoted to figure painting in oil. Shlabitz, most powerful of all his teachers, even took the young Canadian on a walking tour through the Austrian Tyrol, playing flute accompaniments as they hiked along the mountain trails. Harris's art school training had been conventional, but he was shaken into unorthodoxy by a chance meeting with a young German intellectual whose philosophical speculations opened many new doors. Harris sketched in Palestine (he was always much attracted to the mysticism of the ancient East); then, completely reversing the atmosphere in which he worked, he drew a series of illustrations in the frontier logging camps of Minnesota. The young artist returned to Toronto during 1909, and rented his first studio over a grocery store near Bloor and Yonge Streets.

As a creative artist, Harris moved rapidly into a new life in Toronto. The light of the New World, wonderfully clear after the greys of Europe, had an exhilarating buoyancy and energy. He discovered and was excited by Eastern thought and philosophy as expounded by Roy Mitchell. He became a charter member of the Arts and Letters Club, which had been founded in 1908 and moved into more spacious quarters in September 1910. Subsequently all Group members would be closely associated with that club, 'the centre of living culture in Toronto.' Such were but a few of the intellectual stimulations for his receptive mind during those early Toronto years.

The old Toronto Jewish district known as the 'Ward,' which lay astride University Avenue south of College Street, fascinated Harris. With the possible exception of MacDonald, he was the earliest Group member to paint large 'finished' canvases in Toronto, and these were landscapes of the Ward. The group of 'portraits,' dating from 1910 to 1925, is of small rundown houses, many of roughcast, some of brick, with bright touches in their paint trim, and set amid chestnut trees, board fences, and refuse heaps. The façades seem always to be changing as the harsh summer sunlight is replaced in winter by days of dazzling brilliance or grey bluster. The earliest of these pictures are filled with anecdotal detail and accidental light and shade, but gradually the artist worked towards a monumental simplification. Broad surface planes were painted in bold, decisive strokes. A judicious arrangement

of evocative window and door shapes, and the spotting of brilliant colour over the whole, created vibrating surface tensions. For the first time, Post-Impressionist colour, hot and strident, had found its way into Canadian painting, the neutral greys of the roughcast enhancing this intensity (fig. 111).

Both Harris and MacDonald underwent profound changes in their attitudes towards painting during 1912 and 1913; there is obvious alteration in the appearance of their canvases. MacDonald, who had sketched sporadically from his first Grip days, had begun seriously to paint landscapes only a couple of years earlier. A rolling line in some canvases painted in Toronto's High Park during the spring of 1912 is related to the *Art Nouveau* details found in his commercial work. From a 1912 winter sketch he painted *Tracks and Traffic* (fig. 110), a large canvas of a frosty morning in Toronto with railway trains near the station puffing out clouds of smoke and steam. This canvas, worked up from a directly painted field study, is full of life and movement, particularly in the 'artificial' clouds and soft snow; the sketch was made into a stable composition through the heavy accents of vertical gas tanks and the dark horizontal lines of tracks and freight cars. The delicate pinks and yellows turn it into a warm symphony, echoing French Impressionism, even if there is not the same fresh unmixed pigment as in Monet's *Gare Saint-Lazare* of thirty-five years earlier, or even Lismer's landscapes of the next year. MacDonald made a trip to Georgian Bay in 1913, and painted log-pickers at work along the shore line; by shredding the darks of the rolling clouds and other features of the landscape he sought to create repeated controlled movement throughout. That same year he left Toronto for a new rural environment in suburban Thornhill. This stimulated changes in subject matter and composition; the flat farmland with the great open sky was best treated with straight low horizons, which are quiet and at rest. Thereafter he alternated between compositions which are static (as in the late Rocky Mountain landscapes) and those with recurring movements which echo each other like refrains in poetry; the two manners are evident even in canvases painted in the same district, for instance *The Solemn Land* (National Gallery of Canada) as opposed to *Falls, Montreal River* (fig. 112).

For years MacDonald had been aware of a nationalistic feeling buried deep within his subconscious mind. He came to realize that he was not just painting landscapes, but the face of his own country; a generation earlier Watson had had the same feeling. MacDonald discussed with Harris who was his first sketching companion 'an art expression which should embody the moods and character and spirit of

the country.' C. W. Jefferys had observed his new note in reviewing MacDonald's 1911 sketches exhibited at the Arts and Letters Club. It was this same exhibition which had first aroused Harris's interest in his work. Jefferys reported that in contrast to so many imitative tastes in Canada he was delighted to see the native character of this painting:

Mr. MacDonald's art is native – native as the rocks, snow or pine trees that are so largely his theme. In these sketches there is a refreshing absence of Europe, or anything else, save Canada ...[3]

Many nebulous thoughts on Canadian landscape painting were given cohesion and force in the minds of Harris and MacDonald after they saw an exhibition of Scandinavian painting in Buffalo in January 1913. After the visit, Harris wrote about the tremendous impact that recognition of the similarities had on them, for there they saw the rugged Scandinavian landscape which repeated the rocks and trees of Canada's Laurentian shield over and over again.

This visit turned out to be one of the most stimulating and rewarding experiences that either of us had had. Here was a large number of paintings which gave body to our rather nebulous ideas. Here were paintings of northern lands created in the spirit of the lands. Here was a landscape seen through the eyes, felt in the hearts, and understood by the minds of the people who knew and loved it. Here was an art, bold, vigorous, and uncompromising, embodying direct experiences of the great earth.[4]

The Scandinavian artists had reduced this kindred landscape to its basic harmonious rhythms. Some had grouped trees in a way which is reminiscent of Emily Carr's later work. Gustav A. F. Fjaestad's *Ripples*, a realistically painted, close-up study of a sunlit pool, especially impressed MacDonald; Harris was haunted for years by Harald Sohlberg's *Mountains: Winter Landscape*, where a distant peak is veiled in the dramatic mysticism of the unknown. Harris reacted to this Norwegian landscape by showing a growing interest in the development of the metaphysical in landscape, although he himself at this time was probably not fully conscious of it. He was to discover this same mysticism in the works of Nikolai Roerich, an expatriate Russian who visited Toronto some years later. After the visual impact of the Scandinavian exhibition, MacDonald and Harris set out in April on another expedition to paint Canada, sketching around Haliburton and along the upper Ottawa River, and then during October in the Laurentians with its Scandinavian-like terrain.

Alex Jackson was the last principal actor to join the unfolding Toronto drama. Although he was helping to support an over-burdened mother in Montreal, he had managed to attend William Brymner's evening classes, and then went to Europe on a cattle-boat for study at Julian's. Two European trips introduced him to new artistic approaches. He returned to Montreal and held a first, and successful, exhibition in 1910. A third European trip from September 1911 to January 1913 took him through England, France, and northern Italy. Many paintings completed at the time demonstrate a freedom akin to the style of the second-generation Impressionists. But Montreal would have none of this young radical's ideas when he arranged his second Montreal show. Only Sir William Van Horne was collecting Post-Impressionist paintings, and relatively few other collectors were bold enough to buy works even by Cullen or Morrice. Jackson's canvases of Sweetsburg, Quebec, conventional now but daring at the time, were little noticed and attracted no buyers. Discouraged, he seriously considered moving to the United States.

A single letter reversed the course of Jackson's life. Harris had seen *Edge of the Maple Woods* (National Gallery of Canada) and in 1913 asked MacDonald to write to Jackson on his behalf to inquire whether he still owned it. It was a semi-Impressionist painting of a sunlit slope at Sweetsburg, with patches of melting snow interspersed among the trees; in them sap is running, and the artist has paid special attention to the effects of the soft but strengthening April sunshine and to the life-reviving greens and yellows on the twigs. The canvas had been painted three years earlier, but of course Jackson still had it. Harris met him in Kitchener, purchased the painting, and discussed the new spirit enlivening Toronto art circles. He described the practical help which he and MacCallum proposed to give artists through their financing of the new Studio Building. They visualized this structure as a centre in Toronto for creative young painters sympathetic to the new version of Canada and Canadian painting. Here they could rent studios and work creatively without having to depend on commercial art for the bulk of their income. After his meeting with Harris, Jackson headed for Georgian Bay, passed a pleasant summer among friends and relatives, and with the coming of autumn and the departure of visitors settled down to serious painting. MacCallum searched Jackson out at the urging of Harris, and persuaded him to move into his own more comfortable cottage; when Jackson arrived at the MacCallum dock, he found Lismer leaving for Toronto after his first northern sketching trip. After the winter had really set in, Jackson went to Toronto and with Tom Thomson took a studio in the new building.

The first phase in the evolution of the Group of Seven was conclud-ed. Techniques and styles were falling into place. The philosophy, or more properly speaking the cult of Canadianism, symbolized by the Precambrian northern shield, and a sense of common purpose and kinship were generated which would hold these Toronto painters to-gether. They were now ready for productive years as landscape paint-ers with a very definite style new to Canada.

Tom Thomson and Algonquin Park are virtually synonymous from 1913 until Thomson's untimely death in 1917, and it was during these years that he was such a great inspiration to the others as a painter. In his own living he embodied the very spirit of the movement. He was an expert woodsman, he handled a canoe 'like an Indian,' and he was a fisherman of such prodigious success that he had a legendary reputa-tion throughout the whole region. Each year he returned to Mowat's Lodge on Canoe Lake where both the owner and Alex Fraser were his particular friends, and where he worked either as a guide to summer tourists or as a fire-ranger. Thomson particularly disliked the weeks spent as a ranger, since he was not permitted to take along his sketch-box. However he painted in early spring before the tourist influx when the snow lay in the folds of the rocks, or after the summer rush when the leaves had turned to reds, gold, and yellow, and the white birch were silhouetted against the evergreens. Much of the distinctive char-acter of Thomson's sketches came from his ability to pick out the un-dulating flow of line where the snow still lay in the igneous northern shield, and from the designs of autumn when blocks of colour arranged themselves in an almost non-objective manner. By the time he was ready to leave for Toronto in November, masses of rapidly moving clouds would be overshadowing the dead woodlands with their first threats of snow (fig. 113), the wild geese would be flying south, and he would be recording the sombre approach of winter. While working in the Park he painted great numbers of oil sketches on birch panels which measured 8½ by 10½ inches, although he had used smaller pan-els at an earlier date. In the 1915 season, he had already painted over one hundred panels by September. Later that same autumn he ac-companied the river drivers of the Booth Lumber Company down the Mattawa, sketching logs shooting through sluices, their rush as they made a great smooth arc cut by jets of foam, or the quiet lake waters through which the boats passed against a backdrop of rich, tapestry-like autumn colouring. Lumbermen and fishermen were the only figures ever introduced into his landscape.

These sketches by Thomson probed deeper and deeper into the col-

our and mystery of the Algonquin Park region. Tales persist of how he tossed into the bushes those sketches he considered failures, and how his painting companions sometimes rescued them. His colour areas became simpler, larger, and more brilliant. An autumn sketch in the Art Gallery of Ontario is virtually a mosaic of reds, oranges, yellows, and greens on a hillside; the large areas of flat colour are in juxtaposition with the blue band of water in the foreground and the deep blue sky behind. Jackson wrote at that time that 'Tom is doing some exciting stuff. He keeps one up to time. Very often I have to figure if I am leading or following. He plasters on the paint and gets fine quality ...'[5]

Each winter Thomson returned to Toronto. When in 1913 the Ontario government purchased his early canvas, *Northern River*, he abandoned commercial art, and that autumn Dr MacCallum offered him accommodation in the newly completed Studio Building on Severn Street. He left his old boarding house on Isabella Street and in January moved into the new building where he shared quarters with Jackson. In mid-February Jackson left to sketch first on Canoe Lake and then during the summer in the Rockies, but the two worked together again that autumn in the park, along with Varley and Lismer, before Jackson left for Montreal and overseas military service. The association of Thomson and Jackson was really very brief, but undoubtedly they influenced each other.

That winter Thomson and Frank Carmichael shared the studio. Young Carmichael, in spite of his gifts as a designer, had not yet learned to analyse the complex woodland motifs into a simplified pattern. Thomson spent his last two winters in a small abandoned builder's shack behind the Studio Building, which previously had served temporary duty as a henhouse, because he felt financially unable to live in the more luxurious quarters where he had formerly painted. Here he 'camped' in two tiny rooms, cooking 'mulligatawny stew' and frying bacon and eggs on a minute box stove as he would have done on the trail; he served his 'chow' to Curtis Williamson and other artist friends.

Thomson actually painted not more than about thirty canvases. His earliest of the northern landscape, painted in 1913, was dull in colour, but he soon adopted a more chromatic palette. It was Jackson who instructed him in the methods of painting up larger works. Thomson at first called on his early design training as well as on nature itself, but the stylization of commercial art lessened progressively as he developed through the years. Certainly at least one early landscape of pine trees by moonlight, painted about 1913 in muted blue and green and yellow, depends on *Art Nouveau* qualities; sinuous lines

of branches and the masses of foliage trees are repeated in the accented edges of the clouds, and the stylization is more apparent because of the lack of contrasting colours. There is gentler but still pronounced curving linear rhythm in the painting of a fisherman (Poole Foundation, Edmonton) where the swirl of the stream sweeping around a rocky cliff is repeated in the curve of the fisherman's line as he hooks a fish. Thomson's famous *Northern River*, painted in his studio in 1915, with its lattice work of trees and warm evening light bathing the water and shore line beyond, was suggested by an illustration of Swedish tapestry in *The Studio* of March 1913. Other later paintings have this same tapestry-like effect, which naturally meant that there was a very restricted pictorial plane. His best-known work, *West Wind* (fig. 114) still has *Art Nouveau* elements in the lines of the tree trunks blown to one side; on the other hand, the vigorous natural treatment of the clouds and rough water is the very element in his work by which Thomson went beyond a stilted design to breathe originality into his northern sketches. *The Jack Pine* is a stylized tree standing in solemn dignity; it is painted in strokes of broad and pure colour, and has monumental simplicity. *The Pointers* (fig. 115), if less heroic in concept, is one larger work in which integration of material and style has been most successfully achieved. It must be admitted, however, that with few exceptions Thomson found it difficult to bring into play in canvases the degree of vital and spontaneous freedom which made his sketches such unique expressions.

Thomson's sketches had developed with breath-taking rapidity for four years. The climax came in 1917 when he began in early spring to paint a daily record of nature's changing moods and aspects, even to the flowers (fig. 116). By July, he reported his project as virtually completed. The Frasers at Mowat Lodge saw him leaving in his canoe at noon on July 8 for an afternoon of fishing at Tea Lake Dam. The overturned canoe was found later that day, and his body was recovered on July 16. There were many rumours of foul play and much speculation about how the best-known canoeman of the north could have drowned by accident.

The life of this farm boy from Owen Sound, whose 'passionate interpretations' of the Canadian northland were cut short by his premature death, had much of the romantic about it. Adulated by his painter friends, finally discovered by the Canadian public, always news copy, he eventually became a legend. Jackson heard of his death during August 1917, while waiting in England for a passage to France where he was to paint Canadian soldiers in action. He wrote in consternation to MacDonald on 4 August 1917, mourning the loss of Thomson's inspirational spirit.

I could sit down and cry to think that while in all this turmoil over here there is a ray of light, and that the peace and quietness of the north country should be the scene of such a tragedy. It seems like the reversing of another tie which bound us to Canada, because without Tom the north country seems a desolation of bush and rock. He was the guide, the interpreter, and we the guests partaking of his hospitality so generously given. His name is so often coupled with mine in this new movement that it seemed almost like a partnership, and it was, in which I supplied the school learning, and practical methods of working, and helped Tom to realize the dreams which were stored up in the treasure house, while my debt to him is almost that of a new world, the north country, and a truer artist's vision, because as an artist he was rarely gifted.[6]

A memorial plaque, designed by J. E. H. MacDonald, was unveiled on a rocky hillside overlooking the place where Thomson's accidental drowning had occurred. Fellow artists and friends who knew the woodsman, painter, and man of the out-of-doors gathered in boats at a memorial service. At its conclusion they threw bouquets of wild flowers into the water for one who had loved the northern wilderness, and then silently watched as they were taken up by the waves and wind and dashed against the foot of the rocks.

War had dampened the Toronto painters' jubilant spirits in 1914. Harris, Jackson and Varley joined the Canadian Army. Harris was in uniform for nearly two years before being discharged as unfit for service and was the first to resume painting. Early in 1918, after by-passing Manitoulin Island, he and Dr MacCallum briefly visited rugged and paintable Algoma. They returned there with J. E. H. MacDonald and Franz Johnston in the autumn on the first of the celebrated 'boxcar' sketching trips.

Lismer lived in Halifax from 1916 to 1919, where he was principal of the Victoria School of Art and Design, and where he continued his experimental painting. His works at this time included some well-known canvases of camouflaged troop transports returning Canadian boys from overseas.

MacDonald worked on war posters in Toronto. He continued on alone in the city, painting landscapes in the new spirit and exhibiting as sole representative of the new movement. Virtually all the fire formerly directed against the whole 'Hot Mush' School was concentrated on him, so that although Harris was also exhibiting, MacDonald had to bear most of the wrath of enraged critics who were aghast at and indignant with the young radicals. Bitter invective was hurled at several of his paintings exhibited in Toronto during 1916. One was *The Elements, Georgian Bay* (fig. 117), a landscape of rounded ancient rock

knolls which had once been mighty mountains; a stylized sky is accentuated and made dramatic by heavy cloud structures. Simplicity is the keynote, in the best tradition of the new movement. *The Elements* summarizes, in fact, the essential style of the Group of Seven during their finest years: the use of the northland, the groping for a mood of nature, stylization tending to patterning based on the landscape, and the use of pure colour to sustain an inner vitality. MacDonald's *Tangled Garden* (National Gallery of Canada) is a tapestry-like mosaic of sunflowers and other autumn flowers flanked by the painter's frame country house at Thornhill; here, for the first time, MacDonald was living intimately with nature as he found it in Thoreau and Whitman: there was a clear spring brook close by, spruce trees, squirrels, and singing birds all about. In answer to his critics of those war years, MacDonald justified these canvases as 'living Canadian art':

It can be demonstrated that every one of these pictures is sound in composition. Their colour is good, in some cases superbly good; not one of them is too large. Their nationality is unmistakable. Undoubtedly they are not what the artist would like them to be, but they are truly interpretative if one understands and is interested in the Canadian landscape ... It would seem to be a fact that in a new country like ours which is practically unexplored artistically, courageous experiment is not only legitimate but vital to the development of living Canadian art. *Tangled Garden* and *The Elements* and a host more are but items in a big idea, the spirit of our native land. The artists hope to keep on striving to enlarge their own conception of that spirit. And they remember sometimes that the best in this kind are but shadows and the worst are no worse, if imagination amend them.[7]

Lord Beaverbrook, as wartime British Minister of Information, initiated the Canadian War Records. His first plan was that celebrated English artists should paint Canadian troops in action, but the group logically was expanded to include Canadians. Jackson and Varley were the first to be transferred to this branch, and Maurice Cullen, J. W. Beatty, David Milne, Franz Johnston, and others eventually painted Canadians either training or in action.

Jackson, a landscape painter, was astonished when his first assignment, Private J. C. Kerr, vc, was sent to him for a portrait; he struggled manfully to the end even if he did make the hero appear to have wooden matchstick legs. He was happier later in the front lines where he recorded camouflaged huts, bombed buildings, and the desolation of war-ravaged Flanders Fields; such subjects gave him an opportunity to use experimentally all manner of Post-Impressionist as well as

earlier Impressionist colouring effects, and also to exploit the gently undulating line which he so loved.

Throughout his war service, Varley retained his interest in humanity, painting lines of German prisoners being ferried from the front, a marching platoon passing a wayside cross with its shattered Christ, and the heaps of rotting corpses in *For What?* (fig. 118). When he was working in a shelled cemetery, man the living being was uppermost in his mind. He picked up a bone dislodged by a bursting shell, pondered on the life that had been, and entitled his canvas *Some Day the People Will Return* (National Museums of Canada). Varley's war paintings are expressions of tragedy and decay, grey in mood, with rotting greens, mauves, and ochres everywhere, and dominated by the gaunt forms of blasted trunks; all are supreme statements of the futility of war, but it is apparent that stylistically they echo the Expressionism of northern Europe.

David Milne as a war artist painted first in England, where his water-colours recorded Canadian troops in camp. Then went on to the deserted battlefields, with their broken crucifixes and other crushed symbols of Christianity, and the bombed buildings of what had been civilized Ypres. These paintings are in marked contrast to those executed by Jackson and Varley, being delicate studies of beauty with little sense of gloom. But they were painted in the joyful months that followed peace and Milne was able to be more detached than Varley, who had described the horror of the Western Front vividly in a letter to Lismer:

[Y]ou follow up a plank road and then cut off over festering ground, walking on the tips of shell holes which are filled with dark unholy water. You pass over swamps on rotting duck boards, past bleached bones of horses with their harness still on, past isolated crude crosses sticking up from the filth, and the stink of decay is flung all over.[8]

Peace came while Jackson was training in Canada for the projected Canadian Russian expeditionary force to Siberia. He was to accompany the troops as a war artist. He later recalled that his only bonus on discharge was a twelve-tube box of white paint, and mused that he probably became a snow painter because he could find no other use for the 'stuff'. He joined his old friends on their second Algoma trip late in 1919 and then worked in old Georgian Bay haunts in the depth of winter. There he found superb material, painting canvases like *The Freddy Channel* (fig. 119) in which he acieved an overall tapestry effect, as had Thomson earlier, by simplifying the islands, trees, and waters;

he caught the anatomy of the landscape, and then sprinkled his canvas with white as the falling snow blurred its harsh outlines. Jackson's pictorial statement of the Canadian north is simple but eloquent.

A joint exhibition by seven artists, the first 'Group of Seven' show, covered the walls of the Art Museum of Toronto for three weeks in May 1920. Participants were MacDonald, Varley, Jackson, Harris, Carmichael, Lismer, and Johnston. With the conclusion of war the time had come when these young men plainly felt that they should together present their discovery of what was for them a truly Canadian art style. Such a decision was particularly timely and significant: Canadians after their experiences in the First World War had a new sense of maturity and were searching for distinctive symbols of Canada. This first show's principal theme was the Algonquin landscape, and the foreword to the catalogue clearly sounded the new nationalistic note. It discussed art traditions, noting that a country's greatness depends on words, deeds, and art. Since art is an essential quality of human existence, intelligent individuals should welcome 'any form of Art expression that sincerely interprets the spirit of a nation's growth.' The seven exhibitors stoutly maintained that they made no pretence of being the only significant painters working in Canada, but asked for public confidence and public criticism; they realized that indifference to their work would be fatal.

Never before in Canada had a group of artists dared deliberately to paint and exhibit such a panorama of canvases, startling for that time in their bold execution, brilliant colour, and stylization. The perceptive public sensed what was individual and stimulating. Critics were alarmed. Hector Charlesworth led the attack of those who would not believe that this could be recognized as a new Canadian art movement. He and other critics schooled in earlier, muted harmonies were enraged, and, by now thoroughly aroused, poured forth invective even more bitter than they had showered on MacDonald in 1916. Yet, in future years, this same type of painting would come to dominate the art of English-speaking Canada; and in turn, as the cycles changed, would come a reaction against it. Lawren Harris, who wrote the foreword to the exhibition catalogue, has reminisced about the first startling reaction in the Canadian press. He recalled whole pages in newspapers and periodicals, remarking with satisfaction that such a display of 'anger, outrage, and cheap wit had never occurred in Canada before.' The paintings were compared to 'Hungarian goulash,' 'a drunkard's stomach,' 'a head cheese,' and so on. One critic wrote about what he considered was a mass exhibition of bad taste:

Nobody visiting this exhibition is likely to miss having his or her sense of colour, composition, proportion and good taste affronted by these canvases – all tinged with the same blustering spirit of post-impressionism – all conveying the same impression that the artist was out to make a sensation, did not know how to do it, and wasted considerable good pigment in a disastrous attempt.[9]

Caustic comments such as these and the many accusations that they were creating monstrosities failed to daunt the painters or to dampen their spirit.

Just before this first joint exhibition, their sketching expeditions had been resumed with the *camaraderie* of pre-war days. Harris, Jackson, MacDonald, and Lismer each had some part in the annual trips from 1918 to 1921 to the rugged Algoma country to the east of Lake Superior, a land cut by great rivers and dotted with lakes. During these expeditions they lived in a soon-to-be-famous old boxcar of the Algoma Central Railway which, shunted onto sidings, served as a base of operations. The variety of subject matter made them tingle with excitement. But as Jackson pointed out, and as can be seen in a painting of cloud patterns, his *Algoma, November* (National Gallery of Canada), seldom was 'a subject all composed and waiting to be painted. Out of the confusion of motifs, one had to be determined.' He personally preferred the long vistas from hilltops, with ranges of hills piling up in the distance, and tree trunks or some other simple motif providing an anchor in the foreground. The need for continually picking out new themes kept the painters alert. Nature was ever changing. Harris echoed Jackson in a more analytical statement:

We worked from early morning until dark in sun, grey weather or rain ... We found, for instance, that there was a wild richness and clarity of colour in the Algoma woods which made the colour in southern Ontario seem grey and subdued ... We found that one lake would be friendly, another charming and fairy-like, the next one remote in spirit beyond anything we had known, and again the next one harsh and inimical.[10]

Lismer and Harris were most interested in the tall spruce and tamarac which surrounded low-lying lakes. By reducing the spruce to their basic conical shapes, Harris was working towards the abstraction which later would dominate his canvases. MacDonald painted some brilliantly coloured yet intimate studies of low waterfalls, beaver dams, and small lakes. Other canvases assumed monumental proportions in spirit and size. Clouds passing over the richly coloured primeval hills that rim a northern lake add a sombre, brooding quality both

in MacDonald's *Solemn Land* (National Gallery of Canada) and in Franz Johnston's *God's Country*. MacDonald's *Northern Hilltop* (private collection) is dominated by a grotesque stump in the foreground, but a broad, warmly coloured valley stretches away to the far horizon. Among his most lively canvases are a related series of river views: a great rushing torrent tosses itself from rocky wall to rocky wall in its flight to the open valley; it topples the evergreens and everything else in its path, its foaming white waters contrasting with the reds, oranges, and yellows of the hillside and the distant blue haze of Indian summer.

After the Algoma expeditions, MacDonald worked apart from the other members, continuing as in the earlier 1920s to do some commercial art work such as book designing. Then he was named principal of the Ontario College of Art, a position he found exhausting. After his daily grind as a teacher, he would pace the floor at night upset by the stresses of the job. Each year this sensitive man looked forward to the grandeur of the Rockies, which he painted in flat areas of delicate greys, blues, and greens broken by bright touches of advancing yellow-greens, or by a many-hued rainbow; these paintings contrast with the linear patterns in those of Jackson and Harris. One winter he spent in the Bahamas, where the unclouded tropical sky and vivid light were physically and mentally stimulating. His death in 1932 was the first among the Group's members.

The last of the so-called 'Good Companions' sketching trips of the Group were to the Jackfish and Coldwell districts on the rugged shore of Lake Superior in 1922, 1923, and 1924. The trips were particularly significant for two of the men. There Carmichael evolved his distinctive style, building up ranges of clearly defined hills, one lying just above the other in a series of waves which go on and on into the far distance (fig. 120). He drew hundreds of pencil drawings of the northern hills and valleys on these trips. His emphasis on tone and linear draughtsmanship was combined with a deliberate restriction of colour which is often almost monochromatic.

On this north shore, too, Harris entered a completely new phase of development. Now he had unmistakably discovered country which he could paint in the mood he had noted years before at Buffalo in Sohlberg's Norwegian mountain canvas. His had been a continual search for bigness and drama; he painted nature as if it were about to resolve itself into abstraction, and with a simplicity of colour which gave 'a new combination of the arts – a melodious architecture of frozen poetry.' The Algoma woods he had found to be like walls restricting his vision, but now he could gaze out from the vast hills to the im-

mensity of Lake Superior. He discovered a powerful theme in the or-
dering of nature. Harris concentrated on the primeval shapes of the
simple island masses lying off the shore, on tree trunks, and on the
weird effects of the sun breaking through the autumn cloudbanks to
create a mysterious glow over the lake (fig. 121). A new monumental-
ity and impact came to his work which he developed further when he
and Jackson sketched together in the high Rockies. Jackson preferred
to paint the mountains after climbing to a great height so that the
landscape looked like a map spread out below with intersecting lines
of winding river valleys, the lower hills, and patches of vegetation. He
went alone to the Arctic regions in 1927 and 1928, but Harris accom-
panied him on a voyage aboard the *Beothic* in 1930. There Harris
found the same mysterious power which he had felt on the vast unin-
habited Lake Superior shore and among the majestic Rockies. He re-
corded the silent strangeness of the icebergs, with giant cloud forma-
tions whipped up by polar winds which rise like immense powerful
hands over the Arctic seas. Complete abstractions, and the exclusion
of all extraneous subject matter, would be just one further step. These
Lake Superior landscapes were a major bridge between Harris's early
Group landscapes and the radical, non-objective trends which would
revolutionize the outward aspect of world art between the wars.

Lismer was tempted to follow his three friends to the Rockies in the
late 1920s. He has reminisced about the challenge he faced of ade-
quately transferring to canvas the formidable soaring peaks. One ap-
pealed to a romantic facet in his nature. It reminded him of some
great Gothic building (fig. 122), and he tried to re-create the mood of
a medieval church in his painting. But he seems to have preferred to
paint in the more intimate Georgian Bay region. He returned on sev-
eral occasions to set down its rocky outcrops with autumn foliage and
shimmer of blue water and blue sky (fig. 123).

Jackson in these years of the 1920s discoverd the rhythms and the
picturesque qualities in the late autumn or the break-up of winter
along the north shore of the St Lawrence (fig. 124). Known locally as
Père Raquette, he exploited the same country in which Clarence Gag-
non had so successfully painted; here also he was often the sketching
companion of Albert H. Robinson. It seems possible that the basic
style of his landscapes, those sweeping lines which wave across his pic-
tures and which he painted consistently for forty years, was first fully
worked out in his paintings of Quebec snowscapes; they came from the
snow banks whipped up and sculptured by the wind on the rugged
north shore of the St Lawrence.

Although the word 'Seven' was still retained, L. L. FitzGerald,

Edwin Holgate, and A. J. Casson had meanwhile been added to the membership. New members brought new approaches. FitzGerald's contribution was so individualistic that he scarcely seems to belong with the Group. Casson painted the north country's small villages, and both Carmichael and Yvonne McKague Housser had similar interests. Casson's preoccupation with early Ontario architecture was foreshadowed at a fairly early date in his career in a remarkable canvas looking down at the geometrical shapes of snow-laden roof-tops in Toronto's 'Village' (fig. 125).

The Group of Seven held its second exhibition in 1921 and others sporadically until they were disbanded and the 'seven wise men' were replaced by the enlarged Canadian Group of Painters in 1933. Years before Johnston had resigned from the Group. When the new organization came into being, the classical phase of Group of Seven painting had ended.

Varley was the first major member to break away from the closely knit fraternity. In 1926 he was appointed head of the Department of Drawing and Painting at the Vancouver School of Art. Actually he had been the member least integrated with the Group in his approach to painting; he always sought for aesthetic feeling in paint rather than for a nationalistic expression. For him, if a picture lacked feeling, it was nothing. Humanity was really of more interest to him than the inanimate landscape, and some of his most impressive canvases of the 1920s were his portraits of Sir John Parkin and the Rt. Hon. Vincent Massey. These are direct and powerful, with bold silhouettes which give monumentality and dignity; they received instantaneous acclaim from observant critics. But nevertheless he was still a significant landscape painter in the earlier years of the Group movement, and his *Stormy Weather, Georgian Bay* (fig. 126) was one of the greatest individual triumphs in the Group exhibitions. It not only catches the northern spirit, but adds the emotional play of shimmering greens to the mighty struggle of natural forces. When he was to move to the Pacific coast, he looked forward to the rugged western landscape, and there sought for a new home which would have 'the golden sea in front and a snow-capped mountain seated at the bottom of the garden.' During his early years there, he made numerous sketches of Lynn Valley, and Garibaldi Mountain country which he found particularly exhilarating as sketching ground.

Other unexpected rewards came to Varley on the west coast. By 1928 he was caught up in the oriental atmosphere of Vancouver's Hastings Street, and, as he has said, was 'studying an early Chinese

painting and finding in it more of the spirit of British Columbia than any painting I've seen. I feel on the edge of discovering new fields of expression.' This excitement was passed on to his students who substituted for the sterotyped hours of careful academic drawing a freedom in which they 'danced nimbly back [to their easels] to emulate the master and listen eagerly while Varley poured out the heady wine of new freedom.' Fred Amess, who is now the head of the Vancouver School of Art and was then his student, has graphically described the excitement among those who worked under him.

We first imagined Varley to be a self-primed fount of knowledge, but we soon discovered that he was rather a spout through which flowed all the excitement of the world, spiced rather than tamed by sound aesthetic training. It was a violent stream that was hosed upon us, but these roots were nourished even if some washed away; and it was a directed steady stream. We soon learned that the reservoir of this enormous power lay in books. For drawing, it was Vernon Blake's 'Art and Craft of Drawing,' for colour it was Ostwald, and for history Élie Faure, with overtones of Freud in all cases.

For a while we were Oriental – running the gamut from Japanese wood cuts, illustrated by an actual Japanese wood-cutter who gave a convulsive speech in Japanese, and was followed by an interpreter who said, Mr Oshigo-go, he say ... to Hindu mysticism, accompanied by innumerable Oriental models capped by a delicious Russian priest who got the giggles during his poses and spoke no English.

During these periods we were deluged by prints, trips to China-town and fortunately through a Chinese Boy, Yitkon Ho, Chinese food. The girls in the class adopted a slightly squint-eyed aspect and became inscrutable. It was here that I was first introduced to Chinese horses, Persian manuscripts, Matisse and Japanese prints. Puvis de Chavannes was drafted in to defend the Occidental title to the decorative arts with Whistler – Aubrey Beardsley, an original English black and white artist, followed up behind.

Then Mr Varley discovered the Indians through Emily Carr whom he greatly admired and hailed as one of the greatest artists in Canada ... We were taught [in such a way that] ... now careful observation would be the theme, then freedom; flourishes and then meticulous control, sometimes slashing, then actually stroking the soft greys with a feather ...[11]

There is a mystical theme in Varley's own British Columbia paintings. It can be felt in *Dharana* dreaming in her 'timeless state,' as she sits on a porch looking out at the mountains brooding in the distance (fig. 127), or in the green expanse of *The Open Window* (Hart House, University of Toronto) which at one moment resolves itself into a

green sea with breakers beyond, and at another seems like a plain rising up to white-capped peaks. The mystery of darkness overlays *Night Ferry, Vancouver* (private collection). While the spiritual theme in *Dharana* is expressed in the girl with a landscape as setting, in some paintings the natural world itself becomes almost a living thing. In *Snow People* the white drifts swirl up into half-hidden human forms. (This painting the artist never wished to release for sale.) His anthropomorphic tendency became even more pronounced in some works which followed a trip on the northern patrol boat *Nascopi* in 1938. Varley brought back sketches of Eskimos and of the Arctic wastes; even the desolate regions are peopled, for when he stood before them in later years, he mused on the lines of the icebergs which concealed figures in the contours of the melting monoliths as if within even the coldest, most desolate creation of God there was still a living and breathing spirit.

After a number of years in British Columbia, during which he somehow weathered the Depression, Varley returned east. He gave private painting lessons in Ottawa during the war, moved on to Montreal, where sales were few, and finally returned to live in the Toronto area until his death. During these later years he probed deeper and deeper into an expression of mystery of feeling. Sometimes he caught responses similar to those experienced in Bonnard's paintings. At other times there is an almost sensual mystery, best illustrated by his interpretation of womanhood in the amazing *Nude on a Couch*; there are baffling pink tones and a most unusual spacing and composition. Always Varley's canvases have a tender lyrical note which comes from a response of the heart. He is remembered as one of the Group's truly outstanding painters, who went far beyond mere illustration to reveal highly spiritual qualities.

Harris left Toronto in 1934, ending a phase of figurative painting characterized by such works as *Red Sleigh, House – Winter*. He lived in New England until 1939, spent a year at Santa Fé, and then settled in Vancouver. His later paintings were abstractions in which he moved constantly towards non-objectivity. They more properly belong to the story of abstract art in this country rather than to that of the Group of Seven (see chapter 26).

Lismer dedicated his years after the 1920s to a dual rôle, that of creative landscape painter and of teacher and prophet. After the war years in Halifax, he taught from 1919 to 1927 at the Ontario College of Art. His appointment as educational supervisor at the adjoining Art Gallery of Toronto seemed an initiation into his real life work. Here he was committed to introducing the minds and eyes of children to

creativity and creative painting while they were still unhampered by inhibitions and fixed conventions. Lismer's theories were based on those of Cizek, a revolutionary Viennese art teacher, in whom he had such faith that he dared bring a special exhibition of paintings of Cizek's pupils to Toronto in 1927. Cizek's students had been permitted to visualize and create according to their own volition. 'There is an art that children create for themselves. The child makes pictures and drawings, not for grown-ups, but to make real his own desires, inclinations and dreams.'[12] Fortunately the imagination of the public was caught as Lismer's own feelings had been captivated by what these Viennese children could do under discreet guidance. Lismer's exciting morning classes at the Art Gallery of Toronto were carried on in the same spirit, and are remembered by many who first discovered what creativity meant during his nine years of instruction there.

Lismer had been so successful in Toronto that he was invited to South Africa to set up child art centres, then as a visiting professor to Columbia University in New York, where he fought deeply rooted prejudices on art instruction, and finally to Ottawa in an abortive attempt to set up a national art programme under the auspices of the National Gallery of Canada. In 1941 he took over supervision of the Montreal Art Association children's classes, which had been organized so skilfully by Ann Savage. There he continued to work with his beloved children. No man was ever more dedicated to opening the eyes of children to beauty and freeing their imaginations. He would have liked to make all Canadians, old and young, responsive to art. This aspiration is the kernel in an address which he delivered during a nationwide lecture tour in 1932, and in which he prophesied an ideal future where all men could enjoy painting.

'Can art show the way to the kind of cultural life all Canadians of all types and places ought to enjoy? Can it melt the icy grip of acquisitiveness?' How I've felt over and over again that this in an old man's country. The European is a much younger man – he's developed *his* corporate traditions. If we do as much in our own key, how joyfully alive we too can be – how much richer with our good newer customs and insights ...

It is not hard to say, then, what art should be. Art should be *awareness*, a sense of *spiritual alertness*, not put on like poetry. The farmer going out milking may be aware of its beauty, even though completely inarticulate.[13]

Through these years as evangelist and prophet of artistic freedom, Lismer was seeking for new forms of personal expression in his own painting. Radiant light illuminates the tree trunks in his later gloomy

and oppressive western forest interiors; there is a deep glow of stained glass in some still life canvases. These paintings have a heavy solidity, and an introspective approach to nature, far removed from and more contemplative than the obviously analytical paintings of nature's moods done forty or fifty years before.

Of all the seven members, Jackson in later life conformed most closely to the original Group formula. Not only did he continue to live in the Studio Building until 1954 when he moved to Ottawa (other members had left long before), but he continued to sketch in all parts of Canada until he reached advanced years. Field notes blossomed into numerous studio-painted canvases. His primary goal remained consistently the portrayal of the northern landscape; one year he visited the Alberta Foothills, another followed the Alaska Highway to Yellowknife and Great Slave or Great Bear Lake, in yet another painted the Arctic while meandering through the ice fields in a government supply boat with Sir Frederick Banting as his companion. Periodically he returned to the early haunts in Algoma and Algonquin Park. Almost yearly in early spring he revisited Saint-Tite-des-Caps, Baie Saint-Paul, or the Gaspé.

Jackson's colouring and style remained constant throughout the years. His is a symphonic type of painting and grows out of simple curving lines which combine into a larger united whole; he used this line in his treatment of the Precambrian rocks, of the western grain fields after the binder had swept over the rolling hills and left its linear patterning on the slopes, or in fact of any other aspect of nature which he chose to paint. Throughout his career Jackson showed a liking for neutral grey intermediate tones accented by vivid colours and darker lines.

Jackson was to remain the firmest propagandist of Group painting, long extolling its virtues, and long interpreting to all and sundry the message which he and his companions discovered and worked out years ago. He talked to old and young alike, to people with a multiplicity of backgrounds, ranging from miners to farmers to school children and ladies' groups, in many scattered places. His comments when talking and reminiscing to friends were biting and pithy as were blunt pronouncements on other, more public occasions, but this kindly, genial man had a multitude of friends throughout the land, a host of honorary university degrees, and up to his death in 1974 was venerated by many as the grand old man of Canadian painting.

Assessments of the contributions made by the Group of Seven to the whole story of Canadian painting vary, and will continue to vary. No

one, however, will deny that in their full vigour they created a high peak which has become familiar to all their countrymen; such an achievement has been approached on only a very few occasions in this country. There was enormous excitement during the years when the movement came into being, and its members, the first to speak loudly as consciously national Canadian painters, were able to make a real impact in the Dominion. They were not the first to think in this way, but they were the first to make artists and public listen and observe, and they inspired a host of followers. Looking back now, one is aware of the many deficiencies and shortcomings in their search for a painterly approach to picture-making, particularly their emphasis on the pictorial and dramatic elements, their inability to paint textures consistently, and their lack of concern for spatial relationships. But no single event in the story of Canadian art has made the mass of our people as aware of painting as did the struggle of the Group.

Undoubtedly the high point in interest, and the assurance of their final acceptance and triumph in Canada, was inspired from abroad as a result of London's Wembley Exhibition in 1924 and 1925. Eric Brown, director of the National Gallery of Canada, had been abused and dragged verbally in the most humiliating fashion across the floor of the House of Commons in Ottawa for championing the new movement. Members of Parliament were bitterly critical of the strong representation of Group of Seven paintings which he had sent to Wembley. To substantiate the correctness of his decision, he republished articles by various overseas critics who were not involved in any way with the participants in the controversy and could be objective.[14] C. Lewis Hind wrote that 'These Canadian landscapes, I think, are the most vital group of paintings produced since the war – indeed, this century.' J. M. Millman summed up their content as being of the essence of Canada and a genuine achievement of a Canadian spirit in paint:

Canada reveals herself in colours all her own, colours in which the environment of Nature plays no insignificant part. She has mixed her colours with her restless unrestrained energy, her uncontrolled forces. We feel, as we look at these pictures, the rush of the mighty winds as they sweep the prairies, the swirl and roar of the swollen river torrents, and the awful silent majesty of her snows. And such is Canada's art – the 'pourings out' of men and women whose souls reflect the expansiveness of their wide horizons, who dream their dreams, 'and express themselves in form and colour' upon the canvas.[15]

A vast widening of the horizon which enabled them to see and set

down the mighty forces of Canada in all their primeval power was the legacy which these 'young giants' of the Group of Seven bequeathed to future Canadian artists.

23

Contemporaries of the 'Group'

The painting of Canadian landscape was infectious among artists during the 1920s. Undoubtedly the publicity stirred up by the Group of Seven incited other artists to activity, and some of this generation were virtually co-workers of the Toronto men. On occasion they visited and painted with the Torontonians. A. H. Robertson, Randolph Hewton, and others attacked the Quebec winter landscape in much the same spirit as A. Y. Jackson. But other painters with a much more personal and original viewpoint struck out on their own special paths. Each of them had at some time recorded the Canadian landscape on canvas; but they went on to explore other subject matter such as still life or genre, and they approached their painting in a more subjective way. Emily Carr was overwhelmed by the prolific forest growth along the Pacific and the brooding mysticism of Indian mythology and religious belief. Marc-Aurèle Fortin, a few of whose landscapes have characteristics in common with those of the Group, struggled at other times to express a sense of sheer brute power, a religious mysticism, or an orchestration of colour. David Milne, one of the generation's most sophisticated painters, used landscape and still life merely as a point of departure in his search for a purely aesthetic and tonal expression.

Emily Carr, Canada's best-known woman painter, became an effective innovator in an almost totally unsympathetic British Columbia. Her paintings are all the more remarkable since for years there was not one understanding fellow artist with whom she could discuss her ambitions or her problems, or who could intelligently criticize her work or offer words of encouragement.

Victoria was indignant at Emily Carr's personal revolt against convention, and the accounts we have of her struggle against misunderstanding make it apparent that only a woman of character, determination, and an almost superhumanly powerful vision could have

survived the trials she faced. There was a great storm and a deep snow the night she was born, and that storm was never quite lulled in her life, for she was 'always ... tossing and wrestling and buffeting it.' She was a dumpy little woman but she fought for her art with a giant will. A little-suspected kindness lay beneath the brusque defensive shell, and she commanded respect, not from the art club, but from such unlikely people as the Chinese laundryman and the coloured coalman. Lonely Emily in her quest for companionship gave pathetic love to her pet monkey, Woo, and her dogs and cats; respectable Beacon Hill was shocked when she wheeled her animals in a baby carriage while shopping at the local grocery store. Yet she had a practical bent and installed pulleys in the living room ceiling to hoist the furniture high and make a clear studio space when she wanted to paint.

Richard Carr, Emily's father, was an adventurous Englishman who settled in Victoria during 1873 after prospecting for gold in California and visiting out-of-the-way regions in Central and South America. Though he became a prosperous merchant, he passed on to his daughter some of his own feeling for adventure, and he encouraged his little rebel in drawing. After his death, a guardian advanced money for her to study at the San Francisco School of Art. Emily returned home in 1895, fixed up a small studio in an upstairs room of a shed near her home reached by an outside set of stairs, was a model of propriety, and was accepted locally as a successful art teacher. Occasionally she strayed into political cartooning for the local newspaper, and even did some humorous book illustrations, but she kept her paintings satisfactorily conventional and academic.

When Miss Carr began study at London's Westminster School of Art about 1899, she missed the wild Pacific coast, poor health followed, and a year in a sanitorium outside London 'wilted the very life out of me.' She was exhilarated when she returned to the western spaces and began sketching the Indian villages, but she felt she couldn't quite capture the emotional impact which the shy primitive peoples were making on her. Again in 1910 she went overseas where her principal acquaintances during several months in France were Frances Hodgkins and Harry Gibb of Australia. She there learned how pure vibrating Fauve colouring could transfer an emotional impact to a canvas. Thereafter she was an inveterate and unconventional experimenter, who exploited revolutionary trends which went far beyond her timid western Canadian contemporaries. She drove herself on into her future rôle as a solitary worker.

Innumerable sketching trips to Indian villages along the coast (fig. 128) raised her spirits. She observed the Indians themselves, the beau-

tiful old weathered totem poles (fig. 130), and the house fronts, and these she often recorded in brilliant colours. Her pictures were ridiculed locally, and Victoria citizens became so angry that schools where she had formerly taught refused to rehire her. Her only compensation was the momentary exaltation she found in her painting. Yet money was needed to keep alive, so she bought her 'House of All Sorts,' a kind of boarding house. While operating this establishment, she painted infrequently since discouragements forced long periods of idleness. She was so poor that she had to beg local yachtsmen for rides to likely sketching grounds at times when she felt that she was mentally able to cope with work at coastal Indian villages.

More extensive trips aroused her at other times. One to the Skeena River country in 1928 began when she went in from the coast for seven miles to a northern village, riding over the difficult track in a wagon with the local Indian chief, his son and four Indians, one of whom was returning from jail. At Kitwancool village it stormed for five of the ten days of her stay, and sometimes in sheer desperation she crawled into little grave houses which were wet and cold and seldom offered her the view she would have liked; but in spite of her difficulties, she *did* sketch. Miss Carr was attracted to the totems, despite their run-down condition, and felt that the carving had special merit. After she had spent her first night in the open, the chief gave her a corner of his large one-roomed house with its cheery fire and kindly family associations; two babies hung from the rafters in a cradle which kept rocking constantly, for everyone who passed by gave it a shove. These were people whom she instinctively loved and understood. The similarity of the carved faces on the totems to those of the Indians impressed her, and she looked on them as family portraits. Later she lived in an abandoned school house on the Nass River, sketching with her companions, the little dog, Ginger Pup, and a half-dozen starved Indian dogs fending for themselves in the deserted village. She encountered incessant rain in the Queen Charlotte Islands, was seasick on the rough seas, and returned home frustrated at her inability to sketch the exciting Indian villages which she yearned to paint. Nevertheless by means of these and numerous other successful expeditions, she built up through the years a remarkable panorama of the Indian villages.

Life was more tolerable in the later 1920s and 1930s because of new acquaintances. The Indians described their strange woman guest to Marius Barbeau, who sought her out in Victoria. Then came a visit from Eric Brown of the National Gallery of Canada, and a trip which she made to Ottawa and Toronto in 1927 where the enthusiasm, sym-

pathy and understanding of the Group of Seven cheered the lonely artist. Lady Tweedsmuir honoured her with a call a few years later. There were other friends. Mark Tobey spent two summers in Victoria; through him she discovered Cubism, which gave her paintings a new character by supplying an underlying structural form and solidarity.

One memorable year Emily purchased a van with a smelly stove, a bed, and accommodation for Woo, three dogs, a parrot, and a white rat. In this she lived during the summer among the gigantic cedars, painting by day and reading Walt Whitman at night. Her mind absorbed and became a part of the forest while she worked:

One night I had a dream of greenery. I never attacked the painting of growing foliage quite the same after the dream I think; growing foliage had become something different to me. In my dreams I saw a wooded hillside, an ordinary slope such as one might see along any roadside, tree-covered, normal, no particular pattern or design to catch an artist's eye were he seeing subject matter. But in my dream that hillside suddenly lived – weighted with sap, burning green in every leaf, every scrap of it vital.[1]

She tried to catch this vitality, this 'bigness of nature,' and in so doing 'clung to the earth and her dear shapes, her density, her herbage ...'

A serious illness in 1937 slowed her activity and the next September she lived on a farm near Victoria with the forest a few yards from the cottage door; her 'joy at being loose in the woods again was *terrific*.'[2] Even the sea was within her limited walking distance. She painted the forest as if it were a living, powerful sea, wave on wave of trees sweeping over the landscape. The trees were like great gaunt sentinels against a vibrant sky. She poured all of her feelings into this wonder at nature in her native province.

Emily Carr continued to be plagued by illness during her last years, but she painted right up until a few weeks before her death, and wrote of her experiences as a painter and lover of nature during the hours when she was resting. Long-delayed local appreciation of her one-man shows in Vancouver and Victoria was some compensation for the former days when the ladies of Victoria at their annual exhibitions had hidden her paintings on the backs of screens so that they wouldn't disgrace the pretty flower studies. Her triumph was a completely personal one. Her iron will and her sensitivity to her surroundings have not been equalled by any other Canadian woman painter.

W. P. Weston, when he emigrated from his native England to Vancouver in 1909, was overawed by the immense scale of nature, in contrast to Emily Carr who had been inspired by the spiritual quality in

both the primitive peoples and nature itself. Weston has written about the impression this land made upon him:

[F]rom the first [I] was fascinated by the mountains – their terrific size, their wonderful structural forms with the consequent interesting snow patterns. I wanted to paint them, but I lived here for years before fully realizing them and their absolutely different atmosphere to anything I had seen in England.[3]

Weston sometimes climbed high to see the mountains at first hand, and sometimes sailed along the coast to examine them from afar. Gradually he came to feel that the way to express their size and grandeur was to show them as great solitary forms, accented occasionally by equally stark tree trunks. At other times he roamed the beaches of Vancouver Island, and was struck by the gnarled roots of giant cedars which, like the creased faces of old men and women, had a character built up through the many storms of a long lifetime.

Marc-Aurèle Fortin, living in Quebec, had a vacillating and sometimes turbulent soul which is reflected in the many aspects of his paintings; his works range from the vital and meaningful to the mediocre. No integrated, rational stylistic development is apparent in Fortin's paintings in contrast to the evolution readily seen in the works of Emily Carr, yet a vital spark shines out from many, and these make him a major French-speaking landscape painter of his generation.

Fortin's training had been unconventional. As a youth in Montreal he alternately worked in the post office and studied in his spare time with Ludger Larose and Edmond Dyonnet, whose painting creeds left little room for adventure or creativity. He was thus compelled to work out his approaches alone, and the diversities in his style have branded him as an eclectic. He was restless, first going to Edmonton in 1908, and there saving sufficient money for a visit to Chicago, Boston, and New York before he returned home in 1914. He saw great painting for the first time at the Art Institute of Chicago. Three unlikely artists influenced his thinking. Frank Brangwyn, the Anglo-Belgian painter, struck a responsive note because of the vigorous, ambitious, and sweeping effects in his canvases. Sir Alfred East's book on landscape painting provided him with his landscape style. The third artist who impressed him was the today virtually unknown Spaniard, Sorolla y Bastida, and memories of his paintings drew Fortin in 1935 to southern France and northern Italy rather than to Paris and the north. He was briefly interested in the Barbizon painters.

Sometimes Fortin is the gentle lyrical poet as in his best-loved landscapes, pastoral canvases of the villages of Sainte-Rose and others

along the north shore of Montreal Island, which date from the late 1920s and 1930s. In these quiet oils streets are lined with limpid green or yellow-green elms and maples which cast a soothing shade, and great white cumulus clouds drift overhead in the rich blue sky. The village houses in his *Paysage, Ahuntsic* (fig. 129) are biting reds, yellows, and blues as a foil to the more soothing colours. This use of fully chromatic colour with few modulating greys is characteristic of many paintings during this period. Occasionally a summer thunderstorm disturbs the placid countryside, but even the black clouds and forked lightning are subordinated to the beauty of the rural scenes.

For his more vigorous painting, Fortin turned to Montreal. Yet he always kept himself aloof from the city itself, looking at it from afar rather than identifying himself with its life. City streets of Montreal in *Sous le ciel d'Hochelaga* (private collection) and *Paysage à Hochelaga* (National Gallery of Canada) are like dark forbidding canyons, and when he painted the Jacques Cartier Bridge under construction (National Gallery) or other views of the city, the panoramas had an air of detachment.

Fortin's style changed after his trip to southern Europe in 1935. At that time he began painting in brilliant, almost luminous colour, made intense by his working over a dark brown or black underpainting. Sometimes burning ambition, defiance, exasperation with convention all drove him to attempt greater things. He stabbed desperately and quickly with his brush to release in paint the pent-up turbulence within him, and this impetuous approach gave a rough 'unfinished' result. There is some affinity between this intense desire for creation and that of Van Gogh, particularly in Fortin's Venetian landscapes. A powerful coloured drawing of two bulls fighting, possibly inspired by a Brangwyn painting, is completely different in technique but typifies this inner conflict; the animals fairly tear the ground as they hurl their knobby bulks defiantly at each other.

Possibly the vacillation and turbulence in Fortin's painting is explicable in terms of his background. In being an artist at all, he had broken with convention: no judge's son from Sainte-Rose would normally become a painter. His father belonged to a middle-class society doing its conventional duty to church, state, and fellow man, and to defy his family's wishes was no easy decision. Then at times he was filled with religious fervour beyond passive acceptance of the normal creed. It is also possible that he was troubled because he was never able quite to reach his personal goal, and would alternately strive for great things and accept with equanimity the fate of not being of the masters. He was never appreciated in the way he would have liked. True, every

cultured French-Canadian home around Montreal in the 1930s had a Fortin landscape: they were purchased partly because the subject matter was so typical of the beloved Province of Quebec and was painted by one of its sons, and partly because it was the accepted thing to do. But Fortin wanted people not just to buy his paintings but to understand what he wanted to say.

Fortin's later paintings often deteriorated into merely picturesque illustration, lacking tension and dynamism. He was never happy with an urbanized, mechanized world, and with modernism in art; when Montreal bustled with art controversies engendered by Pellan and others in the 1940s, his reaction was to escape to Gaspé. His later years were harsh with ill health, and he was forced to stop painting in 1950 when he lost both legs. He lived apart for twelve years, but with rare courage he resumed painting again in 1962, in a wheel chair, defying his infirmity as he had defied and been indifferent to society for much of his life.

Fortin, in a sense, accomplished in Quebec what the Group of Seven had accomplished in Ontario: he painted the Quebec landscape as a symbol of the way in which he knew and felt it. Yet he was never nationalistic in his feelings, and was too complex to be seduced by any picture-making formula such as a reliance on rhythmical line or rigid stylization. And he had one feature which is never found in the work of the Ontario artists: a religious overtone often lifts Fortin's work above any danger of mere illustration.

Albert H. Robinson painted a more placid Quebec than could Fortin, whose inner emotions often drove him to excesses. Robinson sought inner satisfaction by painting pictures of dull days in gentle warm greys accented by blues, with soft oranges and pinks; occasionally, he saw more brittle colour in the bright sunshine of a clear winter day. Most lack any suggestion of harshness, even in colouring. Robinson had been born in Hamilton, Ontario, but since his parents were married in the Province of Quebec, he often fondly described himself as a 'pea souper' for he loved the older parts of Canada and spent much of his later life in Montreal. Rural villages – the horse and sleigh in winter, the winding streets and roads – gave him his motif. *Afternoon, Saint-Siméon* (fig. 131) is one canvas in which he was tempted to use sharper colouring than usual. The rolling hills and open waters of the St Lawrence in winter recur in his canvases. He refused to allow his art to become romantic or picturesque. *Moonlight, Saint-Tite-des-Caps* (National Gallery of Canada) has subtle counterpoint in the green sky lighted by pin-points of stars and the squares of yellow windows in the winter night. His studies of Montreal churches in the National Gallery

and the Art Gallery of Ontario have painterly qualities that are reminiscent of a more picturesque Morrice.

Montreal had a lively English-speaking art colony in the 1920s of which Robinson was a member. No doubt many of the Montrealers were inspired by their Toronto counterparts; Jackson, a former Montrealer, often visited them. They rented a studio in an old building on Beaver Hall Hill and were known unofficially as the Beaver Hall Group. Edwin Holgate, who had exhibited as a somewhat reluctant member of the Group of Seven, was one of the more important painters of the Beaver Hall Group, but he was as much interested in the men of the north as in the features of the northern landscape. He painted an old fire-ranger (fig. 132) as a living symbol of the woods. But he refused to be restricted to any particular subject, working on nude studies, or flowers and landscapes as the mood struck him. Randolph Hewton also worked from the nude; his Quebec landscapes are so similar to A. Y. Jackson's as to be mistaken sometimes for those of his great mentor. There were many outstanding women painters in this Montreal Group. Prudence Heward, a most intense and complex painter, imparted to her canvases of girls in the outdoors an earthy quality which makes the figures seem part of the landscape itself. Mabel May painted both the balloon man with children in Westmount Park and country vistas along the Ottawa River. Sarah Robinson and Ann Savage found their greatest satisfaction in landscapes, and Lilias Torrance Newton preferred portraiture.

Two men of the 'Group' generation, William Wood and David Milne, each had Georgian Bay connections, for the latter had spent his youth at Owen Sound and the former his old age at Midland, but their paintings are far removed from the symbolic Georgian Bay landscapes of Jackson, Lismer, and the others.

William Wood was one of those humble men who are passionately fond of painting, and he typified the enlightened and sensitive semi-amateurs who have enriched the art of the nation's more ambitious professionals. In later life he was employed in the Midland shipyards, but he had actually had some brief art instruction at the Ontario College of Art in Toronto, where he knew Cruikshank, and in a Boston art school. It was typical of this unassuming man that, in writing of his career, he described how his father was a Scottish immigrant who had delivered milk at the Houses of Parliament in Ottawa and then had moved to a small mortgaged farm near Port Colborne, Ontario. Wood never departed from the austerity of his childhood and his honest forefathers; he worked as a sailor, as a homesteader in Manitoba, dug sewers in Boston, and even for a time assisted in a paint shop operated by

Frank Carmichael's father in Orillia. He painted simple people, the simple things of life, and his friends in their moments of relaxation. *Memory's Melodies* (Hart House, University of Toronto) is not just a portrait of a woman playing a violin; she is Mrs Grant, an old friend's wife, playing the songs of Scotland loved by the Scottish immigrants. Wood believed that he achieved the over-all glow in this painting because he had accidentally used home-made paint compounded with boiled oil, and then declared that he could never let himself go with expensive oil colours. In *Summer Evening*, his friends dance for relaxation. The painting goes far beyond the naïve qualities of the novice amateur, for the artist had an innate sense of spatial relationships and there is a soft tactile quality in the brush strokes. It is closer in its painterly response to Morrice than it is to the figurative Cullen, a strange anomaly since Wood was befriended and encouraged by the Group of Seven.

Certain academically-oriented artists, of course, painted such conventional works that they aroused little wrathful criticism during the years of controversy over the Group. A few, indeed, were even among its vociferous critics. Some were financially very successful, particularly those academicians who took official portraits as their chief interest. Sir E. Wyly Grier and Horne Russell, both portrait painters, served as presidents of the Royal Canadian Academy. The former had much Toronto 'establishment' patronage, although his clients came from all parts of the country; the latter was the painter of fashionable Montreal society and even followed it during summer months to St Andrews and St Stephen on the Bay of Fundy, where he painted seascapes of their holiday resorts. The painting of official portraits was just as vigorous in the twentieth century as in earlier years, since established precedent demands that long rows of politicians, judges, and academics should hang in every official building from the Houses of Parliament in Ottawa to the universities. They also grace the board rooms of wealthy corporations; the wives and daughters of the wealthy gaze from the walls of drawing-rooms. Those artists who could successfully supply the demand charged – and still charge – large sums; they could do so because their canvases were pleasing, and they could give their subjects a dignified and stately air beyond the capabilities of the camera. Some painters caught a noble characterization, others grasped the volume of the head or a remarkable focus of light, but their reputation was built on their ability to set down a likeness and achieve a finished effect.

Successful twentieth-century portrait painters were generally such

long-lived men that their careers seem perennial. Robert Harris was succeeded by John C. Forbes, who had painted Edward VII, William Ewart Gladstone, and various Canadian prime ministers. J. W. L. Forster was a staunch Methodist and painted many clerics, including General Booth, founder of the Salvation Army. He was commissioned to paint the Emperor and Empress of Japan, and when he died, his house on Wellesley Street in Toronto bespoke the affluence of a long and eminent career. Ernest Fosbery of Ottawa, and both Edmond Dyonnet and Charles W. Simpson of Montreal, continued the tradition in those cities in the 1920s. In our own day Kenneth Forbes carries on the work of his father. Lilias Torrance Newton has had royalty for sitters, and Cleeve Horne seeks to create a decorative quality in his portraits.

Paintings were still being exhibited after the First World War by F. McGillivray Knowles, who was phenomenally successful with his seascapes and harbour scenes, and undertook such lucrative commissions as the decorative murals in the Eatons' music room and in the homes of other wealthy Toronto families. Knowles's studio, with its elaborate fireplace, oriental carpets lining the walls, and other atmospheric furnishings, was a mark of his acceptance. Fred Challener made his living from similar work but also specialized in large-scale murals, as for the Royal Alexandra Theatre, Toronto, the Russell Theatre, Ottawa, and the dining-room in the CPR hotel in Winnipeg. Herbert S. Palmer, Fred S. Haines, and Fred Brigden in their prime in the 1920s painted landscapes in a search for figurative truth. W. M. Barnes exhibited smooth and acceptable landscapes with titles like *When Evening Shuts the Gate of Day*. F. S. Coburn, who could catch subtle atmospheric effects and had an impressionistic approach, emulated Horatio Walker in subject matter by painting lumbermen at work in the Quebec winter woods. Charles-Ernest de Belle was still exhibiting *Art Nouveau* improvisations of long-haired maidens rendered with a swirling line and colours so pale as hardly to be noticeable in exhibitions.

All the leaders in the Academy and the organized societies had in common a taste which seldom allowed for any harsh colour. They were careful craftsmen. Their paintings were intended, in accordance with their conception of their rôle, to please or charm, and make no great immediate demand on the mind or emotions. They gave satisfaction by following convention, and most could suitably be labelled 'academic.'

David Milne was entirely the creative aesthete in paint, taking the ordinary things in life for much of his subject matter and seeing the Can-

adian landscape with a quiet analytic eye. His paintings are sparingly composed, in what he described as compressions: by throwing away all extraneous matter, he left only the 'explosive dynamite' to hit the viewer with full vigour on first contact. But this force, as in many a simple landscape, reacts only on the aesthetic sensibilities.

Milne's art was born out of introspective living. As an Owen Sound farm lad, he had spent his boyhood out of doors. Years in New York before the First World War were a revelation, for when Post-Impressionist paintings were considered a perversion in Canada, he and his friends were drinking in their vitality at the Steiglitz '291' Gallery on Fifth Avenue. Its doors opened wide for them in the mornings, with a tacit understanding that the ragamuffin crew with their patches and smells would vacate before likely paying customers arrived in the afternoon. The brilliant colouring of Newfoundland-born Maurice Prendergast directly influenced Milne in New York. In time he was able to create an all-over pattern for his paintings in which every element contributed to the whole in a harmony of pure interacting colour, and he was rewarded by being the only Canadian who exhibited at the famed Armory Show of 1913; his name will be found in the catalogue after that of Matisse. This Fauvism is repeated with more intensity in many flatly designed studies of his wife, sitting in her rocking chair on their Adirondacks front porch or in the living room (fig. 133); these date from the war years. When he returned permanently to Canada in 1928, it was as a lonely wanderer, almost a recluse, shut away from the world and devoted solely to his art.

Milne was profoundly out of tune with the spirit of the Group of Seven. From 1929 to 1933 he was in Palgrave north of Toronto which he described with ironical understatement ás being in hills which extended as far as Hamilton, and where he could paint with introspection during those years when the Group were off to the Rockies. He had no great respect for much contemporary Canadian painting. He distrusted juries, concluding that they were subject to all kinds of personal and political prejudices. He was fully aware of the fact that members of the general public have little aesthetic feeling, and that they often try to get in touch with painting through some kind of literary or intellectual exercise, rather than by allowing pure feeling to determine their judgment. He distrusted the Group's illustrative approach. Tom Thomson he considered a painterly worker, and sometimes he found the same painterly approach in the canvases of MacDonald and Varley. Milne himself was not popularly accepted as an artist of any stature and he would have starved but for the help of two or three private patrons like the Rt Hon. and Mrs Vincent Mas-

sey; he sold scarcely any paintings at public exhibitions until late in life. He was humiliated to find that Canadian ideals were low and the public interested in family possessions, the life of the animal, and 'that is about it.' Canada in his opinion had no painting, music, or literature which represented an aesthetic experience; she had no quickening of life, no creative courage. To mean anything, the worn-out clichés of art for art's sake must be refreshed by a long and profound mental development and clarification of ideas. All of Milne's life was a search for this refreshment.

Milne wrote often about his painting and his soft melodious exposition is as revealing about his approach as are the paintings themselves. In words strangely and wonderfully in tune with his canvases, he described painting in Temagami in the 1930s.

Temagami wasn't much different from Big Moose – or Kingsmere, so far as painting subjects went, but it was a nice place to work. I got an old canoe and a tent with a wooden platform and set to work. Once settled, I never moved more than three miles away from where I started; that was a reasonable distance to paddle to work.

About a third of the time I painted waterlilies, not waterlilies in their wild and dangerous state, as Monet did, but captured and tamed, stuck in pickle bottles, fruit jars and whiskey flasks.[4]

And of that series of waterlily paintings, probably the loveliest is an incredible composition in silver greys with loops and curves of jars, leaves, and petals (fig. 134). Milne in writing about his experiences admitted that he loved colours:

[E]ven then the waterlilies themselves weren't important, they were just an excuse for having the bottles of water round to diffuse and refract light. For six weeks or so I painted pools in Dan O'Connor's iron mine – he says it is an iron mine, iron, copper, silver, gold, arsenic, sulphur, molasses – well, anyway, it looks like a collision between Winsor & Newton's and a coal mine, good for painting.[5]

Later, after a winter spent in a Temagami shack and with spring in the air, he went out to paint nature:

Sunday morning on the sunny edge of a basin in the bush. On this side of the bowl the sun has been strong enough to bare the leaves. Sitting on an old sweater with my back against a stump; in front of me a fire of hemlock bark and beyond that the skis and poles sticking upright in the snow with long

blue shadows stretched towards me. Some chicadees are doing a bit of singing and one red squirrel up a tree pours out a torrent of frantic scolding. Pleasant! A branch released by melting snow, snaps upward. Spring is on the way.

I have had my dinner, bread and butter and a hard boiled egg, plus jam in a little jar, some rather doubtful cake and a handful of raisins. For a moment I was shocked – had that amazed helpless feeling that comes when perfection is just within your grasp and is snatched away, as if you were standing at the gates of Heaven and suddenly remembered that your ticket was in your other clothes. I couldn't find my pipe. I did finally unearth it in the leaves, and there is nothing more to be asked for; people and their troubling works are far away and for me this morning is simple and serene.[6]

And so he settled down to create a work of art out of the early spring landscape with the first ploughed knolls emerging through the melting snows.

On another occasion Milne wrote about a day spent painting flowers in his cabin:

In the morning I went back to the bush and gathered some hepaticas and adder's tongue. I set them in a bowl on the table, looked them over and painted them. It took all day, one way or another. I have forgotten just how they were arranged or what was with them, and what the point of it was, but it wasn't bad. Next morning I got nine flowers, put them in the same bowl, rubbed out the picture, and started all over again, looking at them, changing things round, working arrangements on the canvas, then rubbing them out. By four o'clock I had things placed satisfactorily, and everything planned, but there didn't seem to be enough kick left to start me painting. So I changed the whole arrangement and managed to start. I was through in time to have supper before dark, and I got quite a thrill out of the picture.[7]

He describes how any school boy could do the simple drawing, and put in the daubs of yellow, orange, mauve, and the grey mud tones which are almost his trademark in his later years. Yet, he declared, the application of colour is not the point, for the true artist concentrating on the rectangle of canvas is eager and impatient in his creation, does not wander into side paths, and goes straight for the essential of the thing he sees. Does he achieve a masterpiece? Not necessarily, Milne concluded, but he does achieve a concentration of interest, a blank space on the left driving the eye down, yet these suggestions on the left are not enough to satisfy, and there is 'nothing to feed on until you come to the sharp, strongly accented shapes on the right.' There the eye is held in a concentration of creative lines. So he achieves a solidly composed painting.

The paintings of Emily Carr, David Milne, William Wood, and the others represent some of the more personal approaches which filled areas of art untouched by the Group of Seven. Theirs was a performance without the strong glare of publicity, but in some of their works there is more sensitivity, more awareness of painterly qualities than in some other giants of their generation.

24

Regionalism in the Thirties

The great Depression had by 1930 overwhelmed society with a deadening effect which completely altered the life and thought of Canadians. There were soup kitchens in the cities, women and children trudging wearily along the railway line looking for the coal they needed for warmth and cooking, jungles of wandering and penniless youth, despairing farmers who saw prices for their products fall and fall and fall, and long queues of unemployed whose faces were filled with bitter despair. Memories of these sights seared the minds of a whole generation. After years of unavailing struggle with these conditions, apathy, the worst blight of all, remained. Through these miserable years the creative arts suffered very severely indeed. Art sales were an unheard-of wonder, and only the most celebrated works changed hands; painting seemed an unnecessary luxury for a society in which the prime consideration was the basic necessity of keeping alive. For the established artists, the ordeal was desperate, and many of them turned to teaching or the repetitious routine of commercial assignments, or to work completely outside the artistic field. Prospects were even more hopeless for the younger artists born early in the century who now had reached their first youthful vigour; they could neither sell paintings nor earn money for further study.

Another hindrance felt by these younger men, however, had its origin in the Canadian art climate: by now public acceptance of the Group of Seven paintings was complete, and these artists were regarded as the only ones to have made a significant contribution in Canada. The battles of the 1920s had been so intense and the Group's victory, in style and in their philosophy of Canadianism, so emphatic that no other experiments now seemed worthwhile. The younger artists had lived through these battles during their impressionable teens, and they looked at members of the Group with the reverence and awe

due knights in shining armour. Many of this generation attended the Ontario College of Art in Toronto where J. E. H. MacDonald was principal until 1932, and where other Group members consistently came and went; J. W. Beatty, a painting pioneer in Algonquin Park, presided over classes at the College from 1922 to 1941. Students could not escape the Group influence and were afraid to express any personal vision which differed from it. It was indeed a bold person who dared seek fresh channels.

Yet one senses reluctance by many sensitive and progressive younger artists to fall into conventional Group patterns. They were often relatively isolated individuals. The following survey of them is disjointed. Some appear in the same chapter because they had similar objectives before developing new artistic avenues. Others are mentioned together because they once lived in the same geographical milieu.

Those who had money for study beyond Toronto and Montreal usually headed for New York and the Art Students League. An approximate ratio of three students now went to New York for every one in the older London and Paris haunts. This shift in interest had begun before the Depression, possibly because of war-time and post-war travel restrictions, but shortage of money accelerated it. The rift between experimental European painting and Canadian trends widened. More frequent parallels could be made between Canadian and American painting, particularly in the regional spirit which was vigorous both north and south of the border. Artists who couldn't afford to travel to faraway and exotic regions began to observe their own immediate environment. They glanced at it, then re-examined it in the greatest detail, and after meditation found unexpected wonder and significance in what lay immediately at hand.

Several of the new generation began their career during the hungry thirties with such an intimate search for meaning in their immediate surroundings. The following survey of different painters demonstrates how various individuals went about it and their relative successes.

Carl Schaefer painted the rolling wheat fields and the country houses (fig. 135) in the Hanover district of Ontario. Money was so scarce that for eight successive years he, his wife, and their small children spent their summers on his grandfather's farm whose every fence, stone, and barn he knew, and where he was surrounded by neighbours whom he had known and loved as a boy. Here he painted the unpeopled outdoors, but with an approach quite foreign to that of the Group. He disregarded flamboyant colours, preferring austere yellows, ochres, grey blues, and dull greens. He disciplined himself strictly,

painting and repainting his grain fields, but each time trying to give them a more penetrating look, and each time achieving an inner glow which transforms the grain into a living object. Schaefer has repeatedly quoted Paul Nash's injunction that one should 'Go back to Nature for some fresh definition of order and simplicity.' A similar penetrating look can be found in Charles Burchfield's water-colours of the houses of Buffalo and Upper New York State.

Schaefer has used other subject matter. He has always liked to paint apples, pears, egg plants, and similar objects. More recently he has painted in a small bushland area in a corner of Algonquin Park. It has been said of him that he is both a realist and a lyricist. Each series of studies represents a careful search within the limits of the figurative. His lyricism has a simple and almost melancholy note. He combined these figurative and lyrical elements in such a way as to give a deeper, more contemplative look at one small segment of nature in Canada than would have been possible for the Group of Seven during their sketching jaunts; they were more interested in the obvious elements of design and colour than in a truly introspective examination.

Two men were looking with keen intensity at the Montreal city scene at this time. Both Louis Muhlstock and Adrien Hébert had studied in Paris. Muhlstock returned to a St Famille Street studio. His oils of the 1930s are studies of sunlight and atmosphere enveloping the houses and trees in the adjoining blocks. Others picture nearby Mount Royal. Hebert, in contrast, haunted the waterfront district. He painted innumerable figurative canvases dominated by the striking silhouettes of elevators, steamers, and harbour installations. In them, man's creations are so massive that man as an individual is lost, dwarfed into but a transient bit of matter.

Jack Humphrey was always strongly rooted in the Saint John district of New Brunswick, just as Schaefer was in the Hanover district. Humphrey's windows looked out from high up over Saint John, a city where his ancestors lived for generations. From them he could see the box-like frame houses of this city, where for more than thirty years he recorded dilapidated streets, leaning houses on their rocky eminences, waterfront piers, and boats tied to the wharves. Humphrey examined them with the same loving care that Schaefer gave to the wheat fields, and is a regional artist in the same sense. However, it would be folly to think that such a simple comparison will encompass his works, for he was both a most complex and a most productive artist; he was one of the few men of his generation in Canada who always worked as a creative painter.

Humphrey had a varied training – Boston, New York, Paris, Mex-

ico and pre-Hitler Berlin when the Bauhaus was still a potent force. In his paintings can be found experiments in Cubism, violent Matisse-like Fauvism, Tachism, and various forms of Abstract Expressionism. Many developments came about as a result of annual visits to New York where he sought to associate himself with recent American trends.

His children's portraits of the 1930s and 1940s are the outstanding examples of Canadian regionalism as applied to the faces of the people. Humphrey sometimes chose to paint the sons and daughters of friends as well as the local cityscapes. At other times he would select children from a little knot hanging around outside the newspaper office at press time, waiting for their papers. They needed the few cents. These Depression children have a sad, pathetic look, one which the artist at one time accented with a certain hardness when he took up Cubist conventions and painted stylized almond-like eyes. In the same way that Schaefer looked at the fields around Hanover, Humphrey looked into the faces of Saint John children (fig. 136). He preferred to paint children for he was a shy man and more relaxed with the naturalness of youth than with the preconceived ideas of the adult.

Humphrey made other trials of Cubism in his still life paintings. His first work to catch a critic's eye in Ontario was *The White Pitcher*, painted about 1930, exhibited at the Ontario Society of Artists exhibition in 1931, and now in the Beaverbrook Art Gallery. The legs, seat, and other parts of a stool are made a vivid foil of powerful rich brown and black Cubistic shapes on which stands a large white jug with contrasting curves. *Draped Head* (Hart House, University of Toronto) is superficially a self-portrait with a towel wrapped around the head, but is in fact a composition of planes and shapes. These Cubistic paintings are far removed from the nostalgic still life paintings of the late 1940s where he subtly wove together weathered tree stumps, shore debris, shells and stones against a background of dried yellow birch leaves, creating rather flat but wistfully beautiful paintings.

A disturbing dichotomy makes itself felt in Humphrey's post-war figurative and abstract paintings. Collectors of conventional tastes buy his realistic water-colours of New Brunswick's trees, rivers, seas, and cliffs. These, repainted and abstracted, were converted into virtually non-objective canvases. He closely examined the leaves on the forest floor and painted a half dozen large canvases which progress from stark, photographic, almost illusionistic realism until they become merely areas of Expressionistic colouring, yet the identical origin of each canvas becomes apparent at once when it is compared with its immediate predecessor. Other large and violent compositions in yel-

lows, reds, and greens made brilliant by interweaving black lines have a superficial resemblance to American Abstract Expressionism, but undoubtedly originate in nature, even if subconsciously. Probably Humphrey's most successful paintings are those in which he fused the figurative with the abstract as in his black sky landscapes (National Gallery of Canada). They are almost a return to the spirit of regional painting of a quarter-century ago, but with the knowledge of the intervening years added, for there is more than surface realism here. He added metaphysical overtones. The brooding black sky has an unspoken and unanalysed fear, the insecurity present in the twentieth-century Maritimes: yet in contrast there is sheer beauty of colour in the foreground with clear bright light and vivid warmth in what seems like a symbolical representation of the New Brunswick beaches and fields.

Miller Brittain was a remarkable contemporary of Humphrey who portrayed the local Saint John scene during the 1930s and 1940s in a very different mood. Brittain painted men in the streets, crowds of passengers swaying as little street cars crawled up and down steep hills, dock workers, or party goers whom he dissected with almost cruel introspection (fig. 137). This mass of figures embraced the humanity which peopled Humphrey's background of hills and houses. They are devoid of the delicate sensitivity and introspective intellectualism with which the latter painted children. Brittain's little Saint John world was a microcosm of the bigger New York street crowds of Reginald Marsh and others. It had little relation to the contemporary European art scene. After Brittain returned from Royal Canadian Air Force service during the Second World War, he still retained an interest in New York but shifted his subject matter. In his great old house outside Saint John, he achieved a stage of Surrealism in his later years. He pictured plants, humanity, celestial shapes, and anthropomorphic forms in striking colour and incredible beauty and mystery.

The way in which the Group of Seven spirit permeated art through the influence of the Ontario College of Art is readily seen in the paintings of Illingworth Kerr from Lumsden, Saskatchewan. He had left his father's market garden to study in Toronto, and returned to paint the flat prairies which he loved; but he was not able to free himself from Toronto influences as completely during those first years as Schaefer and Humphrey. Kerr has the unique distinction, as well, of being the first Prairies-born professional artist, a fact which emphasizes the brevity of indigenous western Canadian painting. His second-floor studio in Lumsden was reached by an outside stairway from the main street where squared false fronts reminded visitors of earlier western

days. After returning home from art school, he painted prairie ranches through the passing seasons of an eight-year period; they are pictured in summer, and in winter when the western blizzards drive snow across the plains, and as the snows melt under the characteristic March sky. When necessity forced him to take more desperate measures to make a living, he tended a trap line along the chain of Saskatchewan's northern lakes, painting as he made his regular rounds.

Some may question whether Goodridge Roberts can be properly called a regional painter, since he was interested primarily in invoking certain inner responses to aspects of nature by a painterly investigation of particular districts. He asserted that his paintings are not just an interpretation of nature as it lay before his eyes but far more a reflection of the artist himself in which the viewer can see revealed his inner worth.

Roberts set down a list of the small but essential stepping stones which marked the growth and intensification of his artistic sensibility.[1] During his childhood he lived near Kensington Gardens, London, and there he suddenly became intensely aware of the greenness of trees, of their density and yet lightness, of the compactness of the shrubbery and how the sunlight when falling upon it emphasized its solidarity, and of the smooth, damp pavements. A desire to paint was born at that time and a few days later he produced his first water-colour, a view of the Serpentine.

This same feeling of oneness with nature came to the artist when he found himself in the Gatineau country near Ottawa. Sunlight and the mist of Turner's water-colours he found supremely beautiful, and the verse of Milton and that of the nineteenth-century nature poets strengthened his knowledge of the essence of landscape. Such a reaction to poetry was natural to him for his father, an uncle, Sir Charles G. D. Roberts, and a cousin, Bliss Carman, were the leaders of the celebrated Fredericton group of nature poets, and he himself on occasion had attempted to set down his thoughts in poetry. Formal art education was added to this preparation. As a student he would work for an entire week in an attempt to catch the subtle variation of tone in a drawing of a plaster cast. The first great exhibition which he attended was a Morrice retrospective in Montreal. Study in New York brought a knowledge of Picasso, Matisse, and Cézanne. John Sloan taught him to draw the quick pose, Boardman Robinson the more lengthy nude studies, and Max Weber showed him the aims of the French modernists.

From all these preliminaries, Roberts developed slowly, first paint-

ing the simplest of forms with a very restricted palette, and then proceeding to more complicated compositions where 'each shape and colour had to assert its individual meaning up to the limit imposed on it by the meaning of the whole.' By 1933 his surfaces were denser with 'the white of the paper drowned by the opacity of the pigment, skies became darker with blackish purple, blues or reds and fiery clouds floated through them.' Surroundings were a constant interest. He became aware of deeper meanings and relationships: a pale blue bowl may be a momentary flash of the domed summer sky, or a stone jar with greenery in it may be a rocky bluff with dense green forest rising from its summit into the surrounding air. Above all, he emphasized again and again his view that each part of a painting must have a meaning in relationship to the whole, and when this essential requirement was fulfilled according to Roberts' inner sense of fitness we have one of the artist's typical paintings. He was interested only in the plastic poetry, leaving to the sociologist social problems, to the historian narrative, and to the psychologist psychological problems. He was a man of the 'land of virgin silence and of solitude' from which all extra-pictorial connotations were banished.

Following these aims, Roberts searched out the vital elements in the landscape of several regions: the Gatineau, Georgian Bay, the Eastern Townships, the Ottawa River Valley, and the Fredericton region. Water-colours of Lake Orford are among his strongest paintings. Vivid hues seldom played a vital part in his earlier paintings, but with the passing years, as he graduallly came to work entirely in oil, he occasionally sought a sparkle in autumn scenes and more frequently in still life. At times even his later nudes have a rich Expressionistic colour (fig. 138).

Other men of this generation are much more individualistic painters; some ignored completely the regional aspect. One who always followed his own personal ideas was John Alfsen of Toronto; there is a wide divide between his work and that of his classmates at the Ontario College of Art in the 1920s. He studied at Antwerp, where he saw the masterpieces of Rembrandt, Rubens, and other great northern painters. He became familiar with the paintings of John Corbino in New York while attending the Art Students League. Form, depth, and craftsmanship in what he saw moved him profoundly and his attempt was always to try to recreate these elements as first he found them in the old masters. His figure drawings are marvels of form; his acrobats riding erect on a performing horse in the circus ring have the vitality of Toulouse-Lautrec. He painted innumerable portraits, including many self-portraits. But among Alfsen's greatest triumphs are a few

canvases painted when he was released from a year of teaching drudgery; he spent the winter with the Ringling Brothers Circus in Florida, from which came sad seated clowns (fig. 139), and a great circus procession triumphantly parading off into the landscape. In it is the pomp and pageantry of a Rubens procession.

Jean-Paul Lemieux of Quebec City belongs to this same generation. He studied in Montreal and Paris. His first paintings to strike a Canadian response were colourful Fête-Dieu processions in Quebec streets and other traditional subjects often associated with the religious life of his province (fig. 140): these early paintings may have been as much nationalistic as regional. Lemieux later played a major rôle as a teacher of youth, first in Montreal and then in Quebec where a sense of tradition looms over the ancient capital. He lives surrounded by beautiful wood carvings and other traditional craftsmanship. His youthful painting was considered revolutionary when painted during the thirties, but this gentle man has altered with the passing years until his paintings now are studies in quiet nostalgia, gentle lyricism, and great compassion. As if reflecting memories of the past in this historic environment, he pictures children in daisy fields staring into the future. *Souvenir de 1910* recalls his forefathers, while *Les Moniales* and *La fête au couvent* (fig. 141) comment on religious life. An impressive mural in the Fathers of Confederation Building at Charlottetown pictures the stately builders of a nation wearing high silk hats and deliberating as a new light dawns.

To this generation was assigned also the task of recording Canada's soldiers, sailors, and airmen in action after the declaration of the Second World War in September 1939; they were then in their youthful prime. Canadian artists were used from the first in contrast to the 1914-18 war when the Dominion's painters were added to the War Records Branch as an afterthought. Three divisions were organized in 1939, each working with its own branch of the service. Charles Comfort, as head, served with the army both in the United Kingdom and in Italy. He was by this time well known as a brilliant technician, either in water-colour or in oil. When he had moved from Winnipeg to Toronto in 1925, his wizardry with the brush impressed all and he was regarded with envy as the virtuoso of his day. One of his greatest achievements was his portrait of Carl Schaefer (fig. 142) painted during the Depression, in which the young Canadian sits with great hands ready to work but with little work to be done. He was to repeat this performance as a war artist with an equally brilliant but more sophisticated portrait of the same man in his airman's clothes. With Comfort as an army artist was Edward Hughes of British Columbia,

who worked in Alaska (fig. 144) and other remote places, painting in his own naïve manner. William Ogilvie, his close friend, painted some brilliant studies of the Italian campaign.

The naval group included two men of widely differing interests. Jack Nicholls painted groups of sailors and the huddled pathetic refugees being evacuated from the French beaches, and he saw them with a religious aura. Michael Forster, on the other hand, was interested in the awesome desolation of the shattered and silent Brest submarine pens after the battle had passed.

Two artists in particular are noted for their paintings of the Air Force in action. Carl Schaefer worked with the bombing crews. Lawren Harris, Jr followed the campaign in Italy, painting meticulously in a formalized manner and with a fluid brush technique the destruction which he saw all about him. Goodridge Roberts, one of the same group, was so profoundly disturbed by war as he saw it that his contributions lack the deep richness of his civilian paintings.

The record of these war artists and the many others who worked with them is of widely differing quality. Many paintings and drawings are primarily of archival interest. Some few rose to the heights of genuine achievement as art. This variation was natural: the war was an event and an experience which could almost crush a man of deep sensitivity and only a few great paintings could be expected during the heat of battle.

There were many other painters in this generation in Ontario, for the publicity given to the Group of Seven attracted many other recruits to the ranks of art. Closely identified with the Canadian Group of Painters organization were George Pepper and Yvonne McKague Housser, who closely followed Group prototypes during their earlier years. Kathleen Daly and Paraskeva Clark were spirtually akin but enlarged the range of their subject matter beyond that of the group. (The great number of women painters in Canada, both in Montreal and in Toronto, is one remarkable phenomenon of the times.) Charles Comfort and Will Ogilvie overcame the economic problems of the Depression by establishing a most successful Toronto art studio. Comfort, as a virtuoso, gave novelty to his water-colours by their enormous size and conception, and his oil series of lower St Lawrence and Saguenay River landscapes in the 1930s makes a strong impact through its brittle stylization. Ogilvie, on the other hand, discovered more personal, almost poetical, expressions in the post-1945 years with his gentle water-colours of swamps and grasses which have many parallels with the intimate searchings of Schaefer.

Pegi Nicol MacLeod was a rebel against convention, and her radi-

ant personality lit up the art scene during the 1930s, when the early enthusiasm of the Group of Seven was being superseded by a drier, reactionary, and stodgy academic trend among many second-generation followers, and also in the gloomy war years which came later. She railed at the lifeless painting which she found everywhere in the early years of the decade. Hers was a tremendous zest for life; she was happiest when introducing teachers and young people to creativity at the University of New Brunswick summer school; she delighted in helping farm women create new hooked rug designs, or in painting a mural for a school in Woodstock, N.B., so that children, starved for beauty, would be always exposed to art. She had always been an individualist, and while her early Gatineau region landscapes were in the Group of Seven style, she soon acquired a new freedom after she had created stage sets for Hart House Theatre productions in Toronto. Bubbling life always buoyed her up, and she painted the children crowding around Fredericton's old cast-iron Victorian fountain, sailors training for service overseas, beautiful horses with sleek coats in the fields, and joyous suckling piglets with pink and wriggling bodies. Hers was an urge for life comparable to that of Emily Carr. During later years in New York, she was delighted with her little daughter's many seductive moods and with Christmas crowds skating in Rockefeller Center. Such a cheerful and lively spirit was a marked and happy contrast to much artistic stodginess of her time.

When the Group of Seven was disbanded, it was the generation we have been discussing which became the core of the Canadian Group of Painters. Their exhibitions did not break any radically new ground. These younger painters were torn between their regard for the accomplishments of past giants and their desire to take up new developments. Yet those who did experiment seldom seemed happy in their attempts. Of those who did not succeed, it may often be said that they were unwitting victims of the times.

25

Transformation in the West

Western Canadian painters had by the 1950s become the running mates of the easterners. Their whole transformation from a pioneering state to national prominence and to sophistication in art took place in a surprisingly short time. Artists living in the west at the turn of the century – and there were remarkably few – were very much novices; it is singularly unrewarding to look for even crude amateurs in Saskatchewan and Alberta at that time. Yet the migration of homesteaders was then reaching enormous proportions, and some of the settlers wished to introduce into their new environment those desirable cultural qualities which they had previously known, just as had the French in Quebec and the British in other parts of eastern Canada. Painting was one of the arts which soon emerged. Artists arrived from Ontario and the other eastern provinces, the British Isles, and central Europe, to mix with the few settlers already there. They achieved overnight what had elsewhere taken a century, for the coming of the railway – and later of the aeroplane, telephone and radio and even television, all permitting rapid exchange of ideas over shortened physical distances – quickened the whole pace of living. An art society was formed in Winnipeg in 1902 as the first western art organization, and the Manitoba Society of Artists was established in 1925 through the efforts of A. J. Musgrove, E. Bergman, W. J. Phillips, and others. By the 1930s, Emily Carr and L. L. FitzGerald had emerged as powerful artists on the national scene, and since 1950 more than a dozen westerners have received solid international recognition.

The general pattern between 1900 and 1940 is remarkably constant in all four western provinces. First came a few scattered pioneers, usually landscape water-colourists, who were often English immigrants. They worked in some of the larger communities. Art lovers made themselves

known. These two groups combined to organize art schools and galleries. Art teachers were attracted from the east, students attended the new insititutions, and an atmosphere was created which would encourage the creative surge in the years immediately after the Second World War.

The evolution is well documented in Manitoba. A Woman's Art Exhibition was held in the Manitoba Hotel, Winnipeg, in 1895; there were then some amateur painters in the city. Marion Nelson Hooker, who knew the contemporary art world elsewhere, came as a bride to Selkirk, Manitoba, in 1907; she had gone from her girlhood home in St Catharines, Ontario, to study in Buffalo and Paris. She delighted in painting elderly Indian chieftains. C. W. Jefferys made the first of several annual visits to the province at about that time, and Frederick Challener between 1909 and 1912 carried out a commission in the Royal Alexandra Hotel, Winnipeg, painting murals of western life in its dining room. Both these men stimulated local efforts. Between 1902 and 1912 art enthusiasts banded themselves into the Studio Club, Arts Club, Arts and Crafts Society, and Sketch Club. Winnipeg's artistic life centred around the old Richardson Galleries until a combined art gallery and the Winnipeg School of Art was founded in 1913. At the new gallery's inaugural exhibition, Royal Canadian Academy paintings attracted such interest that on some days 3,500 people attended; the city was obviously starved for paintings to see and to purchase.

New teachers arrived. Alexander Musgrove came from Scotland that year as first principal of the new art school, and himself painted precise figurative water-colours of rather dilapidated and cluttered back yards in the city's older frame quarters. Sometimes he worked at nearby summer beaches. Franz Johnston, principal from 1920 to 1924, introduced Group of Seven influences. Musgrove set up a rival school in 1924, his Western Academy of Art, where painters like Jack Markell received their first training. Walter J. Phillips, another water-colourist (fig. 143), arrived as a teacher in 1913, and first worked briefly at the Winnipeg School of Art and thereafter at the St John's Technical School. He went farther west in 1925; his later career was chiefly as a colour woodblock printer of exceptional ability, with a technique based on that of the Japanese. From 1929 FitzGerald played an ever increasing rôle as a teacher.

Brigdens, a rapidly developing commercial art firm in Winnipeg, paralleled in many ways the rôles of Notman in Montreal and Toronto during the Victorian years and of Grip in Toronto early in the present century. Brigdens employed well-known artists, and several of their apprentices later established independent reputations: Charles

Comfort, Philip Surrey, Bruce Markel, and William Winter. Eric Bergman worked for this firm from 1914 to 1958 as a wood-engraver, retoucher, and photo-engraver. His non-commercial hours were employed in carving most exacting and delicate black and white wood-cuts of prairie flowers and foliage; their simple elegance and feeling must have touched the sensitivities of younger employees. Such men as Fritz Brandtner introduced expressionism and other art concepts considered as revolutionary in that city (see pp. 325-6).

Saskatchewan's three twentieth-century pioneers were Augustus Kenderdine, Inglis Sheldon-Williams, and James Henderson. Henderson, a Scot, settled in the Qu'Appelle Valley in 1916, sometimes painting Indian portraits, and at other times winter landscapes always with sunlight on the snow and as an inevitable focal point a red sleigh by a stream winding through a broad prairie valley. Kenderdine had arrived in the west at an earlier date, settling at Lashburn near Lloydminster in 1907. His home had been Manchester, England. He exhibited his rather pale almost monochromatic landscapes with clumps of prairie scrub from 1920, and was appointed director of the University of Saskatchewan Department of Fine Art at Saskatoon in 1935. Meanwhile, Norman Mackenzie, a lawyer, was promoting art in Regina, commissioning Indian portraits from Henderson, buying landscapes from Sheldon-Williams, and eventually providing money for establishing the Norman Mackenzie Art Gallery in Regina. An adjoining art school was opened which became the most effective advocate of non-objective painting on the Prairies.

Alberta began slowly. James Nicoll has written about the barren local scene in this century's first decade when there were no local painters, and where art as taught in the Alberta school (and indeed he might have added in schools right across Canada) 'was tedious and unimaginative. We laboriously smudged the tone gradations of a cylinder, and progressed to the romantic realism of a McIntosh apple on the teacher's desk.'[1] Frederick G. Cross, a Devon water-colourist, worked at Lethbridge before the First World War, painting as he had painted at home, but using the local prairie and foothills scenery and farm horses drinking as his subject matter. His works were very English, very correct, had good tone and colour, but it must be admitted now that his reputation was somewhat over-rated because he had little competition; he had little real depth of artistic understanding.

The Edmonton Art Association, most of whose members were school teachers, was organized in 1914, but the local art world caught the attention of the public with a resounding noise when the new Calgary Art Club, formed in 1922, was ejected shortly afterwards from the

public library's basement room because they dared draw the figure. Thereafter it 'met somewhere else – like a floating crap game.' Of the club members, modern-minded artists led by Max Bates and Roy Stevenson 'met regularly in a café to argue, over a glass of Coca-Cola, the merits of Carnegie International prize winners and the demerits of emerging Surrealism. Paintings were propped up in booths for discussion. Although rather unwilling, the mystified Greek proprietor was the only supporter of modern art in the city.' A local exhibition of Group of Seven sketches was widely frowned on, and Bates and Stevenson in 1928 had the singular distinction of permanent disbarment from all future shows of a local conservatively minded art group because of their depraved modern tendencies: they had dared to exhibit canvases with non-objective overtones.

Calgary's Provincial Institute of Technology and Art instituted art classes with twelve students in 1926 under a Norwegian Impressionist, Lars Haukness. He died two years later either from a heart attack or as a result of a mauling by a grizzly bear while sketching at Banff. A. C. Leighton came from England to replace him in 1930; he particularly admired oriental art, and his water-colours have a sure tonal sense so that even his direct and spontaneous sketches, such as a study of a chair (fig. 145), have the glow from within of the finest nineteenth-century English work. H. G. Glyde, Leighton's successor, eventually moved to Edmonton where he established the University of Alberta's Department of Art. The Alberta Society of Artists was founded in 1932. Art teaching could be seen to have had its effect when, 'following World War II, the movement [of art] was in full spate. The Old Guard, prepared to defend linear perspective to the vanishing point, saw their work hung Raphael-cheek by Picasso-jowl with essays in the abstract and the automatic.' Painting in Alberta was coming of age.

The vital yet fluid atmosphere of the Prairies was assessed by Eric Newton when he visited Canada shortly after the war:

The Prairies have perhaps not yet found their own mode of expression. Culturally the whole area is maturing and, as it matures, it is bringing its hitherto inadequate equipment up to date. New galleries are becoming available for exhibitions, new organizations are being formed to encourage the arts, but the public is, as yet, hardly aware of the arts and the general level of taste, both in art and design, which leaves the genuine creative artist (and there are many on the Prairies) in a vacuum, a producer with no considerable body of consumers to encourage him. I think this situation will change within the next decade, but universities, art schools and art critics will have to work

hard during that time if the present gap between supply and demand is to be closed.

The supply, however, is there in embryo and I can easily imagine a renaissance of the Arts occurring in Alberta, Saskatchewan and Manitoba, just as suddenly as it occurred in seventeenth-century Holland with the coming of prosperity. The same closeness to and dependence on the soil might produce the same kind of result.[2]

British Columbia's pattern of art development resembled that of the Prairies, except that more painters and workers emerged earlier. By the 1930s, several were achieving national prominence: the native-born Emily Carr, and W. P. Weston, Frederick Varley, and J. W. G. Macdonald.

Early in the century British Columbia had Thomas W. and Charles Fripp, W. Ferris, B. McEvoy, and other water-colourists of the English tradition. Thomas Fripp was a connecting link between pioneer British Columbia and the twentieth century, for he pioneered in the fullest sense, arriving in 1893 determined to clear the British Columbia forest at Hatzic and to be a farmer rather than a painter. He had studied earlier at the St John's Wood and Royal Academy schools in London, and had travelled extensively on the Continent (including a trip to the Alps). An accident forced his return to professional art work. His paintings of mountains, detailed, and with unusual atmospheric effects, are frequently found in collections. Fripp spent thirty years in promoting arts and crafts and was a guiding spirit in the organization of the British Columbia Society of Artists; he served for years as its president. Twenty charter members mustered 179 paintings for their first exhibition in 1909. Charles, Thomas's brother, painted in British Columbia and the Yukon about 1900. His picture of Haida Indians working on a great war canoe was painted for reproduction. One of his unusually fresh water-colours shows an Indian woman of the interior standing in the new-fallen snow with a background of evergreens and a gay mosaic of multi-coloured blankets drying on the line (fig. 146).

The British Columbia Art League assisted in establishing an art school and public gallery in Vancouver during the early 1920s. The school opened in 1925 with Charles Scott as first principal. Scott's own paintings of stumps on the edge of mountain lakes, or of mountain views and coastal scenery, were in the Group of Seven landscape tradition. Sometimes he painted portraits in Edwin Holgate's manner. He and other art school teachers helped create a public consciousness of art. They wrote, lectured, and participated in the Vancouver Art Gallery programmes after its opening in 1931; without such an atmos-

phere, progress would have been impossible. Among many people caught up in this enthusiastic broadening of interest were John Innes, the historical painter, Nan Lawson Cheney, and H. Mortimer Lamb.

One may observe with some fascination that during these years when urban painters with training and a certain sophistication were banding together, an abundance of latent talent was also discovered in various scattered communities. This potentiality for development, found over and over again in the west, explains why a sudden forward step was possible in the 1950s when conditions became favourable. This latent talent may be most readily isolated in the work of emerging folk artists who lived in isolated communities – the scattered towns, villages, or farms throughout the west – who had no opportunity to discuss painting with others, and yet could not stifle a creative urge. Many were Central Europeans from lands where art was traditional; they simply had to express their feeling for it, even if this were possible only in the decoration of Easter eggs. They parallel in a way the ex-voto painters of New France.

One early folk painter was Charles Dudoward, son of the chieftain of the Eagle Clan at Port Simpson, B.C., who by 1873 was painting landscapes of his home village in the curious stylization of the naïve artists. His people's decorative arts were, of course, already a great triumph of Canada's original inhabitants.

Jan Wyers came from his native Holland and eventually farmed at Windhorst, Saskatchewan; without a lesson he began painting one idle winter, using paints he had ordered from Regina. He first set down his impressions of Canadian farm life about 1935. The privately owned *First Saskatchewan Harvest* and *Home Coming* are nostalgic memories of his own experiences, drawn in a simple, direct, and compelling manner, and show the inner satisfaction he received from this self-expression. *Those Good Old Threshing Days* (Norman Mackenzie Art Gallery) recalls his memory of shiny red threshing machines, in the days before the power-combine, bright golden grain, blue skies, and men hurrying to bring their loads to the machine. He knew little of perspective, could not draw the figure properly, and painted horses with short stubby legs and strange rabbit-like faces. But though his pictures give evidence of lack of training, his honesty and his love of his subjects have created a personal style that is not at all hindered by the absence of technical knowledge.

Bill Panko was potentially the most talented of all the many folk painters of the Prairies. He came in 1911 from his native Austria to Canada, where he worked on farms in summer and in the Drumheller coal mines during the winter until he was forced to spend ten years in

a sanitorium. Here the sight of others attempting to paint lit a spark, and with Marion Nicoll's encouragement he painted about thirty water-colours, most of which were bought by artists who responded to his amazing artistic qualities. Mrs Nicoll refused to allow others to give him any formal instruction, and he pursued his own naïve way to the end. Panko's sense of design was unerring. *Birds in a Garden* (private collection) has blossoming trees ranged row on row one above the other, and filled with giant birds in a pictorial representation which takes one back to Roman wall frescoes. *The Round-Up* (fig. 147) is an aerial view of a horse-race with cowboys riding bucking steers for a holiday crowd; it makes daring use of colour. Panko knew all his subjects intimately.

Each painting represented an experience. He had been sent to Harrison Hot Springs in British Columbia for treatment, therefore the series of mountain and fishing scenes. For the most part his work told stories of his life in the Drumheller Valley – stories of his diminutive home and his rich garden along the Rosebud Creek or stories of mining operations. These pictorial tales were always told simply, with good humour and with taste.[3]

Out of his need for self-expression, Panko created the most native and the purest western Canadian art of his twentieth-century generation.

26

Towards Non-Objectivity: Beginnings

Mad, unintelligible, and meaningless paintings, canvases covered with squiggles, wriggles, and seemingly unrelated brush strokes: these are the terms used by numerous sceptics and agnostics in speaking of 'modern' art. Discordant colour, a violent application of paint, and unfamiliar shapes, now linear, now fluid, have been a major factor in Parisian and western European painting generally during much of the twentieth century. Many individuals have refused to accept such painting as art and neither realize nor admit that it is painting based entirely on feeling rather than narration. It is indeed a subjective form of art, created entirely from the artist's probings, rather than art for the layman.

Art with such startling new aspects and altered motives was born in the years when the Fauves, the 'wild beasts,' with their passionate colour and violence of execution were disturbing Paris. The next step was when painters, moving towards Cubism, broke up the surface and structure of natural objects in an attempt to develop and accentuate planes so that the viewer's eye could more readily grasp the whole. They did so at the expense of natural appearance. Eventually the original subject matter disappeared as artists probed further into non-objective painting; no longer are many painters motivated primarily from the outside world, but rather their own inner feelings, emotions, and visions direct their brushes. The new world that they create is purely out of their own imaginations. At this point, for better or worse, art divorces itself completely from the proletariat, who look at paintings for literary interest or delicacy of execution. Art for art's sake theories, which had earlier freed the artist from servitude, carried the new trend to its ultimate conclusion. The wider audience is completely discarded, and the painter becomes the revered god of a few intellectuals, since only a minute proportion of the population has the emotional

sensibilities which enable the viewer to grasp the artist's very personal message; the artist also has become the hero of many who buy for little other than fashionable appeal.

That Canadians were slow in attuning themselves to such movements should cause no surprise, for their origins date from a time when Canadians were much occupied with other, more practical, activities. Prior to 1914, both the general public and the private citizen were busy with prairie settlement, the building of new factories, trade, agricultural developments, and other consuming business interests. Men who are building a country must be intensely practical individuals, and there is little time or inclination for artistic observances. The First World War came before current movements in the arts abroad had found an entry into Canada, although they were introduced into the United States in 1913 through the famous Armory Show. That country had the advantage of three more years of peace to absorb the new ideas. Canada, despite her participation in the war, was nevertheless remarkably insular at that time: 'the twentieth century belongs to Canada.' Then, before the war ended, English-speaking Canada was caught up in the Group of Seven controversy and a whole generation would accept or tolerate no other style. French-speaking Canadian artists, for their part, were completely absorbed in older conventions, dominated as they were by academic tastes of the Montreal and Quebec schools and by the church, which discouraged the intellectual curiosity of radical painting among younger students.

The abstract movement did not reach significant proportions in this country until the years of the Second World War. Several of Canada's pioneering abstract artists spent some time during their early years in Winnipeg and further west, and their work there helped in crystallizing thought. Frequent looks at the New York and Paris scenes also bolstered Canadian workers. But abstract art emerged as a real force in Montreal and Toronto, which enjoyed greater concentrations of population and thus the seeds of a receptive climate. The response in Toronto was a particularly potent factor in laying a foundation. Early Canadian experimentation with the abstract approach is primarily the story of five men – Bertram Brooker, L. L. FitzGerald, Fritz Brandtner, Lawren Harris, and J. W. G. (popularly 'Jock') Macdonald. They echoed various European trends although few of their paintings, even if they point towards it, can fall strictly within Kandinsky's classic definition of 1937 in which he described abstract or non-figurative art as differing from older forms of expression and from Surrealism because it does not start with a basis in nature or the natural object, but rather 'invents' form of expression in other and di-

fferent ways. In the discussion which follows, the word 'abstract' will describe a painting derived from nature or an object, even though the representation may be so formalized that it has little relation to the original; 'non-objective' will describe a creation entirely from the imagination without relation to any natural form.

Bertram Brooker was almost certainly the first Canadian to take an interest in Kandinsky's art and in the radical viewpoint of his associates. Brooker and his father emigrated to Portage La Prairie, Manitoba, early in the century, and both worked on the Grand Trunk Pacific Railway. A story which is contradicted by documentary evidence describes Brooker reading the works of Kandinsky at that time. His fellow workers must have thought him slightly mad for Brooker had an interest in the unconventional. He had had an absorbing interest in music since his boyhood years as a Croydon choir boy, and at some time he presumably read Kandinsky's book, *The Art of Spiritual Harmony*, which was much admired by Schönberg, founder of atonal music in Germany, who was then exploring the links which related one aspect of the arts with another.

The possibilities in the newly developing motion picture industry also fascinated Brooker; he operated a movie house for a time and wrote scenarios for several productions before becoming editor of a Portage newspaper. He moved on to work as a Winnipeg newspaper reporter, and then to Toronto in 1921. Evidently he did not know at that time L. L. FitzGerald, a young and struggling Winnipeg artist who later would interpret the Prairie scene with conviction and feeling. They met and began corresponding frequently about 1929. Brooker kept on expounding to his friend the latest theories on experimental art and related philosophy when they occasionally met later.

Brooker joined the Arts and Letters Club almost immediately after his arrival in Toronto. Group of Seven members lunched there, and the quarrels over their first Group show were a daily topic of discussion. He himself had little interest in their theories or in any representational painting, and probably indeed had little ability as a draughtsman. His approach to life and thought was philosophical and intellectual. He had a keenly analytical mind, and out of his continuing interest in music (he has been called a frustrated musician) he one day declared to Lawren Harris that if he ever painted, he would paint music. Actually Brooker began quietly to experiment with oils in 1922. His first paintings were series of arcs, diminishing and expanding ribbons of colour, and other geometric shapes which he worked into compositions with no recognizable subject matter. He developed

these experiments until his paintings became 'shapes made up of floating areas of colour' conceived as 'verbs representing action and movement.' Sometimes shapes were replaced by semi-recognizable rods of steel, spheres, and similar objects, vast open structures like the intricate skeletons of giant buildings. These shapes, he said, 'were only introduced as the path or climax or culmination of the movement, not its finish!'[1]

Arthur Lismer sponsored an exhibition of these enigmatic new oils at the Arts and Letters Club. He hung them behind a curtain, which was suddenly drawn aside without preliminary explanation; one man recognized them as music painted by Brooker. These and several later paintings with a similar theme (fig. 148) made such an impression and were commented on so often that one, *Sounds Assembling* (Winnipeg Art Gallery), was shown in the Wembley Exhibition in 1925; its curves, the slow tempo of cooler colour passages, and staccato accents in sharp reds all sounded together in a great musical symphony. Two abstracts, *Arise, Shine* and *Endless Dawn*, were exhibited by invitation at the 1927 Ontario Society of Artists annual show; press, critics, and public were shocked and affronted. The artist pointed out that these were abstract, not non-objective paintings, that each had some basis in nature, and that they were an attempt to 'express the experience of an artist in observing or meditating upon certain natural forms.'

The very next year, 1928, Max Bates and Roy Stevenson had their moments of exultation when they were expelled from the local society shows for exhibiting abstract canvases. The controversial paintings do not appear to have survived, and how far they allowed themselves to go in the matter of abstraction has not been determined.

The next proponent of what was still *avant-garde* was again a Winnipeg man, Brandtner; Brooker meanwhile continued his experiments in Toronto. Fritz Brandtner arrived from Danzig in 1928, bringing news of the latest European art developments, of the paintings of Kandinsky, Feininger, Mondrian, Nolde, Kokoshka, Munch, Picasso, Léger, and others. His own special interests were Cubism and the German Bauhaus. But he found Manitoba years behind Europe in its limited outlook on newer art developments.

In Winnipeg I found to my surprise that the painters in the city had never heard of the European painters I mentioned, and seemed only to have arrived at Van Gogh, Gauguin and Cézanne, and what they knew of these men was indeed very vague![2]

Brandtner's one kindred spirit in Winnipeg was Brooker's friend, L.

L. FitzGerald, who exhibited with the Group of Seven. Brandtner and FitzGerald talked and sketched together. The latter had a 'keen interest' in 'advanced ideas'; his work was changing now for he was developing more formalized arrangements in treating plant life (fig. 149) and other subjects unknown in his earlier years. He began to emphasize the sphere as found in the apple, the plane of a cube as found in a garage, the prism as expressed in the local prison cupola which he could see through his studio window, and the cylinder in tree trunks. He built up geometrical patterns on the snowy ground by criss-crossing trees and shadows. These natural forms were 'meditated upon,' to use Brooker's phrase; individual objects were placed in relationship with one another as in a Cubistic painting, and by association of one object with another he built up compositions of interrelated structures (fig. 150). FitzGerald wrote of his new approach (which can be seen in a painting of inter-related rocks on the seashore): 'It is evident that no one object can be segregated in space without the feeling of something around it, and usually it is associated with other objects. The appreciation of the relation of one object to another will help to suggest the sense of solidity in each.'[3] Obviously FitzGerald wanted to pass quickly by the figurative element and concentrate on the formal qualities in painting. Going further, he chose to paint the beautiful effects found in common things; yet he might also have been arranging blocks as used in a lesson in solid geometry. Brooker obtained a small FitzGerald sketch of this period, studied it intensely, and found that it reinforced and expanded his own kindred philosophy. It is probable that he always envied FitzGerald as being a more painterly painter than himself. FitzGerald had followed many of the principles behind non-objective painting twenty years before he discarded the figurative ornaments of his geometrical units. Yet his period of working as a completely non-objective painter lasted for only a few weeks, and came about when Brooker commissioned an oil which he specified should be non-objective and for which FitzGerald made various sketches and at least two oil canvases. FitzGerald was searching in other ways, a series of self-portraits and nudes demonstrate the introspection which conforms with his quiet, probing, and deeply intellectual attitudes.

Brandtner meanwhile had rushed onto the Winnipeg scene, not realizing quite the uproar which he would create. His first one-man show, held shortly after his arrival from Europe, was violently criticized for its 'ultra modernism,' and he was compared to a mad Picasso. Undaunted, he held a second exhibition just before moving to Montreal in 1934. At the same time he kept on discussing modern art.

Many scoffing Winnipeggers assured him that this modern nonsense would carry him right into the provincial mental institution. But he continued to make experimental drawings and water-colours, abstracted from nature, and among the most advanced work of their kind in Canada. Some were landscapes in which he emphasized planes in a kind of Cubistic framework. Some, of which a water-colour of a strange owl is typical, are composed of floating shapes which have much affinity with Kandinsky's forms; others are more whimsical, such as a cat painted in the Paul Klee manner. By 1938 he had painted in Montreal several non-objective panels using two-dimensional experimental lines to define his colour areas (fig. 152).

Brooker in these years became the centre of a whirling intellectual circle in Toronto which met in his house to discuss all manner of philosophical novelties. He continued his preoccupation with music, worked as a music critic, wrote novels and poetry, and illustrated books. He managed his profitable advertising business in such a way that he had free time to indulge his many interests. Typically his most ambitious illustrations were for the *Book of Elijah*: he had delved into religious meanings and was especially interested in Blake. Several former Group of Seven members were active theosophists, but he himself was more concerned with the nature of God and with religious or spiritual philosophies of beauty. He painted a cold, abstract canvas entitled *Entombment* and introduced the cross as a significant object in Cubistic works. In others he experimented with Cubism in Braque-like compositions based on violins, but used his own very personal colour scheme. His later works are allied to those of Matisse, and finally to those of the American woman artist, Georgia O'Keeffe, as when he painted a white derelict stump on green ground with a strangely mystical quality (fig. 151). Always, however, either in his abstract or in his non-figurative works, Brooker looked for a movement suggested by curves, loops, and twisting lines. He was an innovator and experimental painter, jumping so rapidly from one interest to another that he could not completely assimilate any particular phase, or advance very far in the development of any individual aspect; on the other hand he demonstrated the possibilities of new dimensions in painting, and in that sense he truly pioneered.

Kathleen Munn frequented Brooker's evening discussion groups and was exhibiting advanced types of painting with Cubistic backgrounds by 1929. Brooker described them as being 'musical' and bought one which remained in his estate at the time of his death. For years 'an earnest student of the most modern and most ancient art,' Kathleen Munn became a leading woman painter in Canada and re-

tained an interest in Cubism as an effective art style. Hortense Gordon of Hamilton and others were also involved with these more advanced trends.

Lawren Harris and his wife Bess regularly met Brooker until 1934, when they moved to the United States. On their return to Canada in 1940, they settled in Vancouver. Harris for years had been edging towards abstraction and away from the obvious visual appearance of nature. His intellectual probing undoubtedly was a major catalyst in solidifying ideas about non-objectivity in Toronto. Harris's interests had first become pronounced in his 'lollypop' trees of Algoma and in his Lake Superior paintings of the later 1920s, in which he had sought to express a bigness of creation through simplification, and instilled into it a mysticism which he found within himself. The simplification proceeded in his mountain and Arctic canvases.

Harris by 1932 was undoubtedly very much aware of the promise for him in the non-objective approach and was working actively towards a complete break with nature. In the back of his mind was Kandinsky's idea that if a viewer would seek for the inner significance of natural objects and absorb this abstraction, the artist could finally dispense with the forms. This proposition was tested by Harris in 1934 in his first non-representational painting. It began a cycle which lasted until 1950 during which he used many non-objective shapes – triangles, curves, geometrical forms – which are suggested by the natural world but bear no direct relation to any object; in their purity they dispense with nature's accidentals (fig. 153). FitzGerald had endeavoured to paint in the same way, but he was never able to shed the outer resemblance. After 1950, Harris moved towards Abstract Expressionism of a kind more fully exploited by Montreal artists in the post-war years. Brooker and Harris mutually influenced each other.

J. W. G. Macdonald, who early was fascinated by the mountains and Indian life of the west coast (fig. 154), was conducting independent experiments in Vancouver while the others worked in Winnipeg and Toronto. He had painted 'automatics' by 1934, and completely abstract or non-objective works by 1935 or 1936. He had described his experiments in many letters, although he seldom gave details of the whys and wherefores of the philosophical background for his work. He outlined the steps leading to a new style while he was living at Nootka Lighthouse in 1936: 'a new expression (which is yet only being born) which belongs to no school of already seen expression. To fail to follow through the force which is driving me – and which I clearly believe is a true creative art – would be destruction to my very soul.'[4] The new art form was born under the most trying circumstances, during the

Depression years. Without money, he virtually stopped eating and was finally removed to hospital because of undernourishment.

In 1937 Macdonald made a trip to California to visit correspondents to whom he had described his experiments. There he admired a Cézanne show greatly, and an exhibition of moderns in Los Angeles also impressed him. The works were by the leaders in modern art movement – Picasso, Braque, Modigliani, Derain, Max Ernst, Kandinsky, and sculpture by Archipenko:

Having experimented for some time with a type of modern expression – my own – I was naturally most interested in this exhibition and had the audacity to submit for consideration to the New York gentleman in charge of the exhibition one or two examples of my small moderns. I was decidedly stimulated to find that my work made a decided impression and has been retained for permanent placement in exhibitions of new movements in international art.[5]

A year later Macdonald explained more clearly what he was doing:

Those semi-abstracts I call 'Modalities.' This is a new word dug up from the dictionary, and so far I think it is the only classification which interprets the expression of this work. It means 'Expression of *thought* in relation to nature' and was considered by Kant to relate to creative expressions which did not relate to nature (objectively), nor relate to abstract thoughts (subjectively) about nature, but rather included both expressions ... Strangely enough the Vancouver people have not scoffed at these canvases, and many appear to be interested. What I find so interesting is the complete lack of scoffing. The desire for new thought expressions in the arts appears to be more general than one might imagine. This rather suggests that individuals are not quite so materialistic in thought when separated from the expression of the masses.[6]

During the earlier years of the Second World War, his 'modalities' kept him alive artistically, lifting him 'out of the earthiness.'

Macdonald moved first to Calgary where he changed the direction of painting of artists like Marion Nicoll, and then about 1947 to Toronto where College of Art students were inspired by his lucid teaching. There was a dualism in his work of these years, when he painted many experimental canvases side by side with conventional canvases from an earlier period, but the figurative paintings were becoming fewer and fewer. Finally his experiments brought him to a new school of modernism when he associated himself with Painters Eleven. He was to enjoy before his death a couple of years of exhilaration through the success of his completely non-objective canvases (fig. 156).

These were some of the early Canadian experiments towards a purer form of expression in art which would be allied to European developments along the same lines. All these painters, with the exception of Macdonald, maintained an intellectual and analytical approach; consequently their paintings often have a cold, aloof quality with the meaning coming primarily from the artist's mind rather than from his emotions as a person or painter. These early workers failed to exploit, for example, the tactile values of surface textures. Harris alone seems to have been aware of these possible values. He painted a Toronto street scene in the early 1920s in which an enormous billboard forms one pictorial element and he treated its surface as pure 'action' painting, revelling in the surface play of paint and in a riot of variegated colours which radiate feeling without pattern. He did not, however, continue to develop these experimental beginnings, and such an interest did not reappear until Borduas and other Montreal painters emerged as leading Canadian painters in the early 1940s.

27

Reawakening in Montreal

An explosion of thought shook French-speaking Canada during the 1940s and 1950s. This reawakening, this 'quiet' revolution, sparked by liberal-minded professors in the Province of Quebec, initiated a break with traditional social and intellectual customs, encouraged broader and freer educational opportunities, and enlarged horizons of thought. Painting was only one artistic expression to benefit from this new freedom. Attempts to liberalize artistic thought had been destined for failure from the outset for many years, but all shackles now were thrown off by Pellan, Borduas, Riopelle, and a whole new radical group out of which grew the so-called Montreal School.

John Lyman, like Morrice, lived for much of his life as an expatriate, but he returned to the stodgy academic art world of his native Montreal in 1931. To summarize his activities before that date, from 1907 his life had revolved around painting. He had been Marcel Péronneau's pupil in Paris, a student at the Royal College of Art in London, and only two years later with a newly found friend, Matthew Smith, began to study with Henri Matisse. This association with Matisse persisted until the latter's death. Lyman devoted himself to the cause of painterly qualities in art and his chief canon, evolved through many years abroad, was acceptance of pure colour and a new sense of form. This canon he had tried to introduce to Montreal in 1913, when he exhibited several canvases at the Art Association of Montreal Spring Show, but such innovations were unacceptable then. Critics raved about crude and offensive blobs, just as American critics raved that same year over monstrosities in the New York Armory Show. One of them wrote of Lyman's work in especially abusive terms:

Mr. Lyman dabbles mostly in greens of offensive hues. His colours are smeared on the canvas. His drawing would shame a school boy. His composi-

tion would disgrace an artist of the stone age – the paving stone age. Crudity, infelicitous combinations of shades, unharmonious interjuxtaposition of tints, ugly distortion of line, wretched perspective and an atrocious disregard for every known canon of sane art are here. They leap out of the frames and smite you between the eyebrows. They simply ruin the neutral tints of the Art Gallery's well-kept walls.[1]

Lyman left for Paris in disgust after his ineffectual Montreal foray.

Other *avant-garde* Montreal artists had received similar rough treatment early in the century. Henry Clapp had returned from France as an avowed Pointillist. A. Y. Jackson wrote in 1912 about the rejection of Clapp's work at that time, remarking that he supposed Montreal 'still laughs at Clapp, the loud empty laugh which speaks the vacant mind, but they will learn when all are dead.' Jackson was then discovering in Europe that 'Futurists, Cubists and Post-Impressionists are working feverishly and already the old Impressionist Movement seems like ancient history.' When his own paintings, based on these new ideas, wakened little sympathetic response after his return from Italy in 1913, Jackson moved to Toronto and into the orbit of the Group of Seven.

Lyman's return in 1931 was the first event in a more permanent shattering of the local calm. He found there had been few innovations in the Montreal art scene. Painting in French Canada was academically sterile and could not be said to amount to a great deal. Ontario was but little better, for even then the Group of Seven was reaching almost an academic status. Clarence Gagnon was distrustful of the Group as early as 1927 and wrote of its restricting influence:

Nothing can be done to change matters as long as the Group of Seven will fight and dictate to all the other artists in Canada, nothing will happen to make things better. The younger generation of artists seeing that they cannot enter the House of Seven because all of the Seven Rooms are occupied by the Seven Wise Men, rather than sleep on the steps will move along and build a house of their own ... Then it would be again the old question, a fight for supremacy.[2]

Lyman, wishing to build such a house of his own, believed that art was a creative process and a cerebral one, that it should have no sentimental or literary content: it is the relationship of one form to another and of one colour to another in a formal or 'classical' spirit which has true aesthetic value and gives pleasure to the eye (fig. 155). To spread this gospel was his immediate objective. In co-operation with André

Biéler he set up the *Atelier* for artists where they could work after their own ways. Articles on painting published in *The Montrealer* between 1936 and 1940 further promoted his ideas. Artists sympathetic to Lyman's views were by 1937 rallying around their newly found prophet – Prudence Heward, Fritz Brandtner, Goodridge Roberts, Marian Scott, Jack Humphrey, and others. The preparations were made for a ruthless onslaught against meaningless 'pretty pictures' which then cluttered Montreal exhibitions.

The Contemporary Art Society, organized in 1939, included artists and laymen sympathetic to the theories Lyman had been enunciating. Few French-speaking painters were attracted during the first years, although Lyman and Paul-Émile Borduas felt a certain *rapport*. Members of the society had a common interest in the 'formal qualities of art and a broader subjective response.' They were trying to return to essentials, to reach a state where 'dead visual representation ceased to limit expression.' Their manifesto called for each artist to seek personal satisfaction in his own painting and make no attempt to move others directly. This call led to a variety of subjective as opposed to objective outlooks; ultimately it encouraged a non-representational approach since subject matter played no part in such artistic theories.

An exhibition, 'Art in Our Day,' was held in Montreal during May 1939 as the Contemporary Art Society's first project. There were paintings by Derain, Dufy, Kandinsky, Marc, Kisling, Lhote, Modigliani, Pascin, Rivera, Utrillo, Vlaminck, Zadkine, and Matthew Smith. This exhibition was for Montreal a long-delayed opportunity to examine contemporary masters, much like the Armory Show was for New York a quarter-century earlier. The Second World War erupted three months later and it proved to be an indirect influence when refugees from France arrived in the city. André Biéler moved to Kingston to continue his painting crusade there, and the nerve centre of the new movement in Montreal thereafter became the French-speaking community.

Alfred Pellan, one of the key figures in this revolution in the local scene, returned to Canada in 1940. He brought back from Paris no fewer than four hundred of his own paintings and drawings: he has never done anything except in the fullest measure. He was intimately associated with French-speaking Montreal whereas Lyman, although he had many connections in that community, seems chiefly to have moved among the English artistic group. Pellan's return had two important effects: it awakened an interest in the School of Paris, and he himself was a living example of what a Canadian could accomplish with determination and ability.

Pellan's father had been a Quebec City railway engineer who lived on the wrong side of the tracks. He ground into his son a toughness of moral fibre out of which came his vigour in painting. A landscape of snowy Quebec, painted with a purposeful air at the age of sixteen, was bought by the National Gallery of Canada. Four years later, he won the first Province of Quebec art scholarship for study in Paris. By 1928, Pellan had exhibited 170 Parisian designs and sketches at his old school, Quebec's École des Beaux-Arts. The hard-working young man was already a legend and a tradition when war was declared.

Paris had been a revelation to the young Quebecker. He went everywhere, saw everything, and broke down all the inhibitions of his native Canadian reserve. He steeped himself in the advanced manifestos of each Paris exhibition, in the colour and vigour of Bonnard and Van Gogh, in the whimsical Klee, and in Léger. The Cubists and the Surrealists, Max Ernst and André Breton, fascinated him. Clarence Gagnon described how in 1929 Simard, head of the school at Quebec, begged him 'to go and see Pelland [he later changed his name to Pellan as sounding more plastic], one of their Quebec pups, who had gone mad on Picasso and try to bring him back to the fold!' The older man had no success. Pellan found the great Picasso retrospective of 1932 'overwhelming.' Parisian art critics discovered the young man and he was awarded the Salon des Arts mural prize in 1937, then exhibited with the Surindépendants in Paris, Prague, Amsterdam, London, and Washington. Everywhere the young artist was hailed as a prodigy except in his native Quebec, where the École des Beaux-Arts refused him a teaching post in 1936 because the management saw in him a potential corrupter of the artistic ideals of youthful painters. But Pellan's exhibition at the Montreal Museum of Fine Arts shortly after his return to Canada in 1940 received the fanfare of a conqueror.

Montreal's École des Beaux-Arts now engaged Pellan as an instructor. He brought his philosophy of modernism to his classroom, trying to open his students' eyes to the potentialities inherent in painting, and then leaving them free to work out their problems according to their own personal inclinations. He counselled experimentation and the abandonment of outworn academic tradition for more meaningful art, all of which was most acceptable to his students but not to the conservative director, Maillard. The break came in 1945 when the paintings were chosen for the school's annual graduation exhibition. Pellan submitted works of his gifted students, a nude and a Last Supper. The director ordered them withdrawn as offensive to morality. Removed they were, but Pellan resubmitted them with drapes painted over the nude, and the Last Supper turned into a bacchanalian feast by the

substitution of a bottle of beer for the wine. There was a final explosion when on the opening night students barred the director's exit from the building, shouting 'A bas, Maillard! Vive Pellan!' Friends in the street picked up the cry until the police were called to disperse the mob. Maillard resigned. The battle for free thought was won by young French-Canadian painters, and Pellan painted an allegorical version of the incident, his *Sujet de peinture, ou surprise académique,* with the central figure's head jerked back in his alarm; at the same time the viewer must be alarmed at the evident disarticulation.

Pellan's earliest paintings were based on nature. There are superb youthful flower studies of vases of tulips in vivid oranges and greens with colour areas extended to create solid units which give a cubistic strength. This strength sometimes becomes brutality, but Pellan is gentler in his *Jeune fille aux anémones,* in which the young woman poses quietly before a harsh background which serves to emphasize her sophisticated air, her blond hair, and her two-toned red costume. But on the other side there is almost viciously cruel frankness and truthfulness in his *Fillette aux lunettes* (private collection); she will never become a gay extrovert, but is doomed to a life of sadness because of her unattractive features, her short-sighted eyes, her prominent teeth; already she shrinks back into a hidden world. Then in *Le Bûcheron* (private collection) he painted a ruddy face with the harsh features of the workman carefully mapped; the *bûcheron* is a tough, unyielding, and unfeeling man, a vivid contrast to the soft face of the harlequin in *Jeune comédien* (National Gallery of Canada) who sits daintily in his chair with his carnival hat and gay costume.

In Pellan's more stylized painting, his subject is the life-forces of man and it is always emphasized in powerful forms. Most remarkable is the great concentration of hidden strength in his *Hommes-rugby* (private collection), where unwinding lines are like those of some giant spring about to unleash its powerful torque. It is an allegory of the vigour of young manhood, with even a bull's head introduced as a symbol of brute strength. This inner vitality is carried over into a whole series of tough, vigorous paintings sexually motivated. They contain nothing lewd or distasteful; they simply reflect the response of virile young manhood to an inner well-spring of strength. In the illusionistic *Sur la plage* (National Gallery of Canada) a huge head of a young man, erect and proud, fills the canvas with all the alertness and strutting of a young cockerel, while nude forms recline on the beach. At other times Pellan painted nudes as part of powerful compositions bound together by lines of strength and force (fig. 157); the interplay of colour creates an almost supernatural atmosphere which relates his work to Surreal-

ism. Such painting could only develop from his Parisian years when he had divorced himself from Quebec's staid atmosphere. The preoccupation with sex carried Pellan even further into the creation of allegories in such canvases as *Floraison* (National Gallery of Canada) in which natural forces are illustrated symbolically through the swelling and bursting of the seed, the upward thrust of the plant through the hard ground, and finally the blossom and the seed pod; the life cycle then begins again, for nature cannot be subdued. Not the least important feature of this painting is the strident colour – rainbows of yellows, reds, greens, blues, and pinks that charge the canvas with vibrant emotion.

Pellan's choice of subject matter is omnivorous. His landscapes range from his earlier conventional Quebec scenes (fig. 159), firmly painted, to the brilliance of a Greek seaside town. Each canvas in a series of gardens painted during 1958 is simply a flat plane with abstracted flower and garden symbols scattered across the surface like jewels. Then, in a more whimsical mood, he caricatured a nightmare of yowling cats on a back fence. His mind probes everywhere; he draws from a hundred sources.

Possibly Pellan's most active creative period was between the end of the war and his retrospective at the Paris Musée de l'Art Moderne in 1955. Then his colours were most daring, his compositions most complex, and his canvases the largest of his career. His work achieved mature sophistication, was so complex and of such technical accomplishment and personality as to discourage imitation. His place in Canadian art has been that of prophet and creator, rather than that of an inspirer of style. His has been a great personal achievement. Canada's first French-speaking modernist now lives in a cottage in Sainte-Rose near Montreal.

Jacques de Tonnancour has remarked that what the Province of Quebec needed was a vigorous blow from the outside to break the lethargy which had existed for years; this blow Pellan gave and a renaissance began. Tonnancour himself through his own searchings into the basic truths of modern painting, through his teaching, and by his example as a painter, has done much to promote sensitive painting in Montreal. He discovered Matisse at an early date in his development, and painted young women in rich full colouring after the Matisse manner. He progressed to a study of Picasso, and then turned to nature and interpretation of the Canadian landscape. Tonnancour's earlier interpretation of the northern landscape was bold and vigorous, the greens rich, the blues unmodulated. Gradually he refined his treatment, softening the colours, using a more delicate line as he painted young evergreens stunted by under-nourishment on a sandy waste.

Paul-Émile Borduas has had a greater influence than Pellan on younger minds, both as an active mentor and as a creator of style. Pellan's personal paintings were a *fait accompli* of such staggering impressiveness before he first became widely known in his home country that students felt like novices afraid to fraternize with a Picasso or with some remote god-like figure. Borduas, on the other hand, grew in stature as a painter in Montreal where the younger artists could see every step in his development. While teaching at the École du Meuble, he was searching constantly for his *métier*, and at the same time discussing his ideals with his students. He examined and was inspired by the works of children and youth, and made the young people around him feel that they were active participants with him in a new revolutionary movement. His final non-objective, *tachiste*, or automatic paintings had simplicity as a key-note, something which even the beginner could experience and emulate although he might be unable to achieve the powerful intensity and emotion of which Borduas was capable. Consequently followers, imitators, and missionaries gathered around him, and their devotion to the new cause was so great as to ensure for several years its virtual domination of the revolutionary art scene in Montreal.

Ozias Leduc was Borduas's well-spring of inspiration. He had been born in the older painter's native Saint-Hilaire and had attended the local village church where he first knew Leduc through his murals. Borduas later worked as a student with Leduc and assisted him in church decoration. He received from the older man a 'spiritual atmosphere of the Renaissance.' From him Borduas learned dedication to artistic purpose and integrity. It was at Leduc's urging that he attended the École des Beaux-Arts in Montreal. A trip to Paris threw him on his own resources and he began to develop his own personal talents; there he experienced creativity through Renoir canvases, and sensitivy towards matter in those of Soutine. For some years after his return home he taught in the secondary schools by day and painted by night. Radical innovations were few in the early landscapes and portraits of this period with their simple forms and sensitive surface textures, but progressive boldness and simplification appear with the passing years. Borduas himself was dissatisfied with his work. By 1939 and 1940 new radical developments were becoming apparent in his paintings, which reached the austerity of *La Femme au Bijou* (private collection) in which brush slashes define the head and body, subject matter seems seems no longer as important as vitality, and the very act of execution becomes the essential element.

Various external forces crowded in on Borduas during these most

critical years; Pellan's 1940 exhibition made a great impression on him, although he showed absolutely no inclination to imitate his style. He discovered André Breton's writings on Surrealism; out of these grew *gouaches* which he at that time described as being surrealistic but later admitted were nearer to Cubism. Other radical writings added their quota of thought.

Association with his students always had a marked effect on Borduas. As early as 1933 he sensed the uninhibited freedom of approach in the work of his young pupils, but in 1937, when he was appointed to the École du Meuble staff, he met such bright, fresh and vigorous young minds as those of Riopelle, Barbeau, and Mousseau. Fernand Leduc, a former École des Beaux-Arts student, later became associated with this group. Borduas admitted that these advanced students terrified him, for he was not yet sure of himself and had not yet worked out his own philosophy. Six years later, Borduas was solving problems in conjunction with them. He has described joint sessions in which they studied reproductions to try to discover the unity between the present and the past, searching for the common element in all painting and all schools which makes each canvas into a work of art. This he found to be what he called a 'plastic' quality, or, as he described it 'a moral quality, consistent throughout the centuries, made evident by an infinite variety of plastic qualities.' This discovery opened new paths, for if the plastic was the only important quality, each student was free to experiment with it rather than mould himself on anything reproduced from the past; Borduas 'had become an intelligent man searching for the solution to his problems of expression.' (fig. 160). Individual feeling became a legitimate expression, for it was the artist's feeling transmitted to canvas which transformed a painting into a work of art.

Borduas's association with more mature minds also provided mental stimulus and challenge. There was a *rapport* with other staff members of the École du Meuble, particularly Marcel Parizeau, professor of architecture, who was expounding a new and youthful approach to building design which combined unity of idea and purpose. This, Parizeau felt, was more significant than the conventional thinking of tired men whom he found everywhere in Canada and who failed to go beyond old architectural canons; he saw them as a vivid contrast to certain youthful, robust Europeans. Maurice Gagnon, professor of history at the school, was very much aware of Borduas's searching for new meaning in art. In 1945 he had the courage to extol Borduas's profoundly poetical and cerebral searching into art expression at a time when the public was still largely sceptical. He discussed how Borduas's theories were built on a deeply sensitive basis:

Borduas opens up to us an infinite universe of poetry, and that is what is important and what delights us. What a marvellous dreamer! He is a more vibrant poet than any we have had in our literature, and is, moreover, a powerful and free poet, a tormented poet who carries us to the very heart of the enigmas, of the dream, and there imposes the irradiating beauty of the beings which he catches in his sombre and vigorous emotion. His sensibility, so profoundly individualistic, is truly pictorial and of an indescribable richness. The past painting whispered light airs and hummed modulations in a low voice. Borduas fills the present with a song of such voluminous resonances, of such breadth, that it will reverberate untiringly. Borduas is the poet.[3]

Borduas met John Lyman in 1938 just at the time when he was discovering the subtle painterly qualities in the canvases of James Wilson Morrice. Lyman, with his intimate knowledge of current Parisian intellectual and aesthetic trends, stimulated Borduas to read contemporary French writings, out of which emerged his Surrealistic interests. Two powerful art figures then came onto the Montreal scene as a result of the German occupation of Paris. Père Couturier, an intellectual and an authority on world art movements, lectured and taught locally, and organized exhibitions of 'les Indépendants' in collaboration with the Contemporary Art Society. Fernand Léger, a refugee living in New York, on occasion lectured in Montreal and talked with the more radical painters. The whole atmosphere tingled with excitement.

After convincing himself that the figurative element had no essential meaning in a painting, Borduas rejected not only all subject matter (although he still retained a certain affinity with landscape) but also his interests in Picasso, the Cubists, and the Surrealists. Instead he adopted 'automatic writing' and later Automatism and Tachism. These had inspired an art practised by Jackson Pollock and other New York painters but virtually unknown to Paris. Its aesthetic is found in the significant meaning of the medium itself: the infinite variety of surfaces, the light or heavy application of paint, the swirls of the brush or palette knife, and the accidentals of colour. It was Borduas's conviction that the artist's inner spirit will automatically reveal itself by means of an uncontrollable force which ignores the human world; the painter's unconscious mind will accept and set down or reject and refuse to record artistic feelings as the brush wanders freely over the canvas. Borduas went beyond automatic writing to a union with a kind of cosmic force of life and truth in space, in which no conscious artistic mind is recognized. The new movement's first real triumph came in 1947 when Barbeau, Fauteux, Fernand Leduc, Mousseau, and Riopelle unleashed the results of the new theories on the local art world in their Automatiste Montreal exhibition.

Borduas's life was completely altered through the publication of his famous *Refus global* manifesto in 1948. This series of essays was prepared when Automatism had already become a vital and recognized entity. He felt that it was more than an artistic approach, but rather had become the philosophy of young French Canadians, embodying an exasperated revolt of younger minds against rationalization and mechanization. It made possible a poetic perception of life and the world, and it demanded freedom for the powers of imagination and sensibility. The *Refus global* was written primarily to support these views, but in composing a manifesto of independence Borduas attacked every,thing which he saw as a restraining influence, even the church which he felt was perpetuating a sterile order in its refusal to allow complete artistic freedom. He and his co-signers were bitterly denounced. Borduas himself was dismissed from the École du Meuble. Pellan criticized his authoritarian ways and associated himself with a short-lived group, the *Prisme d'yeux*. Jacques de Tonnancour, in writing a manifesto setting out the views of Borduas's opponents, stressed that purity of expresson did not diminish human values, and that pictorial expression must be a projection of life if it aspires to universality. Thereafter Borduas devoted himself solely to his painting, first working in Saint-Hilaire, then in New York from 1953 to 1955, and finally in Paris.

Borduas's health begain to fail in 1949 and for a time he was forced to conserve his strength by painting largely in water-colour. Two years later he sculptured briefly at Saint-Hilaire. Only when he reached New York did he really discover light, since previously he had painted at night. His joy and exhilaration at the revelation of qualities which light could give were reflected in increasingly large white areas on his canvas; they often seem like great swirling snow-storms tinged with reds, blues, greens, or blacks; they sweep over his canvases in misty triumph. His analytical development continued in Paris. The colour scheme was reduced to stark black and white (fig. 158) with sometimes an accent of green, brown, pink, or some other single colour. His last great study was how to eliminate ambiguity of space in the viewer's mind, and replace it with a definite vision which the artist himself was able to control by what he set down; this new search was prompted by his observation of Mondrian paintings.

Borduas was unhappy in Paris, separated from his family, in financial difficulties, and constantly plagued by illness. There were some lighter and happy moments when he toured Switzerland, Italy, and the southern countries. He even reached Greece where the bright light was an unutterable joy. Much of his later life was spent in writing es-

says, but these have disappeared. He died of a heart attack early in 1960. The last canvas on his easel was totally black, like a curtain of mourning drawn down over a life of continuous searching. That struggle had always been carried on with painful intensity, for to Borduas a man's value lies always in his total intensity, not in compromise which diminishes one's feelings.

Jean-Paul Riopelle, the best known painter to emerge from the clique of young men who surrounded Borduas, has sought ultimate meanings in a romantic exploitation of Borduas's discoveries. His outlook is at the opposite pole to that of the earlier painter. Borduas was an analytical, introspective individual who developed his mysticism to a point where classical overtones appear. Riopelle began as a conventional Montreal landscape and still life painter, but he had an exceptional love of colour. About 1945 he joined the Borduas dissidents at the time when they were the dominant element in the Contemporary Art Society. The group hired a hall and disturbed the established order with their unconventional painting.

Riopelle had discovered new modes of expression at some date prior to signing the *Refus global*. He has reminisced about how he looked into a pool of water and became aware of strange and unfamiliar surface patterns. A segment of the design he saw there, when painted on an enlarged scale, produced an exciting new visual aspect of nature. Superficially he had achieved an abstract painting. Basically it was a completely figurative representation of patterns in a pool of water which the artist remoulded to get a new and strange visual impact.

In his youth Riopelle visited Germany and Paris. While living in New York in 1946, he joined his Montreal confrères in participating in the International Surrealist Exhibition. He moved shortly after to Paris, but made frequent trips back to Canada. Early Paris friends were Fernand Leduc, his old Montreal companion, Mathieu whom he knew for a brief time, and the widow of Henri Matisse who was a second mother to the young Canadian away from home. But Riopelle does not spend long hours discussing intellectual and philosophic concepts of life and art. He has shunned the theorizing and interminable harangues of the Parisians. Rather since boyhood he has spent long hours out of doors, hunting and fishing in Canada, driving fast cars, and yachting on the Mediterranean when the brisk wind bites into the cheeks. He loves to laugh with circus acrobats and clowns. As his painting took on new vitality, the public and critics became aware of his robust, original approach. His rise was meteoric, and he has achieved an international reputation among art connoisseurs.

With fame came an opportunity to wander, to travel in search of

inspiration. He had roamed the Montreal and Gaspé areas before go-
ing to Paris. His first European contacts were in the Île de France but
he probed farther afield, visiting the little island off the Brittany coast
where the Acadian descendants of the 1755 deportation still dream
about the land of their forefathers. Riopelle has revelled in the warm
south of France, the colourful and romantic Camargue region with its
gypsy life, the Chevreuse valley, and the Riviera shoreline with its var-
iegated plant life. In the Alps during 1954, he studied glaciers at close
range. There were trips to Spain, Holland, Germany, Greece, and
Turkey, and to upper Long Island where he hid from the great city's
bustle in an old farm house adjoining an Indian reservation.

Riopelle has painted in oil, and experimented in other media such
as coloured ink, water-colour, and pastel. A *gouache* series is of particu-
lar interest since it is based on West Coast Indian masks with eye-
brows, lips, cheeks, and other decorative patterning used as isolated
units and re-oriented into an over-all pattern of rose, green, ochre, and
black like a rich visual mosaic. By contrast, many water-colours and
coloured ink paintings are inspired by submarine plant life.

Earlier artists have received Riopelle's unstinted admiration. As for
so many of his generation in Quebec, Ozias Leduc is the old Canadian
master, and several drawings by the hermit of Saint-Hilaire are
among his prized possessions. He likes individual canvases by Euro-
pean painters rather than any single artist's complete *œuvre*: certain
paintings by Géricault he mentions as masterly examples of vigorous
action, and others of Tintoretto he singles out for their great bursts of
light which seem to shatter the surrounding gloom. He has an affinity
with Van Gogh, and has even painted a canvas in homage to the
Dutch artist since he, like Riopelle, loved brilliant colours and earthy
people. The artists mentioned are all of a romantic school, colourful
and emotional, as opposed to the classical, introspective, and intellec-
tual. Riopelle's style thus diverged from that of Borduas in the days
following the *Refus global* when both were motivated by the same rebel-
lious spirit; Borduas became more 'classical,' finally reducing his
paintings to a point where in colour they are a stark black and white,
whereas Riopelle became more concerned with a romantic evocation,
expressed through colour and light, of the ecstasy of the momentary
sensation. Yet Riopelle continued to base his work on real life experi-
ence whereas Borduas became completely non-objective.

A single example clearly illustrates Riopelle's flashes of romanti-
cism and his use of the natural phenomenon as an inspiration. Walk-
ing along a Paris street on a January afternoon, he remarked on the
beauty of an eerie light cast by the sun from behind a cloud. The

whole atmosphere was charged with an inexplicable vibration, which had to be felt to be appreciated, when a tiny shaft of golden light ringed with its complementary mauve pierced the cloud ceiling. That fragment of mysterious light, caught up and enlarged on canvas, broken into prisms of juxtaposed facets of pure colour, would make a typical Riopelle painting, and its origin would be unrecognizable after it had been re-oriented and set down in paint by the artist. He would extract only the mystery, the emotional reactions, the excitements which the inner man would experience. This vital man creates something new out of the momentary excitement of nature's moods, painting his impression in a colourful, satisfying, full manner and yet producing constant change; all his complex reactions would be integrated in the painting. It would express a universal truth in a personal language and he would have extracted and moulded it from the world about him.

His significant abstract and non-objective years may be divided neatly into various progressive stages. By 1947 Riopelle was a Tachist or Automatist, painting his canvases with superhuman energy, applying strokes of green, orange, and white, and achieving results which he likened to the fury of a waterfall or to the haunted woods in which stray flickers of light penetrate the gloom. Gradually the vigour became more controlled and in this stage he built up a surface pattern of criss-crossed colour threads in a more deliberate poetry (fig. 161). But the work best known to Canadians began to emerge in 1953 when he flattened out his rebellious blobs of paint as they were squeezed from the tube. Soon his surface became a modelled mosaic of flat textured colours, skilfully laced together in exhilarating sensations of romantic colour harmonies and varied vibrations of light. The surface takes on a tactile, three-dimensional effect, the flat tapestry-like surface disappears so that, as has been suggested, the ensemble slowly becomes animated, the colour planes become alive and slide, incline and overlap one into the other, and compose themselves into complex and infinitely subtle spatial relationships. To this phase belongs his *Pavane* (National Gallery of Canada) which captures the slow majesty of the Spanish dance in the streets at night. This phase gradually gave way to calligraphy of meandering green, blue, mauve, or black lines. By 1960 Riopelle was painting solid forms, as echoed in *Composition*, in which there is no longer an outdoor landscape wilderness but a world of fierce primeval beings. Strangely enough, Riopelle's work, like that of Pellan, has been too personal in its style to tempt close imitators.

New developments which grew out of Borduas's thinking manifested

themselves for years in Montreal. Borduas had left the city in 1953 and returned for only brief intervals. Certainly he remained in close contact with his 'Automatiste' circle, but it was no longer the same intimate day after day and night after night association. Perhaps his physical removal from the scene was one reason for new changes in direction. Four Montreal painters, Louis Belzile, Rodolphe de Repentigny, Jean-Paul Jérôme, and Fernand Toupin exhibited their new paintings jointly in 1955. They called themselves the *Plasticiens* and issued a manifesto setting out their objectives. In this they advocated a *pure* strain in painting; it was opposed to the humanitarian overtones advocated by the *Prisme d'yeux* followers who did not exclude figurative allusions. The *Plasticiens* declared that their ultimate goal was unity in painting, *pure* order with no extraneous incidentals, and a spontaneous expression of the subconscious. Their paintings resolved themselves into coloured geometric shapes, eliminating such aspects as suggestions of visible space and ultimately textural effects. There is little in them to suggest the anger of protest found in the Tachist gesture.

The *Automatiste* philosophy adapted itself readily to an alliance with painters working in a 'hard-edge' geometric style. Fernand Leduc, Guido Molinari, Marcelle Ferron, and others became members of the Non-Figurative Artists' Association of Montreal in 1956. Jean McEwen, Paterson Ewen, Rita Letendre, Marcel Barbeau, Jean-Paul Mousseau, and Claude Tousignant were all involved in the very lively non-figurative milieu. Each artist's work had personal characteristics. Fernand Leduc's great flat interlocking geometric shapes transformed his canvases into gripping visual experiences. He spent much time in Paris and New York – indeed, many of the young Quebeckers carried on an emotional and romantic courtship with Paris, and New York played a definite role in Montreal artistic life in the late 1950s when Charles Gagnon and others were studying there. Gagnon brought back with him memories of confining walls and pavements, whimsical experiences of alley cats inspecting numbered garbage cans, and the acid bite of John Cage's music to be captured in harsh green, white, and black paint. Molinari and Tousignant both may have been influenced by the colour field painting of American orientation. Molinari exhibited new paintings in 1959 and steadily preached and promoted his theories of colour related to space. He achieved pictorial depth through juxtaposition of flat coloured stripes: areas advance and recede as the eye travels over the surface. Tousignant achieved a cerebral impression through optical effects, painting concentric rings of colour in biting contrasts.

Jean McEwen eliminated subject but retained colour and texture.

While Borduas discarded most colour towards the end of his career, restricting himself virtually to black and white, McEwen's richly stippled yellows, browns, and reds glow like old leather. A series of his canvases can be likened to glimpses into the atmosphere during the progressing day; there is lyricism in the pinks of early morning, joy and jubilation in the sunset colours of his 'flag' series, and both sadness and nostalgia in the deep blues of the night sky. But in his striving for stark simplicity, one is reminded also of the blank square mannerisms of Rothko, the Russian-born American, who demonstrated the power inherent in the simplified canvas.

Figurative artists did persist and drew their inspiration from nature, even if the more noisy non-objective painters seemed to grasp all the publicity. In addition to such artists as Lyman, Lemieux, and Pellan, there were isolated workers like Jean Dallaire. He has been termed a Surrealist. In one painting he satirized the situation of the United Nations by picturing the United States as a rooming-house keeper hanging out her shingle; on another occasion he painted an allegory on devastated Hiroshima (fig. 162). Léon Bellefleur's paintings incorporate Surrealistic overtones. Suzanne Bergeron painted landscapes of rivers, romantic docks, and trees in low-keyed colours and an Expressionistic technique. Edmund Alleyn never foresook figurative and literary overtones in his visually rich canvases. English-speaking artists, Philip Surrey in cityscapes and Goodridge Roberts in figure, still life, and landscape paintings, incorporated a mood consistent wth the Montreal milieu in which they were conceived.

Pellan and Borduas were but two French-speaking Canadian artists whose styles emerged in part from Parisian painting of the 1930s. One also may trace in Montreal some influence from the New York movements. Yet each major painter in Montreal during the 1940s and 1950s demonstrated his own inherent power through personal interpretations beyond influences from outside the province.

28

Anglophone Revolt in the Fifties

New faces, youth, impatience with past convention, restlessness, and ambition characterized the fifteen years following resumption of peace in Europe during 1945. The groundwork for revolt against traditionalism had been laid in Toronto by Harris, Brooker, Macdonald, and others in the 1930s. But generally these pioneers were contemplative men rather than active revolutionaries, and their concepts, unorthodox for Canadians, received but minor attention. Members belonging to the undoubtedly sincere and well-meaning art societies still dominated the artistic communities in the later forties. Ontario looked to the Canadian Group of Painters, the Ontario Society of Artists, and the prestigious but remote and rather cold Royal Canadian Academy. Very conventional art was being taught at schools throughout the country. Nowhere was there suggestion of *real* revolt.

In Ontario, there seemed a set of unwritten rules which dictated that artists should spend summers sketching at Go-Home Bay, Bobcaygeon, and other equally pleasant places; the more effective field sketches would be enlarged at home into a few ambitious works destined for annual winter exhibitions. Old formulae, particularly landscape rules established by the Group of Seven, were reworked. Sometimes the results were effective, but they embodied little sense of an all-embracing probe for new adventure in feeling. Lifeless paintings resulted from the absence of artistic search.

Established men traded on past reputations for occasional sales and usually pictured the Ontario northland; their real living came from adequate salaries as commercial artists or teachers. In the absence of high idealism, few graduates of art schools acquired more than a pedestrian motivation. One school in which real artistic conviction was an overpowering consideration was set up by Varley and Macdonald in Vancouver during 1933, but quickly fell apart two years later

through lack of monetary support by the social establishment. In the immediate post-war days, Pegi Nicol MacLeod had been horrified at the exhibitions of the Ontario Society of Artists: she found in them a complete absence of even the joy which she herself experienced in painting, and described neat rows of paintings looking as if they were made with the aid of stencils or stippled with an air brush. Art in Toronto had become something of a bore. The verve of the Group of Seven of a quarter-century earlier was dissipated, and one would be sorely tried to find real creative excitement in English-Canadian painting with the exception of canvases by a few lonely individuals.

The resumption of normal life styles in the late 1940s and new emerging groups of artists combined to promote change. There was a sense of artistic isolation in much of Canada, but ideas *did* penetrate from outside. Restless individuals looked to and envied the New York scene with its lively Abstract Expressionist movements. In Toronto, revolt smouldered among young radicals who envisioned a life dedicated to creativity and undiluted by exhaustion from commercial art and teaching. They may even have been jealous of the shouts, jeers, and cat-calls shattering Montreal. But there was no patron like MacCallum and Harris to provide economic stability as a necessary foundation for artistic growth. Perhaps it was sheer frustration with convention that triggered militant action and prompted the Painters Eleven to first exhibit as a united group in 1954 and thereby shake the foundations of the Toronto establishment.

Painters Eleven was a name chosen by a group of local artists who made no pretence of embracing a common artistic philosophy. They organized simply for mutual convenience in promoting their own canvases locally. But their united front was a chilling and disquieting storm in a comfortable living room. Their democratic and free-wheeling organization was born one night during 1953 in a downtown department store as publicity men photographed room settings hung with abstract and non-objective paintings by several Toronto artists. The pictures had been collected by William Ronald. Someone suggested that all the artists should exhibit together. A meeting was arranged at Alexandra Luke's lakeside studio near Oshawa to discuss specific proposals for positive action, primarily for an exhibition solely of their type of work 'and not disbursed among all the junk current in all Art Society shows.' With a sense of destiny and an awareness that they were crossing a divide, they recorded the noisy, argumentative, and often incoherent discussion on tape. There were some older artists there. Hortense Gordon from Hamilton had been known as a perennial experimenter. Jack Bush had long worked as a commercial artist,

and throughout the life of the organization was its treasurer. The revolutionary Jock Macdonald, then teaching at the Ontario College of Art, was noted for the zest with which he discovered new talent. Among the younger men was Harold Town, who wrote the organization's catalogues. He worked closely with Walter Yarwood, who with Tom Hodgson did the design work for the organization. William Ronald maintained links with the New York scene. Others were Kazuo Nakamura, Ray Mead, and Oscar Cahen, an artist with a colourful flare who died tragically in a motor accident three years after the organization was founded. It was significant that all members had exhibited in local and national art exhibitions which catered to every taste, but now for the first time in staid Toronto they were daring to raise a revolutionary flag by organizing a completely abstract and non-objective non-juried show.

The exhibition opened during February 1954 at the Roberts Gallery, where Jack Bush had previously had paintings. In two weeks more people attended than had ever visited the gallery in a similar period. The younger local artists were excited. Whenever Painters Eleven met, they fought and argued about *painting*. Painters Eleven showings were held in various centres throughout Ontario during the next two years, although the chief support came only from a core of fervent admirers. But in April 1956, through Ronald's contacts, they were invited to New York as guest exhibitors at the annual American Abstract Painters Exhibition. Critics heaped words of praise, several members held one-man shows in that city's commercial galleries, and Ronald moved to New York. The U.S. experience gave the group as a whole their first physical contact with kindred spirits outside their own parish. It also made a strong impression on Canadians, probably in large part because of the laudatory seal of approval from the American press.

While Montrealers had Parisian interests, and the Torontonians had close ties to New York, the progressive groups in both cities realized that they were carrying on a joint struggle. A combined exhibition by artists of the two cities was held in Toronto during 1958; canvases by Painters Eleven were hung with those of Bellefleur, Borduas, Dumouchel, Ewen, McEwen, Pellan, Picher, Riopelle, and Tonnancour. The solid front of revolution and dedication was unique in the history of Canadian painting.

The Abstract Expressionism which dominated the thinking of Painters Eleven lacked the racial overtones found in French-speaking Montreal's art and artists of the decade. Several of the Toronto men were particularly concerned with the sensual life in which love and

mating played a vivid role. This philosophical approach can be readily isolated in Oscar Cahen's paintings; his grey abstractions enhanced with colour were inspired, it would seem, by bursting seed pods or other natural forces associated with the fruition of nature (fig. 163). The life-cycle theme is analgous to that which underlies Pellan's great triumphs in paint.

Some group members, and in restospect probably those who have had the most lasting influence, lashed paint on canvas in revolutionary gestures. They expressed creative release in the very act of applying paint. It was the flamboyance of these younger men – reminiscent of Jackson Pollock – which projected the organization into the local artistic spotlight. Such sensational showmanship was an essential ingredient for success in the Painters Eleven crusade, for without it no dint would have been made in the façade of conservative thought. William Ronald, Jock Macdonald's preferred student, was colourful in his personality as well as his work: he had the 'bold brashness so unusual in the Canadian temperament.' His 1955 canvas, *Central Black* (Robert McLaughlin Art Gallery), is typical of many. It proclaims his affinity to New York Abstract Expressionism, the movement which had played a critical role in Macdonald's thinking. Ronald was drawn to that city as much by compatibility with its thinking as by his vociferously expressed dissatifaction with Canadian conservatism. There he pursued an extremely successful painting career for a number of years before returning to Toronto.

Irreverent Harold Town was the other spectactular member of the group. His personality, a combination of genius, supreme egotism and self-confidence, exuberance, spectacular showmanship, and gentle introspection, catapulted him repeatedly into newspaper headlines. His verve and deceptive bluster tended to hide his great sensitivity. His evangelistic argument that artists must be free to express themselves at will, untramelled by traditional yokes, was waged in a bristling, brusque, and impetuous fight. It is mirrored in the devastating gesture, so evident in *The Turner Reprise* (fig. 164). His free calligraphic application of paint directly squeezed from the tube, a building up of layer after layer of impasto over a two-year period, has created a complex and highly expressive visual structure. But this virtuoso could turn from such turbulence to quieter canvases. Some originated in street traffic or highway overpasses. Others incorporated great seals and Viking or oriental motifs prompted by his discoveries in the Royal Ontario Museum; a magnificent collage, *Homage to Currelly*, honours the man principally responsible for creating that institution. There are bacchanals and Spanish Don Juans. Town long proclaimed that he

didn't need to leave Toronto for even brief exploratory visits; he declared that his only real needs were a combination of life in his own surroundings and of antiquity as discovered in the Royal Ontario Museum. Few other painters rival his ability to be equally at home in large paintings which dominate exhibitions, in the seductive coluring of his serigraphs and collages, and in his brilliant draughtsmanship.

Flamboyance was an inherent quality in much other art of Painters Eleven. Jack Bush chose to paint canvases huge for that time. They evolved into the epitome of simple inconography and colour; their large colour areas were allied to New York internationalism of the late fifties and early sixties. But in 1960 his *The White Cross* (Agnes Etherington Art Centre) still demonstrated feverish brush strokes. Tom Hodgson, an Abstract Expressionist, painted the figure with a vigorous facility which has been described as reminiscent of de Kooning. Graham Coughtry, closely allied to the Eleven but never one of the group, demonstrated great technical facility and fluid freedom in painting the nude but remained closer to the figurative element. His artistic involvement with his subject matter was more personal than Hodgson's; painting for Coughtry was like a sensual act, whereas Hodgson's application of pigment seemed rather a release of physical energy.

The diversity of approaches in Painters Eleven is highlighted by comparing the paintings of Kazuo Nakamura with those of his friends. During the fifties he painted Muskoka pines, potted plants, and box-like structures reminiscent of prairie grain elevators (fig. 165). Always his paintings are refined and restrained, each a fresh probing for further purity of artistic expression. The subject matter is Canadian but the feeling eastern. About 1960 Nakamura began a series of non-objective pale grey canvases. These embraced delicate checkerboard themes or series of gentle parallel lines intended to invoke a purely contemplative mood. Their surfaces were made meaningful through textural relief and gentle tone; they read in the manner of Ronald Bloore's white paintings. Among the group Nakamura was the cloistered monk with none of the demagogue's traits found in some of his associates.

Painters Eleven disbanded in 1960. The new approach and exuberance was a healthy blow for Toronto and English-speaking Canada. It was a reaction to instinctive desperation and tore down a 'high parochial fence.' It paralleled the Montreal upheaval.

A surge of painting activity in British Columbia during the forties and fifties reached a point where some regarded it as a western art renaissance. The new painting embodied qualities unique to that province

and retained a local Pacific coast flavour. This was in sharp contrast to Regina painting at the peak of activity there; Regina was internationalist in outlook but strongly motivated by New York. British Columbia in the fifties clung to abstraction but avoided non-objectivity; seemingly when nestled between the mountains and the sea, nature herself was so dramatic that artists could not completely dismiss their surroundings. More particularly Vancouver saw itself as part of a Pacific community. It was isolated by mountains and distance from eastern Canadian influences. Ever-present nature was at its immediate door. Lively and easily accessible American communities such as Seattle and San Francisco were to the south; Jock Macdonald had found sympathetic ears in California for his Nootka Island experiments, and other artists also had north-south interests. Vancouver too was Canada's gateway to the East, and the oriental community provided another dimension to local painting.

One spokesman of modernism was Bert Binning, who taught at the University of British Columbia. Binning had achieved an international reputation as a draughtsman before turning to oils in 1948. He came from a family of architects and built his painting in an ordered architectural manner with elements growing out of Cubism and Abstraction. This basically cold approach he balanced with an inner radiance and a joy in water and boats. Binning's little yachts frolic in the waves; his great liners are abstracted in such monumental canvases as *Ships in a Classical Calm* (National Gallery of Canada). Always there is control and balance counteracted by humanization, 'this business of serious joy,' in which the artist dreams of quiet spaces, rich notes of colour, and the sea.

Jack Shadbolt evolved into a much more prolific and significant painter. His youthful beginnings were inspired by Emily Carr and F. H. Varley; Cézanne loomed in his background. Shadbolt painted water-colours of Vancouver street scenes that were executed in the 1940s but relate directly to paintings of the regionally oriented thirties. Then he was lured by romantic North West Coast Indian carvings with their seductive and insistent red, blues, and greens; echoes of this local source were introduced into his freely brushed Abstract Expressionist passages. For a period, Shadbolt immersed himself in subtle ochres, yellows, and greys, sometimes picturing bird forms, sometimes plants (fig. 166). Beginning in 1957, he made the first of repeated visits to the Mediterranean and Near East, where he found brilliant colour and dazzling light. Sometimes he felt that Tachist technique was appropriate for catching this shimmer. In his repertoire, medieval Mediterranean cities counterbalanced Vancouver's sombre winter rains

and fog. On other occasions, his deliberately lyrical and flowing 'growthy' iconography, drawn from Islamic writing, was transformed by local Indian colours. This versatile painter is unique in that he is a real internationalist in outlook but overlays his art with an inspirational urge from British Columbian subject matter. He retains strong regional links.

Others in the fifties were breaking old conventional figurative painting barriers. Four Vancouverites can be singled out. Gordon Smith in *Pruned Trees* and *Structure with Red Sun* (National Gallery of Canada) of 1955 began to re-visualize the forest in terms of lyrical abstraction before emerging as a purely non-objective painter in later years. Two years earlier Donald Jarvis had looked both to the forest and to humanity. In *A Section of the Populace* (National Gallery of Canada), he employed cubistic abstraction but with free brush work; he has continued to explot Expressionistic techniques combined with brilliant singing colour accents – reds, oranges, and yellows – which betray his love of lyricism. Takao Tanabe's canvases, particularly in his earlier years, show his oriental ancestry, and John Korner formalized nature into cool Cubistic abstractions. A foundation for further free uninhibited artistic development came with the arrival in 1959 of Roy Kiyooka, who had been in the exploding Regina scene, and the contemplative Toni Onley.

Victoria also had its artists in the fifties. Margaret Peterson lived in Emily Carr's house and felt the same spiritual affinity to totem poles and the Indian religious world. She replaced the anecdotal and narrative details which underlay the older woman's Indians subjects with solid Picasso-like shapes which expressed thunderous expressions of primitive force. Her red and green, white and black colours were harsh and stridently simple. Herbert Siebner was a most dynamic local man. The older rebel, Max Bates, moved from Calgary and ruthlessly recorded with knife-like clarity the littleness of humanity as found in the straight-laced sector of Victoria and in Canadian society (fig. 167). Thus unhampered by any strong local tradition, a group of artists had reached a position in 1960 where they were poised for further experimentation and expansion in company with younger colleagues.

One stroke completely transformed prairie painting in the late 1950s. Virtually overnight, rather conventional canvases turned into non-objective, highly sophisticated presentations based on deep intellectual searching. This was in marked contrast to British Columbia's slower evolution. When Jock Macdonald had been a Calgary prophet during

1938, he was admired by Marion Nicoll, Max Bates, and others, but that circle did not generate sufficient propulsive force to shake convention. The new 'modernist' wave of the late fifties, on the other hand, spread out from Regina to touch in some way all but a very few prairie dissidents. Regina painting for a brief period was better known in the New York art world than that of many larger American cities. New York trends and philosophies plus much local vigour altered the face of painting in the three Canadian prairie provinces.

A succession of interlocking incidents combined neatly to create the new focus. Several aggressive and daring young painters met in Regina – where a paucity of distractions forced on them a certain *camaraderie*. Kenneth Lochhead of Ottawa became director of the Regina Art School in 1950. Two years later Arthur McKay joined the staff. Ronald Bloore was appointed director of the Norman Mackenzie Art Gallery, and for a time shared a studio with Ted Godwin who had been born in Calgary. Douglas Morton moved there from Winnipeg in 1954. The five discussed art at length and examined one another's paintings, with much bantering. It was a situation found on numerous occasions in the development of Canadian art and duplicated the Group of Seven, Painters Eleven, and other regional movements. The interchanges were a healthy mixture of western robustness, intellectual searching, friendly rivalry, and unspoken ambition.

Lochhead and McKay promoted liberalism through the local art school, and re-emphasized it at the annual summer school course given at nearby Emma Lake. In turn the Emma Lake workshop drew painters from the whole prairie region and beyond. It was an annual recharging of artistic thought. The workshop of the fifties grew out of a summer school first organized in 1930 by Augustus Kenderdine with local backing. Lochhead and McKay reoriented it in 1955 to examine broader and more contemporary trends. Outside experts were invited annually to lead discussion. Jack Shadbolt supervised during the first year of the new policy and Joe Plaskett in the second. William Barnett of the Art Students League, New York, took over in 1957; his tremendous personality inspired unbounded admiration for New York innovations. Local enthusiasts, including those artists who earlier had been impressed by Macdonald, were rich in praise. Subsequent guests were Barnett Newman, John Farin, Herman Cherry, Clement Greenberg, and Kenneth Nolan. The original Regina five maintained very personal painting styles: New York Abstract Expressionist thought was marked, but there seems to have been an open attitude which permitted each artist to seek his own subjective solutions, with the individual's reaction paramount. A change was felt by many after

Greenberg arrived in 1962. He was accused of dictatorial authoritar-
ianism. His dogma changed as he formulated new post-painterly ab-
straction theories. Subsequently rebellion and controversy split the
closely knit group and indeed the whole peaceful prairie scene. The
majority of the five moved east, but the Greenberg controversy still
echoes years after the invaders left Saskatchewan.

Fascinating and very individual paintings did result from the fer-
ment. Creative fires burned fiercely in McKay. He had been in New
York in 1956 and 1957 and there saw the great Jackson Pollock exhi-
bition after the artist's accidental death. He was a major mover in in-
viting Barnett Newman to Emma Lake during 1959, and Newman
influenced both him and Bloore. During summers, McKay lived with
his family in an isolated cabin in northern Saskatchewan. He began
painting a series of sombre black, brown, and green works, completely
non-representational, astringently simple. *The Void* (fig. 168) is simply
a disc motif, which Bloore also used. On other occasions he used rec-
tangles. In these works McKay achieved a state of slow illusionistic
flux which creates alternate senses of substance and of void in the pic-
ture plane. He found meaning in this sense of movement and sugges-
tion of action rather than in figurative representations of objects as
such.

Bloore was a coldly intellectual artist and a strongly independent
thinker. One part of his artistic preparation had been a thorough
grounding in the great art traditions. He had been a prolific painter
earlier, but he destroyed much of this work as unsatisfactory after he
developed a mature style in Regina. His colours became as astringent
as those of McKay. Some monochromatic works are simply surfaces
brought alive by textural manipulation. At other times he found per-
fection in pure white or white in association with symbol-like motifs
painted in delicate colour as in his *Hommage to Matisse* (CIL Collection).
Circle medallions with radiating lines could be likened to ancient Chi-
nese sun discs (fig. 169). Even more puritanically austere are his low-
relief panels of interlocking geometric shapes in pure white. They
make no concession or compromise to popular taste and achieve a per-
fection of aesthetic unity by long and tedious deliberation of thought
plus meticulous execution. He offered to his audience what for him
was meaningful painting; the meaning which the public might give to
it depended entirely on their own experience. Sophisticates with sensi-
tivities attuned to appreciate the inward meanings are profoundly
moved; others may find them empty.

Lochhead is a contrast to McKay and Bloore in that his output re-
solves itself into phases, each quite different from that of the preceding

cycle. His first Regina paintings, Pseudo-Surrealistic in approach, picture puppet-like figures in great open spaces (fig. 170), and demonstrate great technical accomplishment. *The Dignitary* (National Gallery of Canada) satirizes western ceremonial in its Gilbert and Sullivan pomp. Then with the full flowering of the Emma Lake experience he recalled the gesture painting of New York and contacts with Zen Buddhism; he eliminated colour to paint black and white abstract expressionist configurations inspired by such nondescript subject matter as roots of trees. He has paid tribute to such artists as Kline and De Kooning, and to Paul Klee's 'tender wit.' When he turned his back on austere black and white, he used simple, carefully controlled colour areas conforming to Greenberg theories and chose to make his canvases ever larger. From this, he turned to the application of floating colours on canvas like lingering mist in some exotic dreams.

Other significant prairie painters lived outside Regina. Saskatoon was an activist centre where Eli Bornstein, a Constructivist, undertook such large commissions as a mural in the Winnipeg airport. Otto Rogers taught at the University of Saskatchewan and Ernest Lindner began to examine realism. Roy Kiyooka was then a young artist in Calgary. But many prairie artists developed as significant national painters only after 1960.

Traditionally the Atlantic region is that part of Canada which has clung most tenaciously to tradition. Indeed this has been particularly the case with painting. Innovators sensed little local backing or support. Jack Humphrey in Saint John had found Cubism and other twentieth-century art innovations when studying abroad early in his career. He returned to live from portraiture and landscape painting, bemoaning both a need to be conventional and his isolation from progressive thought. His answer to continued isolation was to redouble his efforts, be more 'modern,' and look beyond his home milieu for patronage. His neighbour, Miller Brittain, was in virtually the same position. Brittain began to espouse Surrealism and other trends from personal experimentation; for long periods he was virtually shut off from local artistic contacts, but sent works to one-man New York exhibitions in the fifties. Bruno Bobak examined canvases by Münch, noted the freedom of Expressionist painters, searched deeper into man's inner psyche, and moved to Fredericton. There he has continued a somewhat solitary pursuit for meaning (fig. 171).

Alex Colville, teaching at Mount Allison University in Sackville, New Brunswick, still believed that one valid element in painting was subject matter. His intense conviction crystallized into a strain quite

new to Canadian painting, which burgeoned into a whole 'High Realism' or 'Magic Realism' movement. Colville had studied under Stanley Royle at Sackville. His teacher had painted deliberately executed realistic landscapes and exploited a precise technique with measured brush strokes and meticulously considered tone and colour. Colville's debt to him is clearly evident in his war paintings, in which the viewer is confronted with the stark and undisguised horror of gaunt dead soldiers lying where they were shot in face-to-face confrontation. On returning to Canada, Colville returned to his old university as a teacher and remained there for seventeen years. Diversions were few. He was a 'loner' by temperament and a meticulous person. His paintings became more refined in their austerely detailed and 'finished' aspects. Some reflected an intimacy with American realists like Andrew Wyeth. They were solid, complete entities, lacking any sense of 'becoming.' His themes were common subjects found close at hand but the artist has kept them at arm's length; it is a contradiction for that is a region where isolation readily invites companionship. He painted such works as *Visitors are Invited to Register* (Mendel Art Gallery) picturing the interior of a pioneer church which had a life of its own in the past and which no tourist can quite catch. There is a *Girl on a Piebald Horse*, figures lie on a beach, animals are grouped at an agricultural fair, and a boy and his dog penetrate the growth on a river bank. Subjects embody the essence of the Maritimes. But Colville paints them as a detached observer, and in that austerity precludes audience participation except in a passive sense. This indeed is one fascination in his art, a sensed need to penetrate beneath the surface and a baffling realization that there is a sealed privacy. Other qualities imbue his paintings with a fascination far beyond that of nineteenth-century *trompe l'œil* paintings. He uses an exact sense of correct placing and proportion. There is an aura of mystery which suggests magic or even Surrealistic feelings. *Horse and Train* (fig. 173) is an inevitable confrontation. Will it be impending doom, or is there a solution?

Such artistic approaches appealed to several Colville students. Christopher Pratt, from even more artistically isolated Newfoundland, was the first to achieve distinction in his own right. His *Demolition on the South Side* (fig. 172) eloquently exploits philosophical and allusionistic traits other than those of Colville. It is starkly objective; this heightens the sense of realism and emphasizes the social implications of slum clearance. Hugh McKenzie and others influenced by Colville may produce few pictures, but each has painted with a sense of deliberation and rightness, a mood that truthfulness will endure for all time. Paintings with this implied conscientious integrity epitomize the most valid

of the reactions to the revolutionary painting of the fifties. It is classicism in thought, pitted against emotional romanticism rooted in sensory conviction.

Painting in Canada has mirrored a northern people's growth during three centuries of evolution from colony to nationhood. It shows how a highly sophisticated European culture has been imported into and adapted for the New World. It is thus a demonstration of how people will struggle to achieve a sense of identity. Painting, like music, writing, and the other arts, has been woven into and become an element of Canadian society in evolution.

The first canvases were completely imitative of French art, although an early but still very weak local expression began to emerge before the Seven Years' War gave entry to the English tradition. Art in Canada later underwent a period of conscious nationalism between Confederation and the Second World War. During that period a deliberate attempt to create the outward signs of a cultured people became evident in the establishment of an official academy and organized art societies. Similar objectives were manifested in the first use in figurative painting of symbols taken from the native terrain to make the canvases distinctively 'Canadian.'

But art always evolves. Older approaches disappear when they come to lack 'feeling'; an artist can recall his highest expression only when the indefinable quality of 'sensitivity' is brought into full play. There have been significant paintings throughout the history of Canadian art which have demonstrated such freedom. In recent decades freedom has been felt to lie for the artist in a search for the expression of his own individualism; it has been accepted that a truly gifted artist must ultimately produce for his own satisfaction. He must find his own personal devices for releasing the creative forces within his own mind and heart.

108 / Charles W. Jefferys: *Western Sunlight, Lost Mountain Lake*, oil
35 3/4 x 57 3/4 inches (90.8 x 146.7 cm), 1911
National Gallery of Canada

109 / Robert Holmes: *Witch-Hazel*, gouache
13 1/2 x 19 1/2 inches (34.3 x 49.5 cm), undated
Art Gallery of Ontario

357

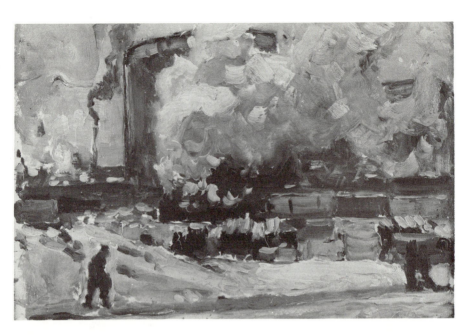

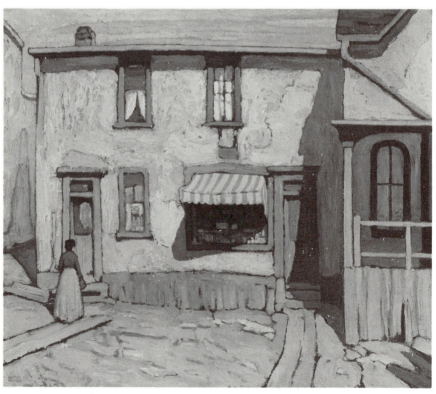

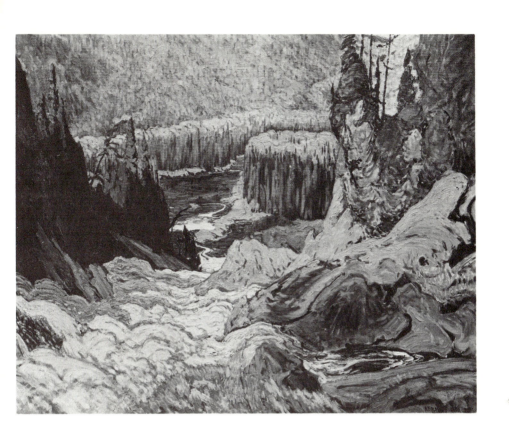

110 / *opposite, top* / J.E.H. MacDonald: *Tracks and Traffic*, oil
6 x 10 inches (15.2 x 25.4 cm), 1912
Robert A. Laidlaw, Toronto

111 / *opposite, bottom* / Lawren S. Harris: *Italian Store in the Ward*, oil
32 1/4 x 38 inches (81.9 x 96.5 cm), 1922
National Gallery of Canada

112 / *above* / J.E.H. MacDonald: *Falls, Montreal River* , oil
48 x 60 1/4 inches (121.9 x 153 cm), 1920
Art Gallery of Ontario

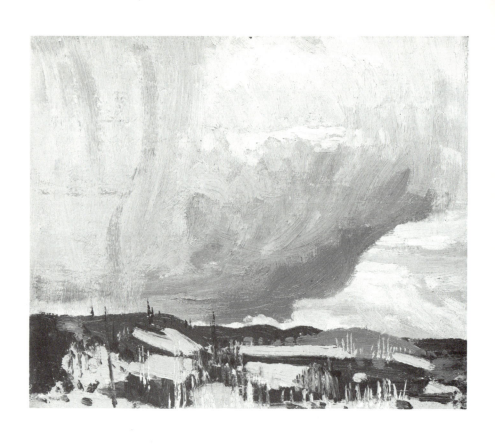

113 / Tom Thomson: *Approaching Snowstorm*
oil, 8 1/2 x 10 1/2 inches (21.6 x 26.7 cm), undated
National Gallery of Canada

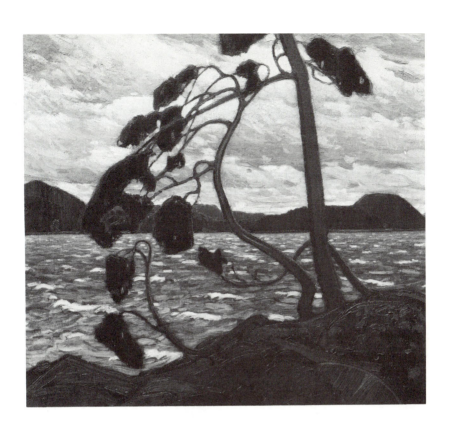

114 / Tom Thomson: *The West Wind*, oil
47 1/2 x 54 1/8 inches (120.6 x 137.5 cm), undated
Art Gallery of Ontario

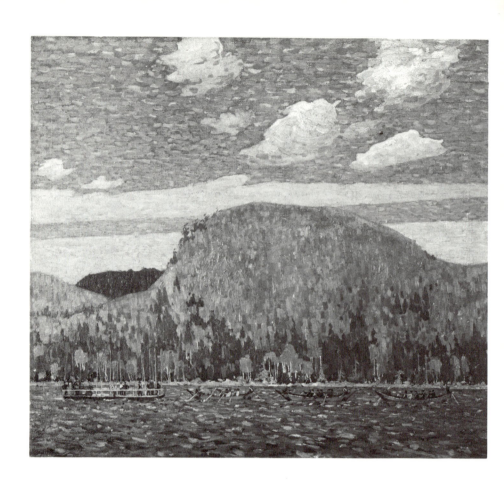

115 / Tom Thomson: *The Pointers*, oil
40 x 46 inches (101.6 x 116.8 cm), 1916-17
Hart House, University of Toronto

116 / Tom Thomson: *Mocassin Flower*, oil
10 1/2 x 8 1/2 inches (26.7 x 21.6 cm), undated
private collection

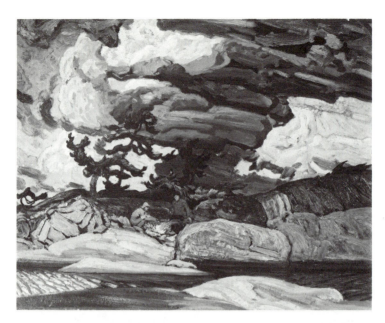

117 / J.E.H. MacDonald: *The Elements*, oil
28 x 36 1/8 inches (71.1 x 91.8 cm), 1916
Art Gallery of Ontario

118 / Frederick H. Varley: *For What?*
oil, 58 x 72 inches (147.3 x 182.9 cm), undated
National Gallery of Canada

364

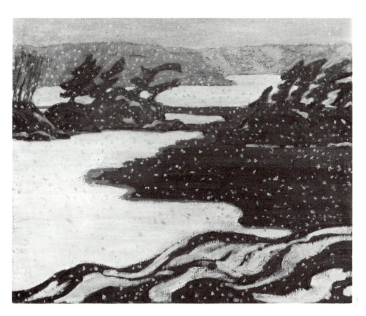

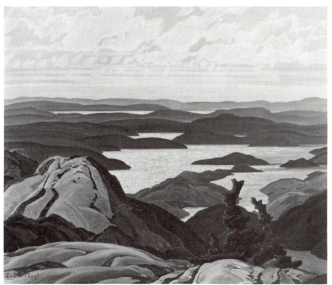

119 / A.Y. Jackson: *The Freddy Channel*, oil
21 x 26 inches (53.3 x 66 cm), *c* 1920
Estate of C.S. Band, Toronto

120 / Frank Carmichael: *Northern Tundra*, oil
30 x 36 inches (76.2 x 91.4 cm), 1931
Estate of R.S. McLaughlin, Oshawa

365

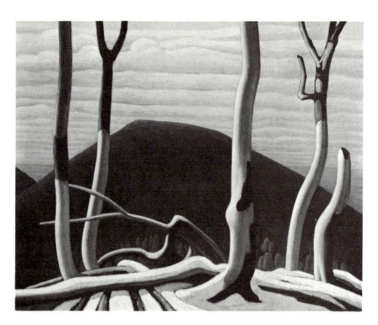

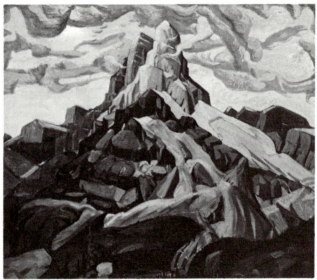

121 / Lawren S. Harris: *Above Lake Superior*, oil
48 x 60 inches (121.9 x 152.4 cm), *c* 1922
Art Gallery of Ontario

122 / Arthur Lismer: *Cathedral Mountain*, oil
48 x 56 inches (121.9 x 142.2 cm), 1928
Montreal Museum of Fine Arts

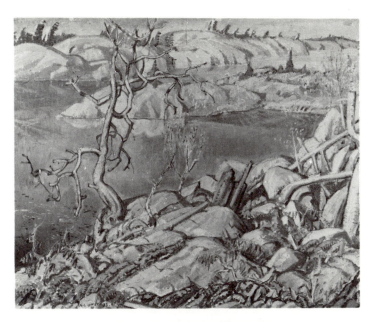

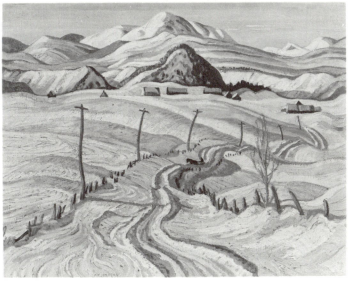

123 / Arthur Lismer: *September Sunlight, Georgian Bay*, oil
32 x 40 inches (81.3 x 101.6 cm), 1933
Art Gallery of Ontario

124 / A.Y. Jackson: *Winter, Charlevoix County*, oil
25 x 32 inches (63.5 x 81.3 cm), 1933
Art Gallery of Ontario

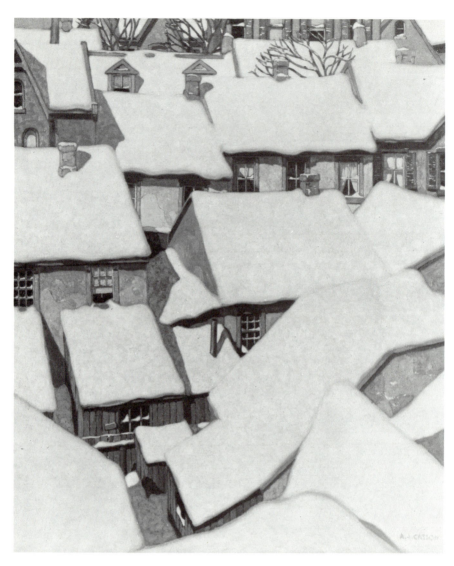

125 / *above* / A.J. Casson: *Housetops in the Ward*, oil
37 x 45 inches (94 x 114.3 cm), 1924
private collection

126 / *opposite, top* / Frederick H. Varley: *Stormy Weather, Georgian Bay*, oil
52 x 64 inches (132 x 162.6 cm), *c* 1920
National Gallery of Canada

127 / *opposite, bottom* / Frederick H. Varley: *Dharana*, oil
34 x 40 inches (86.4 x 101.6 cm), *c* 1932
Art Gallery of Ontario

368

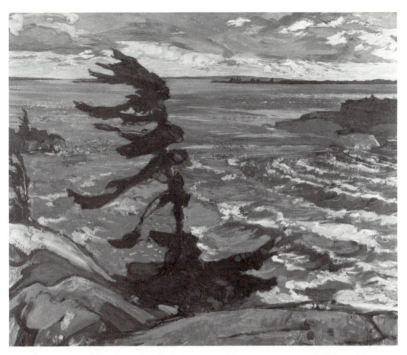

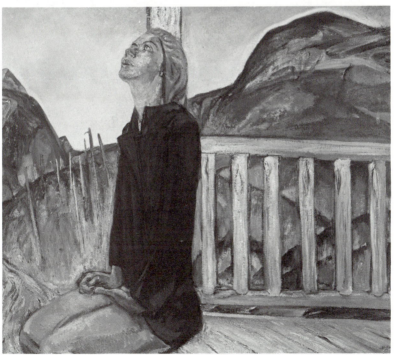

128 / *opposite, top* / Emily Carr: *Old Time Coast Village* , oil
15 1/2 x 36 inches (39.4 x 91.4 cm), undated
Vancouver Art Gallery

129 / *opposite, bottom* / Marc-Aurèle Fortin: *Paysage, Ahuntsic*, oil
48 x 55 inches (121.9 x 139.7 cm), undated
National Gallery of Canada

130 / *above* / Emily Carr: *Yan Mortuary Poles*, oil
33 1/4 x 23 3/4 inches (84.5 x 60.3 cm), *c* 1928-9
Art Gallery of Windsor

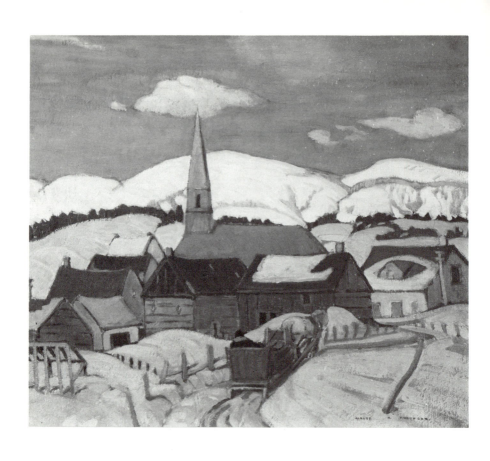

131 / Albert H. Robinson: *Afternoon, Saint-Siméon*, oil
21 1/2 x 25 1/2 inches (54.6 x 64.8 cm), undated
Estate of Arthur Gill, Montreal

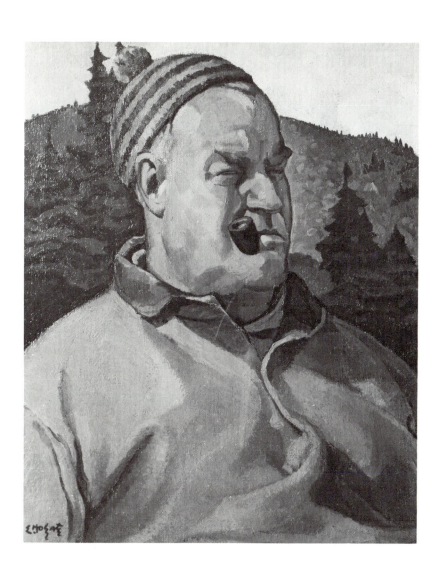

132 / Edwin H. Holgate: *Fire-Ranger*, oil
22 x 18 inches (55.9 x 45.7 cm), 1926
Hart House, University of Toronto

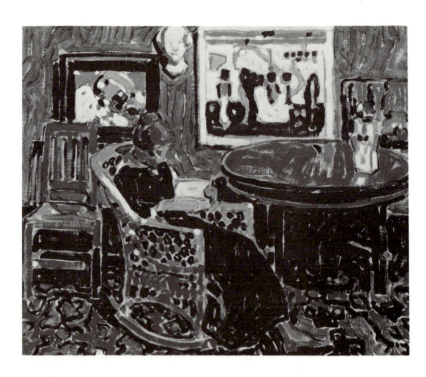

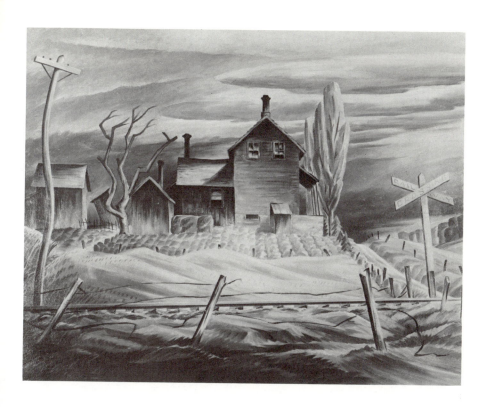

133 / *opposite, top* / David Milne: *Interior with Paintings*, oil
20 x 24 inches (50.8 x 61 cm), 1914
Winnipeg Art Gallery

134 / *opposite, bottom* / David Milne: *Water Lilies and Glass Bowls*, oil
16 x 20 inches (40.6 x 50.8 cm), undated
National Gallery of Canada

135 / *above* / Carl F. Schaefer: *Farmhouse by the Railway*, oil
34 x 46 inches (86.4 x 116.8 cm), undated
Art Gallery of Hamilton

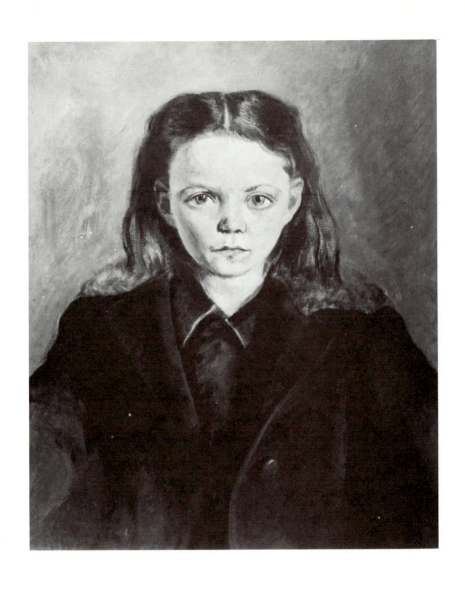

136 / Jack W. Humphrey: *Charlotte*, oil
24 x 19 7/8 inches (61 x 50.5 cm), 1939
Art Gallery of Ontario

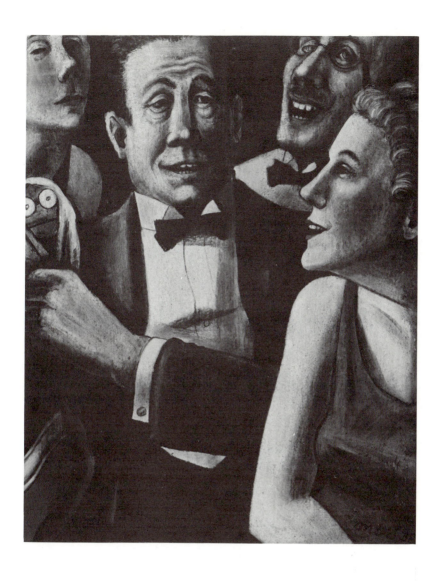

137 / Miller Brittain: *Formal Party*, oil
22 x 18 inches (55.9 x 45.7 cm), 1938
John Saywell, Toronto

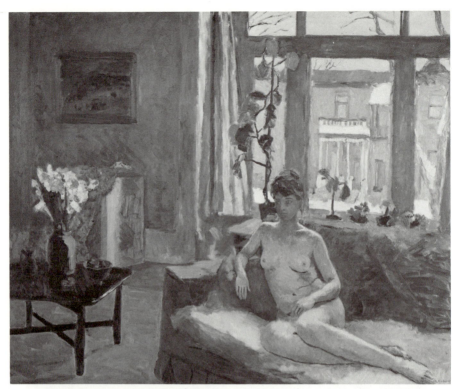

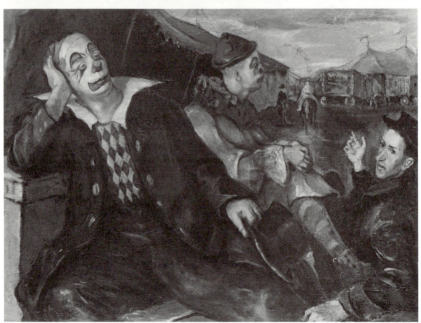

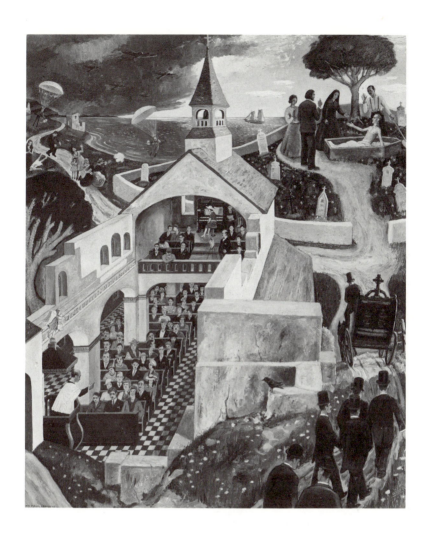

138 / *opposite, top* / Goodridge Roberts: *Nude in Interior*, oil
48 x 60 inches (121.9 x 152.4 cm), undated
the late Donald Buchanan, Montreal

139 / *opposite, bottom* / John M. Alfsen: *Clown Alley*, oil
36 x 50 inches (91.4 x 127 cm), 1951
Canadian National Exhibition
on loan to the Art Gallery of Ontario

140 / *above* / Jean-Paul Lemieux: *Lazare*
oil, 39 3/4 x 32 3/4 inches (101 x 83.2 cm), 1941
Art Gallery of Ontario

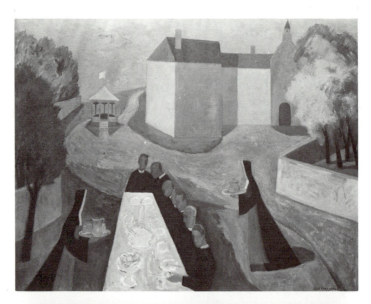

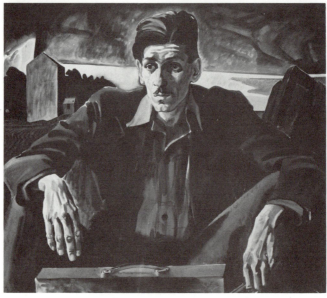

141 / Jean-Paul Lemieux: *La fête au couvent*
oil, 42 1/2 x 56 1/4 inches (108 x 142.9 cm), 1955
National Gallery of Canada

142 / Charles Comfort: *Young Canadian*, w.c.
36 x 42 inches (91.4 x 106.7 cm), 1932
Hart House, University of Toronto

380

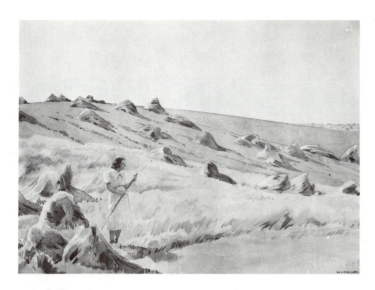

143 / Walter J. Phillips: *Harvest in Manitoba*, w.c.
14 1/2 x 21 inches (36.8 x 53.3 cm), 1934
private collection

144 / Edward J. Hughes: *American and Canadian Troops
Medupat Main Post Exchange, Kiska, Alaska*, oil
40 x 48 inches (101.6 x 121.9 cm), 1944
National Gallery of Canada

146 / *bottom* / Charles Fripp: *The Winter Home*, w.c.
6 1/2 x 13 1/2 inches (16.5 x 34.3 cm), undated
private collection

382

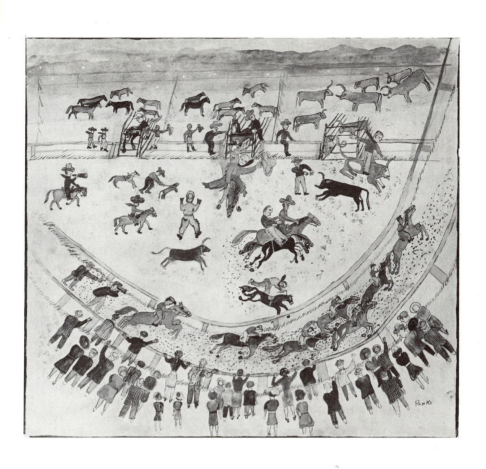

145 / *opposite, top* / A.C. Leighton: *Still Life, Seebe*, w.c.
13 1/2 x 15 3/4 inches (34.3 x 40 cm), 1954
Mrs J. Nicoll, Bowness, Alta.

147 / *above* / William Panko: *The Round-Up*
w.c., 14 1/2 x 16 1/4 inches (36.8 x 41.3 cm), undated
McCord Museum, McGill University

383

148 / Bertram Brooker: *Alleluiah*, oil
48 x 48 inches (121.9 x 121.9 cm), 1929
National Gallery of Canada

384

149 / L.L. FitzGerald: *The Little Flower*, oil
24 x 18 1/4 inches (61 x 46.4 cm), 1947
The McMichael Canadian Collection, Kleinburg

150 / *opposite, top* / L.L. FitzGerald: *Farm Yard*, oil
13 3/4 x 16 3/4 inches (34.9 x 42.5 cm), 1931
National Gallery of Canada

151 / *opposite, bottom* / Bertram Brooker: *Driftwood*, oil
26 x 39 inches (66 x 99 cm), 1945
Mr Victor Brooker, Toronto

152 / *above* / Fritz Brandtner: *Design No. 4*, oil
9 x 6 inches (22.9 x 15.2 cm), undated
private collection

153 / Lawren S. Harris: *Abstract*, oil
42 x 30 inches (106.7 x 76.2 cm), 1942
Hart House, University of Toronto

154 / *opposite, top* / J.W.G. (Jock) Macdonald: *Drying Herring Roe*, oil
28 x 34 inches (78.1 x 86.4 cm), undated
International Business Machines

155 / *opposite, bottom* / John Lyman: *The Beach, Saint-Jean-de-Luz*, oil
18 x 22 inches (45.7 x 55.9 cm), 1926
Dr Max Stern, Montreal

388

389

156 / J.W.G. (Jock) Macdonald: *Heroic Mould*, oil
72 x 48 inches (182.9 x 121.9 cm), 1959
Art Gallery of Ontario, Bequest of Charles S. Band

157 / Alfred Pellan: *Femme d'une Pomme*, oil
63 3/8 x 51 1/16 inches (161 x 129.7 cm), 1946
Art Gallery of Ontario

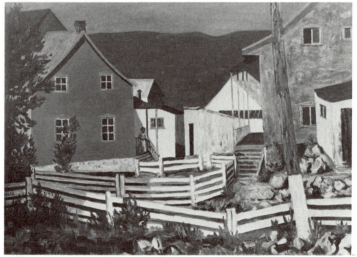

158 / Paul-Émile Borduas: *3 + 4 + 1*, oil
78 x 98 inches (198.1 x 248.9 cm), 1956
National Gallery of Canada

159 / Alfred Pellan: *Maisons de Charlevoix*, oil
25 x 36 inches (63.5 x 91.4 cm), 1941
Dr J. Gordon Petrie, Como

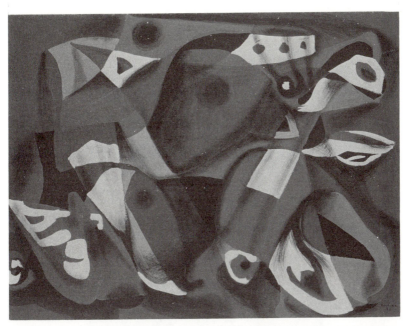

160 / Paul-Émile Borduas: *Cimetière marin*, gouache
18 1/4 x 24 1/4 inches (46.4 x 61.6 cm), 1942
Gérard Beaulieu, Montreal

161 / Jean-Paul Riopelle: *Knight Watch*
oil, 38 x 76 3/4 inches (96.5 x 194.9 cm), 1953
National Gallery of Canada

393

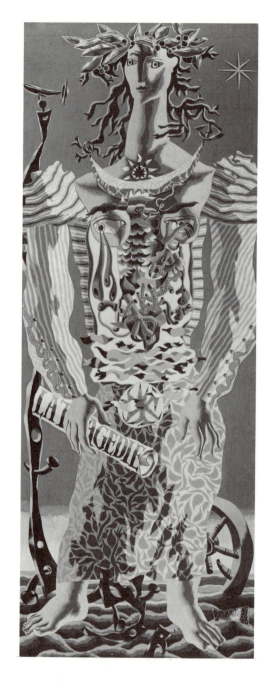

162 / Jean Dallaire: *La Tragédie*
oil, 88 x 34 inches (223.5 x 86.3 cm), 1947-8
Dr Max Stern, Montreal

163 / Oscar Cahen: *Trophy*
oil, 49 5/8 x 32 inches (126 x 81.3 cm), undated
Art Gallery of Ontario

395

164 / Harold Town: *The Turner Reprise*, oil and lucite
48 x 66 inches (121.9 x 167.6 cm), 1958-60
collection of the artist

165 / Kazuo Nakamura: *Prairie Towers*, oil
34 x 48 inches (86.3 x 121.9 cm), 1956
National Gallery of Canada

166 / Jack Shadbolt: *Dark Fruition*, ink and casein
26 1/2 x 35 1/4 inches (67.3 x 89.5 cm), 1952
Seattle Art Museum

167 / Max Bates: *Girls at the Café Congo*, oil
36 x 48 inches (91.4 x 121.9 cm), 1963
collection of the artist

397

168 / Arthur McKay: *The Void*, enamel
48 3/4 x 48 3/4 inches (123.8 x 123.8 cm), 1961
Tod Greenaway, Toronto

169 / Ronald Bloore: *White Sun*, oil
48 x 48 inches (121.9 x 121.9 cm), 1960
Jessie and Percy Waxer Collection, Toronto

170 / Kenneth Lochhead: *Return to Humanity*, oil
16 x 30 1/4 inches (40.6 x 76.8 cm), 1955
Mendel Art Gallery, Saskatoon

171 / Bruno Bobak: *Saint John Harbour*, oil.
24 x 58 inches (61 x 147.3 cm), 1961
CIL Collection, Montreal

172 / Christopher Pratt: *Demolitions on the South Side*, oil
18 1/2 x 40 inches (47 x 101.6 cm), 1961
Dalhousie University, Halifax

173 / Alex Colville: *Horse and Train*
oil, 16 x 21 1/4 inches (40.6 x 54 cm), 1954
Art Gallery of Hamilton

402

Biographies

Ackermann, George (active 1866-77). Teacher of art at Ontario Institution for Deaf and Dumb, Belleville. Landscape painter in water-colour.

Ahrens, Carl Henry von (1863-1936). b. Winfield, Ont. ed. Kitchener and Hamilton. Travelled in Canadian Northwest and Montana 1879-81. Studied with J. W. L. Forster and G. A. Reid 1887, and in New York. In Lambton Mills, Ont. 1898-99, East Aurora, N.Y. 1900-06, Meadowvale, Ont. 1903-19, and Galt *c* 1924 to death. Lifelong cripple. OSA 1890, ARCA 1891.

Aide-Créquy, Jean-Antoine (1749) [1746?]-80. b. Quebec. Studied at Jesuit College, Quebec; ordained 1773. d. Hôtel-Dieu, Quebec. Worked for churches at Île-aux-Coudres, Baie-Saint-Paul and Saint-Roch-des-Aulnaies, and for cathedral and Ursuline Convent at Quebec.

Alfsen, John (1902-71). b. Long Rapids, Mich. Moved to Toronto 1915. Studied at Ontario College of Art under Lismer, Varley, others; at Art Students League, New York, under Kenneth Hayes Miller; studied sculpture under Bourdelle. Travelled widely in Europe. Taught at Ontario College of Art. ARCA 1939, RCA 1959. d. Toronto.

Armstrong, William (1822-1914). b. Dublin, Ire. Studied art in Dublin. Apprentice engineer on Irish and English railways. In Toronto from 1851, with CPR as engineer; painter of landscapes and Indian life of Ontario, Quebec, Manitoba, and Rockies; drawing-master at Toronto Normal School. ARCA 1882.

Back, Sir George (1796-1878). b. Stockport, Eng. Entered British Navy 1808; rose to admiral by 1867. With Sir John Franklin on Arctic Expedition of 1818-22 and 1824-27, led search for Sir John Ross in Arctic 1833-35; re-visited Arctic 1836. d. London, Eng.

Baillairgé, François (1759-1830). b. Quebec, son of wood-sculptor and architect. ed. Académie Royale, Paris, 1778-81; studied with Jean-Baptiste Stouf, sculptor, and Jean-Jacques Lagrenée, painter. Studio in Quebec 1781 as sculptor, architect, painter; introduced Louis XVI style to Canada; taught painting 1784-1800; appointed Quebec City Treasurer 1812. d. Quebec.

Bamford, Thomas (1861-after 1941). b. Liverpool, Eng. Studied at Liverpool School of Art. Emigrated to Canada before 1886; in Vancouver and Victoria. Member of Islands Arts and Crafts Society, Victoria.

Bannerman, Frances M. (Jones) (1855-1940). b. Halifax. ARCA 1882. In Eng. after marriage; exhibited at Royal Academy and Paris Salon. Painted interiors in oil 1882-83; black-and-white illustrator.

Barbeau, Marcel (1925-). b. Montreal. Studied with Borduas; lives in New York.

Barnes, Wilfred M. (1892-1955). b. Montreal. Studied at Art Association of Montreal and New York School of Art. ARCA 1920, RCA 1946. d. Montreal.

Barnsley, James Macdonald (1861-1929). b. West Flamboro, Ont. Studied at St Louis School of Fine Arts 1879-82; painted in France and Scotland 1883-8; moved to Montreal 1889; painted in Ireland and Massachusetts 1891. Confined to mental home in later life. d. Montreal.

Bates, Maxwell B. (1906-). b. Calgary. Studied architecture at Provincial Institute of Technology and Art, Calgary, and at Brooklyn Art School 1949-50. Lives in Victoria.

Beastalt (Beastall), William (active 1795-7). Advertised as miniaturist in Portsmouth, N.H. 1795. Listed as Freeman of City of Saint John, N.B. 1797, under profession of portrait painter.

Beatty, John William (1869-1941). b. and d. Toronto. Toronto fireman in youth; served in Riel Rebellion 1885. Studied at Central Ontario School of Art under J. W. L. Forster and G. A. Reid, and at Académie Julian, Paris. Lived principally in Toronto. OSA 1901. ARCA 1903, RCA 1913. Taught at Ontario College of Art 1912-41.

Beau, Henri (1863-1949). b. Montreal. Studied in Paris under Gérôme 1880, again 1889 and 1893-4. Lived in Paris for 20 years as employee of Public Archives of Canada. Exhibited RCA 1896-1914. d. Paris.

Beauclerk, Lord Charles (1818-61). Son of 8th Duke of St Albans; in Canada as captain, 1st Royals, Rebellion of 1837. Drowned at Scarborough, England, attempting rescue in storm.

Beaucourt, François Malepart de (1740-94). b. Laprairie, near Montreal. In Quebec City during Seven Years' War; to France possibly 1771. Studied at Bordeaux under Joseph Camagne; painted religious murals in Bordeaux; in Paris and Nantes before return to Canada 1786; worked in Philadelphia early 1792; in Montreal June, 1792 until death.

Beaucourt, Paul (1700-56). b. Paris. Came to Canada with French marine 1720. Stationed at Laprairie, P.Q.; left army c 1741 or 1745; worked as painter in Quebec and died there.

Bécart de Granville et de Fonville, Charles (1675-1703). b. Quebec. Entered French

marine as ensign; draughtsman and mapmaker. Named *procureur de la prévôté de Québec* 1700. d. Quebec.

Bell, Delos C. (active 1867-76). b. Beamsville, Ont. Portrait painter in Hamilton and Ottawa.

Belle, Charles-Ernest de (1873-1939). b. Budapest. Studied in Antwerp, Paris, and London. In Montreal after 1912. ARCA 1919. d. Montreal.

Bellefleur, Léon (1910-) b. Montreal. Studied at École des Beaux-Arts, Montreal; lives in Paris.

Bell-Smith, Frederic Marlett (1846-1923). b. London, Eng. Studied at South Kensington Art Schools, London. Emigrated to Canada 1866; photographer, painter, illustrator in Montreal, Toronto, Hamilton, London. Studied at Académie Colarossi, Paris 1896. Art instructor, Alma College, St Thomas. OSA 1872, ARCA 1880, RCA 1886. d. Montreal.

Bell-Smith, John (1810-83). b. Rotherhithe, Kent, Eng. Secretary-treasurer, Institute of Fine Arts, Portland Gallery, London, 1835-61. Emigrated to Canada 1866; in Montreal to 1878; briefly in Toronto, then in Hamilton. Painted oil portraits, miniatures in oil and water-colour on ivory. d. Toronto.

Belzile, Louis (1929-). b. Rimouski, P.Q. Studied at Ontario College of Art, Toronto, and in France with André Lhote. Lives in Montreal.

Berczy, William, Senior (1749-1813). b. Saxony; youth in Vienna. ed. as diplomat; studied art in Italy 1785-90; in England 1790-92. Brought group of German emigrants to New York State 1792, then to Markham Township, near Toronto. Painted portraits in Toronto 1795. In financial difficulties and turned to full-time professional painting *c* 1803. Lived thereafter in Montreal; also worked in Quebec. d. on trip to New York.

Berger, Jean (1682-after 1710). b. Saint-Didier, near Lyon, France. Came to Canada with French marine 1700; painted altar frontal for Church of Sainte-Famille, Île d'Orléans, 1706; painted in Montreal 1707. Banished from Canada 1710.

Bergeron, Suzanne (1930-). b. Causapscal, Quebec. Studied at École des Beaux-Arts, Quebec; lives on Île d'Orléans.

Berthon, George Theodore (1806-92). b. Vienna, son of court painter to Napoleon I. Studied in Paris under David. Painted in England 1827-37, 1841-4; painted in Toronto 1837-41, 1844 until death. Early years painted portraits in oil and pastel, landscapes and small genre; later years fashionable portrait painter.

Binning, Bertram C. (1909-1976). b. Medicine Hat, Alta. Studied at Vancouver School of Art; Art Students League, New York; in London with Henry Moore. Taught at Vancouver School of Art 1939-49; head of art department, University of British Columbia since 1949. Painted oils since 1948. ARCA 1954. d. Vancouver.

Birrell, Ebenezer (1801-88). b. Scotland. Emigrated to Canada 1834; thereafter in Pickering, Ont. Exhibited Scottish and Canadian landscapes at Upper Canada Provincial Exhibitions; also portrait painter. Prominent agriculturist and lieutenant-colonel commanding 4th Battalion Ontario Militia.

Bloore, Ronald L. (1925-). b. Brampton, Ont. Studied at University of Toronto, Institute of Fine Arts of New York University, University of Washington, St Louis, and abroad. In Regina 1958-1966. Teaches at York University, Toronto.

Bobak, Bruno (1923-). b. Poland. Came to Canada 1927. Studied at Central Technical School, Toronto; now artist-in-residence at University of New Brunswick, Fredericton.

Bobak, Molly (1922-). b. Vancouver. Studied at Vancouver School of Art. Lives in Fredericton.

Borduas, Paul-Émile (1905-60). b. Saint-Hilaire, P.Q. Studied with Ozias Leduc, at École des Beaux-Arts, Montreal and École d'Art Sacré, Paris, under Maurice Denis. Influenced by Surrealist theories of André Breton. Published 1948 *Refus global*, manifesto of the *Automatistes* of whom he was leader. Lived in New York 1953-4, thereafter in Paris.

Bornstein, Eli (1922-). b. Milwaukee. Studied at University of Milwaukee. Taught at University of Saskatchewan, Saskatoon, from 1950.

Bouchette, Joseph (1774-1841). b. Montreal. In navy 1791-6. Studied with François Bailliargé 1796; surveyor with his uncle, Samuel Holland, Director of Surveys for British North America; named Surveyor-General of Lower Canada 1804. Executed water-colour topographical views on trips through Canada, some of which illustrated his *Description Topographique du Bas-Canada* 1815, and *British Dominions in North America* 1832.

Bouker (active 1807-14). Itinerant silhouettist in Fredericton 1807-8, Toronto, Kingston, other Ontario centres 1807-9; in Quebec 1809; thereafter seems to have worked in United States.

Bourassa, Napoléon (1827-1916). b. L'Acadie, P.Q. ed. at Sulpician Seminary, Montreal. Married daughter of Louis-Joseph Papineau and was ardent French-Canadian nationalist. Wrote extensively; also musician. Studied with Théophile Hamel in Quebec; in Rome, Florence 1825-6 with Nazarenes. Attempted to introduce significant mural painting into Canada. Portrait and religious painter in Montreal, Ottawa, Saint-Hyacinthe 1856-62. Attempted to improve Canadian art education 1877. d. Lachenaie, P.Q.

Bradford, William (1823-92). b. Fairhaven, near New Bedford, Mass. Annual sketching trips to Labrador 1861-7 and 1880-9. Elected to National Academy. Arctic scenes exhibited in England and United States. d. New York.

Bradish, Alvah (1806-1901). b. Sherburne, N.Y. Worked in Rochester, N.Y. 1837-47; periodic trips to Toronto and other centres. Professor of art, University of Michigan 1852-65; for many years one of Detroit's most successful portrait painters.

Brandtner, Fritz (1896-1969). b. Danzig. Studied in Danzig under Fritz August Pfuhle; influenced by German Expressionists. Travelled widely in Europe. Taught at University of Danzig 1924-6. Emigrated to Canada 1928. In Winnipeg to 1934, thereafter in Montreal, Taught at McGill University and University of New Brunswick. d. Montreal.

Brekenmacher, Jean-Melchior. See François, Father

Brigden, Frederick H. (1871-1956). b. London, Eng. In Canada from childhood. Studied at Central Ontario School of Art and Art Students League, New York. OSA 1898. ARCA 1934, RCA 1939. Lived in Toronto.

Brittain, Miller (1912-1968). b. and d. Saint John, N.B. Studied at Art Students League, New York.

Brooker, Bertram (1888-1955). b. Croydon, Eng. Emigrated to Canada 1905; lived in Portage la Prairie, Man., in Neepawa, Winnipeg, Regina 1913-21, Toronto thereafter. Advertising executive, musician, poet, novelist, painter, and illustrator. d. Toronto.

Browne, William Henry James (d. 1872). Son of Harbour Master of Dublin. With Royal Navy in Fiji Islands and Arctic with Ross expedition 1848-9 and again in 1850-1. Retired as commander 1864. Painted Arctic scenes in water-colour; scene painter in Royal Arctic Theatre. d. Woolwich.

Brownell, Franklin (1857-1946). b. New Bedford, Mass. Studied at Museum of Fine Arts, Boston, under Thomas W. Dewing, and Académie Julian, Paris. Emigrated to Canada 1886. Principal of Ottawa Art School. ARCA 1894, RCA 1895. Member Canadian Art Club 1907. d. Ottawa.

Bruce, William Blair (1859-1906) b. Hamilton. Attended Hamilton Art School and Académie Julian, Paris, 1881. Lived thereafter in Paris and on Gotland Island, Sweden. d. Stockholm.

Brymner, William (1855-1925). b. Greenock, Scot. Brought to Canada 1857. Studied architecture in Ottawa. Studied at Académie Julian and with Carolus-Duran in Paris after 1878. Directed classes, Art Association of Montreal 1886-1921, OSA 1886, ARCA 1883, RCA 1886, PRCA 1909-18, CMG 1916. d. Wallasey, Cheshire.

Bush, Jack (1909-1977). b. Toronto. Studied at Ontario College of Art and in Montreal. Lived in Toronto.

Cahen, Oscar (1916-56). b. Copenhagen. Studied at the Kunstakademie, Dresden, and in Paris, Italy, Stockholm, Prague; emigrated to Canada 1940. Illustrator and painter at King, Ont. d. Toronto.

Cappello, Luigi G. (active c 1870-87). Italian by birth, emigrated to Canada c 1870. Fashionable painter in Montreal area. Exhibited at RCA 1880-7. Taught drawing in Montreal. Executed religious frescoes in churches.

Carlisle, William Ogle (active 1870-86). Lieutenant, British Army Engineers; in Canada 1870-1; worked on construction of Lévis forts opposite Quebec.

Carmichael, Franklin (1890-1945). b. Orillia, Ont. Studied at Ontario College of Art with Wm. Cruikshank and G. A. Reid, at Toronto Technical School, and Antwerp Academy. Commercial artist in Toronto; later taught at Ontario College of Art. OSA 1917, ARCA 1935, RCA 1938. Member Group of Seven 1920; Canadian Group of Painters 1933. d. Toronto.

Carr, M. Emily (1871-1945). b. and d. Victoria. Studied at San Francisco School of Art 1889-c 1895, Westminster School of Art, London c 1899-1904, and Paris 1910-11. Came in contact with Group of Seven and Mark Tobey. Member Canadian Group of Painters 1933.

Casson, Alfred J. (1898-). b. Toronto. Studied at Hamilton Technical School and Ontario College of Art, Toronto. Apprentice lithographer; associated with F. Carmichael as commercial artist 1919. Member Group of Seven 1926, Canadian Group of Painters 1933. ARCA 1926, RCA 1939, PRCA 1948-52.

Chabert, Abbé Joseph (active 1865-90). b. France. Directed École des Beaux-Arts, Ternes, Paris. Emigrated to Quebec 1865. Professor of drawing, Ottawa College 1867. Principal, École des Arts et Métiers, Montreal 1871 to at least 1886.

Challener, Frederick S. (1869-1959). b. Whetstone, Middlesex, Eng. Came to Canada 1870; returned to London 1876-83. Studied at Central Ontario School of Art, Toronto. Taught at Ontario College of Art 1927-52. ARCA 1891, RCA 1899. d. Toronto.

Chamberlin, Agnes Dunbar (FitzGibbon) (d. 1910). b. Belleville, Ont., daughter of authoress Susanna Strickland Moodie; m. Charles FitzGibbon, then Brown Chamberlin. In Toronto painted Canadian flowers and copied landscapes 1864-90; illustrated flower books.

Chauchetière, Claude (1645-1709). b. Poitiers, France, Ordained Jesuit; missionary to Caughnawaga Iroquois near Montreal 1679-94; d. Quebec. Drew illustrations for mission teaching; illustrated his 1668 narrative of mission work; some illustrations subsequently engraved.

Clapp, William Henry (1879-1954). b. Montreal. Studied at school of Art Association of Montreal under Brymner, in Paris with Lucien Simon. Travelled and painted in France, Spain, Cuba, United States. ARCA 1911. A pioneer exponent of Pointillism in Canada. d. Oakland, Cal.

Clew, Clepham J. *See* Clow

Clow (Clew), Clepham, J. (active c 1831-50). Arrived Halifax from Europe 1831. Itinerant portrait and miniature painter in oil and water-colour; returned to Halifax 1837, 1839, 1840, and on other occasions to 1850. Took daguerreotypes and painted miniatures, Saint John, N.B. 1842.

Coates, Richard (1778-1868). b. Thornton, Yorkshire; relative of Sir Joshua Reynolds. Bandmaster in Napoleonic Wars. Emigrated to Toronto 1817 as portrait and decorative painter, musician, choirmaster, organ builder. Probably Toronto's first resident professional painter. Moved to Oakville, Ont. 1831 and later to Aldborough Township, north of Lake Erie.

Coburn, Frederick S. (1871-1960). b. Upper Melbourne, P.Q. Studied in Montreal, New York, Berlin, London and Antwerp. ARCA 1920, RCA 1927.

Cockburn, James Pattison (1778-1847). b. Woolwich, Eng. Attended Royal Military College 1793; entered British Army. Lieutenant-colonel, 60th Regt. of Artillery, Quebec, c 1826-32. Named director of Royal Laboratory, Woolwich 1838; promoted to major-general shortly before death at Woolwich.

Colville, Alex (1920-). b. Toronto. Studied and taught at Mount Allison University, Sackville, N.B. Lives at Wolfville. N.S.

Comfort, Charles Fraser (1900-). b. Edinburgh, Scot. Came to Winnipeg 1912. Studied at Winnipeg School of Art and Art Students League, New York. Moved to Toronto 1925. Director National Gallery of Canada 1960-5. ARCA 1936, RCA 1942, PRCA 1957. Member Canadian Group of Painters 1933.

Comingo, Joseph Brown (1784-after 1820). b. Nova Scotia, of Dutch ancestry. Worked in Halifax as miniaturist on vellum and painter of small oil portraits. Visited Saint John, N.B. 1814 to paint miniatures and landscapes in water-colour.

Cook, Nelson. *See* Cooke

Cooke (Cook), Nelson (1817-92). Portrait painter in Toronto c 1835-7, at Saratoga Springs, N.Y. 1841-4 and 1857-9, Rochester, N.Y. 1852 and 1857. Returned periodically to Toronto. d. Boston, Mass.

Coughtry, Graham (1931-). b. St Lambert, P.Q. Studied at Montreal Museum of Fine Arts, Ontario College of Art, and abroad. Lives in Toronto.

Cruikshank, William (1849-1922). b. Broughty Ferry, Scot. Settled in Toronto 1857. Studied at Royal Scottish Academy, Edinburgh, Royal Academy Schools, London, and Atelier Yvon, Paris. Returned to Toronto 1873; taught at Central Ontario School of Art. Moved to Kansas City 1919. OSA 1882, ARCA 1884, RCA 1894. d. Kansas City.

Cullen, Maurice Galbraith (1866-1934). b. St John's, Nfld. Moved to Montreal 1870. Studied sculpture with Philippe Hébert and painting at École des Beaux-Arts, Paris 1889-92. Subsequent European trips. Painted chiefly in Montreal after 1895; summers at Beaupré to 1920 and thereafter at Lac Tremblant. ARCA 1899, RCA 1907. Member Canadian Art Club 1908-15. d. Chambly, P.Q.

Dallaire, Jean (1916-65). b. Hull, P.Q. Studied at technical schools in Hull and Toronto, and at school of Museum of Fine Arts, Boston. d. France.

Dartnell, George Russell (1798-1878). Surgeon of First Royal Regiment, stationed in Canada 1836-43. Sketched at Penetanguishene, Ont. and Niagara Falls 1836, London, Ont. 1840, and Quebec 1843.

Davies, Thomas (c 1737-1812). Entered Royal Military Academy, Woolwich 1755; in British Army 1757. In Nova Scotia and New England 1758; on Lake Champlain 1759; at capture of Montreal 1760; in New York c 1766; in Halifax and New York

during American Revolutionary War 1776-9; also in Canada as lieutenant-colonel 1786-90. Rose to lieutenant-general. d. Blackheath, Eng.

Day, Forshaw (1837-1903). b. London, Eng. Studied architecture and design at Royal Dublin Society and Gore House, South Kensington. Naval draughtsman, Halifax 1862-79; professor of drawing, Royal Military College, Kingston 1879-97. OSA 1879, RCA 1880. d. Kingston.

De Heer, Louis Chrétien. *See* Heer

Des Barres, Joseph Frederic Wallet (1722-1824). Of Hugenot descent; ed. in Switzerland and at Royal Military Academy, Woolwich. Joined British Army; in Canada at beginning of Seven Years' War; made survey of Nova Scotia and Cape Breton coasts 1763-73. Lieutenant-governor of Cape Breton 1784-7, of Prince Edward Island 1804-12. d. Halifax.

Dessailliant de Richeterre, Michel (active *c* 1700-10). Studied at Saint-Joachim School of Arts and Crafts before 1701; in Detroit 1706; known to have worked in Montreal; in Quebec 1709-10 (possibly to 1721). Paintings in Hôtel-Dieu, Montreal, Church of L'Ange Gardien, Quebec (1707), Hôpital Général and Hôtel-Dieu, Quebec 1708.

Drake, John Poad (1794-1883). b. Devonshire, Eng., descendant of Admiral Drake. Draughtsman and naval architect in youth. Lived in Charlottetown, Halifax, Montreal, and possibly Quebec 1819-30. Returned to England to work as inventor and naval designer. d. Fowey, Cornwall.

Dudoward, Charles (active 1873). Son of chief of Eagle Clan, Port Simpson, B.C. Painter of primitive landscapes and genre illustrating Port Simpson region.

Dulongpré, Louis (1754-1843). b. Saint-Denis. Studied in Paris. Served in French Army in America during American Revolution 1778-83. Settled in Montreal, worked as music teacher and then artist; associated with Louis-Joseph Papineau and other prominent French community members. d. Saint-Hyacinthe, P.Q.

Dumouchel, Albert (1916-1971). b. Valleyfield, P.Q. Studied graphics with James Lowell and sculpture with Médard Bourgault in Montreal. d. Montreal.

Duncan, James (1806-81). b. Coleraine, Ireland. Settled in Montreal 1827; taught painting and executed oil and w.c. landscapes. Also worked as illustrator. d. Montreal.

Dynes, Joseph (1825-97). b. Hamilton. Portrait and religious painter, Quebec 1865-91; visited Montreal periodically. Said to have copied Krieghoff paintings. Photographer, tinter of photographs, painter; later abandoned photography, but continued to paint portraits, landscapes, and religious paintings for Quebec churches. d. Burlington, Ont.

Dyonnet, Edmond (1859-1954) b. Crest, France. Studied in Turin and Naples. In Montreal after 1875. ARCA 1893, RCA 1901. d. Montreal.

Eager, William (*c* 1796-1839). b. Ireland. In St John's, Nfld. *c* 1831-4; painted landscapes. Moved to Halifax 1835; travelled widely in Maritimes painting views in oil and water-colour, and oil portraits. d. Saint John, N.B.

Eaton, Wyatt (1849-96). b. Phillipsburg, P.Q. Studied at National Academy of Design, New York 1867-72, in France under Gérôme; associated with Whistler, Millet and Barbizon 1873-4. Worked in France and Italy early 1880s. Painted many portraits in Montreal 1892-3. Member Society of Canadian Artists 1867. d. Newport, R.I.

Edema, Gerard van (*c* 1652-*c* 1700). b. Amsterdam, Holland. Emigrated to London 1670; made sketches in Norway, Newfoundland, and New York from which he painted landscapes later. Known as Salvator Rosa of the North. d. Richmond, near London.

Edson, Aaron Allan (1846-88). b. Stanbridge, P.Q. Studied in Paris with Léon Pelouse 1864-6. Member Society of Canadian Artists 1867. RCA 1880. d. Glen Sutton, P.Q.

Estcourt, Sir James B. Bucknall (1802-55). b. Gloucestershire, Eng.; ed. Harrow. Entered British Army 1820; 43rd Monmouthshire Light Infantry; in Canada 1838-9 and 1844-7 at Saint John, N.B., Quebec, Montreal, and Niagara. Killed in Crimean War. His wife, Caroline, also sketched in water-colour in Canada.

Ewen, Paterson (1925-). b. Montreal. Studied at McGill University and school of Montreal Museum of Fine Arts; lives in Montreal.

Falardeau, Antoine Sébastien (1822-89). b. Cap Santé, P.Q. Lived in Quebec 1836-1846 where he went to learn to paint; associated with Vezina, Hamel, Todd, and Fascio. In Italy for study 1846. Visited Montreal and Quebec 1862 and 1882. d. Italy.

Ferron, Marcelle (1924-). b. Louiseville, P.Q. Studied with Lemieux, Hayter. Lived in Paris and Montreal.

Field, Robert (*c* 1769-1819). Probably b. Gloucestershire, Eng. Studied engraving at Royal Academy School, London 1790; emigrated to United States 1794. Portrait and miniature painter in Baltimore, Boston, Philadelphia, Washington. In Halifax May 1808 to 1816 (or 1817), where was leading Canadian portrait painter on eastern seaboard. d. Kingston, Jamaica, of yellow fever.

FitzGerald, Lionel LeMoine (1890-1956). b. and d. Winnipeg. Studied at A. S. Keszthelyi's School of Art, Winnipeg, and Art Students League, New York. Taught at Winnipeg School of Art from 1924. Member Group of Seven 1932-3, Canadian Group of Painters 1933. Visited British Columbia and Mexico.

Fonville. *See* Bécart

Forbes, John Colin (1846-1925). b. and d. Toronto. Studied at South Kensington and Royal Academy Schools, London. Painted many official portraits for Canadian Government. Painted in Canadian Rockies 1886. OSA 1872, RCA 1880.

Forbes, Kenneth (1892-). b. Toronto. Studied at St. John's Wood and other London art schools. ARCA 1927, RCA 1933. Lives in Toronto.

Forster, John W. L. (1850-1938). b. Norval, Ont. Studied with J. W. Bridgman and at Académie Julian, Paris. OSA 1883, ARCA 1884. d. Toronto.

Forster, Michael (1907-). Artist with the Royal Canadian Navy during Second World War. Lives in Ottawa.

Fortin, Marc-Aurèle (1888-1970). b. and d. Sainte-Rose, P.Q. Studied in Montreal with Ludger Larose and Edmond Dyonnet, at Art Institute of Chicago, and in southern Europe. Lived in Sainte-Rose.

Fosbery, Ernest G. (1874-1960). b. Ottawa. Studied with Brownell and in Paris. Lived in Ottawa after 1911. ARCA 1912, RCA 1929, PRCA 1943-48. d. Cowansville, P.Q.

Fothergill, Charles (1782-1842). b. Yorkshire, Eng. Emigrated to Ontario c 1816. Named King's Printer of Upper Canada 1827. Edited *Upper Canada Gazette* 1822-27; Member of Legislative Assembly 1827-30. Founded magazine *Palladium of British America* 1837. Water-colour painter of landscapes and natural history specimens.

Foulis, Robert (1796-1866). b. Glasgow. Portrait and miniature painter Halifax 1819-20. In Saint John, N.B. 1820 as inventor, daguerreotypist, land surveyor; chiefly portraitist, but also heraldic painter and engraver; operated Foulis School of Art in 1830s and 1840s. d. Saint John.

Fowler, Daniel (1810-94). b. Down, Kent, Eng. Studied with J. D. Harding. Emigrated to Canada 1843. Farmer; resumed painting professionally 1857. OSA 1872, RCA 1880. d. Amherst Island, Ont.

Franchère, Joseph-Charles (1866-1921). b. and d. Montreal. Studied in Paris under Gérôme and Joseph Blanc and at Académie Colarossi; in Montreal after 1890. ARCA 1902.

François, Claude. *See* Luc

François, Father (Jean-Melchior Brekenmacher) (active 1732-56). With Recollet order at Quebec; painted at Beauport 1732, Berthier-en-Bas and Varennes 1735. Paintings attributed to him at Church of St Bernard (Dorchester), St Peter (Montmagny), and at Lotbinière.

Fraser, John Arthur (1838-98). b. London, Eng. ed. Royal Academy School, London. Emigrated to Eastern Townships, P.Q. 1856. Worked for Notman Photographic Studios Montreal and Toronto 1860-83; thereafter in United States. Painted in Rockies 1886. Member Society of Canadian Artists, Montreal 1867. OSA 1872; RCA 1880. d. New York.

Fraser, William Lewis (1841-1905). b. London, Eng. Emigrated to Canada 1856; in Montreal by 1865, chiefly in Notman Photographic Studios. Later in New York to edit *Century Magazine*; associated with *St. Nicholas Magazine*. Member Society of Canadian Artists, Montreal, 1867.

Fripp, Charles Edwin (1854-1906). b. England. Illustrator for *London Graphic*. Painted during Klondike Gold Rush 1908 and Indian life in B.C. d. Montreal.

Fripp, Thomas William (1864-1931). b. London, Eng. Studied with father, George Arthur Fripp, at St John's Wood Art School, Royal Academy Schools, and in France, Italy. Emigrated to British Columbia as pioneer farmer 1893. Returned to painting as result of accident. Founder and first president of B.C. Society of Fine Arts 1908. d. Vancouver.

Gagen, Robert Ford (1848-1926). b. London, Eng. Emigrated to Seaforth, Ont. 1862. Studied in London and Toronto with William Cresswell and John A. Fraser. Worked at Notman Photographic Studios, Toronto; taught at Central Ontario School of Art. OSA 1872, ARCA 1880, RCA 1914. d. Toronto.

Gagnon, Charles (1934-). b. Montreal. Studied at Parsons School of Design and Art Students League, New York; lives in Montreal.

Gagnon, Clarence-A. (1881-1942). b. and d. Montreal. Studied at art school of Art Association of Montreal under Brymner 1897-1900; Académie Julian, Paris, 1904-5. Lived in Montreal, Baie-Saint-Paul, Paris. ARCA 1909, RCA 1922.

Giffard, Alexandre-S. (active 1865-78). Lived in Quebec and Saint-Roch suburbs; said to have studied with Krieghoff. Painted landscapes, marines, and ships in gouache and oil; portrait of curé of Les Grondines, P.Q. 1877 or after.

Gilbert, Grove Sheldon (1805-85). b. Clinton, N.Y. Graduated from Middlebury Academy 1825. Painted and taught at LeRoy, N.Y., Niagara, Ont., then in Toronto 1833-4. Moved to Rochester, N.Y. 1834. Exhibited as professional at Society of Artists and Amateurs, Toronto 1834, at Toronto Society of Arts 1847.

Gill, Charles (1871-1918). b. Sorel, P.Q. Studied under William Brymner and at École des Beaux-Arts and at Atelier Gérôme, Paris.

Gillespie, J.H. (1793-after 1849). b. England. Profile miniaturist, London, Edinburgh, Liverpool. Probably came to Halifax 1829; Saint John, N.B. 1830. In New York, Baltimore, Philadelphia 1837-8. By 1841 in Toronto painting portraits and miniatures; exhibited at Toronto Society of Arts 1847; won prizes for oil landscapes at Upper Canada Provincial Exhibition 1849. d. before 1876.

Gillespie, John (active 1841-9). Painter of oil and water-colour landscapes and portraits working in Toronto and district.

Glyde, H. G. (1906-). b. England. Emigrated to Canada 1935. Taught at Provincial Institute of Technology and Art, Calgary 1936-46; head of art department, University of Alberta, Edmonton, since 1946. ARCA 1942, RCA 1949.

Godwin, Ted (1933-). b. Calgary. Studied at Provincial Institute of Technology and Art, Calgary. Lives in Regina.

Gordon, Hortense (1887-1961). b. and d. Hamilton. Taught at Hamilton Technical Institute. Member Painters Eleven. ARCA 1930.

Granville. *See* Bécart

Grier, Sir Wyly (1862-1957). b. Melbourne, Australia. Came to Canada 1876. Studied at Slade School, London, in Rome and at Académie Julian, Paris. OSA 1896, ARCA 1893, RCA 1894, PRCA 1930-39. d. Toronto.

Griffiths, James (1814-96). b. Newcastle, Staffordshire, Eng. China decorator in Staffordshire Potteries in youth. Emigrated to London 1854; deputy clerk of Crown. OSA 1873, RCA 1880.

Griffiths, John H. (active 1851-97). b. Staffordshire. Painted china in Minton Works in youth. Emigrated to London, Ont. c 1849; photographer, teacher, china painter. Founded Western School of Art and Design, London, Ont. Exhibited oils, water-colours and miniatures at Upper Canada Provincial Exhibitions.

Guindon, Arthur (1864-1923). b. Saint-Polycarpe, P.Q. Member of Sulpitian order: taught at Montreal College 1897-1906. Retired from teaching because of deafness. Later wrote poetry and painted. d. Montreal.

Guyon, Jean (1659-87). b. Quebec. Studied at Quebec Seminary; ordained 1683; appointed cathedral canon and secretary to Bishop Laval 1684. Accompanied Laval to France to study painting. d. Paris.

Haines, Frederick S. (1879-1960). b. Meaford, Ont. Studied at Central Ontario School of Art and Antwerp Academy. OSA 1906, ARCA 1919, RCA 1933, PRCA 1940-42. d. Thornhill, Ont.

Hall, Basil (1788-1844). b. Scotland. Noted traveller, author, naval officer; visited North America 1827-8.

Hamel, Joseph Arthur Eugène (1845-1932). b. Quebec. ed. Quebec and Montreal; studied with Théophile Hamel 1862-67, then in Antwerp, Brussels, Rome 1867-72. Portrait painter in Quebec 1872-80 and 1885-92; in Rome 1880-4. Appointed to Quebec Civil Service 1892.

Hamel, Théophile (1817-70). b. Sainte-Foy, P.Q. Apprentice to Plamondon 1834-40; portrait painter, Toronto 1842-3. Studied in Rome, Paris, Antwerp 1843-6. Studio in Quebec 1846, Montreal 1848-9, Toronto 1850-51; briefly in Kingston, Hamilton, and United States; in Quebec after 1852.

Hamilton, James (1810-98). b. Cornwall, Eng. Bank teller in Toronto, later manager Bank of Upper Canada, London, Ont.; promoted toll roads. Exhibited at Society of Artists and Amateurs of Toronto 1834, Toronto Society of Arts 1847. d. London.

Hamilton, John (d. 1796). Of Irish descent. Entered British Army 1754; in Seven Years' War; sketched in Nova Scotia 1753-5.

Hammond, John (1843-1939). b. Montreal. Lived in London and New Zealand 1866-9. Worked at Notman Photographic Studios, Montreal. Associated with Millet and Whistler in Europe. Painted in Rocky Mountains. Directed Owens Art Institute, Saint John, and later School of Art, Mount Allison University 1907-19. OSA 1873, ARCA 1890, RCA 1893. d. Sackville, N.B.

Hankes, Jarvis F. *See* Hanks

Hanks (Hankes), Jarvis F. (active 1827-34). Silhouettist, probably b. Oswego, N.Y. Worked in Great Britain before visiting Toronto 1827; in Halifax 1830-1, where exhibited gallery of paper cuttings and cut silhouettes touched in bronze by an assistant, Reynolds.

Harris, Lawren P. (1910-). b. Toronto. Studied at Central Technical School, Toronto, and school of Museum of Fine Arts, Boston. Taught at Northern Vocational School, Toronto, at Trinity College School, Port Hope; head of art department of Mount Allison University 1946-75.

Harris, Lawren S. (1885-1970). b. Brantford, Ont. Studied at University of Toronto, and in Berlin and Munich 1905-7. Returned to Toronto 1910. Moving force in creation of nationalistic school. Adapted abstract style *c* 1940. OSA 1911. Founding member, Canadian Group of Painters 1933. Lived in Vancouver after 1942. d. Vancouver.

Harris, Robert (1849-1919). b. Vale of Conway, Wales. Brought by parents to Charlottetown 1856. Surveyor, Prince Edward Island 1868-78. Studied art in Boston, London under Alphonse Legros, Paris with Léon Bonnat. In Toronto 1879-81 and then Montreal. OSA 1879, RCA 1880, PRCA 1893-1906. d. Montreal.

Harvey, George (1846-1910). b. Torquay, Devon, Eng. In Halifax *c* 1882-95. Principal, Victoria School of Art and Design 1887-94. ARCA 1883.

Hatton, W. S. (active 1855-64). Artist in Toronto, Quebec, and Montreal 1856-62. Executed views of British Columbia mountain scenery 1863-4. Worked mainly in water-colour.

Hébert, Adrien (1890-1967). b. Paris. Son of Louis-Philippe Hébert. Studied under Dyonnet, Saint-Charles, and Brymner in Montréal and École des Beaux-Arts, Paris. Painter of Montreal cityscapes. ARCA 1932, RCA 1941. d. Montreal.

Heer, Louis-Chrétien de (*c* 1750- before 1808). b. Guebwiller, Alsace. Possibly with French forces in American Revolution; arrived Montreal by 1783. Opened Quebec studio 1787; taught painting; returned to Montreal 1789; known works date from 1788 to 1796.

Henderson, Sir Edmund Yeamans Wolcott (1821-96). b. Christchurch, Hampshire, Eng. Served in Royal Engineers; in Canada 1839-45 and 1847-8, Halifax 1848. Retired from army 1863; Commissioner of London Metropolitan Police 1869-86. d. London.

Henderson, James (1871-1951). b. Glasgow, Scot. Glasgow lithographer; studied at Glasgow School of Art. Visited Canadian Prairies 1910; settled in Qu'Appelle Valley, Saskatchewan 1916. d. Regina.

Heriot, George (1766-1844). b. Haddington, Scot. Attended Royal Military Academy, Woolwich; in Quebec as civilian 1791; named deputy postmaster-general of British North America 1800; resigned after dispute with Sir George Drummond, Administrator of Province of Quebec 1816.

Heward, Prudence (1896-1947). b. Montreal. Studied at School of Art Association of Montreal under Wm. Brymner and Randolph Hewton, and at Académie Colarossi, Paris. Painted in Montreal, Brockville, the Laurentians. Member Canadian Group of Painters 1933. d. California.

Hind, William George Richardson (1833-88). b. Nottingham, Eng. Studied art in London and continental Europe. Emigrated to Toronto 1852; taught drawing at Normal School. In Canada 1861 as official artist to his brother's exploration party to Labrador. Travelled to Cariboo 1862. Professional artist in Victoria to 1865. Later railway worker in Nova Scotia and New Brunswick. d. Sussex, N.B.

Hodgson, Tom (1924-). b. Toronto. Studied at Western Technical School and Ontario College of Art, Toronto. Lives in Toronto.

Holdstock, Alfred Worsley (1820-1901). b. Bath, Eng. ed. Oxford. Emigrated to Montreal 1850; drawing-master. Painted landscapes in Thousand Islands, Ottawa River, Laurentians, etc. in oil, water-colour, pastel.

Holgate, Edwin H. (1892-). b. Allandale, Ontario. Studied under William Brymner and in Paris. ARCA 1934, RCA 1935. Member Group of Seven 1931-3; Canadian Group of Painters 1933. Lives at Morin Heights, P.Q.

Holmes, Robert (1861-1930). b. Cannington, Ont. Studied at Central Ontario School of Art under Wm. Cruikshank and at Royal College of Art, London. Taught at Upper Canada College and Ontario College of Art, Toronto. OSA 1909, ARCA 1909, RCA 1920. d. Toronto.

Hooker, Marion Nelson (1866-1946). b. Richmond, Va. Studied painting in St Catharines, at Buffalo Art League, under G. B. Bridgman in New York, and in Britain, France, and Holland. Painted in Selkirk, Man. 1907-35. OSA 1905. d. St Catharines, Ont.

Hopkins, Frances Ann (Beechy) (1838-1918). b. England. Married secretary to Sir George Simpson, Governor of Hudson's Bay Co.; lived in Canada 1858-70. Sketched fur trade scenes and Indian life. With Wolseley during Red River expedition 1870.

Horne, Cleeve (1912-). b. Jamaica. In Canada after 1913. Studied at Ontario College of Art in London, England. ARCA 1947, RCA 1951.

Howard, John George (1803-90). b. England, where served architectural apprenticeship. Emigrated to Toronto 1832; architect, civil engineer, and drawing master at Upper Canada College 1833-c 1866. Exhibited as professional at Society of Artists and Amateurs, Toronto 1834, and Toronto Society of Arts 1847. Used *camera lucida*. Exhibited landscapes in water-colour and pencil. d. Toronto.

Hughes, Edward J. (1913-). b. Vancouver. Studied at Vancouver School of Art. Has lived on Vancouver Island since 1946.

Humphrey, Jack Weldon (1901-1967). b. and d. Saint John, N.B. Studied at school of Museum of Fine Arts, Boston, Art Students League, New York, in Paris and Munich

1929-30; travelled extensively. Member Canadian Group of Painters 1933. Lived in Saint John.

Huot, Charles (1855-1930). b. Quebec. Studied at École des Beaux-Arts, Paris, under Cabanel 1874-8. Executed mural decorations for Legislative Buildings, Quebec, 1913-29. d. Quebec.

Inglefield, Sir Edward Augustus (1820-94). In Royal Navy; reached rank of Admiral. In Arctic as commander of HMS *The Isabel* 1852, and *Phoenix* 1853-4 during search for Sir John Franklin. In Halifax 1879. Exhibited at Halifax 1879, and as honorary exhibitor at Royal Academy 1851-68.

Innes, John (1863-1941). b. London, Ont. ed. London, Ont. and Eng. Studied engineering. Cartoonist for *Calgary Herald* 1885. Studied with Wm. Cruikshank in Toronto. Newspaper illustrator, New York 1907-13. Later historical illustrator, Vancouver. OSA 1904. Member B.C. Society of Fine Arts. d. Vancouver.

Jackson, Alexander Young (1882-1974). b. Montreal. Studied at Monument National, Montreal, Chicago Art Institute, Académie Julian, Paris. Many early painting trips to Europe. Moved to Toronto 1913. ARCA 1914, OSA 1915, RCA 1919. Member Group of Seven 1920, Canadian Group of Painters 1933. Lived in Manotick, Ottawa, and Kleinburg from 1955. d. Toronto.

Jacobi, Otto Reinhold (1812-1901). b. East Prussia. Studied at Königsberg, Berlin, Düsseldorf Academies. Court painter to Duchess of Nassau, Wiesbaden. Emigrated to New York; came to Canada for Prince of Wales's visit 1860. Lived principally in Montreal 1860-91, then in Toronto. Member Society of Canadian Artists 1867. OSA 1876, RCA 1880, PRCA 1890-93.

Jarvis, Donald (1923-). b. Vancouver. Studied at Vancouver School of Art and with Hans Hofmann. Lives in Vancouver.

Jefferys, Charles W. (1869-1952). b. Rochester, Eng. During youth lived in Philadelphia, Hamilton, Toronto. Apprentice lithographer with Toronto newspapers. Studied with G. A. Reid, C. M. Manly. OSA 1902, ARCA 1912, RCA 1925. d. Toronto.

Jérôme, Jean-Paul (1928-). b. Montreal. Studied at Ecole des Beaux-Arts, Montreal, and with Stanley Cosgrove. Lives in Montreal.

Johnston, Franz (Francis, Frank) H. (1888-1949). b. and d. Toronto. Studied at Central Technical School and Central Ontario School of Art, Toronto, and Pennsylvania Academy. Commercial artist, New York and Toronto. Principal, Winnipeg School of Art 1920-4; taught at Ontario College of Art 1927-9. OSA 1917, ARCA 1919. Member Group of Seven 1920.

Julien, Henri (1852-1908). b. Quebec. Apprentice printer in Quebec, later apprentice lithographer in Montreal. Began as newspaper illustrator and cartoonist for Montreal newspapers and periodicals *c* 1874. Draughtsman and painter of French-Canadian *habitant* life. d. Montreal.

Kane, Paul (1810-71). b. Mallow, Ire. Emigrated to Toronto 1818 or 1819. Apprentice to furniture decorator, Cobourg, Ont. until 1830 and portrait painter there 1830-6; itinerant painter in United States 1836-41; student in Europe 1841-5; sketched Indian life in Western Canada 1845-8; painter in Toronto after 1848. d. Toronto.

Kenderdine, Augustus (1870-1947). b. Manchester, Eng. Studied at Manchester School of Art and Académie Julian, Paris. Emigrated to Canada 1907; was rancher at Lashburn, Sask. First exhibited paintings in 1920; director of Fine Art, University of Saskatchewan, from 1935. d. Saskatoon.

Kerr, Illingworth H. (1905-). b. Lumsden, Sask. Studied at Central Technical School, Toronto, Ontario College of Art under several Group of Seven members, Westminster School of Art, London. Returned to Prairies 1928. Head of art department of Provincial Institute of Technology and Art, Calgary, since 1947.

Kerr-Lawson, James (1864-1939). b. Anstruther, Scot. Emigrated to Hamilton, Ont. 1865. Studied painting in Rome and Paris; returned to Toronto for a time but spent much of later life in England and Scotland.

King, William (active c 1785-1809). b. Salem, Mass.; cabinet-maker and ivory-turner to 1804. Began taking profiles with mechanical device in New England; in Halifax 1806, Saint John, N.B. 1807, and Newfoundland. Left for southern United States 1807.

Kiyooka, Roy (1926-). b. Moose Jaw. Studied at Provincial Institute of Technology and Art, Calgary, and in Mexico. Lived in Montreal, Halifax and Vancouver.

Knowles, F. McGillivray (1859-1932). b. Syracuse, N.Y. Studied with John A. Fraser in Toronto, and in London and Paris. OSA 1885, ARCA 1890, RCA 1898. d. Toronto.

Korner, John (1913-). b. Nový Jicîn, Czechoslovakia. Studied in Prague and in Paris with Othon Friesz. Lives in Vancouver.

Kreighoff, Cornelius (1815-72). b. Amsterdam; youth near Schweinfurt, Bavaria. Said to have studied in Rotterdam and Düsseldorf. Travelled through Europe as itinerant artist and musician. Emigrated to United States c 1836. Served with American Army in Seminole War. Moved to Canada after marriage to French-Canadian girl. Lived briefly in Toronto and Longueuil; in Montreal 1847-53, and Quebec 1854-63 and 1869-71. d. Chicago.

Larose, Ludger (1868-1915). b. and d. Montreal. Studied with Gustav Moreau and Jean-Paul Laurens in Paris 1887.

Latour, Jacques. See Leblond

Laure, Pierre (1686-1738). b. Orléans, France. Emigrated to Canada 1711; in charge of Saguenay Mission 1720-38. d. Les Éboulements, P.Q.

Le Ber, Pierre (1669-1707). b. Montreal. Joined Institute of the Charon Brothers c 1694. Taught painting at the Charon Brothers; Chaboillez one of his pupils. d. Montreal.

Leblond de Latour, Jacques (1670-1715). b. Bordeaux, France, son of painter. Brought to Canada by Bishop Laval 1695; directed sculpture atelier at Saint-Joachim School of Arts and Crafts. Worked as layman 1695-6, and cleric 1698-1706; ordained 1706. Served in Acadia and at Baie-Saint-Paul, where he died.

Leduc, Fernand (1916-). b. Montreal. Studied at École des Beaux-Arts, Montreal, in Paris 1947-53; associated with *Automatistes*. Lives in Paris.

Leduc, Ozias (1864-1955). b. Saint-Hilaire, P.Q. Mainly self-taught. Church decorator with Luigi Cappello and Adolphe Rho. Visited France with Suzor-Coté 1897. ARCA 1916. d. Saint-Hyacinthe, P.Q.

Légaré, Joseph (1795-1855). b. Quebec. Interested in politics, supporting 1837 uprisings and Papineau-Annexationist Party 1849. Named Quebec Legislative Councillor 1855. Principally self-taught by copying religious works and restoring Desjardins Collection. Made numerous oil views of Quebec scenery; Canada's first important native-born pioneer landscape painter.

Leighton, A. C. (1901-1965). b. Hastings, Sussex, Eng. Studied at Hastings School of Art, Hornsey School of Art, London, and in Paris. Settled in Calgary 1929. Art director of Province of Alberta 1929-37. Founder of Alberta Society of Artists 1931. d. Calgary.

Lemieux, Jean-Paul (1904-). b. Quebec. Studied at École des Beaux-Arts, Montreal, and Académies Colarossi and Grande Chaumière, Paris. Taught at École des Beaux-Arts, Montreal 1935-6; since 1937 at École des Beaux-Arts, Quebec. ARCA 1951, RCA 1956.

Letendre, Rita (1929-). b. Drummondville, P.Q. Studied at École des Beaux-Arts, Montreal, and in Paris; lives in Montreal.

Levinge, Sir Richard George Augustus (1811-89). b. England. Joined British Army 1828; with 43rd Monmouthshire Light Infantry 1835-40 in Saint John, N.B., then in Quebec. Elected English MP after leaving army. d. West Meath, Ireland.

Lindner, Ernest (1897-). b. Vienna. Studied architecture in England; in Canada since 1926. Teaches in Saskatoon.

Linnen, John (c 1800-after 1860). b. Greenlaw, Scot. Studied at Royal Scottish Academy, Edinburgh. Emigrated to Toronto by 1834. Exhibited 18 portraits as professional at Society of Artists and Amateurs, Toronto 1834, at Toronto Society of Arts, 1847. Worked in New York 1837-60.

Lismer, Arthur (1885-1969). b. Sheffield, Eng. Studied at Sheffield School of Art and Antwerp Academy. Came to Toronto 1911; commercial artist. Principal, Nova Scotia College of Art 1916-19; vice-principal, Ontario College of Art 1920-7; educational supervisor, Art Gallery of Toronto 1929-36; principal, School of Montreal Museum of Fine Arts 1940. OSA 1913, ARCA 1919, RCA 1946. Member Group of Seven 1920, Canadian Group of Painters 1963. d. Montreal.

Lochhead, Kenneth C. (1926-). b. Ottawa. Studied at Queen's University, Pennsylvania Academy, Barnes Foundation. Lived in Regina, Winnipeg, and Toronto. Teaching at University of Ottawa from 1975.

Lockwood, (active 1834-49). Advertised in Toronto 1834; exhibited at Toronto Society of Arts 1847. Perhaps the same man as William Lockwood, who worked in Montreal and Quebec and died at the Marine Hospital, Quebec, 1866, when described as 'a painter of talent.' Probably itinerant miniaturist.

Luc, Frère (Claude François) (1614-85). b. Amiens, France. Studied, Paris under Simon Vouet 1632, then in Rome; worked on Louvre decoration under Poussin 1640-2; established atelier as 'Painter to the King.' Joined Recollet order 1644; taught painting; produced paintings for Amiens Cathedral, Chapel of Suzanne, and Gobelin tapestries. Visited Quebec, spring 1670-1. d. Paris.

Luke, Alexandra (1901-). b. Montreal. Principally self-taught but worked at Banff School of Fine Arts and with Hans Hofmann; lives in Oshawa, Ont.

Lyall, Laura Muntz (1860-1930). b. Radford, Eng. Emigrated to Canada in youth, lived on Muskoka farm. Studied with J. W. L. Forster, in Hamilton and at Académie Colarossi, Paris. Worked principally in Toronto. OSA 1891, ARCA 1895. d. Toronto.

Lyman, John G. (1886-1967). b. Biddeford, Maine, Childhood in Montreal. Studied in Paris with Marcel Péronneau and at Académie Julian and Royal College of Art, London. Associate of Henri Matisse and Matthew Smith. Early paintings not well received in Canada. Spent much of early life abroad; returned to Montreal 1931. Founder of Contemporary Art Society. d. Barbados.

Lynn, Washington Frank (d. 1906). Studied painting at Royal Academy Schools, London. Emigrated to Toronto; in Winnipeg after c 1875. Newspaper correspondent and artist, painted portraits and landscapes of historical and topographical interest. d. Winnipeg.

Lyttleton, Westcott Witchurch (1818-79). British officer, 64th Regiment, Halifax, N.S. 1840-3. Returned to Halifax 1849-66. d. Keswick, England.

MacCrea, George (active 1783-1802). b. Edinburgh. Appointed secretary of North British Society, Halifax, 1783. Returned to Scotland 1802.

MacDonald, James E. H. (1873-1932). b. Durham, Eng. Came to Hamilton 1887; studied at Hamilton Art School and Central Ontario School of Art under Wm. Cruikshank, G. A. Reid. Graphic designer, Toronto 1895-1904 and 1907-11, and London, Eng. 1904-7. Painted and taught after 1911. Painted at Thornhill, Ont., along Atlantic seaboard, in West Indies and Rockies. OSA 1909, ARCA 1912, RCA 1931. Member Group of Seven. d. Toronto.

Macdonald, James W. G. (Jock) (1897-1960). b. Thurso, Scot. Studied at Edinburgh College of Art to 1922; fabric designer 1922-5. Taught at Lincoln School of Art, at Vancouver School of Art 1926-33, at School of Decorative and Applied Arts, Vancouver 1933-5, at Provincial Institute of Technology and Art, Calgary, and at Ontario

College of Art after 1947. Member Canadian Group of Painters 1933, Painters Eleven. d. Toronto.

McEwen, Jean (1923-). b. Montreal. Principally self-taught; lives in Montreal.

McGregor, Edward (Edwin?) (active 1847-72). In partnership with T. H. Stevenson 1847. Exhibited at Toronto Society of Arts, 1847. Worked only briefly in Ontario; was probably an itinerant and the same McGregor who worked in Baltimore, Maryland, 1853-72. Painted portraits, landscapes, and genre.

McKay, Arthur F. (1926-). b. Nipawin, Sask. Studied in Calgary, Paris, Regina. Lives in Regina.

MacLeod, Pegi Nicol (1904-1949). b. Listowel, Ont. ed. Ottawa. Studied under Franklin Brownell and at École des Beaux-Arts, Montreal. Directed summer courses, University of New Brunswick from 1940. Member Canadian Group of Painters 1933. d. New York.

McNicoll, Helen (1879-1915). b. Toronto. Studied with Wm. Brymner in Montreal and at Slade School, London, with A. Talmage. ARCA 1914. d. Swanage, Eng.

Manly, Charles Macdonald (1855-1924). b. Englefield Green, Surrey, Eng. Came to Canada in youth. Studied at Heatherly School of Art, London, and Metropolitan School of Art, Dublin. Taught at Ontario College of Art. Later lived at Conestoga, Ont. OSA 1876, ARCA 1890. Founded Toronto Art Students League 1886. Member Graphic Arts Club 1904. d. Toronto.

Marseille, Jean *See* Natte

Martin, Thomas Mower (1838-1934). b. London, Eng. Emigrated to Canada 1862. Homesteaded in Muskoka, then moved to Toronto where he worked as art teacher and painter of landscapes; OSA 1872, RCA 1880. d. Toronto.

Matthews, Marmaduke (1837-1913). b. Barcheston, Warwickshire, Eng. ed. Cowley School, Oxford, with Richardson. Came to Toronto 1860. OSA 1872, ARCA 1880, RCA 1883. Painted in Canadian Rockies. d. Toronto.

Maufils de Saint-Louis, Marie-Madeleine (1670-1702). b. Quebec, daughter of Pierre Maufils. Jointed religious order at Hôtel-Dieu, Quebec. Said to have been promising painter and to have painted local landscapes. d. Quebec.

Mayne, R. C. (1835-92). Royal Naval Lieutenant on HMS *Plumper* on Vancouver Island naval survey 1856-61. Retired as rear-admiral 1870. Sketched on British Columbia and Vancouver Island coast. Published *Four Years in British Columbia and Vancouver Island* with his own illustrations.

Mercer, Alexander Cavalie (1783-1868?). b. England, son of general; ed. Royal Military College, Woolwich. Served at Waterloo; promoted to lieutenant-colonel 1837, later to general. In Canada 1838-42.

Meredith, John (1933-). b. Fergus, Ont. Studied at Ontario College of Art. Lives in Brampton, Ont.

Metcalf, Eliab (1785-1834). b. United States (probably New York). Painted miniature portraits and cut silhouettes. Worked as itinerant, visiting Quebec 1809 and Halifax 1810; made his headquarters in New York.

Meyer, Hoppner Francis (active 1832-60). b. London, Eng., son of engraver and painter. Portrait painter Quebec City 1832-3; miniaturist and engraver Toronto 1840-62. Exhibited Toronto Society of Arts 1847, and Upper Canada Provincial Exhibition. Returned to England.

Miller (Morris), Maria E. (1813-75). b. Halifax, where spent entire life. Conducted drawing classes for young ladies Halifax 1830. Began painting flowers c 1834 with Titus Smith, local botanist. Published series of prints of Nova Scotia flowers 1840, 1853, 1867.

Milne, David Brown (1882-1953). b. Paisley, Ont. Studied in New York 1904. Commercial artist until 1914. Painted in New York and district 1914-17, 1919-23, 1924-8. In Canada 1923-4 and after 1928, painting in Montreal, Ottawa, Toronto, and northern Ontario. d. Toronto.

Molinari, Guido (1933-). b. Montreal. Studied at École des Beaux-Arts, Montreal, and at school of Art Association of Montreal with Marian Scott. Lives in Montreal.

Morrice, James Wilson (1865-1924). b. Montreal. Studied painting at Académie Julian, Paris c 1889, and under Henri Harpignies; influenced by Whistler and Puvis de Chavannes. Lived principally in Paris, but visited Canada, West Indies, North Africa, and Venice. Painted with Matisse. Member Canadian Art Club 1907-15. RCA 1913.

Morris, Edmund Montague (1871-1913). b. Perth, Ont. Studied in Toronto with Wm. Cruikshank, at Art Students League, New York, and at Académie Julian and École des Beaux-Arts, Paris. Returned to Toronto 1896. OSA 1905, ARCA 1898. Secretary Canadian Art Club 1907.

Morris, Kathleen M. (1893- ·). b. Montreal. Studied at school of Art Association of Montreal under William Brymner. ARCA 1929. Lives in Montreal.

Morris, Marie E. See Miller

Mousseau, Jean-Paul (1927-). b. Montreal. Associated with Borduas and Automatistes; lives in Montreal.

Muhlstock, Louis (1904-). b. Narajow, Poland. Living in Montreal since 1911. Studied in Montreal and under Louis Biloul, Paris, 1928-31. Painter of landscapes, figure, and animal studies. Member CGP, CAS.

Munn, Kathleen (1887-). b. Toronto. Studied under F. McGillivray Knowles, at Art Students League, New York, and Philadelphia Academy of Art. Worked in Toronto.

Musgrove, Alexander (1882-1952). b. Edinburgh, Scot. Attended Edinburgh University and Glasgow School of Art. Director of Winnipeg Art School and Winnipeg Art Gallery 1913-21. Founder member of Manitoba Society of Artists 1925. d. Winnipeg.

Nakamura, Kazuo (1926-). b. Vancouver. Studied at Central Technical School, Toronto. Lives in Toronto.

Natte *dit* Marseille, Jean (active 1772-92). Painter in Quebec who made and demonstrated marionnettes; did religious painting in churches at Saint-Michel, Rivière-Ouelle, Lauzon.

Nicoll, Marion (1909-). b. Calgary. Student in Calgary, Toronto, London, New York. Lives in Calgary.

O'Brien, John (1832-91). b. at sea while parents emigrating from Cork, Ireland, to Halifax. Showed such promise as marine painter in youth that local Halifax merchants subscribed money to send him to England, France, Italy. d. Halifax. Perhaps Halifax's first marine painter, working there from *c* 1850.

O'Brien, Lucius Richard (1832-99). b. Shanty Bay, Ont. ed. Upper Canada College, Toronto; architect and civil engineer. Professional painter *c* 1872; OSA 1873; first president RCA 1880-90. Supervised publication of *Picturesque Canada*.

Ogilvie, William A. (1901-). b. Cape Province, S. Africa. Studied at Johannesburg and Art Students League, New York. In Canada since 1925. Director of school of Art Association of Montreal 1938-41. Has taught at Ontario College of Art since 1946.

Palmer, Herbert S. (1881-1970). b. Toronto. Studied at Central Ontario School of Art, Toronto. OSA 1909, ARCA 1915, RCA 1934. Lived in Toronto.

Palmer, Samuel (active 1834-45). Perhaps b. London, Eng. Painted in Saint John, N.B. 1834-5 and 1837; then studied in United States. Came to Quebec via Montreal 1842 where he worked until 1845. Painted miniatures and larger portraits in oil, sought out as fashionable artist; often in debt.

Panko, William (1892-1948). b. Tulukow, Austria. Emigrated to Canada 1911; worked in Drumheller coal mines in winter, on farms in summer. Contracted tuberculosis 1937; painted primitives in sanatorium 1937-47. Had no art instruction. d. Edmonton.

Paulmiers, Hugues. *See* Pommier

Paumies, Hugues. *See* Pommier

Peachey, James (active in America 1774-97). English army officer attached to office of Samuel Holland, Director of Surveys for British North America, *c* 1781; later named deputy surveyor-general. Prepared many maps and plans of Lower Canada.

Pearron, Jean. *See* Pierron

424 Biographies

Peel, Paul (1860-91). b. London, Ont. Studied at Pennsylvania Academy, Philadelphia 1877-80, Royal Academy Schools, London, 1880, and École des Beaux-Arts, Paris, under Gérôme 1881. Lived thereafter principally in Paris. OSA 1880, ARCA 1882, RCA 1890. d. Paris.

Pellan, Alfred (1906-). b. Quebec. Studied at École des Beaux-Arts, Quebec 1920-5, in Paris at École des Beaux-Arts with Lucien Simon, at Grande Chaumière, and other academies. Associate of Picasso, Léger, Miró, Surrealists. Returned to Canada 1940. Has lived in Montreal since 1955.

Pemberton, Sophie (1869-1959). b. and d. Victoria. Studied at South Kensington Schools, London, at Académie Julian and with J. P. Laurens and Benjamin Constant in Paris. Lived in Victoria, B.C. and London. Exhibited at RA, AAM, RCA, and French Salon 1893-1909.

Perré, Henri (1828-90). b. Strasbourg. Fled to United States after Saxony uprisings 1849. Emigrated to Canada 1860. Taught at Central Ontario School of Art, Toronto, OSA 1874, RCA 1880. d. Toronto.

Peterson, Margaret (1902-). b. Seattle. Associated with University of California. Lived in Victoria and Sicily.

Petitot, Émile (1838-1917). b. Marseilles, France. Member of Oblate order. Came to Canada 1861; served on Mackenzie River as first regular missionary north of Arctic Circle. d. Marguit-les-Reaux, France.

Phillips, Walter Joseph (1884-1963). b. Barton-on-Humber, Lincolnshire, Eng. Studied at Birmingham School of Art 1899-1902. Lived in Winnipeg 1913-24. Moved to Calgary 1940; taught at Provincial Institute of Technology and Art and Banff Summer School.

Pierron (Pearron), Jean (1631-1700). b. Lorraine, France. Ordained Jesuit, Nancy 1650. Copied Old Masters. Served at Pont-à-Mousson, Reims, Verdun, Metz. Arrived Quebec 1667; then to Iroquois mission field, New York State. Visited Quebec 1668 and other times. d. Pont-à-Mousson.

Plamondon, Antoine-Sébastien (1804-95). b. near Quebec. Studied with Légaré 1817 and in Paris 1826-30 under Guérin, follower of David. In Quebec City 1830-52; leading Quebec painter. Retired to Pointe-aux-Trembles in 1852; named first vice-president of RCA 1880. d. Neuville.

Pommier (Paulmiers, Paumies), Hugues (c 1637-86). b. Vendôme, France. Ordained, Paris; joined Foreign Missions 1663. Wintered Plaisance, Newfoundland 1663-4; arrived Quebec June 1664; taught at Quebec Seminary 1664-9. Parish priest, Boucherville 1669, Sorel 1670, Beauport 1676; returned to France 1680.

Pratt, Christopher (1935-). b. St John's, Nfld. Studied at Mount Allison University and Glasgow School of Art. Lives in St John's.

Racle, Sébastien. *See* Rasles

Rales (Rasles, Racles), Sébastien (1657-1724). b. Pontarlier, France. Ordained Jesuit 1675; came to Canada as missionary 1689. With Abenaki Indians at Saint-François-de-Sales, near Quebec 1689-91; at Michilimackinac, Detroit, and in Illinois 1691-3; with Abenakis at Norridgewock (near Kennebec) 1694-1724. Killed in war with the Indians.

Ramage, John (c 1748-1802). b. Dublin. Studied at Dublin School of Artists 1763. Halifax miniaturist 1772 and 1774; in Boston to 1776; returned to Halifax for year as portrait painter; moved to New York where had prominent sitters including George Washington. Moved to Montreal 1794 because of marital difficulties.

Raphael, William (1833-1914). b. Prussia. Studied at Berlin Academy. Emigrated to New York as portrait painter 1856; moved to Montreal 1857. Member Society of Canadian Artists 1867. RCA 1880. d. Montreal.

Reid, George Agnew (1860-1947). b. Wingham, Ont. Studied at Central Ontario School of Art under Robert Harris and John A. Fraser 1879-82, at Pennsylvania Academy, Philadelphia under Thomas Eakins 1882-5, and at Académies Julien and Colarossi, Paris 1888-9. Painted principally in Toronto. Taught at Ontario College of Art 1890-1928. OSA 1885, ARCA 1885, RCA 1890, PRCA 1906-7. d. Toronto.

Rho, Joseph Adolphe (1835-1905). b. Gentilly, P.Q. Worked in youth as wood sculptor. Studied at École des Beaux-Arts, Paris, 1878 and in Rome c 1885. Thereafter both sculptor and religious and portrait painter. d. Bécancour, P.Q.

Richardson, Edward M. (active in Canada 1863-4). ed. Royal Academy School, London, under Sir George Hayter. Three years on Great Northern Railway survey, western United States. Sketched landscapes in water-colour in British Columbia.

Richeterre. *See* Dessailliant

Rindisbacher, Peter (1806-34). b. Switzerland. Emigrated to Selkirk's Red River Colony via Hudson Bay 1821. Painter of western life in water-colour at Red River to 1826, in Wisconsin 1826-9, then at St Louis. d. St Louis.

Riopelle, Jean-Paul (1923-). b. Montreal. Associated in youth with *Automatistes* led by Borduas. Lived principally in Paris since 1947, but travelled extensively. Achieved international reputation in *Tachisme* or 'action painting.'

Roberts, H. Tomtu (c 1858-1938). b. Wales. Emigrated to Vancouver 1886. Painted small oil landscapes of early Vancouver. d. Vancouver.

Roberts, W. Goodridge (1904-1974). b. Barbados. Youth in Fredericton. Studied at École des Beaux-Arts, Montreal, and Art Students League, New York under John Sloan and Boardman Robinson. Lived in Ottawa, Kingston, and Montreal. ARCA 1952, RCA 1956. d. Montreal.

Robinson, Albert Henry (1881-1956). b. Hamilton. Studied with John S. Gordon at Hamilton Art School, at Académie Julian and École des Beaux-Arts, Paris, and in United States. Closely associated with A. Y. Jackson. Member Canadian Group of Painters 1933. ARCA 1911, RCA 1920. d. Montreal.

Rogers, Donald Otto (1935-). b. Kerrobert, Sask. Studied at University of Saskatchewan Summer Schools, Saskatoon Teachers College, and University of Wisconsin. Lives in Saskatoon.

Ronald, William (1926-). b. Stratford, Ont. Studied at Ontario College of Art and with Hans Hofmann; living in New York for several years from 1955. Now in Toronto.

Roper, Edward (1857-91). English painter and illustrator who visited Canada several times. Last visit 1887, when lived in British Columbia for some months. Fascinated by pioneer western life and painted numerous canvases depicting settlement in 1880s. Illustrated and published *By Track and Trail Through Canada*, 1891.

Rosenberg, Henry M. (1858-1947). b. New Brunswick, N.J. Studied in Munich with Duveneck, in Venice with Whistler. Moved to Halifax 1897; principal Victoria School of Art and Design 1898-1909. d. Halifax.

Roy-Audy, Jean-Baptiste (c 1785-1845). b. Charlesbourg. P.Q. Carpenter; self-taught painter; professional artist c 1815; itinerant painter in Toronto, Rochester, Montreal, Boucherville, Three Rivers, Quebec. d. Three Rivers.

Ruelland, Ludger (1827-96). b. Saint-Michel (Bellechasse), P.Q., of humble parentage. Studied portrait painting under Théophile Hamel. d. Lévis, P.Q. in straightened circumstances.

Russell, Edward John (1832-1906). b. Isle of Wight. Mercantile clerk in London in youth. Emigrated to Saint John, N.B. 1851; principally painter of ships in water-colour, also illustrator and cartoonist. Lived in Saint John 1851-7, 1862-82, 1890-5, in Fredericton 1857-61; in Boston 1882-9 and 1895 to death.

Russell, G. Horne (1861-1933). b. Banff, Scot. Studied at Aberdeen School of Art and at South Kensington School, London. Came to Montreal 1890. ARCA 1909, RCA 1918, PRCA 1922-6. d. St Stephens, N.B.

Russell, John Wentworth (1879-1959). b. Binbrook, Ont. Studied and lived in Paris c 1906-c 1927. Conducted art school in Toronto after 1932. d. Toronto.

Saint-Charles, Joseph (1868-1956). b. and d. Montreal. Studied with Chabert in Montreal, under Gérôme at École des Beaux-Arts, Paris.

Sandham, J. Henry (1842-1910). b. Montreal. Worked at Notman Photographic Studios, Montreal with Jacobi, Fraser and others; in Saint John, N.B. late 1870s. Studied in England 1880. Successful illustrator, Boston 1888. OSA 1873, RCA 1880. d. in neglect in Eng.

Sawyer, William (1820-89). b. Montreal. Studied in New York, London, Paris and Antwerp 1851-c 1854. Portrait painter in Montreal to 1851, in Kingston after c 1854. Member Montreal Society of Artists 1847, Society of Canadian Artists 1867. d. Kingston.

Schaefer, Carl F. (1903-). b. Hanover, Ont. Studied at Ontario College of Art 1921-4. Taught at Central Technical School, Toronto and Ontario College of Art since 1948. ARCA 1949. Lives in Toronto.

Scott, Charles (1886-1964). b. Newmilne, Ayrshire, Scot. Studied at Glasgow School of Art and in Belgium, Holland, and Germany. Moved to Calgary 1912; subsequently to Vancouver. President of B.C. Society of Fine Arts 1921-2; director of Vancouver School of Art 1925-52. d. Vancouver.

Scott, Marian (1906-). b. Montreal. Studied at school of Art Association of Montreal, École des Beaux-Arts, Montreal, and Slade School, London with Henry Tonks. Lives in Montreal.

Scott, Samuel (1710?-72). b. London, Eng. Close friend of Hogarth. Evidently visited America during Seven Years' War. d. Bath.

Seavey, Julian R. (1857-1940). b. Boston. Studied three years in Paris, Rome, Germany; lived in Hamilton on return to America except 1884-95 when taught in London and St Thomas. Taught at Hamilton Normal School 1908-31. First president, Art Students League, Hamilton 1895. d. Hamilton.

Shadbolt, Jack L. (1909-). b. Shoeburyness, Eng. Studied in London with Victor Pasmore, in Paris with Lhote, and at Art Students League, New York. Lives in Vancouver.

Sheldon-Williams, Inglis (1870-1940). b. and d. England. Studied at Slade School, London, and École des Beaux-Arts, Paris. Lived in Saskatchewan in youth and later taught at Regina College.

Short, Richard (active 1759-61). Served in Royal Navy; visited Halifax; in Quebec garrison 1759-60. Executed topographical views of Halifax and Quebec, twelve of which engraved in London 1761.

Siebner, Herbert (1925-). b. Stettin. Studied in Stettin and at Berlin Academy. Lives in Victoria.

Simpson, Charles W. (1878-1942). b. Montreal. Studied at Art Association of Montreal and Art Students League, New York. ARCA 1913, RCA 1920.

Smith, George N. (1789-1854). b. and ed. Edinburgh. Emigrated to New Brunswick 1824; surveyor. Published St. Andrews *Standard*; wrote for American periodicals. Landscape painter in New Brunswick after 1838; exhibited in Saint John 1840 and 1850; taught drawing, Saint John; lectured on history of art.

Smith, Gordon (1919-). b. Hove, Sussex, Eng. Studied at Winnipeg School of Art, California School of Fine Art, Vancouver School of Art. Lives in Vancouver.

Smyth, Hervey (1734-1811). Grandson of Lord Bristol. Joined British Army 1753; in attack on Louisbourg 1758; aide-de-camp to Wolfe, Quebec 1759. Left army 1769; baronetcy. Sketched series of Canadian views of British campaign in Canada, subsequently engraved by Francis Swaine.

Smyth, William (active 1813-43). Entered British Navy 1813. In Pacific; crossed Andes and Brazil 1831-5. With Capt. Back in Arctic 1836-7. Managed Royal Theatre, taught school; Sketches used in Back's report while wintering in Arctic. In South America 1838-43.

Somerville, Martin (active 1834-55). Painter and drawing-teacher in Montreal; living in Quebec 1855. Exhibited with Montreal Society of Artists 1847. Painted winter scenes of Indians and sleighing incidents in manner adopted by Krieghoff in oil.

Stephenson, Lionel McDonald (1854-1907). b. France. ed. in England and France, where also studied painting. Emigrated to Canada 1885; painted views of Fort Garry in Winnipeg for soldiers serving in Northwest Rebellion.

Surrey, Philip H. (1910-). b. Calgary. Studied at Winnipeg School of Art 1926-7, with F. H. Varley in Vancouver, and at Art Students League, New York. Travelled in Europe and Orient. Lives in Montreal.

Suzor-Coté, Aurèle de Foy (1869-1937). b. Arthabaska, P.Q. Assisted Maxime Rousseau in church decoration at Arthabaska. Studied at École des Beaux-Arts and Académies Julian and Colarossi, Paris, 1890-3. Subsequently in Paris for varying periods. In Montreal after 1908, at Arthabaska in summers. ARCA 1911, RCA 1914. d. Daytona Beach.

Tanabe, Takao (1926-). b. Prince Rupert, B.C. Studied at Winnipeg School of Art, Brooklyn Museum of Art, and Tokyo University of Fine Arts. Taught at Vancouver School of Art 1961-8, and Banff School of Fine Arts from 1973.

Thomson, Tom (1877-1917). b. Claremont, Ont. Youth near Owen Sound. Commercial artist in Seattle, 1901-5, at Grip Studios and Rous and Mann, Toronto 1905-14. Principally landscape painter, sketched in Algonquin Park in summer, painted canvases in Toronto during winter. OSA 1914. d. Canoe Lake, Ont.

Thresher, George Godsall (1779-1859). Probably b. England. In Royal Navy; taught art in British Isles; marine painter and teacher New York 1806-12, Philadelphia, and Montreal 1816. Operated Academy of Fine Art at Halifax 1821; moved to Charlottetown 1829, where operated drawing school with his wife. Appointed deputy colonial secretary and registrar of deeds at Charlottetown 1843. d. Charlottetown.

Todd, Robert Clow (1809-1866). b. Berwick-on-Tweed, Eng. Emigrated to Quebec c 1834; decorative painter and carver; lived briefly near Montmorency; moved to Toronto c 1853 to work as decorative artist and mural painter. Taught at Quebec Seminary and Loretto Abbey, Toronto. Painted landscapes and horse-portraits in distinctive, rather dry, linear style.

Toler, Joseph (active 1831-42). Probably son of John G. Toler, Halifax painter and draughtsman. Goldsmith and silversmith 1831; turned to miniature painting; moved to Saint John, N.B. 1838; taught drawing, landscape painting, and portraiture in Saint John from 1840.

Tonnancour, Jacques de (1917-). b. Montreal. Studied at Art Association of Montreal with Goodridge Roberts. Lives at Saint-Lambert, P.Q.

Toupin, Fernand (1930-). b. Montreal. Studied at Mont Saint-Louis, Montreal, École des Beaux-Arts, Montreal, and with Jean-Paul Jérôme. Lives in Montreal.

Tousignant, Claude (1932-). b. Montreal. Studied with Lismer, Tonnancour, Webber, Scott, and in Paris at Académie de la Cloison d'Or and Académie Ronson. Lives in Montreal.

Town, Harold (1924-). b. Toronto. Studied at Western Technical School and Ontario College of Art, Toronto. Lives in Toronto.

Townshend, George, Marquis (1724-1807). Entered British Army 1745; second-in-command to Wolfe, Canadian campaign 1759; took command of army on Wolfe's death, but recalled to England October, 1759.

Triaud, Louis-Hubert (1794-1836). b. London, Eng. of French parentage. Probably spent youth in France; emigrated to Quebec 1819; taught drawing and painting at Ursuline Convent. Friend of Légaré; assisted him in decorating new Théâtre Royal, Quebec, 1832.

Urquhart, Tony (1934-). b. Niagara Falls, Ont. Studied at Albright Art School, Buffalo, and Yale Norfolk Summer School. Lives in London, Ont.

Valentine, William (1798-1849). b. Whitehaven, Cumberland, Eng. Emigrated to Halifax 1818; taught drawing; portrait and landscape painter; house painter and decorator. From 1830 devoted full time to portraiture, visiting various parts of Atlantic provinces. Studied in England 1836; influenced by Sir Thomas Lawrence. Opened first Halifax daguerreotype studio 1844. d. Halifax.

Vanière, Henri (active 1787). Miniature painter, Lower Town, Quebec, 1787; advertised that had studied five years in Paris and worked in sixteen countries.

Varley, Frederick H. (1881-1969). b. Sheffield, Eng. Studied at Sheffield School of Art and Antwerp Academy. Commercial artist, London, Eng. 1904-8, Sheffield 1908-11, Toronto 1912-17. Taught in Toronto and Vancouver. Lived in Toronto after 1945. ARCA 1922. Member Group of Seven 1920, Canadian Group of Painters 1933. d. Unionville.

Verner, Frederick Arthur (1836-1928). b. Sheridan, Ont. Studied in England 1856-60. Fought with British Legion in Garibaldi's army 1860-1. Painted in Canada 1862-80 and thereafter in England except for two Canadian visits. Worked in Toronto and in Northwest, painting Indian life and buffalo. OSA 1872, ARCA 1893. d. London.

Verrier (active in Canada c 1731-45). b. France. Engineer at Louisbourg; designed and constructed fortifications. Returned to France after fall of Louisbourg; assigned to official work on English Channel fortifications; prepared topographical water-colour of Louisbourg.

Vincent, Zacharie (1812-96). b. Lorette, near Quebec; said to be last of Huron Indians of pure blood: Indian name 'Theolariolin.' Studied under Plamondon.

Vogt, Adolphe (1843-71). b. Bad Liebenstein, Ger. Spent childhood in United States. Studied in Philadelphia, Munich, Switzerland 1861-5, Paris 1866-7. Lived in Montreal 1867-70, working for Notman Photographic Studios. Member Society of Canadian Artists 1867. d. New York.

Walker, Horatio (1858-1938). b. Listowel, Ont. First visited Quebec 1870. Worked at Notman Photographic Studios, Toronto 1873 with R. F. Gagen and John A. Fraser. Moved to New York 1878. Returned to Île d'Orléans 1883, but sold paintings principally in New York. RCA 1918. d. Île d'Orléans, P.Q.

Walsh, Edward (1756-1832). b. Waterford, Ire. Lieutenant-surgeon in 49th (Herfordshire) Regt. of British Army 1800; in Montreal, Niagara, and Detroit 1803-5.

Wandesford, James Buckingham (1817-72). b. Scotland. Lived near Goderich, Ont. 1847-c 1855; sawmill operator and itinerant painter. Painted in New York State 1855-60. Moved to California during gold rush; elected first president San Francisco Art Association 1872. d. San Francisco.

Ward, Charles Caleb (c 1831-1896). b. Saint John, N.B. Studied in England under William Henry Hunt 1846. In New York 1880-1. Maintained studios intermittently in Saint John, New York, Boston. Lived in Rothesay, N.B., after 1882.

Warre, Henry James (1818/19-98). b. England or Cape of Good Hope. British army officer in Canada with 14th Buckinghamshire Regt. 1842-6; in New Zealand and Crimea with Wiltshire Regt. Rose to rank of general. Painted water-colour sketches of Quebec and West on secret trip to Oregon Territory 1845-6. d. England.

Watson, Homer (1855-1936). b. and d. Doon, Ont. Worked in Notman Photographic Studios 1874-5. Visited New York 1876-7; painted for a decade in Hudson River School manner. Visited England 1887-90 and later; influenced by Sir George Clausen and Baribizon. OSA 1878, ARCA 1880, RCA 1882, PRCA 1918-22.

Waugh, Samuel B. (1814-85). b. Mercer, Pa. Exhibited as professional at Society of Artists and Amateurs, Toronto 1834. Left Toronto to study in Italy; returned to Philadelphia 1841. Exhibited in Toronto 1847; worked briefly in New York. d. Janesville, Wisconsin.

Wentworth, Thomas Hanford (1781-1849). b. Norwalk, Conn.; reared in Saint John, N.B. Visited England 1805; settled in Oswego, N.Y. 1806. Itinerant portrait-draughtsman; in Saint John, N.B. 1831-42, painting profiles and selling engravings of his own views; daguerreotypist. d. Oswego, N.Y.

Weston, William Percy (1879-). b. London, Eng. Studied at Putney School of Art, London. Emigrated 1909. Taught in Vancouver Schools 1910-46. Member Canadian Group of Painters 1933. ARCA 1936. Lives in Vancouver.

Whale, Robert Reginald (1805-87). b. Cornwall, Eng. Studied in London; influenced by Sir Joshua Reynolds. Lived in Burford and Brantford, Ont. after 1852. OSA 1872, ARCA 1881. d. Brantford.

White, G. Harlow (1817-88). b. and d. London, Eng. Painted professionally from 1839. Farmed in Oro Twp. near Lake Simcoe, Ont. 1871-6. Painted in Toronto 1876-c 1880. OSA 1873, RCA 1880. Landscape painter of Ontario pioneer scenes.

Whymper, Frederick (active 1863-70). b. England. Artist with Western Union Telegraph Expedition in Alaska and western United States 1860s. On Vancouver Island 1863-5 and probably at Norton Sound, Behring Sea 1865-7. Executed landscapes in Victoria; sketched on Waddington Exploration expedition on Vancouver Island.

Wolf, Louis Augustin. *See* Wolff

Wolff (Wolf), Louis Augustin (active 1765-87). b. Germany. University education; sketched as hobby. Came to Canada with Brunswick Troops as clerk in paymaster's department at end of Seven Years' War.

Wood, William John (1877-1954). b. Ottawa. Youth in Port Colborne. Studied at Central Ontario School of Art, Toronto under G. A. Reid and Wm. Cruikshank, and in Boston. Lived in Northern Ontario and Orillia; worked in Midland shipyards. Member Canadian Group of Painters 1933. d. Midland, Ont.

Woodcock, Percy F. (1855-1936). b. Athens, Ont. Studied at École des Beaux-Arts, Paris 1878-84 and with Constant 1884-7. Lived in Brockville, Ont. 1887-1911, then in Montreal. ARCA 1883, RCA 1886. d. Montreal.

Woolford, John Elliott (1778-1866). b. England. With British Army in Halifax, Saint John, N.B. and Fredericton, 1818-58. Amateur landscape and portrait painter, constructed architectural models. d. Fredericton.

Wyers, Jan G. (c 1891-). b. Steendern, Holland. Emigrated to Canada 1916; first painted when guard at prisoner of war camp, Ontario. Has painted continuously in winters since c 1936 on his farm at Windhorst, Sask.

Yarwood, Walter (1927-). b. Toronto. Studied at Western Technical School, Toronto; lives in Toronto.

Young, Thomas (active 1835-47). b. England. Worked chiefly as architect and designer. Member Toronto Society of Arts 1847; painted series of Toronto landscapes in oil; taught both figure drawing and landscape painting.

Notes and Appendices

Notes

In the captions to illustrations, dimensions of most pictures were recorded originally in inches; the metric dimensions in parentheses are equivalents.

CHAPTER 1

1 Nicholas Abraham, 'painter and sculptor,' spent a few months in New France in 1653, returning to Rouen during November of that year. There are no records of paintings which he may have completed in Canada during his visit.
2 Abbé Louis Bertrand de Latour, *Mémoires sur la vie de M. de Laval, premier évêque de Québec* (Cologne, J. F. Motiens, 1761)
3 François Ducreux, *Historiæ Canadensis seu Novæ Françiæ libri decem* (Paris, 1664)
4 Mgr de Baunard, *Vie de la Vénérable Marie de l'Incarnation, Ursuline* (Paris, 1793), 489
5 Christian Le Clercq, *First Establishment of the Faith in New France,* trans. J. G. Shea (New York, 1881), II, 75
6 Pierre-François-Xavier de Charlevoix, *Journal d'un voyage fait par ordre du roi dans l'Amérique Septentrionale* (Paris, 1744), V, 110

CHAPTER 2

1 Claude Picher, 'Ex-Voto Paintings,' *Canadian Art* (Ottawa), July/August 1961

2 John Knox, *An Historical Journal of the Campaigns in North America* (London, 1769), II, 224-5

CHAPTER 3

1 Jules Bazin, 'Le vrai visage de Marguerite Bourgeoys,' *Vie des Arts* (Montreal), XXVI, 14
2 *Ibid.,* 13
3 Gérard Morisset, *La Peinture traditionnelle au Canada français* (Ottawa, 1960), 39

CHAPTER 5

1 François-Alexandre Frédéric, Duc de La Rochefoucauld-Liancourt, *Travels in Canada 1795,* Ontario Archives, 13th Report (Toronto, 1916), 101

CHAPTER 6

1 F. St. George Spendlove, *The Face of Early Canada* (Toronto, 1958), 38
2 L. A. Aylmer, 'Recollections of Canada' (Letters), *Rapport de l'Archiviste de la Province de Québec,* 1934-5, 283-4

CHAPTER 7

1 J. Ross Robertson, ed., *The Diary of Mrs. John Graves Simcoe* (Toronto, 1934), 141
2 Letters of William von Moll Berczy, *Rapport de l'Archiviste de la Province de Québec*, 1940-1, 74
3 *La Vielle Église de Saint-Charles Borromée* (Quebec, 1929)
4 Gérard Morisset, *Peintres et tableaux* (Quebec, 1936-7), I, 102

CHAPTER 11

1 Letter from Krieghoff to the Honourable A. T. Galt, Quebec, 6 March, 1859, in the Public Archives of Canada, Ottawa
2 G. M. Fairchild, Jr, *From My Quebec Scrap-Book* (Quebec, 1907), 126

CHAPTER 12

1 Francis Hall, *Travels in Canada and the United States* (London, 1818), 123
2 J. W. L. Forster, *Under the Studio Light* (Toronto, 1928), 13
3 *Canadian Journal: A Repertory of Industry, Science and Art and a Record of the Proceedings of the Canadian Institute*, I (Toronto, 1853)
4 *Journal of the Board of Arts and Manufactures for Upper Canada*, I (Toronto, 1861), 258
5 *Canadian Journal: A Repertory ...*
6 *Ibid.*

CHAPTER 13

1 Paul Kane, *Wanderings of an Artist among the Indians of North America* (Toronto, 1925), lii
2 George Catlin, *Letters and Notes on ... North American Indians* (London, 1841), I, 2
3 Paul Kane, *Wanderings*, lii
4 *Ibid.*, 19-20
5 *Journals of the Legislative Assembly of Canada*, June 1851, as quoted in Paul Kane, *Wanderings*, xxvi

6 *Canadian Monthly and National Review* (Toronto), XI (1877), 682
7 *Ibid.*, X (1876), 92
8 R. H. Wilenski, *English Painting* (London, 1954), 225
9 *Colonist* (Victoria, B.C.), 25 Feb., 1863

CHAPTER 14

1 Sir John Franklin, *Narrative of a Second Expedition to the Shore of the Polar Sea ...* (London, 1828)
2 Sir John Ross, *Narrative of a Second Voyage in Search of a North-west Passage ...* (London, 1853)
3 Sir George Back, *Narrative of an Expedition in H.M.S. Terror ...* (London, 1838)
4 W. Parker Snow, *Voyage of the Prince Albert in Search of Sir John Franklin* (London, 1851), 249
5 Quoted in National Maritime Museum, *Polar Art* (London, 1950), 6

CHAPTER 15

1 J. H. Long, 'The Age in Which We Live,' *Canadian Monthly* (Toronto), Feb. 1877, 139
2 J. G. Bourinot, *Canada's Intellectual Strength and Weakness* (Montreal, 1893), 2
3 W. Stewart McNutt, *Days of Lorne* (Fredericton, 1955), 137-8

CHAPTER 16

1 *Edinburgh Review*, CXIX (1834), 59
2 Thomas R. Lee, 'An Artist Inspects Upper Canada,' *Ontario History*, L, 212, quoting R. F. Gagen

CHAPTER 17

1 W. A. Sherwood, 'A National Spirit in Art,' *Canadian Magazine*, Oct. 1894, 500
2 Harriet Ford, 'The Royal Canadian Academy of Arts,' *Canadian Magazine*, May 1894, 47

CHAPTER 18

1 Homer Watson to John M. Lyle, 15
Feb., 1933 (Collection of Mrs H. C.
Van Every)
2 From a note in the files of the Na-
tional Gallery of Canada Library
3 Homer Watson to H. McCurry, 18
April, 1934 (Collection of the Na-
tional Gallery of Canada)
4 Undated mss. notes made by Homer
Watson (Collection of Mrs H. C. Van
Every)

CHAPTER 19

1 W. A. Sherwood, 'The Influence of
the French School on Recent Art,'
Canadian Magazine (Toronto), Oct.
1893, 638-41
2 Douglas Brymner to William Brym-
ner, 7 May, 1884. Photostated in the
McCord Museum
3 Douglas Brymner to William Brym-
ner, 31 Jan., 1885
4 Douglas Brymner to William Brym-
ner, 23 May, 1884
5 Canada, Dept of Agriculture, *Report of
Sir Charles Tupper ... on the Colonial and
Indian Exhibition ... 1886* (Ottawa),
1887), 67
6 Canada, Dept. of Agriculture, *Colonial
and Indian Exhibition of 1886* (Ottawa,
1887), 79
7 *Ibid.,* 78
8 Canada, Dept. of Agriculture, *Report
of Sir Charles Tupper ...* , 68
9 Wm. Cruikshank to Edmund Morris,
May 1893 (Collection of the Art Gal-
lery of Ontario)
10 Wm. Cruikshank to Edmund Morris,
10 Oct. 1898 (Collection of the Art
Gallery of Ontario)

CHAPTER 21

1 *Free Press* (Ottawa), 8 March, 1880
2 J. W. Morrice to Edmund Morris, 12
Feb., 1911 (Collection of the Art Gal-
lery of Ontario)

3 J. W. Morrice to Edmund Morris, 30
Jan., 1911? (Collection of the Art Gal-
lery of Ontario)
4 John Russell to Edmund Morris, 1907
(Collection of the Art Gallery of On-
tario)
5 Arts and Letters Club of Toronto, *The
Yearbook of Canadian Art,* 1913 (Toron-
to), 227

CHAPTER 22

1 W. A. Sherwood, 'A National Spirit
in Art,' *Canadian Magazine,* Oct. 1894,
408
2 J. E. H. MacDonald to F. B. Housser,
1925, criticizing his book, *A Canadian
Art Movement;* the letter was never
mailed (Collection of T. MacDonald)
3 Albert H. Robson, *J. E. H. MacDonald*
(Toronto, n.d.), 5, quoting from C. W.
Jefferys' review of the 1911 exhibition
of MacDonald paintings at the Arts
and Letters Club, Toronto, which ap-
peared in the Club's magazine, *Lamps*
4 Lawren Harris, 'The Group of Seven
in Canadian History,' *Canadian Histor-
ical Association, Report of Annual Meeting*
(Toronto, 1948), 5
5 A. Y. Jackson to J. E. H. MacDonald,
5 Oct., 1914 (Collection of T. Mac-
Donald)
6 A. Y. Jackson to J. E. H. MacDo-
nald, 4 Aug., 1917 (Collection of T.
MacDonald)
7 Letter by J. E. H. MacDonald,
'Bouquets from a Tangled Garden,'
Globe (Toronto) 27 Mar., 1916
8 J. A. B. McLeish, *September Gale* (To-
ronto, 1955), 67
9 As quoted in Lawren Harris, 'The
Group of Seven,' 37
10 *Ibid.,* 34
11 Unpublished address delivered by
Fred Amess of Vancouver
12 J. A. B. McLeish, *September Gale,* 123
13 *Ibid.,* 107
14 *Press Comments on the Canadian Section of
Fine Arts, British Empire Exhibition,*
1924-1925
15 *Ibid.,* 28

CHAPTER 23

1 Emily Carr, *Growing Pains, The Autiobi-
ography of Emily Carr* (Toronto, 1946),
355
2 Emily Carr to Eric Brown, 4 Sept.,
1938 (Collection of the National Gal-
lery of Canada)
3 W. P. Weston to the author, 27 June,
1948
4 David Milne to H. McCurry, undat-
ed, *c* 1928 (Collection of the National
Gallery of Canada)
5 *Ibid.*
6 *Ibid.*
7 David B. Milne to D. Buchanan, un-
dated

CHAPTER 24

1 Goodridge Roberts, 'From this point I
looked out,' *Queen's Quarterly,* LX, 316

CHAPTER 25

1 Preface to catalogue, Calgary Allied
Art Centre, *Jubilee Exhibition of Alberta
Paintings* (Calgary, 1955), 5
2 Eric Newton, 'Canadian Art in
Perspective,' *Canadian Art,* XI, 3
(1954), 94-5
3 A. F. Key, 'William Panko,' *Folk
Painters of the Canadian West* (National
Gallery of Canada)

CHAPTER 26

1 Thomas R. Lee, 'Bertram Brooker
1888-1955, *Canadian Art,* XIII, 3, 287
2 Fritz Brandtner to the author, 8 Dec.,
1963
3 Quoted in *L. L. FitzGerald 1890-1956,
A Memorial Exhibition* (National Gal-
lery of Canada, 1958)
4 J. W. G. Macdonald to H. McCurry,
26 Mar., 1937 (National Gallery of
Canada files)
5 J. W. G. Macdonald to H. McCurry,
23 Oct., 1937 (National Gallery of
Canada files)

6 J. W. G. Macdonald to H. McCurry,
22 July, 1938 (National Gallery of
Canada files)

CHAPTER 27

1 S. Morgan Powell's letter of 23 May,
1913 to *The Star,* Montreal, quoted in
John Lyman (Montreal: Montreal Mu-
seum of Fine Arts, 1963)
2 Clarence-A. Gagnon to Eric Brown,
26 May, 1927 (National Gallery of
Canada files)
3 Maurice Gagnon, *Peinture canadienne*
(Montreal, 1945), 86

Selected Bibliography

BOOKS AND PAMPHLETS

Barbeau, C. M. *Cornelius Krieghoff.* Toronto: Macmillan Co., 1934. Pp. 152, illus.
– *Cornelius Krieghoff.* Toronto: The Society for Art Publicatios/McClelland and Stewart Ltd., n.d. Pp. 30, illus.
– *Henri Julien.* Toronto: Ryerson Press, 1941. Pp. 44, illus.
Bell, Michael. *Painters in a New Land.* Toronto: McClelland and Stewart Ltd., 1973. Pp. 224, illus.
Bellerive, G. *Artistes-peintres, canadiens-français: les anciens.* 2 vols. Quebec: Garneau, 1925-26. Illus.
Bourassa, Anne. *Napoléon Bourassa Un Artiste Canadien-Français.* Montreal: n.p., 1968. Pp. 87, illus.
Bourassa, N. *Lettres d'un artiste canadien.* Bruges: Desclée de Brouwer, 1929. Pp. 496.
Brigden, F. H. *Canadian Landscape: Biographical Notes by J. E. Middleton.* Toronto: Ryerson Press, 1944. Pp. 111, illus.
Buchanan, D. W. *Alfred Pellan.* Toronto: The Society for Art Publications/McClelland and Stewart Ltd., n.d. Pp. 30, illus.
– *Canadian Painters.* Oxford and London: Phaidon Press, 1945. Pp. 25, 87 pl.
– *The Growth of Canadian Painting.* Toronto: Collins, 1950. Pp. 112, illus.
– *James Wilson Morrice.* Toronto: Ryerson Press, 1936. Pp. 195, illus.

Carr, Emily. *The Book of Small.* Toronto: Oxford University Press, 1942. Pp. 245.
– *Growing Pains, The Autobiography of Emily Carr.* Toronto: Oxford University Press, 1946. Pp. 381.
– *Klee Wyck.* Toronto: Oxford University Press, 1941. Pp. 154.
Cauchon, Michel. *Jean-Baptiste Roy-Audy 1778-c. 1848.* Quebec: Ministère des Affaires culturelles, 1971. Pp. 121, illus.
Chauvin, J. *Ateliers; études sur vingt-deux peintres et sculpteurs canadiens.* Montreal: Carrier, 1928. Pp. 268, illus.
Colgate, William. *Canadian Art: Its Origin and Development.* Toronto: Ryerson Press, 1943. Pp. 295, illus.
– *C. W. Jefferys.* Toronto: Ryerson Press, 1945. Pp. 42, illus.
– *The Toronto Art Students' League 1886-1904.* Toronto: Ryerson Press, 1954. Illus.
Comfort, Charles. *Artists at War.* Toronto: Ryerson Press, 1956. Pp. 187, illus.
Davies, B. *Paddle and Palette: The Story of Tom Thomson.* Toronto: Ryerson Press, 1930. Pp. 35, illus.
– *A Study of Tom Thomson.* Toronto: Discus Press, 1935. Pp. 141, illus.
Dow, Helen J. *The Art of Alex Colville.* Toronto: McGraw-Hill Ryerson Ltd., 1972. Pp. 231, illus.
Dumas, P. *John Lyman.* ('Collection Art Vivant,' No. 4.) Montreal: Éditions de l'Arbre, 1944. Pp. 52, illus.

Duval, Paul. *Alfred Joseph Casson.* Toronto: Ryerson Press, 1951. Pp. 64, illus.

– *Canadian Drawings and Prints.* Toronto: Burns and MacEachern Ltd., 1952. Illus.

– *Canadian Water-Colour Painting.* Toronto: Burns and MacEachern Ltd., 1954. Illus.

– *Four Decades: The Canadian Group of Painters and their contemporaries, 1930-1970.* Toronto: Clarke, Irwin & Co. Ltd., 1972. Pp. 191, illus.

– *Group of Seven Drawings.* Toronto: Burns and MacEachern Ltd., 1965. Illus.

– *High Realism in Canada.* Toronto: Clarke, Irwin & Co. Ltd., 1974. Pp. 175, illus.

Élie, R. *Paul-Émile Borduas.* ('Collection Art Vivant,' No. 2.) Montreal: Éditions de l'Arbre, 1943. Pp. 64, illus.

Fairchild, G. M. *From My Quebec Scrap-Book.* Quebec: Frank Carrel, 1907. Pp. 316.

Falardeau, É. *Artistes et artisans du Canada.* 4 vols. Montreal: Ducharme, 1940-43. Illus.

– *Un maître de la peinture, Antoine-Sébastien Falardeau.* ('Figures canadiennes.') Montreal: Levesque, 1937. Pp. 165.

Forster, J. W. L. *Sight and Insight.* Toronto: Oxford University Press, 1941. Pp. 176.

– *Under the Studio Light.* Toronto: Oxford University Press, 1928. Pp. 244.

Gagnon, M. *Peinture moderne.* 2nd ed. Montreal: Éditions Bernard Valiquette, 1940. Pp. 152, illus.

– *Alfred Pellan.* ('Collection Art Vivant,' No. 1.) Montreal: Éditions de l'Arbre, 1943. Pp. 56.

Grant, G. M. *Picturesque Canada.* (L. R. O'Brien art editor.) 2 vols. Toronto: Belden Bros., 1882. Illus.

Groves, Naomi Jackson. *A. Y.'s Canada.* Toronto: Clarke, Irwin & Co. Ltd., 1968. Pp. 248, illus.

Hammond, M. P. *Painting and Sculpture in Canada.* Toronto: Ryerson Press, 1930. Pp. 74, illus.

Harper, J. Russell. *Early Painters and Engravers in Canada.* Toronto: University of Toronto Press, 1970. Pp. 376.

– *Paul Kane's Frontier.* Toronto: University of Toronto Press, 1971. Pp. 350, illus.

– *A People's Art: Primitive, Naïve, Provincial and Folk Painting in Canada.* Toronto: University of Toronto Press, 1974. Pp. 176, illus.

Harris, Bess and Colgrove, R. G. P. *Lawren Harris.* Toronto: Macmillan of Canada, 1969. Pp. 146, illus.

Housser, F. B. *A Canadian Art Movement: The Story of the 'Group of Seven.'* Toronto: Macmillan Co., 1926. Pp. 221, illus.

Hubbard, R. H. *An Anthology of Canadian Art.* Toronto: Oxford University Press, 1960. Pp. 187, illus.

– *The Development of Canadian Art.* Ottawa: National Gallery of Canada, 1963. Pp. 137, illus.

– *Tom Thomson.* Toronto: The Society for Art Publications/McClelland and Stewart Ltd., 1962. Pp. 30, illus.

Hunter, E. R. *J. E. H. MacDonald.* Toronto: Ryerson Press, 1960. Pp. 74, illus.

Jackson, A. Y. *A Painter's Country.* Toronto: Clarke, Irwin & Co. Ltd., 1958. Pp. 170, illus.

Jarvis, Alan. *David Milne.* Toronto: The Society for Art Publications/McClelland and Stewart Ltd., 1962. Pp. 30, illus.

Jones, Hugh G., and Dyonnet, Edmond. 'History of the Royal Canadian Academy.' Unpublished typescript, 1933-34. Pp. 101.

Josephy, Alvin M. Jr. *The Artist Was a Young Man. The Life Story of Peter Rindisbacher.* Fort Worth: Amon Carter Museum, 1970. Pp. 102, illus.

Laberge, A. *Peintres et écrivains d'hier et d'aujourd'hui.* Montreal: Private edition, 1938. Pp. 252, illus.

Lefebvre, Germain. *Pellan.* Toronto: McClelland and Stewart Ltd., 1973. Pp. 159, illus.

Lesage, Jules S. *Mélanges.* Quebec: Ernest Tremblay, 1946. Pp. 232.

Les Automatistes. Montreal: *La Barre Du Jour,* Janvier-août 1969. Pp. 369.

MacDonald, Colin S. *A Dictionary of Canadian Artists.* 4 vols. Ottawa: Canadian Paperbacks, 1967-74.

MacDonald, Thoreau. *Group of Seven.* ('Canadian Art Series.') Toronto: Ryerson Press, 1944. Pp. 38, illus.

McInnes, G. *A Short History of Canadian Art.* Toronto: Macmillan Co., 1939. Pp. 125, illus.

McLeish, John A. B. *September Gale.* Toronto: J. M. Dent & Sons, 1955. Pp. 212, illus.

MacTavish, N. *Ars Longa.* Toronto: Ontario Publishing Co., 1938, Pp. 236.

– *The Fine Arts in Canada.* Toronto: Macmillan Co., 1925. Pp. 181 illus.

Magnan, H. *Charles Huot, artiste-peintre, officier de l'instruction publique.* Quebec, 1932. Pp. 42, illus.

Maurault, O. *L'Art au Canada.* ('*Marges d'histoire,*' Vol. I.) Montreal: Librairie d'Action canadienne-française, 1929. Pp. 310.

Mellen, Peter. *The Group of Seven.* Toronto: McClelland and Stewart Ltd., 1970. Pp. 231, illus.

Miller, M. *Homer Watson, the Man of Doon.* Toronto: Ryerson Press, 1938. Pp. 172, illus.

Miner, Muriel Miller. *G. A. Reid, Canadian Artist.* Toronto: Ryerson Press, 1946. Pp. 230, illus.

Morisset, G. *Coup d'œil sur les arts en Nouvelle-France.* Quebec, 1941. Pp. 171, illus.

– *Peintres et tableaux.* ('Les Arts au Canada français.') 2 vols. Quebec: Les Éditions du Chevalet, 1936-37. Illus.

– *La Peinture traditionnelle au Canada français.* Ottawa: Le Cercle du Livre de France, 1960. Pp. 216, illus.

– *La vie et l'œuvre du frère Luc.* ('Collection Champlain.') Quebec: Médium, 1944. Pp. 172, illus.

Morris, Jerrold. *The Nude in Canadian Painting.* Toronto: New Press, 1972. Pp. 89, illus.

Musée du Québec, *Borduas et les Automatistes.* Québec: Ministère des Affaires culturelles du Québec, 1971. Pp. 154, illus.

– *Le Diocèse de Québec 1674-1974.* Quebec: Ministère des Affaires culturelles du Québec, 1974. Pp. 57, illus.

– *Trésors des Communautées Religieuses de la Ville de Québec.* Quebec: Ministère des Affaires culturelles du Québec, 1973. Pp. 199, illus.

National Gallery of Canada. *Thomas Davies c. 1737-1812.* Ottawa: National Gallery of Canada, 1972. Pp. 225, illus.

– *Three Hundred Years of Canadian Art.* Ottawa: National Gallery of Canada, 1967. Pp. 254, illus.

Ostiguy, Jean-René. *Ozias Leduc: Symbolist and Religious Painting.* Ottawa: National Gallery of Canada, 1974. Pp. 224, illus.

– *Un siècle de peinture canadienne 1870-1970.* Quebec: Les Presses de l'université Laval, 1971. Pp. 206, illus.

Pierce, Lorne. *E. Grace Coombs.* Toronto: Ryerson Press, 1949. Pp. 32, illus.

Piers, H. *Artists in Nova Scotia.* ('Nova Scotia Historical Society Collections,' Vol. XVIII, pp. 101-65.) Halifax, 1914.

– *Robert Field.* New York: F. F. Sherman, 1927. Pp. 216, illus.

Price, F. N. *Horatio Walker.* New York and Montreal: Carrier, 1928. Pp. 52, illus.

Reid, Dennis. *A Concise History of Canadian Painting.* Toronto: Oxford University Press, 1973. Pp. 319, illus.

– *The Group of Seven.* Ottawa: The National Gallery of Canada, 1970. Pp. 247, illus.

Robert, Guy. *École de Montréal: situation et tendances.* Montreal: Éditions du Centre de Psychologie et de Pédagogie, 1964. Pp. 152, illus.

– *Pellan: sa vie et son œuvre.* ('Collection Artistes canadiens.') Montreal: Éditions du Centre de Psychologie et de Pédagogie, 1963. Pp. 136.

– *Riopelle.* Montreal: Les Editions de l'Homme, 1970. Pp. 217, Illus.

Robson, A. H. *Canadian Landscape Painters.* Toronto: Ryerson Press, 1932. Pp. 227, illus.

– *Clarence A. Gagnon.* ('Canadian Artists

Series.') Toronto: Ryerson Press, 1932. Pp. 227, illus.

Ross, Alexander M. *William Henry Bartlett: Artist, Author & Traveller.* Toronto: University of Toronto Press, 1973. Pp. 164, illus.

Shadbolt, Jack. *In Search of Form.* Toronto: McClelland and Stewart Ltd., 1968. Pp. 235, illus.

Spendlove, F. St George. *The Face of Early Canada.* Toronto: Ryerson Press, 1958. Pp. 162, illus.

Stevens, Gerald. *Frederick Simpson Coburn, R.C.A.* Toronto: Ryerson Press, 1958. Pp. 72, illus.

Tonnancour, J. G. de. *Goodridge Roberts.* ('Collection Art Vivant.') Montreal: Éditions de l'Arbre, 1944. Pp. 52, illus.

Townsend, William, ed. *Canadian Art Today.* Greenwich: New York Graphic Society, 1970. Pp. 114, illus.

Tweedie, R. A., ed. *Arts in New Brunswick.* Fredericton: Brunswick Press, 1967. Pp. 280, illus.

Vézina, Raymond. *Cornelius Krieghoff.* Ottawa: Editions du Pélican, 1972. Pp. 220, illus.

Viau, Guy. *La Peinture moderne au Canada français.* Quebec: Ministère des Affaires culturelles, 1964. Pp. 93, illus.

Watson, W. R. *Maurice Cullen.* Toronto: Ryerson Press, 1931. Pp. 45, illus.

Williamson, Moncrieff. *Robert Harris, 1849-1919: An Unconventional Biography.* Toronto: McClelland and Stewart Ltd., 1970. Pp. 222, illus.

Withrow, William. *Contemporary Canadian Painting.* Toronto: McClelland and Stewart Ltd., 1972. Pp. 223, illus.

Yearbook of the Arts in Canada, ed. Bertram Brooker. 2 vols. (Vol. I: 1928-29, Vol. II: 1936.) Toronto: Macmillan Co. Illus.

Yearbook of Canadian Art, 1913. (Compiled by the Arts and Letters Club of Toronto: Literature, Architecture, Music, Painting, Sculpture.) London: J. M. Dent & Sons, 1913. Pp. 291, illus.

PERIODICALS

Arts Canada. Toronto. Continuation of *Canadian Art.*

Bulletin des recherches historiques. Lévis, 1895-

Canadian Architect & Builder. Toronto, 1887-95

Canadian Art. Ottawa, 1943-

Canadian Magazine. (Early issues called *Canadian Monthly.*) Toronto, 1872-1939

Canadian Review of Music and Art. Toronto, 1942-

Journal Of Canadian Art History. Montreal 1974-

Maritime Art Magazine. Halifax, 1940-43

Rapport de l'Archiviste de la Province de Québec. Quebec

Royal Society of Canada. Ottawa

Saturday Night. Toronto, 1887-

Vie des Arts. Montreal, 1955-

CATALOGUES OF COLLECTIONS

Catalogues of the following collections have been published:
Fredericton: Beaverbrook Art Gallery
Hamilton: Art Gallery of Hamilton
Kingston: Agnes Etherington Art Centre
Montreal: Art Association of Montreal
Murray Bay, P.Q.: Manoir Richelieu
Ottawa: National Gallery of Canada
Quebec: Hôtel-Dieu Les Ursulines
Saint John: John Clarence Webster Collection of Canadiana (3 vols.)
Saint-Anne de Beaupré, P.Q. (Guidebook)
Toronto: Art Gallery of Ontario. Hart House, University of Toronto. Royal Ontario Museum, Sigmund Samuel Collection
Toronto Public Library, John Ross Robertson Collection (2 vols.)

EXHIBITION CATALOGUES

No attempt has been made to compile a listing of the many exhibition catalogues related to Canadian painting. However, the serious student should avail himself of

the publications of the following: British
Columbia Society of Arts, Canadian Art
Club, Canadian Group of Painters, Can-
adian National Exhibition, Canadian
Society of Painters in Water-Colour,
Group of Seven, Manitoba Society of
Artists, Nova Scotia Society of Artists,
Ontario Society of Artists, Royal Cana-
dian Academy of Arts. The catalogue of
special one-man and other exhibitions
held in the National Gallery of Canada,
the Montreal Museum of Fine Arts, the
Quebec Museum, and those in many
other public art galleries and museums
across Canada are particularly valuable
reference works.

Photographic Credits

Mervyn Ruggles, Ottawa 128
D. Saltmarche, Windsor 164
Robert Taylor, Regina 167
TDF Photographic (Murray Dwan) 167
TDF Photographic (Eberhard Otto) 1, 3, 5, 6, 7, 14, 21, 31,
 33, 34, 59, 72, 74, 75, 80, 96, 99, 100, 107, 110, 116, 119,
 125, 131, 134, 146, 147, 148, 151, 157, 160, 168
Toronto Public Libraries, John Ross Robertson Collection 56
Early Canadian Picture Collections 78
Ron Vickers Ltd, Toronto 95, 115
Williams Bros., Photographers, Vancouver 67

Index

Page numbers in *italic* indicate illustrations; those in brackets indicate biographies.